Development of the Global Film Industry

The global film industry has witnessed significant transformations in the past few years. Regions outside the USA have begun to prosper while non-traditional production companies such as Netflix have assumed a larger market share and online movies adapted from literature have continued to gain in popularity. How have these trends shaped the global film industry? This book answers this question by analyzing an increasingly globalized business through a global lens.

Development of the Global Film Industry examines the recent history and current state of the business in all parts of the world. While many existing studies focus on the internal workings of the industry, such as production, distribution and screening, this study takes a "big picture" view, encompassing the transnational integration of the cultural and entertainment industry as a whole, and pays more attention to the coordinated development of the film industry in the light of influence from literature, television, animation, games and other sectors.

This volume is a critical reference for students, scholars and the public to help them understand the major trends facing the global film industry in today's world.

Qiao Li is Associate Professor at Taylor's University, Selangor, Malaysia, and Visiting Professor at the Université Paris 1 Panthéon-Sorbonne. He has a PhD in Film Studies from the University of Gloucestershire, UK, with expertise in Chinese-language cinema. He is a PhD supervisor, a film festival jury member, and an enthusiast of digital filmmaking with award-winning short films. He is the editor of *Migration and Memory: Arts and Cinemas of the Chinese Diaspora* (Maison des Sciences et de l'Homme du Pacifique, 2019).

Yanqiu Guan is Associate Professor at Beijing Film Academy Modern Creative Media College, Qingdao, China. She has published more than 20 research articles and papers on film producing and entertainment law, including *Research on Film Industry Promotion Law* (Blue Book of Film, 2018).

Hong Lu is a lecturer in the Art and Communication School at Beijing Technology and Business University, Beijing, China. Her research interests are in animation creation and the animation market. She has published more than a dozen papers on Chinese TV animation and the Chinese animation film industry, including *Report on the Development of Chinese Animation Film Industry* (Blue Book of Film, 2019).

China Perspectives

The *China Perspectives* series focuses on translating and publishing works by leading Chinese scholars, writing about both global topics and China-related themes. It covers Humanities & Social Sciences, Education, Media and Psychology, as well as many interdisciplinary themes.

This is the first time any of these books have been published in English for international readers. The series aims to put forward a Chinese perspective, give insights into cutting-edge academic thinking in China, and inspire researchers globally.

Titles in arts currently include:

Establishment of "Drama" Orientation
Transition of the Research Paradigm of Chinese Dramas in the 1920s and 1930s
Zhang Yifan

Embodiment and Disembodiment in Live Art
From Grotowski to Hologram
Shi Ke

China in the Age of Global Capitalism
Jia Zhangke's Filmic World
Wang Xiaoping

A History of Chinese Animation
Edited by Sun Lijun

A History of Chinese Theatre in the 20th Century I
Fu Jin

Development of the Global Film Industry
Industrial Competition and Cooperation in the Context of Globalization
Edited by Qiao Li, Yanqiu Guan and Hong Lu

For more information, please visit www.routledge.com/series/CPH

Development of the Global Film Industry

Industrial Competition and Cooperation in the Context of Globalization

Edited by Qiao Li, Yanqiu Guan and Hong Lu

LONDON AND NEW YORK

First published in English 2021
by Routledge
2 Park Square, Milton Park, Abingdon, Oxon OX14 4RN

and by Routledge
52 Vanderbilt Avenue, New York, NY 10017

Routledge is an imprint of the Taylor & Francis Group, an informa business

British Library Cataloguing-in-Publication Data
A catalogue record for this book is available from the British Library

Library of Congress Cataloging-in-Publication Data
A catalog record has been requested for this book

ISBN: 978-0-367-50823-4 (hbk)
ISBN: 978-1-003-05150-3 (ebk)

Typeset in Times New Roman
by Newgen Publishing UK

Contents

vi *Contents*

Figures

Tables

Contributors

Chao Yu, Assistant Researcher at the Global Film Industry Research Centre, Beijing Film Academy Modern Creative Media College.

Dandan Li, Assistant Professor of Qingdao Binhai College; research area: film industry.

David Wilson, Honorary Doctor/Researcher in Film of the University of Bradford in UK, Guest Professor of the Beijing Film Academy Modern Creative Media College, Qingdao, Director of Bradford (UK) the UNESCO City of Film.

Guanqun Gao, Associate Researcher of the International Film Industry Research Center at Beijing Film Academy Modern Creative Media College. Main research field: Intellectual Property (IP).

Hong Lu, is a lecturer in the Art and Communication School at Beijing Technology and Business University, Beijing, China. Her research interests are in animation creation and the animation market. She has published more than a dozen papers on Chinese TV animation and the Chinese animation film industry, including *Report on the Development of Chinese Animation Film Industry* (Blue Book of Film, 2019).

Korean Film Council (KOFIC) was established on May 28, 1999, with the objective of adopting a Commission based management style composed of nine individual film specialists to discuss Korean film promotion related issues.

Linli Yu, Lecturer at Qingdao Binhai College; main research fields: film art and culture. PhD in Literature and Art Aesthetics from Shandong University.

Lora Yan Chen, Guest Professor at the Beijing Film Academy. President of Hollywood China Media Consulting Co., Ltd.

Luyao Li, Assistant Researcher at the Global Film Industry Research Center, Beijing Film Academy Modern Creative Media College; research area: new media.

Mingsong Li, Researcher at the International Film Industry Research Center of Beijing Film Academy Modern Creative Media College. Director of the film and television production office; research focus: the film industry and film production; has participated in the production of many movies and TV series.

Nannan Li, Associate Researcher at the International Film Industry Research Center, Beijing Film Academy Modern Creative Media College. Master's degree from the University of Nice, France, majoring in media and cultural management. Research interests include cross-cultural communication, European film industry, film distribution and marketing, advertising and exhibition.

Qiao Li, is Associate Professor at Taylor's University, Selangor, Malaysia, and Visiting Professor at the Université Paris 1 Panthéon- Sorbonne. He has a PhD in Film Studies from the University of Gloucestershire, UK, with expertise in Chinese- language cinema. He is a PhD supervisor, a film festival jury member, and an enthusiast of digital filmmaking with award-winning short films. He is the editor of *Migration and Memory: Arts and Cinemas of the Chinese Diaspora* (Maison des Sciences et de l'Homme du Pacifique, 2019).

Shuzhen Sun, Associate Professor, Beijing Film Academy Modern Creative Media College. Senior Accountant. Main research focus: film and television investment and financing, film and television financial management.

Xiaojuan Yan, Researcher at the International Film Industry Research Center, Beijing Film Academy Modern Creative Media College. Major research direction: new media management.

Xingzhen Niu, Associate Professor at Beijing Film Academy Modern Creative Media College. Editor-in-Chief of *Report on Development of Global Film Industry*. Deputy Director of the Global Film Industry Research Center.

Yanqiu Guan, is Associate Professor at Beijing Film Academy Modern Creative Media College, Qingdao, China. She has published more than 20 research articles and papers on film producing and entertainment law, including *Research on Film Industry Promotion Law* (Blue Book of Film, 2018).

Yestin Deng, filmmaker and guest Professor at Beijing Film Academy Modern Creative Media College, Qingdao. Teaching Consultant and Supervisor of New Element International Art Studio in Canada.

Zenghan Zhuang, Researcher at the International Film Industry Research Center, Beijing Film Academy Modern Creative Media College. Bachelor of business administration from Youshi University, South Korea; Master's in finance management, University of East Anglia, UK. Main research direction: film markets.

Zhengshan Liu, Deputy Secretary-General and Director of the national film think tank of Beijing Film Academy, Research Fellow and master tutor; research interests include film development strategy, film public policy and film economics.

Preface

Bin Lu

Since its birth in 1895 as a juggling entertainment, film has gone through 125 years of development. As a cultural art form, it not only affects human society spiritually and culturally and satisfies the needs of entertainment aesthetics in a unique audiovisual way, but also has an important role in the world economy of the twenty-first century. Today, 125 years after its birth, the National Film Think Tank of Beijing Film Academy and the Global Film Industry Research Center jointly analyze and demonstrate the latest film industry data and the film market hot issues worldwide. Based on the research, the *Annual Report on Development of Global Film Industry: Industrial Competition and Cooperation in the Context of Globalization* is now jointly published by Social Sciences Academic Press (China) and Routledge (the UK).

The Chinese version of this book was included in the "Blue Book" series of Humanities and Social Sciences Research of Social Sciences Academic Press. The "Blue Book" series is a platform for annual special research reports on different academic fields, edited and published by Social Sciences Academic Press. Since its establishment in 1998, in more than 20 years, it has published more than 2,000 books in total, becoming a well-known book imprint in the field of humanities and social sciences. The *Blue Book of Film: Annual Report on Development of the Global Film Industry* is such a research achievement launched by the Humanities and Social Science Think Tank Platform. Based on the real-time dynamic data collection and monitoring of the development status and hot issues of the world film industry, it analyzes and predicts the development trends of film industries in different nations and regions, applying the unique perspectives and empirical research methods of Chinese and foreign experts and scholars, with the characteristics of comprehensiveness, internationalism and continuity. In contrast to the yearbooks and annual reports, it comprehensively absorbs the advantages of professional journals, monograph books, papers, and other publishing forms, emphasizing originality, empirical research, forward-looking timeliness and authority. In the process of compiling and editing, we invited experts and scholars all over the world to write film-themed articles, making this book a brainstorming session, a collection of suggestions that can be applied in policy research

instead of pure academic research. This form provides a powerful information resource and information carrier for the promotion of the global integration of film production, education and research as well as the cooperation and development of the international film industry.

This book is the first volume compiled by more than 20 experts and scholars from China, the United States, Canada, the United Kingdom, France, Australia, and South Korea. Contents include: The Development of the Global Film Industry, the World Film Industry Index Research Report, the Development of the North American Film Industry, the Development of the European Film Industry, the Development of the Latin American Film Industry. Among the chapters, the Development of the Chinese Film Industry, the Development of the South Korean Film Industry, Challenges and Opportunities for the British Film Industry were respectively written by experts from UNESCO City of Film winners in China, South Korea, and the United Kingdom. The book also emphasizes Chinese film production, Chinese animated films, the integrations of the Internet and films, online drama-derived film operations, copyright of films adapted from online literary works, cinema operations and other hot issues.

We expect that due to the combination, diversity, and annual update form, this book can be a powerful carrier for promoting information exchange and communication in the international film industry, promoting interactive cooperation among film industry members, governments, international organizations, industrial associations, academic institutions, and other interested parties. In a word, this book is expected to make a significant contribution to the Chinese film standing on the international stage, serving the world film industry, and will contribute to the integrated development of the global film industry.

Beyond being a book itself, it is also a think-tank platform project, using industry-academia-research resources. Based on the Global Film Data Collection Center, through database construction and data statistical analysis, a set of scientific quantitative research and analysis methods is formed to provide data support services for teaching and scientific research, and use this as a carrier and focus to strengthen contacts, exchanges and cooperation with industrial institutions, such as enterprises, government departments, film and television companies, academies and research institutes. Through exchanges and cooperation with various film industries, academia and research institutes in the world, we strive to make it an important information carrier for global film cultural exchange and the promotion of industrial cooperation.

Regarding the successful publishing and distribution of the first English version of *Development of the Global Film Industry*, as the Executive Director of this book, I would like to express my sincere thanks to the "Blue Book" series platform set up by the Social Science Academic Press (China). Thank you for many years of guidance and support on this book. Also, thank you to but not limited to the following people and organizations.

First, from 2004 to 2017, the editor-in-chief team from the Film and Television Animation Industry Economic Research Institute, Beijing Film Academy published *Annual Report on China Animation Industry* for 14 years in a row, which accumulated rich experience and data.

Second, UNESCO awarded Qingdao the title of the ninth City of Film on 31 October 2017, which has given Qingdao, the city with a history of 110 years of commercial cinema, an important obligation to lead China to be a movie power in the world. Just in time, the editor-in-chief team of the Film and Television Animation Industry Economic Research Institute, Beijing Film Academy came to Qingdao, set up the Global Film Industry Research Center, and began to research the integration and development of the global film industry.

Third, the Chinese version of this book was included in the Academy of Social Sciences "Thirteenth Five-Year" publishing project "Blue Book" series of Social Sciences Academic Press. The launch of the book was held at the National Film Festival, Shanghai Cooperation Organization (SCO) Qingdao Summit. At the SCO National Film Festival, the book attracted national news media, becoming a highlight of the festival. The China News Agency, one of the national news agencies, reported "The *Report on Development of Global Film Industry*: Digital technology opens the 'silver era' of the global film industry to China and other countries," available at: China.com. People.com, Youth.cn, CCTV.com, 1905.com and other national websites also reported the conference. Once published, the Chinese version of this book has been listed No. 1 bestseller in the film industry category on Amazon.

Fourth, with the guidance, cooperation and help of UNESCO, the International Council for Film, Television and Audiovisual Communication (ICFT), UNESCO Chinese Representatives, the editorial team of this book has made close academic liaison with 18 Cities of Film from 17 countries. At the 13th UNESCO Creative Cities Network Conference in Fabiano, Italy, in 2019, David Wilson, the Director of the Bradford Film Office, UK, in the name of the Chairman of International Expert Advisory Committee of this book, has recommended the book to every delegate of the UNESCO City of Film. The book won high praise and the recognition of co-research and collaboration, making this book an international cooperation project by UNESCO world City of Film.

In the era of competition and integration, we deeply feel the great responsibility of promoting the integration and cooperation of the global film industry. In view of this, we planned and launched the English version of *Development of the Global Film Industry.*

We believe that this book will inform the world of the current developments in the film industry in North America (especially in Hollywood), Europe, and the Asia-Pacific region, and the latest developments in the Chinese film industry. State film authorities can produce scientific policies for the development of the film industry using our comparative analysis, research data and case studies; film companies can fully understand the development trends

of the international film industry and the market dynamics; professional scholars can obtain real-time development information and data on the world film industry; film artists can have the chance to understand and enter international film festivals by making outstanding film works; every film fan can feel the charm of films, the unique world language, in a higher and broader perspective.

Finally, sincere thanks goes to Routledge (UK) for their cooperation.

Acknowledgments

Bin Lu

The editorial team sincerely thanks Professor Honghai Wang, former Vice President of Beijing Film Academy, Honorary Dean of Beijing Film Academy Modern Creative Media College, for his support, guidance and help in the production of this book. In 2010, with the approval of the China Ministry of Education, Professor Wang pioneered the establishment of the first independent college of the Beijing Film Academy in Qingdao. He strongly supports this research, approved the establishment of the Global Film Industry Research Center and made great contributions to the process of Qingdao winning the UNESCO World City of Film award in 2017. In 2018, at the National Film Festival, Shanghai Cooperation Organization (SCO) Qingdao Summit, he hosted the launch of the Chinese version of this book, which was the signal to start compiling and publishing the international scientific research project.

Heartfelt thanks to Professor Chenglian Wang, senior Professor at the Beijing Film Academy, Deputy Dean of the Beijing Film Academy Modern Creative Media College. Professor Wang is the founder of higher education in Chinese Film Management, a major that film talents and filmmakers at home and abroad have taken for over 35 years. Professor Wang made great contributions to the process of Qingdao winning the UNESCO World City of Film title in 2017. He personally participated in the editing of the book, and paid the publication fee. There is no doubt that without Professor Wang's dedication, this work would not be completed. The editorial team pays him the highest respect.

Sincere thanks to Professor Jianhong Yu, Deputy Principal, Doctoral Supervisor of the Beijing Film Academy. Professor Yu has served as Director of the Foreign Affairs Office, Director of the International Training Center and Dean of the School of Management, Beijing Film Academy. He has been the President of the Centre International de Liaison des Ecoles de Cinéma et de Télévision (CILECT) for the Asia-Pacific region. Since 2019, Professor Yu has been in charge of the scientific research work of the Beijing Film Academy. He has written articles and used this book for the scientific research project of the Advanced Innovation Center for Future Visual Entertainment, at the Beijing Film Academy, which is one of the strongest supports for this book.

Many thanks to Professor Xingzhen Niu, Associate Professor at the Beijing Film Academy Modern Creative Media College, and Deputy Director of the Global Film Industry Research Center. As a senior expert on the domestic animation industry, Professor Niu has pioneered the database research system of China's animation industry and has hosted many national-level animation industry development research projects. Since 2017, Professor Niu has been researching and compiling the "Blue Book" of film as the editor-in-chief of the *Development of the Global Film Industry*, published by the China Social Science Academic Press. The editorial team expresses their sincere gratitude to Professor Xingzhen Niu.

Many thanks to Dr. Zhengshan Liu, famous economist, Deputy Secretary-General of the National Film Think Tank, Beijing Film Academy. Dr. Liu is one of the main researchers on China's Happiness Index, enjoying the reputation of "the creator of happiness economics". He received his PhD from Dongbei University of Finance and Economics in December 2007 and taught at Beijing Film Academy after his postdoctoral research at Tsinghua University. Since 2017, Dr. Zhengshan Liu has been the editor-in-chief and chief researcher of *Development of the Global Film Industry*, with his works *World Film Industry Index Research Report*, *Report on the Development of Latin American Film Industry* and *Report on the Development of German Film Industry*, which are the solid foundation of this book.

Thanks also to the following people:

Ae-Gyung Shim, film, media and entertainment industry research scholar.

Baiqing Zhang, Researcher and Doctoral Supervisor, former Director of the Film Research Institute of the China Academy of Art. Honorary President of China Film Critics Association. Expert on the Film Review Committee of the State Film Bureau.

Baoguo Cui, Professor and Doctoral Supervisor, School of Journalism and Communication, Tsinghua University. Editor-in-chief of *Development of China Media Industry.*

Bin Lu, Professor and Master's Supervisor at the Beijing Film Academy. Dean of Department of Media Management, the Beijing Film Academy Modern Creative Media College. Director of Global Film Industry Research Center. Editor-in-chief of *The Blue Book of Film: Annual Report on Development of Global Film Industry*.

Brian Yecies, Senior Lecturer, School of Media and Communication, University of Wollongong, Australia.

Celine Curtin, Head of Department of Creative Arts & Media, Galway-Mayo Institute of Technology, Ireland.

Charlotte Crofts, Associate Professor in Filmmaking, Department of Film & Journalism, University of Western England, Bristol, UK. Member of Steering Committee of Bristol City of Film, UNESCO.

Deb Verhoeven, CEO of the Australian Film Institute. Deputy Chair of the National Film and Sound Archive, Australia.

Dong Yu, China Film Elite. Vice Chairman of the China Film Association. Chairman and General Manager of Bona Film Group Co., Ltd.

Francesca Medolago Albani, CEO of the Italian National Association of Multimedia Audio-Visual Image Industry, Italy.

Guangming Hou, Professor and Doctoral Supervisor, former Secretary of the Party Committee, the Beijing Film Academy. Secretary-General of the National Film Think Tank. State Council Special Allowance Expert. Vice Deputy of the China Institute of Management Science. Director of the Film Education and Industrial Development Committee of the China Film Association.

Hong Yin, Professor and Doctoral Supervisor. Director of Film and Television Research Center, School of Journalism and Communication, Tsinghua University. Vice Chairman of China Film Association. Vice Chairman of China Art Critics Association. Vice Chairman of the Beijing Film Artists Association.

Hongmin Wang, Professor at the Beijing Film Academy. Secretary of the Party Committee and Executive Deputy of the Beijing Film Academy Modern Creative Media College.

Hongwei Xu, Deputy Inspector, the Qingdao Bureau of Culture and Tourism (Press, Publication, Radio and Television Bureau, Heritage Bureau). Director of the City of Film Qingdao Office, China, UNESCO.

Juan-José Caballero-Molina, Professor of Cultural Communication, University of Barcelona, Spain.

Jordi Hernàndez-Prat, Professor of Cultural Communication, University of Barcelona, Spain.

Joy Zhu, Guest Professor at the Beijing Film Academy Modern Creative Media College. Executive Vice President of New York Film Academy, USA.

Kiyoaki Okubo, Associate Professor of Humanities and Social Sciences, Yamagata University, Japan.

Kulmeet Makkar, CEO of Producers Guild of India.

Lijie Sun, Member of the CPC Qingdao Municipal Committee. Minister of Publicity Department, Qingdao.

Niedja de Andrade e Silva Forte dos Santos, Director of Santos, Brazil.

Peng Lu, Assistant Provost of International Programs at Florida International University, USA. American science fiction screenwriter.

Shouguang Xie, President of Social Sciences Academic Press, Chinese Academy of Social Sciences. Secretary-General of the Chinese Sociological Association.

Song Kyoung-won, film magazine columnist of *Cine 21*, South Korea.

Suman Li, Secretary of the Party Committee and Director of the Qingdao Municipal Bureau of Culture and Tourism (Press, Publication, Radio and Television Bureau, Heritage Bureau).

Wei Ji, Professor and Master's Supervisor at the Beijing Film Academy. Director of Film Production Management at the Beijing Film Academy Modern Creative Media College. Senior film producer.

Xiaoxia Lin, Associate Professor and Master's Supervisor at the Beijing Film Academy.

Yang Weng, Deputy Director and Researcher at the Advanced Innovation Center for Future Visual Entertainment, faculty of Management Department, the Beijing Film Academy.

Yanling Li, President of the International Division, Social Sciences Academic Press, Chinese Academy of Social Sciences.

Yuehua Song, President of the Humanities Division, the Social Sciences Academic Press, the Chinese Academy of Social Sciences.

Zhaodun Situ, Professor at the Beijing Film Academy. State Council Special Allowance Expert. Dean of Department of Directing, the Beijing Film Academy Modern Creative Media College.

Zoe Shan, Associate Professor at the Beijing Film Academy. French film scholar.

Thanks also to the following translators:

Andrew Edward Bailey, expert in English Literature and History of Art. Former Librarian for the London Borough of Lewisham.

Hong Lu, Lecturer in the Art and Communication School at Beijing Technology and Business University.

Jeannette Pope, Professor at the Beijing Film Academy Modern Creative Media College.

Linna Bao, Lecturer at the Beijing Film Academy Modern Creative Media College.

Lei Li, Lecturer at the Beijing Film Academy Modern Creative Media College.

Qiao Li, Associate Professor at Taylor's University, Selangor, Malaysia. Visiting Professor at the Université Paris 1 Panthéon-Sorbonne.

Shang Zhang, CIIC Qingdao Economic & Technical Cooperation Co. Ltd., Human Resource Management Consultant.

Tong Wu, Lecturer at the Beijing Film Academy Modern Creative Media College.

Xu Han, Lecturer at the Beijing Film Academy Modern Creative Media College.

Xingzhen Niu, Associate Professor at the Beijing Film Academy Modern Creative Media College.

Ying Wang, Professor at the Beijing Film Academy Modern Creative Media College.

Yanqiu Guan, Associate Professor at the Beijing Film Academy Modern Creative Media College.

Zhen Fang, Lecturer at the Beijing Film Academy Modern Creative Media College.

Zenghan Zhuang, Lecturer at the Beijing Film Academy Modern Creative Media College.

1 The development of the global film industry between 2017 and 2018

Xingzhen Niu

Interpretation of the global film industry data

Total global box office

Global box office: scale and growth

According to statistics from the internationally renowned market research company comScore, in 2018, the global box office totaled US$41.1 billion, its highest ever record. This was an increase of 1.48 percent compared with that of 2017, but the growth rate slowed down. According to the statistics, in the past ten years, the global box office has continued to grow. The global box office growth rate was 4.02 percent in 2008–2018 (Figure 1.1).

Global box office: regional structural changes

The data show that benefiting from the double increase in the viewing numbers for movies (1.3 billion), the box office in North America totaled US$11.9 billion in 2018 (Figure 1.2), a record high in recent years. The Chinese film market had also contributed significantly to the growth of the global box office in 2018. According to the data released by the Chinese National Film Bureau, the total box office of Chinese movies in 2018 was 60.976 billion yuan, and the number of people watching movies reached 1.72 billion, up 9 percent and 6 percent respectively compared with that of 2017.

From the regional perspective, the box office (US$11.9 billion) in North America (hereafter referred to as the US and Canada) increased by 7 percent in 2018 compared with 2017, while the total box office in other regions (US$29.2 billion) declined 1 percent, accounting for 71 percent of the global box office, which is down 2 percent from 2017. Of them, the box office in the Asia-Pacific region (US$16.7 billion) was up 5 percent from 2017, and the main driving force is China; the box office in Europe, the Middle East and Africa (EMEA) was down 3 percent from 2017, mainly due to the decline in box office in Germany and Russia. After a 21 percent increase in 2017, the box office in Latin America fell by 21 percent in 2018, and in Brazil fell

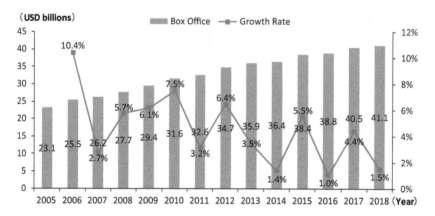

Figure 1.1 Global box office and growth rate, 2005–2018.

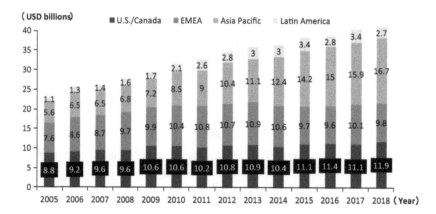

Figure 1.2 Regional structure of the global box office, 2005–2018.

by 22 percent on a yearly basis, and the currency depreciation in Argentina (-41 percent) and Mexico (-2 percent) further intensified an overall decline in the box office in Latin America. In terms of long-term development, the growth of the box office in North America and Europe, the Middle East and Africa has slowed down and even stagnated in recent years, while the Asia-Pacific region has shown rapid growth. Emerging markets are becoming the driving force for the global box office growth. Since the Asia-Pacific region replaced North America in 2013 as the world's largest ticket market, the gap between the Asia-Pacific region and North America has grown. In terms of regional structure, in 2018, the box office in the Asia-Pacific region accounted for 40.6 percent of the global box office, North America accounted for

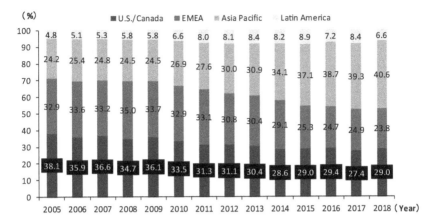

Figure 1.3 Regional structure share of global movie box office, 2005–2018.

29 percent, Europe, the Middle East and Africa accounted for 23.8 percent, and Latin America accounted for 6.6 percent (Figure 1.3).

Global box office: changes in terms of national structure

In 2018, the top three global box office markets (excluding the US and Canada) were China (US\$9 billion, including online ticketing fees), Japan (US\$2 billion) and the United Kingdom (US\$1.7 billion), the same as 2017; Malaysia and the United Arab Emirates replaced Argentina and Turkey, to be ranked in the top 20. In recent years, the pattern of the world's major film markets has also undergone major changes, mainly in the emerging markets represented by the BRICS countries (Brazil, Russia, India, China and South Africa). The previous mature markets are mostly showing slow growth, stable stagnation and even decline. At present, North America is still the world's largest film market. China has replaced Japan as the second largest box office market in the world since 2012. It is now approaching the size of the North American market. China and the United States jointly dominate the global film market. The "G2 pattern" is increasingly appearing (the North American and Chinese markets account for more than 50 percent of the global box office). In 2011, the top ten box office countries (excluding North America) were Japan, China, France, Britain, India, Germany, Russia, Australia, South Korea and Italy. In 2018, the top ten box office countries (excluding North America) were China, Japan, Britain, South Korea, France, India, Germany, Australia, Russia and Brazil. The top ten countries in the total box office from 2011 to 2018 (excluding North America) were China, Japan, Britain, France, India, South Korea, Germany, Russia, Australia and Brazil (Table 1.1, Figure 1.4).

Table 1.1 Top 10 countries with the largest box office revenue, 2011–2018 (excluding North America) (hundred million)

Number	Country	2011	2012	2013	2014	2015	2016	2017	2018	Total
1	China	20	27	36	48	68	66	79	90	434
2	Japan	23	24	24	20	18	20	20	20	169
3	United Kingdom	17	17	17	17	19	17	16	17	137
4	France	20	17	16	18	14	16	15	16	132
5	India	14	14	15	17	16	19	16	15	126
6	South Korea	11	13	14	16	15	15	16	16	116
7	Germany	13	13	13	13	13	11	12	10	98
8	Russia	12	12	14	12	8	7	10	9	84
9	Australia	11	12	11	10	9	9	9	9	80
10	Brazil	—	8	9	8	7	7	9	7	55

Source: Compiled by the author from data in IHS Markit, etc., cited by Motion Picture Association of America.

Note: Brazil was not among the top ten in 2011, the box office there is unknown; in 2018, the Chinese box office includes online ticketing fees.

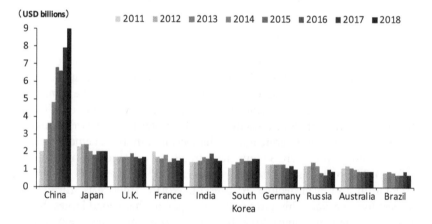

Figure 1.4 Top ten countries with global box office receipts, 2011–2018 (excluding North America).

Global film production output

According to UNESCO's statistics, total global film production in 2017 was 6,442 films, a decrease of 27.08 percent compared with 2016, and a compound growth rate of 1.24 percent compared with 5,559 films in 2005 (Figure 1.5). From a global perspective, 2,324 films were produced in Asia in 2017, accounting for 36.08 percent of the total; in Europe, 2,419 films, accounting for 37.55 percent; in North America, 978 films, accounting for 15.18 percent; in

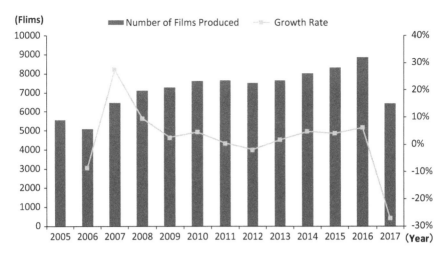

Figure 1.5 Global film production and growth rate, 2005–2017.

Table 1.2 Global film production by continent, 2005–2017

Continent	2005	2006	2007	2008	2009	2010	2011	2012	2013	2014	2015	2016	2017
Asia	2278	2498	2794	3038	3063	3052	3145	3823	3828	3993	4174	4619	2324
Europe	1368	1454	1508	1803	1897	2069	2047	2184	2213	2326	2379	2492	2419
North America	815	826	966	937	917	991	1001	961	965	910	948	951	978
South America	132	175	198	247	247	253	283	316	398	448	504	502	523
Africa	938	98	980	1035	1099	1189	1105	163	178	247	254	205	123
Oceania	28	34	37	45	60	58	68	53	51	72	62	65	75
Total	5559	5085	6483	7105	7283	7612	7649	7500	7633	7996	8321	8834	6442

Source: UNESCO, available at: ⟨http://data.uis.unesco.org/⟩, accessed February 2019.

South America, 523 films, accounting for 8.12 percent; in Africa, 123 films, accounting for 1.91 percent; and in Oceania, 75 films, accounting for 1.16 percent (Table 1.2). Looking at the compound growth rate from 2005 to 2017, South America's compound growth rate (12.16 percent) was the highest, followed by Oceania (8.56 percent), Europe (4.86 percent), North America (1.53 percent), and Asia (0.17. percent), but Africa was (-15.57 percent).

Looking at the developed countries or regions, the OECD (the Organisation for Economic Co-operation and Development) and the BRICS countries have different rates of growth in both film production and global share. The film production of 43 developed countries or regions increased from 2,518 films in 2005 to 3,499 films in 2017, with the proportion increasing from 45.30 percent to 54.32 percent; the film production of the 36 OECD member

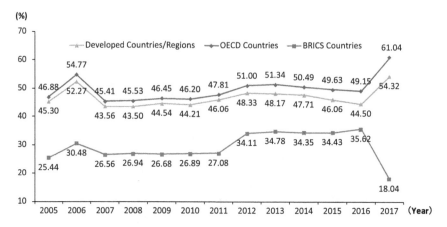

Figure 1.6 Film production proportion of global economies, 2005–2017.

countries increased from 2,606 films in 2005 to 3,932 films in 2017, with the proportion increasing from 46.88 percent to 61.04 percent; film production in the BRICS countries dropped from 1,414 films in 2005 to 1,162 films in 2017, and the proportion dropped from 25.44 percent to 18.04 percent (Figure 1.6). It should be noted that due to the lack of data from Nigeria in 2006 and 2012–2017, the proportion of other countries or regions has been increased. Excluding this factor, in other years, the developed countries or regions, the OECD and BRICS countries have increased to varying degrees compared to 2005.

From 2005 to 2017, the top ten film production countries were: India, the United States, China, Japan, Nigeria, the United Kingdom, France, Germany, Spain, and South Korea. In 2017, the number of US films produced was 791, accounting for 12.28 percent of the total, with a compound growth rate of - 0.48 percent in the past 12 years; China produced 874 films, 13.57 percent, compound growth rate of 10.63 percent; Japan produced 594 films, accounting for 9.22 percent. The compound growth rate was 4.36 percent; the UK produced 285 films, accounting for 4.42 percent, and the compound growth rate was 8.59 percent; France produced 300 films, accounting for 4.66 percent, and the compound growth rate was 2.26 percent; Germany produced 226 films, accounting for 3.51 percent, compound growth rate was 4.47 percent; Spain produced 255 films, accounting for 3.96 percent, with a compound growth rate of 1.88 percent; in 2016, India's film production was 1,986 films, with a compound growth rate of 6.05 percent; South Korea's film production in 2016 was 339 films, with a compound growth rate of 13.16 percent; Nigerian film production increased from 872 films in 2005 to 997 films in 2011, accounting for 13.03 percent to 15.69 percent, with a compound growth rate of 2.26 percent (Figure 1.7).

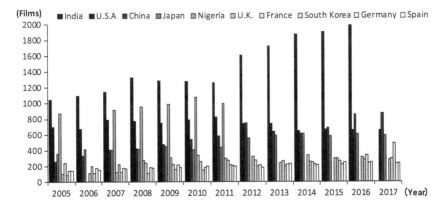

Figure 1.7 Top ten film production countries, 2005–2017.

The spectacle movie boosts the experience economy

Visual pleasure is the essential nature of film

The visual pleasure is the essential nature of film. The history of the spectacle film can be traced back to hundreds of short films by Georges Méliès, and western film scholars have constructed a binary pattern of "narrative spectacle," in which the original meaning of spectacle refers to "the rare and special, unexpected, unpredictable sights and things that are directly perceived by the visual (or audiovisual)." In this sense, all kinds of natural or human characters and storylines that transcend the scope of people's experience can be regarded as movie wonders. There are four main types of spectacle films: (1) action spectacle; (2) body spectacle; (3) speed spectacle; and (4) scene spectacle (Table 1.3). The true movie spectacle was gradually developed along with advances in electronic technology. Especially since the 1970s, with the wide application of computer graphics technology in the film industry, a large number of special effects and strange scenes have become common in science fiction movies, and action and disaster movies. From *Jurassic Park* and *Titanic* to *Avatar*, the extraordinary visual representation manipulated by CGI and special effects highlights the infinite charm of film.

Movie entertainment: an important consumption method in the era of the experience economy

American scholars B. Joseph Pine II and James H. Gilmore proposed that, after the era of the agricultural economy, the industrial economy, and the service economy, human society has now entered the era of the experience economy (Chunjuan, 2015). The experience economy includes four types: (1)

Table 1.3 Four main types of spectacle films

Type	Meaning	Applications
Action spectacle	Thrilling and exciting action attracts people's attention	Cowboy shoot-outs in Westerns, gun battles and stunts in detective movies, strange action design in the science fiction film, Chinese Kung Fu, etc.
Body spectacle	Apply various film means to show human bodies	Female bodies; male masculinity
Speed spectacle	Create special visual effects by speed	The speed or rhythm of the lens, the speed of the object or of the human body, and the superposition and combination of the two speeds
Scene spectacle	Unique scenes of various sceneries and environments	Natural spectacle, human spectacle, virtual spectacle

entertainment experience; (2) educational experience; (3) escape experience; and (4) aesthetic experience. The entertainment experience is a kind of joy and inspiration brought about by participating in or interacting with others. With the development of society and technology, ways of leisure and entertainment vary. With the continuous evolution of the entertainment economy, the entertainment experience has gradually been developed, and an experience economy based on the entertainment experience has emerged. The entertainment experience refers to an economic situation once society has developed to a certain stage, when directly or indirectly the public is entertained by products or services, essentially a manifestation of the spiritual value of material consumption. The core of the entertainment experience is to create the innermost extreme experience. The essence of market competition is actually to compete for people's leisure time.

Movies are the product of modern technology and digital technology has had a major impact on film. Digital production, the distribution and projection technology have greatly enhanced the audiovisual experience of film, especially the special effects films with 4D and 5D special effects technology to bring the audience a new sense of entertainment (in a variety of senses), such as sounds, sight, smell, touch and movement. The spectacle characteristics of film have further promoted the transformation of the film industry from "watching" to "experiencing."

Digital movies made with computer graphics, with their extraordinary spectacle and shocking effects, strong entertainment experience and unique appeal, win extraordinarily high box office receipts around the world. Since the 1990s, *Terminator 2*, *Jurassic Park*, *Independence Day*, *Titanic*, the *Star Wars* series, and the *Harry Potter* series have been popular for their digital effects, the *Lord of the Rings* series, the *Pirates of the Caribbean* series, *Avatar*,

the *Avengers* series, *Transformers 4*, *Captain America 3: Civil War* and others, plus special effects blockbusters, and animated films such as *Aladdin*, *The Lion King*, *Toy Story*, *Shrek 2*, *Toy Story 3*, and *Frozen* have become the global box office champions with a strong entertainment experience and money-attracting ability (Table 1.4).

Sci-fi movies become mainstream movie types

According to the statistics, from 1982 to 2018, North America released a total of 15,827 movies, with a total box office of US$271.168 billion, and an average box office of about US$17.1333 billion for each movie. In terms of genre, they were mostly dramas (2,110), comedies (1,997), documentaries (1,861), and action films (971), with a number of foreign language films (1,814) accounting for 55.30 percent of the total. In terms of box office, the best performers were action movies (US$52.646 billion), comedies (US$37.15 billion), animations (US$27.16 billion), science fiction (US$22.619 billion) and feature films (167.87 billion), accounting for 57.64 percent of the overall box office. From the average box office (by genre), sci-fi (US$56.5229 million), action movies (US$53.9099 million), animations (US$50.3044 million), fantasy (US$49.2617 million) and adventure (US$41.6479 million) were the top (Figure 1.8). It can be seen that the number of dramas, documentaries and foreign language films was large, but the performance was average; the number of comedies and action movies was not only large, but also brought in great box office receipts; the number of science fiction films, animations and adventure films was small, but the box office performance was better.

The number of sci-fi films and fantasy films has grown steadily, with numbers of 23 and 21 in 2018 respectively; the number of animations has increased significantly (73 in 2018). In terms of the box office, animations brought in US$1.617 billion, and the average box office receipt was US$22.1563 million; sci-fi and fantasy films achieved US$704 million and US$481 million, respectively, with an average box office receipt of US$30.601 million and US$22.8851 million, respectively (Figure 1.9).

As one of the mainstream film types, sci-fi films enjoy great success at the box office, and the reason can be traced back to the early black-and-white film *Le Voyage dans la Lune* by Georges Méliès in the early twentieth century. In the course of more than one hundred years of development, sci-fi films have stimulated philosophical thinking about human existence and aroused environmental concern among audiences for the future survival of the planet and future human development through profound sci-fi concepts, while also relying on film technology to create amazing visual wonders, with astounding artistic and great commercial value.

As early as the 1920s, the golden age of American science fiction, sci-fi movies had made great progress, gradually changing from low-level popular B-class films to A-level films with unique and elegant content and form. In the late 1970s, with the emergence of the *Star Wars* series, sci-fi movies, with

Table 1.4 Global box office champions, 1989–2018

Year	Title	Distributor	Global box office (10,000)	Proportion of North America (%)	Proportion of international (%)
1989	Indiana Jones and the Last Crusade	Paramount	47420	41.6	58.4
1990	Ghost	Paramount	50570	43.0	57.0
1991	Terminator 2*	Sony Columbia	51980	39.4	60.6
1992	Aladdin	Disney Buena Vista International	50410	43.1	56.9
1993	Jurassic Park*	Universal	98380	36.3	63.7
1994	The Lion King	Disney Buena Vista International	85860	36.4	63.6
1995	Toy Story	Disney Buena Vista International	37360	51.3	48.7
1996	Independence Day*	Fox	81740	37.5	62.5
1997	Titanic*	Paramount	212890	28.2	71.8
1998	Armageddon	Disney Buena Vista International	55370	36.4	63.6
1999	Star Wars: Episode I - The Phantom Menace	Fox	98360	43.8	56.2
2000	Mission: Impossible II	Paramount	54640	39.4	60.6
2001	Harry Potter and the Sorcerer's Stone	Warner Bros.	97480	32.6	67.4
2002	The Lord of the Rings: The Two Towers*	New Line Cinema	92330	36.8	63.2
2003	The Lord of the Rings: The Return of the King*	New Line Cinema	111910	33.7	66.3
2004	Shrek 2	Dream Works Studios	91980	48.0	52.0
2005	Harry Potter and the Goblet of Fire	Warner Bros.	89690	32.30	67.70
2006	Pirates of the Caribbean: Dead Man's Chest*	Disney Buena Vista International	106620	39.70	60.30

Year	Title	Distributor			
2007	Pirates of the Caribbean: At World's End	Disney Buena Vista International	96340	32.10	67.90
2008	The Dark Knight	Warner Bros.	100300	53.20	46.80
2009	Avatar*	Fox	277720	27.00	73.00
2010	Toy Story 3**	Disney Buena Vista International	106700	38.90	61.10
2011	Harry Potter and the Deathly Hallows: Part 2	Warner Bros.	134150	28.40	71.60
2012	The Avengers	Disney Buena Vista International	151880	41.00	59.00
2013	Frozen**	Disney Buena Vista International	127650	31.40	68.60
2014	Transformers: Age of Extinction	Paramount	110410	22.20	77.80
2015	Star Wars: The Force Awakens	Disney Buena Vista International	206820	45.30	54.70
2016	Captain America: Civil War	Disney Buena Vista International	115330	35.40	64.60
2017	Star Wars: The Last Jedi	Disney Buena Vista International	133250	46.50	53.50
2018	Avengers: Infinity War	Disney Buena Vista International	204650	33.20	66.80

Source: www.boxofficemojo.com/, accessed December 31, 2018.
Notes: *Winner of the Academy Award for Best Visual Effects.
**Winner of the Academy Award for Best Animated Features.

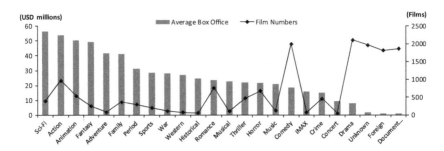

Figure 1.8 Number of major types and average box office receipts in the North American film market, 1982–2018.

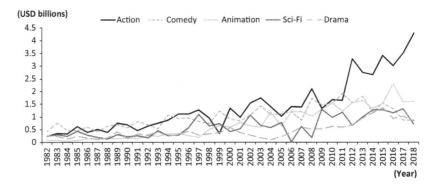

Figure 1.9 North American film market total box office trend of main film types, 1982–2018.

unprecedented innovation and great impact, became the symbol of social popular culture and gained an important role in the film industry. *Star Wars, Star Trek, Terminator, Alien, Back to the Future, Jurassic Park, The Matrix, Transformers, Rise of the Planet of the Apes* and other series of sci-fi movies have won great successes at the box office, constantly renewing the box office record. The global box office of *Avatar* reached US$2.788 billion, making it a great success in the global film industry. The director James Cameron believes that sci-fi movies tell stories of human beings' love and hate for the future of technology. The main attraction of sci-fi films is that it brings a new sense of freshness, and also curiosity about the future and concern for our own destiny.

Sci-fi movies are the main film genre that presents computer-generated images, paying more attention to special effects and spectacular visual presentations. From the earliest *Le Voyage dans la Lune*, through *Earth vs. the Flying Saucers*, to *Transformers*, the new technology continues to strengthen this genre to show new power, new form and new spectacle to the world.

Despite the fact that computer-generated images can be used in all types of modern movies, sci-fi films are still the main genre for special effects technology and spectacular images. A spectacle is usually an event designed specifically for the general public, not for individuals, but for a large number of viewers. Stars, colors, sound design, widescreen and 3D all create a sense of pleasure in a film, but the visual spectacle in sci-fi movies is the specific element of its success. Props, sets and costumes are often enhanced with the help of special effects techniques. Special effects technology sits on the boundary between reality and fantasy. This creates a stunning picture of the world and also makes such a world seem authentic. The sci-fi film realizes the visual and speculative narrative through the novel sci-fi concept and its conceptual design, and creates a stunning visual spectacle using digital production technology.

Reference

Chunjuan, W. (2015). Entertainment Consumption Experience. Beijing: China Economic Publishing House.

2 The global film industry index research report, 2019

Zhengshan Liu

The revision of the theoretical model of the comprehensive index of the film industry

There is no clear definition of the film industry in film scholarship, and a statistical standard for the film industry with relevant statistics does not exist. For instance, the Classification of National Economy Industry (GB/T 4754–2017) used presently by China follows the classification method of the International Standard Industrial Classification (ISIC) of All Economic Activities (United Nations, 2012) issued by the United Nations Statistics Division. According to the classification of the main category, film belongs to "R which includes culture, sport and the industry of entertainment" (ibid.), so film is just part of this category, which is integrated with many other industries. There is a category for broadcasting, television, film and sound recording, but no independent categories for "film production," "film distribution" and "film screening."

In addition, the statistics of the film industry at present are not comprehensive enough because they do not cover all the links in the film industry and many significant parts are missing, such as scriptwriting and the film production-related service sectors, film investment and finance-related sectors, the contribution of film theme parks, film tax, film education and employment in the film industry, etc. In China, the only film output data are found in the *China Statistical Yearbook* but not even box office data are included there.

In order to scientifically evaluate the development status of the film industry, it is necessary to clearly define the extent of the film industry. It is equally important to construct a set of theoretical models, on the basis of which a set of comprehensive film evaluation index systems can be established, in order to conduct a comparative analysis of the developmental status of film industries in many different countries. In the meantime, the availability and representativeness of the data should also be taken into consideration.

The value chain model of the film industry

The value chain theory is often used when analyzing the contents of film production in international film scholarship. Although the definition of the film

value chain varies from one scholar to another, it is generally agreed that the core phases are:

1 Pre-production
2 Production
3 Post-production
4 Distribution and exhibition
5 Film derivatives or peripheral products, etc.

The author of this chapter has considered the actual situation of film industry and has constructed a film industry value chain model which is very close to the actual situation of film industry. The model not only covers the core value chain which includes production, distribution and exhibition and its expansion sectors, but also considers the supporting and constraining elements of the development of film industry. However, there are still flaws in the present model. As a result, on the basis of previous studies, this chapter further extends the film industry value chain and considers that a complete film industry value chain includes pre-production, production, post-production, distribution and exhibition, film derivatives and the film service industry.

The *pre-production stage* involves the planning of the film project, feasibility research and financing. The *production stage* is the phase of filming and production of the film. Post-production is also included in this period. For *film promotion and publicity*, the marketing and distribution of the film are major tasks. The *film construction project* mainly involves the construction of cinemas, film parks and film shooting locations. The *film production industry* includes the equipment manufacture industry, which is related to shooting and exhibition, and the *film service industry*, including the education and training of film agents and talents.

The film industry comprehensive evaluation model

Measuring the development status of the film industry is not what a film value chain model deals with but an issue that the film evaluation theory should describe. We have constructed a film industry comprehensive evaluation model, entitled "Comprehensive Evaluation and Empirical Analysis of Chinese Films" (Zhengshan, 2018), which mainly discusses "the environment and supporting conditions of the film industry," "the film industry scale" and "the efficiency and the influence of the film industry." The film industry comprehensive evaluation model is shown in Figure 2.1.

The film industry's environment and supporting conditions

In theory, the development of the film industry cannot be separated from the economy, policy and environment of the nation. The first element is the environment because the economic foundation is critical. According to "the

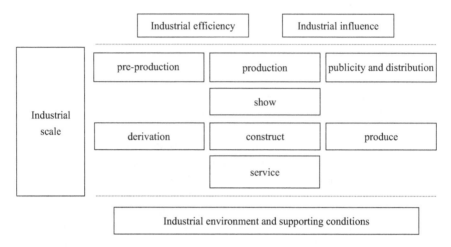

Figure 2.1 The film industry comprehensive evaluation model.

lipstick effect," advanced by earlier research, the film box office increases when the economic situation is in a depression. However, with research and investigation, we found that this effect is not applicable in all cases. On the contrary, the development status of the film industry of a country (measured by overall box office) is positively related to the economic aggregate of that country. The second significant element is policy and regulation. By observing the development status of the film industry in many different countries in recent years, we find that the support of relevant policies and regulations, including all kinds of government grants, financial subsidies, tax reductions and exemptions play a significant role in promoting the film industry of that country or region, for example, the film industry in Germany and South Africa. The third element is technology. It is well known that film is the result of technological progress. In recent years, with the development of "Internet+," online film ticket sales have prospered, and the production process of film is undergoing dramatic changes. In addition, it is highly likely that the development of the latest LED screens will trigger a technology revolution in film screening and exhibition, which will have a strong effect on the development of the film industry.

Besides the elements discussed above, there are some other supporting conditions, such as household consumption. For instance, recent research suggests that "young people from small towns" influence film consumption (see https://baike.baidu.com), and obviously that audiences are vital to a film's performance at the box office. In other words, the box office is influenced by the choices of the moviegoers. Although we do not fully agree with the earlier statement regarding the relationship between film consumption and "young people from small towns," public demand is indeed the determining factor of a film's performance at the box office, which is closely related to the degree of

urbanization, increasing disposable income and the change in residents' consumption structure.

Film industry scale

In theory, the measurement of the film industry scale should include the entire film industrial process, which is the whole film industry value chain, including pre-production, production, publicity, distribution and exhibition and other related film service sectors.

THE PRE-PRODUCTION PERIOD

The pre-production stage involves financing, the preparation period or development. There are an increasing number of channels and a variety of modes in film financing. With regard to channels, there are bank loans, private equity, film funding of special projects, Internet financing and government funding. The mode of financing includes state financing, equity financing, cross-collateral and pre-sales financing.

Project planning, feasibility research and evaluation assess the originality of the film or television project, then develop the screenplay and select suitable projects as alternatives. There is also the verification of the screenplay and confirmation of investments as well as the overall investment scale. Project planning is the film investor's assumption of the film project's marketability before a final decision is made. This involves a macroscopic analysis of the project value and considers whether the target project complies with market needs and the policies, as well as the legal regulations, of the country. In addition, investment value and economic conditions are also taken into consideration. Based on the proposal for the project, the feasibility study takes all of a project's relevant factors into account, and considers the feasibility and rationality of the target project. The project evaluation is the basis for the decision after analyzing and assessing the feasibility study report. It is called the "Green Light System" in Hollywood.

In the project preparation period, after confirming the project, decisions are made about how it is going to proceed. Key members of the production team are confirmed at this stage. Other work in this period includes financing, verification and calculation of the budget, the crew and the shooting duration.

THE PRODUCTION STAGE

This stage includes the establishment of the camera crew, the management of the personnel, the funds and the shooting process. All this is to make sure that the progress of the film's production follows the plan, which sets out the coordination for post-production, the production of the final version after approval by relevant government departments, the cooperation and

negotiation with film distribution and publicity parties, and the preparation for distribution and exhibition.

THE PUBLICITY PERIOD

This period mainly involves film distribution, film marketing and the international film trade. According to different means of transmission, films are distributed through cinemas, the Internet platform, or screening on television. The distribution stage also includes copyrighting audio and video products. Distribution in a narrow sense refers to the way that member cinemas receive the films from their cinema chain and screen them to their moviegoers. This can only happen when a cinema chain obtains the screening rights for a film for its membership cinemas, for a certain period of time from the distribution company that has secured the copyright of the film from the film production company.

Film marketing is the promotional process of film. Publicity for the film includes the creation of a film promotion plan, confirmation of the advertising channels, selection of media partners, the production and presentation of film publicity materials, film premiere ceremonies at film festivals, and all kinds of promotional activities, such as press conferences, star interviews, etc.

Commercial development mainly is a commercial marketing service for its clients, such as product placement and advertisements before the screening of film, and the sponsorship of the film's premiere, etc. The international film trade is the process of importing foreign films and the marketing of domestic films to the overseas market.

FILM EXHIBITION

Film exhibition mainly involves cinema chains and their investment and business activities. The cinema chain companies have developed as independent management units that connect the film distribution team and the film exhibition teams, and ensure the uniformity of film arrangements, operations and management to the member cinemas.

Cinemas mainly provide the screening service and other film-related supporting services, including the sale of products and derivatives or other value-added services.

THE DERIVATIVE MARKET

The derivative marked is based on the development and sales of peripheral products related to film products, such as toys, stage property and souvenirs. Theme parks also belong in this category, for instance, Disneyland in different countries, Universal Studios and others.

FILM CONSTRUCTION, PRODUCTION AND THE SERVICE INDUSTRY

Film construction projects mainly involve the construction of cinemas, film theme parks and film locations. The film production sector refers to the equipment manufacturing sector related to film shooting and screening. The film service sector includes the sales of filmmaking equipment, such as cameras and lamps, etc. and post-production. Also the sales of film screening equipment, such as a digital screening system and stereo system, installation and debugging, after-sales service, the ticketing system of cinemas, the R&D of the management systems, the sales and technology service, and the technology service of the cinema construction project, etc. In addition, it covers film and entertainment brokerage and education and training of film talent.

The efficiency of the film industry

Many scholars of industrial economics have adopted the data envelopment analysis (DEA) model to evaluate industry efficiency. This is a data analysis method based on input and output indexes and applies a linear programming method to conduct a relative efficiency evaluation of the units that are comparable and belong to the same category.

In essence, the DEA model is a kind of optimization algorithm, and what it calculates is the optimal input-output ratio under a constraint condition, so this method could be adopted as a comprehensive evaluation. It is also applicable to the indicators that measure input and output efficiency. For instance, by conducting a literature review from different countries, we can see that the best indicators reflecting film industry efficiency are the gross box office per indoor screen and the admissions per indoor screen.

An objective attitude should be taken toward the gross box office per indoor screen and the admissions per indoor screen. When conducting film industry analysis in cities in China, it is of note that though the box office scale of many cities is not large and there are not many screens, their gross box office takings per indoor screen are even higher than that of some highly developed regions. This is because there are fewer screens in those regions. In conclusion, the commercial film environment of these cities is relatively undeveloped, though the film industry efficiency is very high.

We can also look at the indicators dynamically. For instance, the film industry efficiency of some regions is in flux, but in other regions is stable. This shows that the film industry efficiency of the former is more dynamic than the latter.

The influence of the film industry

Although the analysis shows that a film industry could become the dominant industry of a country or region, it is very difficult for it to become the main pillar industry, because the scale of the film industry is relatively

limited, compared to other industries. For instance, though the film box office in China ranked in second place in the world in 2018 and its box office takings exceeded 60 billion yuan, the production value of the film industry in China is even less than the annual consumption of crayfish of Chinese residents.

However, a small industry can also have significant influence. A national cinema is the carrier of national culture and also reflects a nation's economic power. The influence of the film industry is a very important aspect of this, and we can focus on two indicators: the internal and the external. The internal indicator refers to the domestic box office whose success is critical to the protection and spread of traditional culture. The second indicator is the overseas market. If national films win prizes at international film festivals, national cinema, in this case, becomes a source of soft power.

The comprehensive index and the indicator system in the film industry

Similar to the index in other industries, the basic idea behind the establishment of the comprehensive index and indicator system in the film industry is to turn the multi-indicators directly into data that can be processed by statistical analysis and technology, and to create single data to show the development status of the film industry.

Principles for the design of a comprehensive index for the film industry

In *The Construction and Analysis of the World Film Industry Index* (Zhengshan 2018), the index design principles were discussed Since these principles are relatively constant, they are applicable in this chapter. These principles are:

- The indicator system should possess scientific validity.
- The indicator system should be comprehensive.
- The indicator system should be feasible.
- The indicator system should present comparables.
- The indicator system should reflect the entire dynamic process.

Scientific validity

This means that the selected indicator should correspond to the given evaluation target. It should be able not only to comprehensively reflect the industry being evaluated (to cover as many dimensions of the industry evaluation as possible, for instance, the four dimensionalities selected in this research project) but should also emphasize the core issues. We cannot include all the indicators (except by complicated calculation, while the existence of multicollinearity is possible).

Comprehensive

With more than a hundred years of development, the global film industry has become a comprehensive cultural industry. Therefore, we should follow the principle of comprehensiveness before selecting the indicators which are to be incorporated into all the links of the film industry. These indicators include the production, distribution and exhibition of films. However, comprehensiveness does not mean that we can cover all aspects. Taking the representativeness of the index into consideration, we should adopt a statistical method to conduct a dimension reduction process.

Feasible

When designing the indicator's contents, we should consider not only their scientific validity and comprehensiveness, but also take the availability or feasibility of index data into consideration. In fact, the majority of research institutions have to exclude some ideal indicators because of the lack of research budget, research personnel and data collecting ability. Besides, there are some indicators which are theoretically important but lack relevant statistical data. In this case, we had to exclude such indicators because it is very hard to collect the relevant data. In view of this situation, our previous theoretical model was an ideal model which incorporated almost every aspect that should be considered in a comprehensive evaluation of the film industry. But this theoretical model did not take the availability of the relevant data into consideration. As a result, in the data system outlined in this chapter, only available data are used.

Comparables

The evaluation indicators should reflect the common features of the film industry, which means not only can they measure certain aspects of the film industry but also they can make a horizontal comparison between different regions. Regarding comparability, on the one hand, the data selected are independent (in the sense of statistics); on the other, many of the indicators cannot be compared and or calculated in practice. For instance, box office income is measured by currency unit; however, the number of screens is not a currency unit, so it is meaningless to directly compare these two indicators or compile statistics. Instead, dimensionless methods should be adopted to analyze the indicators.

Entire dynamic framework

The establishment of the index system for the film industry should reflect the entire process of the operation of the film industry. With the rapid advances in technology and the development of new media, the forms of film are

Table 2.1 The comprehensive index and indicator system of the international film industry

First-level indicator	Second-level indicator
Industry environment and supporting conditions	Growth rate of urban and town population
	Per capita GNI
	The proportion of research and development expenditure in GDP
Industry scale	Number of screens
	Box office income
	Admissions
Industry efficiency	Admissions per indoor screen
	Gross box office per indoor screen
Industry influence	Global box office share
	Domestic market occupancy
	Mainstream film festival awards

changing all the time. So, when selecting a comprehensive evaluation index for the film industry, we should have both inclusive thinking and dynamic adjustment. The index system eventually adopted in this study is different from the ones employed in previous studies.

The index and indicator framework of the international film industry

Taking the theoretical model and the index design principles (especially the availability or feasibility of data) of the film industry evaluation into consideration, the index framework of the international film industry in this study is shown in Table 2.1, with two levels. The first-level indicators are the general headings and the second-level indicators probe deeper into the process of film production.

The industry environment and supporting conditions

In theory, the industry environment and the supporting conditions should include the environment, the economy, policy and regulation, technology, and other supporting conditions, such as household consumption, etc. However, taking the availability of the data into consideration, we finally chose the growth rate of city and town populations, the GNI (gross national income) per capita, and the proportion of R&D (research and development) expenditure in gross domestic product (GDP), as the representative indicators. These indicators basically reflect the development of the film industry and supporting conditions. According to the World Bank, per capita GNI is obtained by dividing the gross national income by the mid-year population. GNI is generally made up of three parts, which is the total added value created by all the resident workers, all the product taxes (with

allowances deducted) which are not included in the production value estimation, and the net earnings of original income (salary of employees and property income) from overseas business. The World Bank generally classifies the per capita GNI into high income, middle income and low income. The study reveals that there is strong connection between income level and the development of the film industry, so the per capita GNI is adopted in this study as one of the indicators measuring the potential or the supporting condition of the film industry's development in a country or region. As a matter of fact, Abraham Maslow's Hierarchy of Needs had revealed this connection long ago: It is only when people's income has reached a certain level that the needs of film, which is the kind of product with a relatively large price elasticity of demand, will achieve a breakthrough.

The growth rate of urban and town populations is based on the urbanization rate figures provided by the population predictions of the *World Urbanization Prospects* (United Nations, 2014) and the World Bank. This indicator is also able to reflect the supporting conditions and the environment of film industry development. Under normal conditions, the faster the urban population growth of a country or region, the larger its demand for cultural consumption, such as films.

The proportion of R&D expenditure in GDP (data also from the World Bank) reflects the R&D status of a country or region and is a method of measuring innovation ability. Film is the product of the advances in technology, and the progress of technology is going to further update the film industry. For instance, previous technological progress has brought us color and talking pictures, and contributed to significant advances in the global film industry. Despite competition from television, technological progress such as 3D and IMAX brought consumers back into the cinemas. In South Korea, cinema attendance has increased by around 20 percent due to the installation of LED screens in recent years.

Industry scale

Theoretically, the indicator of industry scale is supposed to include pre-production, production, publicity, distribution and exhibition, derivative products, and film-related sectors, etc. However, as the necessary statistical data for many sectors of the film industry in many different countries are lacking, and it costs too much to investigate and obtain the data, a sample of representative indicators, which can be obtained and evaluated (such as box office income, number of screens, number of moviegoer admissions) have been selected to reflect the size of the film industry. The number of screens is able to directly reflect the hardware ability or supply capacity of the film market of a country or region. The box office income reflects the film industry development of a country or region, and the number of moviegoer admissions is a very important indicator which can objectively reflect the film market size of a country or region, though it partially overlaps with box office income.

Industry efficiency

As mentioned earlier, it is feasible to adopt the two representative indicators of admissions per indoor screen and gross box office per indoor screen. Admissions per indoor screen indicate the utilization efficiency of the screen, and gross box office per indoor screen reflects the efficiency of the film box office income. However, considering the deficiency of these two indicators which was analyzed earlier, their importance in the evaluation is not considerable.

The influence of the film industry

In the analysis, the following elements were used: the domestic market occupancy of native films, indicators such as the awards won by native films in mainstream film festivals or film exhibitions, and the percentage of native film box office at the global box office, to reflect the influence of the film industry of a country or region. The value of the awards given by mainstream film festivals or film exhibitions is rated according to the grade of the awards, such as Academy Awards, awards from the three major film festivals in Europe (Cannes, Berlin and Venice), and awards from A-class international film festivals. For instance, the grade for Best Picture (Academy Award) and Best Foreign Language Film (Academy Award) is 10. The grade for Best Director, Best Scriptwriter, Best Actor in a Leading Role, and the Best Actress in a Leading Role is 6, and the grade for Best Actor in a Supporting Role is 3.

Compiling the comprehensive index of the international film industry

Compilation of the comprehensive index of the international film industry mainly involves the nondimensionalized processing of original data, the weight setting for each indicator, and the final compound calculation of each indicator.

Standardized processing of indicators

Because of the different dimensions of indicators or the different units of measurement that have been selected, standardized processing of the original data has been conducted instead of analyzing the indicators themselves.

The standardized processing of indicator data adopted is as follows:

- With percentage indicators, if the maximum value or target value of the indicator could reach 100 percent, we adopted the observation principle as the standardized value.
- As for indicators which have a unit of measurement, if the indicators are forward pointers (the bigger the better), the equation employed is:

$$Z_i = \frac{X_i}{X_{max}} \tag{2.1}$$

- For indicators which have a unit of measurement, if the indicators are contrary indicators (the smaller the better), the equation employed is:

$$Z_j = \frac{X_{min}}{X_j} \tag{2.2}$$

- If the maximum value of indicators does not possess the above features, the standardized processing of objective indicators that have a unit of measurement will be employed.

All the indicators, after standardized processing, are distributed from 0 to 1, with 1 representing the highest level.

The determination of the weight of an indicator

The weight of an indicator is decided by its degree of importance in its index, which means the more important the indicator, the larger its assignment value. But it is very difficult to reach an agreement as to what kind of indicators are the most important. As a result, each indicators' weight in the index has been adopted on the basis of a combination of subjective weighting and the Delphi method. The weight distribution situation is shown in Table 2.2.

Table 2.2 The indicator weight distribution of the international film industry index

First-level indicator (weight)	(%)	Second-level indicator (weight)	(%)
Industry environment and supporting conditions	25	Growth rate of urban and town population	20
		Per capita GNI	45
		The proportion of research and development expenditure in GDP	(35%)
Industry scale	25	Number of screens	(20%)
		Box office income	40
		Admissions	40
Industry efficiency	20	Admissions per indoor screen	50
		Gross box office per indoor screen	50
Industry influence	30	Global box office share	30
		Domestic market occupancy	30
		Mainstream film festival awards	40

Compound calculation of the comprehensive index

The synthesis score of the entire evaluation system is obtained by totaling all the indicators processed by standardized processing.

The synthetic method of the sub-entry indexes

The sub-entry index is obtained by calculating the numerical value obtained from the nondimensionalization of all the indicators in the certain category and from its weight by applying Equation (2.3).

$$I_i = \frac{\sum Z_j W_j}{\sum W_j} \tag{2.3}$$

The synthetic method of the comprehensive index

The comprehensive index is obtained from the calculation of the numerical value based on the nondimensionalization of all indicators at different levels in the comprehensive index of film industry development and its value by applying Equation (2.4).

$$I = \frac{\sum_{i=1}^{N} Z_i W_i}{\sum_{i=1}^{N} W_i} \tag{2.4}$$

Index calculation results and analysis

Taking the feasibility of data collection into consideration, the analysis of the film industry situation is limited to the top nine countries in the world, showing the top nine box office earnings ranking. The nine countries are China, France, Germany, Japan, South Korea, Russia, India, the United Kingdom and the United States of America. We can obtain the comprehensive index and sub-entry index of the film industry of the nine countries from the indicator framework and calculation method described earlier.

The comprehensive index analysis of the film industry

According to Table 2.3, we can see that the comprehensive index value of the American film industry has continually occupied the first place, and that the country which enjoyed the most dramatic change is China, whose global ranking in the comprehensive index of the film industry in 2017 was in second place, an increase from its ranking of fifth in 2010.

Table 2.3 The comprehensive index of film industry of the nine countries, 2010–2017

Year	China	France	Germany	India	Japan	Korea	Russia	Britain	America
2010	0.28	0.26	0.28	0.41	0.35	0.21	0.17	0.20	0.63
2011	0.31	0.26	0.31	0.42	0.35	0.22	0.19	0.26	0.59
2012	0.31	0.28	0.30	0.41	0.36	0.33	0.16	0.21	0.60
2013	0.35	0.25	0.31	0.40	0.32	0.32	0.18	0.23	0.63
2014	0.39	0.24	0.30	0.37	0.32	0.32	0.17	0.22	0.64
2015	0.47	0.26	0.30	0.37	0.32	0.31	0.13	0.26	0.62
2016	0.45	0.22	0.30	0.39	0.33	0.30	0.12	0.22	0.62
2017	0.48	0.21	0.29	0.39	0.31	0.33	0.14	0.22	0.62

Note: The nine countries are classified into three classes according to K-means.

- Classified by the comprehensive index of 2017, countries in the first class were the United States of America and China. Countries in the second class were France, the United Kingdom and Russia. South Korea, Japan, Germany and India belonged to the third class.
- The classification of the comprehensive index in 2010 is used to compare with the classification in 2017. In 2010, the United States of America was the only country in the first class. Countries in the second class were the United Kingdom, South Korea and Russia. Countries in the third class were France, Germany, Japan, China and India.

Based on the above comparison, the Chinese film industry has been developing rapidly in recent years and has moved from the third class of the global film industry up to the first class in seven years. The situation in other classes is that France was moving up but South Korea was moving down. India remained in the third class, though developing strongly.

In the film industry as a whole, American films were dominant not only in the American film market but also in the global film market, and even had a monolithic status in the film markets of many countries. As a result, the increase in the box office of American films was very steady, and the comprehensive index of American film remained constant in first place in the global ranking.

The UK was the first country to have an industrial revolution, and its economic power was the strongest in the world. However, after the Second World War, the UK was in recession and its film industry was in decline. When Prime Minister Margaret Thatcher was in power, the film industry in the UK was at a low ebb. In 1997, Prime Minister Tony Blair announced a policy for a "creative economy" and began to give support to the creative industries. As a result, the British film industry revived and began to rise again. Until now, according to box office data, the UK has steadily occupied the fourth place, with annual admissions of 170 million people and a yearly frequency of film watching of about 2.7 times per person. Statistics from the British Film Institute (BFI) reveal that the quality of UK film production is consistent

with its status as a major and powerful film country, since the number of awards won in mainstream international film festivals accounts for more than 15 percent of the total number of British films.

The development of the German film industry was not smooth either and was rapidly declining, especially after 2000. Since 2007, a series of policies and regulations regarding the film industry have been launched by the government, and they have contributed to the rise of German films. From 2007 to 2017, Germany produced about 200 films every year on average. Since 2009, the German film industry has entered a phase of steady and mature development. In 2017, the German box office income reached US$1.2 billion, an increase of 5.3 percent compared to the box office in 2016.

Although the box office ranking of France in 2017 dropped from third place to fifth place in comparison with its ranking in 2010, the French film industry was prosperous. The box office of France in 2017 was the third best in the past 50 years, and France was the second largest film exporting country in the world, second only to America. The development of the French film industry was promoted by favorable policies to support French films, including the International Film Production Fund Policy (TRIP) and the international tax reduction policy, which attracted a large number of international production teams to produce their films in France. Both the film quota policy of France regarding reducing the "invasion" of Hollywood films to some extent, and the French films' award-winning performance at international film festivals have contributed to the prosperity of the French film industry.

The South Korean film industry has been continually making progress. In 2010, the South Korean box office ranked eighth in the world, and its ranking went up one place to seventh in 2017. South Korea's film policies to support the film industry were well acknowledged by film academics. However, since the size of South Korean film market is limited, the international influence of South Korean films has slightly declined in recent years.

The success of the Japanese film industry was mainly reflected in its animation films, and the Japanese film industry has been steadily developing. But compared to South Korea's film industry, the pace of overseas market development for Japanese films was not very impressive because of Japan's relatively small national market and certain limitations.

Indian films had an absolute advantage in its domestic market and its film industry is developing steadily. It also had a remarkable performance in film exports. Films such as *3 Idiots, P.K., Dangal, Secret Superstar* and *Toilet – Ek Prem Katha* were familiar to Chinese moviegoers. But, generally speaking, Indian film was still ranked in the third class.

Analysis of the sub-entry index of the film industry

Table 2.4 indicates the sub-entry index result of the film industry environment and the supporting conditions of the nine countries. We can see that all the numerical values of this indicator are relatively stable except for China.

Table 2.4 The sub-entry index of the film industry environment and the supporting conditions of the nine countries, 2010–2017

Year	China	France	Germany	India	Japan	South Korea	Russia	Britain	America
2010	0.52	0.39	0.38	0.29	0.57	0.41	0.16	0.30	0.81
2011	0.57	0.39	0.41	0.31	0.58	0.45	0.19	0.31	0.82
2012	0.59	0.37	0.40	0.30	0.52	0.44	0.21	0.30	0.80
2013	0.61	0.34	0.40	0.29	0.50	0.42	0.17	0.29	0.77
2014	0.63	0.32	0.39	0.29	0.45	0.42	0.17	0.28	0.75
2015	0.64	0.31	0.39	0.29	0.43	0.42	0.15	0.29	0.75
2016	0.64	0.30	0.44	0.30	0.42	0.43	0.15	0.29	0.74
2017	0.66	0.30	0.38	0.29	0.41	0.43	0.14	0.28	0.75

Note: The nine countries were divided into three classes by applying a hierarchical clustering method.

- In 2010, only one country (America) was in the first class. Countries in the second class included Japan and China. Countries in the third class were France, Germany, South Korea, the UK, Russia and India.
- In 2017, the countries in the first class were the USA and China. Countries in the second class were the UK, France, Germany, Japan, South Korea and India. Russia was the only country in the third class.

As shown above, the change in the sub-entry index of the development environment and supporting conditions of the Chinese film industry was the most dramatic. The progress of the Chinese film industry from the second rank to the first rank was closely related to China's steady economic growth, the rapid increase of per capita GNI, and the continuing progress of urbanization. From the correlation coefficient between the comprehensive index and its relative variable, it is seen that the correlation coefficient of per capita GNI of 2017 and the comprehensive index of 2017 is 0.8776, and also that the correlation coefficient of GDP and the comprehensive index of 2017 is 0.8782. The growth in economic power and residents' income has created favorable conditions for the exploration of the Chinese film market's potential, improvement of the film industry's environment, and the guarantee of market support.

As shown in Table 2.5, China's film industry achieved its fastest growth in terms of industry size. In 2017, the index of Chinese film industry scale surpassed the USA and ranked first in the world. It is now expected that the Chinese film box office will have a chance to replace the USA as the first in the world around 2020. By that time, the sub-entry index of the Chinese film industry's size would also be ranked in first place.

It is agreed that the above progress is closely related to the improvement of the policy and the promotion of film infrastructure in China in recent years. For instance, the overall objective of the film industry and the construction

Table 2.5 The sub-entry index of the film industry size of the nine countries, 2010–2017

Year	China	France	Germany	India	Japan	South Korea	Russia	Britain	America
2010	0.13	0.12	0.09	0.50	0.12	0.08	0.07	0.10	0.79
2011	0.18	0.13	0.09	0.51	0.11	0.08	0.08	0.10	0.79
2012	0.23	0.12	0.09	0.52	0.12	0.09	0.07	0.10	0.78
2013	0.31	0.11	0.09	0.51	0.11	0.09	0.09	0.11	0.80
2014	0.48	0.13	0.09	0.51	0.12	0.11	0.10	0.12	0.87
2015	0.65	0.12	0.10	0.50	0.12	0.11	0.08	0.12	0.86
2016	0.67	0.12	0.08	0.52	0.14	0.10	0.08	0.10	0.84

of a public film service system by the end of 2015 were clearly stated in "The Instruction for Promoting the Prosperous Development of the Film Industry" (State Council Office, 2010), issued by the General Office of the State Council. The report to the Eighteenth National Congress of the Communist Party of China in 2012 states that the cultural industry ought to become a pillar industry of the national economy by 2020. In addition, 21 favorable policies and reforms by the Chinese government, such as the introduction of the "Notification of Some Economic Policies Supportive to Film Development" (Ministry of Finance & Ministry of Education, 2014), the implementation of "The Film Industry Promotion Law of the People's Republic of China" in 2017, the institutional reform in the government in 2018, and the incorporation of the National Film Board into the Publicity Department of the Communist Party of China, all provide good foundations and support to the continuing and steady development of the film industry. In 2017, the number of film screens in China surpassed the combined numbers of film screens of both the USA and Canada, and ranked first in the world. In addition, it is clearly stated in "The Opinion about Promoting the Prosperous Development of the Film Market and Accelerating Cinema Construction" (National Film Board 2018), that the construction and investment of cinemas should be encouraged. The number of screens in China will exceed 80,000 in 2020.

It is indicated from Table 2.6 that the sub-entry index of Chinese film industry efficiency was below expectations, and it did not rise alongside the increase in box office revenue or the comprehensive strength of the film industry. It ranked last among the nine countries. In recent years, the development of the Chinese film industry has been characterized by extensive development driven by quantity.

Figure 2.2 shows that the Chinese film industry's efficiency was generally declining after 2010, according to the gross box office per indoor screen, and so one of the major constraining factors in the development of the Chinese film industry was how to improve industry efficiency.

As shown in the sub-entry index of native film influence on the film industry in the nine countries in Table 2.7, the ranking of China was fluctuating, but

Table 2.6 The sub-entry index of film industry efficiency of the nine countries, 2010–2017

Year	China	France	Germany	India	Japan	South Korea	Russia	Britain	America
2010	0.27	0.31	0.74	0.61	0.59	0.15	0.45	0.39	0.27
2011	0.26	0.35	0.75	0.61	0.58	0.17	0.47	0.38	0.28
2012	0.21	0.29	0.72	0.57	0.58	0.64	0.32	0.35	0.26
2013	0.21	0.29	0.74	0.54	0.52	0.67	0.39	0.44	0.28
2014	0.23	0.31	0.72	0.44	0.53	0.68	0.34	0.46	0.28
2015	0.25	0.28	0.73	0.40	0.58	0.62	0.23	0.46	0.29
2016	0.17	0.23	0.65	0.50	0.60	0.54	0.20	0.33	0.25
2017	0.19	0.29	0.71	0.53	0.56	0.67	0.26	0.38	0.28

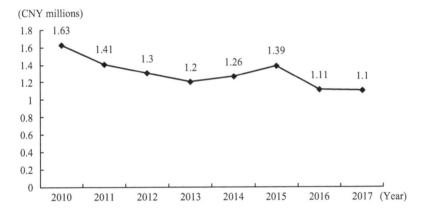

Figure 2.2 The gross box office per indoor screen of China, 2010–2017.

was generally rising. The advantages of China were mainly reflected in the occupancy of the domestic box office and international market share, but the overseas box office of native films was poor, and not as many awards were won at mainstream international film festivals as expected.

The nine countries are divided into three classes by applying the arithmetic of K-means.

- In 2010, America was the only country in the first class. Countries in the second class include the UK, Germany and Russia. Countries in the third class were China, France, India, Japan and South Korea.
- In 2017, America was the only country in the first class. Countries in the second class include Germany and Russia. Countries in the third class were China, France, India, Japan, South Korea and the UK. The comparison shows that France was the only country which has experienced

Table 2.7 The sub-entry index of native film influence of the film industry in the nine countries, 2010–2017

Year	China	France	Germany	India	Japan	South Korea	Russia	Britain	America
2010	0.20	0.22	0.06	0.31	0.20	0.18	0.06	0.09	0.59
2011	0.24	0.21	0.11	0.33	0.20	0.18	0.09	0.29	0.45
2012	0.20	0.35	0.13	0.31	0.27	0.24	0.07	0.12	0.50
2013	0.26	0.25	0.12	0.31	0.21	0.20	0.11	0.13	0.59
2014	0.22	0.21	0.13	0.29	0.24	0.17	0.13	0.11	0.59
2015	0.33	0.33	0.10	0.30	0.20	0.19	0.07	0.21	0.52
2016	0.30	0.22	0.15	0.28	0.23	0.20	0.09	0.18	0.59
2017	0.24	0.16	0.12	0.28	0.20	0.19	0.09	0.17	0.58

some changes in terms of film influence, and other countries generally stayed where they were and did not have any change in their classifications and categories.

Conclusion

Using the earlier evaluation theoretical model of the film industry and the framework of the comprehensive index, the findings have been revised to take account of the new research results, and a calculation and comparative analysis of the comprehensive index of the film industry of the nine countries, whose box office ranked from first to ninth place, have been conducted, by applying the newly collected data.

In terms of the comprehensive index, America had always occupied first place, but China has risen from fifth place in 2010 to second in 2017. Using K-means, the Chinese film industry in 2017 had entered the first class along with America.

Viewed from the perspective of the sub-entry index of the film industry environment and supporting conditions, the change in the Chinese film industry is the most dramatic, and it has entered the first class, but Russia has dropped to third class, which is influenced by the economic development, progress of urbanization and scientific and technological progress in Russia.

Based on the sub-entry index of film industry size, the growth of China is the fastest, and it has surpassed America to be the country whose film industry scale ranks first in the world. As viewed from the sub-entry of film industry efficiency, the ranking of China is below expectations, and it did not rise alongside the increase in the box office or the promotion of the film industry. Basically, it ranks last among the nine countries.

Viewed from the sub-entry index of film industry influence, the nine countries are divided into three classes by applying K-means. By comparing the data of 2017 and that of 2010, it shows that France is the only country which

experienced some changes in film influence and that other countries generally stayed where they were and did not change in ranking.

In addition, we also have verified the relationship between the film industry the comprehensive index and economic strength and found that the correlation coefficient of per capita GNI of 2017 and the comprehensive index of 2017 is 0.8776, and the correlation coefficient of GDP and the comprehensive index of 2017 is 0.8782. This shows that the comprehensive strength of film is consistent with economic strength. With the further development of China's economic strength, as the concentrated reflection of soft power, the film industry is undertaking more important missions. However, the film industry of China needs to make continuous efforts to promote its industry efficiency and international influence.

References

Ministry of Finance and Ministry of Education (2014). "Notification of Some Economic Policies Supportive to Film Development," No. 56. Available at: www.shuangyashan.gov.cn/NewCMS/index/html/newsHtmlPage/20191009/13438824.html.

National Film Board (2018). "The Opinion about Promoting the Prosperous Development of the Film Market and Accelerating Cinema Construction." Available at: www.chinafilms.net/html/cydt/3884.html.

State Council Office (2010). "The Instruction for Promoting the Prosperous Development of the Film Industry," No. 9. Available at: www.gov.cn/zwgk/2010-01/25/content_1518665.htm.

United Nations (2012). "International Standard Industrial Classification (ISIC) of All Economic Activities." Available at: https://unstats.un.org/unsd/classifications/Econ/isic.

United Nations (2014). "World Urbanization Prospects". Available at: https://population.un.org/wup/.

Zhengshan, L. (2018). *The Construction and Analysis of the* World *Film Industry Index*. Beijing: China Film Press, pp. 54–68.

3 The development of the North American film industry in 2018

Lora Yan Chen

The general state of the North American film and television industry

The new trends in the North American film market

Founded in 1922, the Motion Picture Association of America (MPA or MPAA) is a non-profitable organization that provides services for the six major film companies in America. Members of MPAA include the six major Hollywood film production and distribution companies:

1 The Walt Disney Company
2 Universal Pictures
3 Warner Bros. Entertainment Inc.
4 20th Century Fox Film Corporation
5 Paramount Pictures Inc.
6 Sony Pictures Entertainment

As the representative of the six major studios, the work of MPA mainly includes the following aspects: (1) communicating with the government as well as with other industries and businesses; (2) implementing and promoting the relevant laws and policies governing society; (3) protecting intellectual property rights and stopping the pirating of films; (4) investigating the film and television market and commissioning a market survey report of the film and television industry as well as a report on the relations between the film and television industry and the national economy; and (5) giving film gradings.

Every year, the MPAA supervises and produces the market report of global film box office for its member companies and provides detailed data and information on the North American market.

As shown in Table 3.1, the global box office in 2018 reached US$41.1 billion which had increased by 1.5 percent compared to the box office performance of 2017, and by 13 percent compared to the global box office income in 2014. The major reason for the rapid increase in global box office was the dramatic increase in overseas box office income. Although the overseas box office in

Table 3.1 Box office and growth rate in North America and international regions, 2014–2018 (US$100 million)

Regions	2014	2015	2016	2017	2018	Growth rate 1 (%)	Growth rate 2 (%)
North America	104	111	114	111	119	7	14.4
International regions	260	273	274	294	292	–1	12
Total	364	384	388	405	411	1.5	13

Source: Motion Picture Association of America, see (www.mpaa.org/).

Notes: North America refers to the United States and Canada, international regions refer to other countries except North America; growth rate 1 refers to the growth rate of 2018 relative to 2017, while growth rate 2 refers to the growth rate of 2018 relative to 2014.

Table 3.2 Box office and growth rate of the three major international regions, 2014–2018 (US$100 million)

Regions	2014	2015	2016	2017	2018	Growth rate 1 (%)	Growth rate 2 (%)
Europe, the Middle East and Africa	106	97	96	101	98	–3	–8
Asia & Pacific	124	142	150	159	167	5	35
Latin America	30	34	28	34	27	–21	–10
Total	260	273	274	294	292	–1	12

Source: Motion Picture Association of America, see (www.mpaa.org/).

Note: Growth rate 1 refers to the growth rate of 2018 relative to 2017, while growth rate 2 refers to the growth rate of 2018 relative to 2014.

2018 (US$29.2 billion) decreased a little compared with the box office in 2017, it had increased by 12 percent compared to the box office performance in 2014.

It is seen from the comparison of overall box office among different regions in Table 3.2 that the Asia & Pacific region achieved the highest increase rate in overall box office in 2018 (US$16.7 billion), compared with the box office income of the Asia & Pacific region in 2014 (US$12.4 billion). The box office of the region in 2018 increased by 5 percent compared to 2017 and 35 percent compared to 2014, respectively.

It is shown in Table 3.3 that the annual admission numbers of filmgoers in North America in 2018 was 1.3 billion, which was a slight increase compared to 2017 and the average cinema attendance per person was 3.7 times, which also was an increase compared to 2017.

As shown in Table 3.4, the cinema admission numbers in North America were 1.304 billion, which was much higher than the numbers of admission of visitors to theme parks and sports events whose total was 0.552 billion.

Table 3.3 Comparison of the number of people watching movies in North America and the number of times per capita, 2007–2018 (100 million people)

Index	2007	2008	2009	2010	2011	2012	2013	2014	2015	2016	2017	2018
The number of people	14.0	13.4	14.2	13.4	12.8	13.6	13.4	12.7	13.2	13.2	12.4	13.0
Average number of times of attendance	4.4	4.2	4.3	4.1	3.9	4.1	4.0	3.7	3.8	3.8	3.6	3.7

Source: Motion Picture Association of America, see (www.mpaa.org/).

Table 3.4 The participation rates of different entertainment activities in North America, 2009–2018 (100 million people)

Year	Cinema attendance	Number of theme park visitors	The number of people who watch sports in a stadium
2009	14.15	3.42	1.33
2010	13.41	3.39	1.32
2011	12.85	3.50	1.33
2012	13.58	3.59	1.31
2013	13.43	3.71	1.25
2014	12.68	3.79	1.34
2015	13.21	3.88	1.34
2016	13.15	4.10	1.34
2017	12.40	4.14	1.33
2018	13.04	4.21	1.31

Source: Motion Picture Association of America (www.mpaa.org/).

As shown in Tables 3.5 and 3.6, the number of films that have been rated in recent years has been declining. The number of rated films in 2018 was far less than the number of films distributed. In 2018, there were 564 rated films and 758 distributed films, which demonstrated that more unrated art films and documentaries could be seen in cinemas. More independent and low-budget productions have entered the cinema circuit. This is a healthy and ecological trend.

Although the number of films released by the six major film studios has declined year on year in the past 10 years, the total box office revenue is not necessarily lower than before. In 2018, the six major Hollywood companies and their art film brands released a total of 127 films, including those released in 2017 which continue to be released in 2018. Among the top 100 box office films in North America, films released by the six major studios accounted for 78, with a total box office of US$9.67 billion, accounting for approximately 81.3 percent of North America's annual box office. This data clearly demonstrate that the film industry and box office still pose great

Table 3.5 Number of films released in North America, 2007–2018

Type	2007	2008	2009	2010	2011	2012	2013	2014	2015	2016	2017	2018
Number of films released	611	638	557	563	609	678	658	706	707	732	785	758
The number of 3D films released	6	8	18	29	53	56	54	48	39	51	46	42
The number of large screens releases, such as IMAX	11	15	14	16	21	26	32	30	36	42	41	56
The number of films produced by MPAA member companies	107	108	111	104	104	94	84	99	100	101	86	92
The number of films produced by art films brands of MPAA member companies	82	60	47	37	37	34	30	36	47	42	44	35
MPAA member companies' total number of films	189	168	158	141	141	128	114	135	147	143	130	127
The number of films produced by non-members of the MPAA	422	470	399	422	468	550	544	571	560	589	655	631

Source: Motion Picture Association of America, see (www.mpaa.org/).

Table 3.6 The number of films rated in North America, 2007–2018

Type	2007	2008	2009	2010	2011	2012	2013	2014	2015	2016	2017	2018
The number of films produced by MPAA member companies	233	201	177	174	169	166	169	165	167	176	176	166
The number of films produced by non-members of the MPAA	607	696	616	532	589	560	544	543	446	429	387	398
Total	840	897	793	706	758	726	713	708	613	605	563	564

Source: Motion Picture Association of America (www.mpaa.org/).

challenges for independent film production and distribution companies, but in different forms.

Changes in the scale and structure of the US film and television industry

According to the information provided by the US Department of Commerce in early 2019, the market size of the US Entertainment and Media industry (including film and television entertainment and music,

broadcasting, publishing, games and other related industries) in 2018 was US$735 billion, and the trend of this data is continuing to rise. According to PricewaterhouseCoopers, this amount will increase to US$830.6 billion by 2022.

According to the MPAA statistics, in 2010, the box office accounted for a small portion (20 percent) of the total revenue of the American film industry, TV revenue (including cable TV, TVB, pay-per-view TV) accounted for 40 percent, home entertainment audio-visual products accounted for 36 percent. In addition, there was 4 percent of ancillary service revenue, including revenue from broadcasting services provided on cruise ships, airplanes, trains and other transportation forms.

In 2018, the box office in North America was US$11.9 billion, and the total revenue of the home entertainment audio-visual market and digital distribution was US$23.279 billion. In recent years, with the rapid development of digital technology and the popularity of the Internet with high speed streaming, sales of traditional home entertainment DVD and Blu-ray discs in the United States have declined, but sales of digital home entertainment products have been on the rise. Digital home entertainment products include electronic downloads, video-on-demand (VOD) and streaming subscriptions or annual subscription services. In 2018, the sales and rental output value of traditional home entertainment DVD and Blu-ray discs in North America were US$4 billion and US$1.79 billion, a decrease of 14.6 percent and 15.6 percent, respectively, compared to the same period in 2017, and a decrease of more than 50 percent compared to 10 years ago. In 2018, the output value of digital media of home entertainment products reached US$17.46 billion, an increase of 24.3 percent compared to the same period in 2017 (see Table 3.7).

The rapid development of digital technology has brought great challenges to traditional media forms and has had a negative impact on the movie box office, yet digital technology is actually an indispensable aspect in the development of the film industry. Most of the successful movies today use advanced movie technology, and many new technologies appear in movies every year. Films such as *Avatar*, *Jurassic World*, *Avengers: Infinity War* applied many new digital technologies. Some films waited many years before shooting, because it is necessary to wait until the technology has been developed and matured, new visual effects thus can be made. *Alita: Battle Angel* is an example.

Comparison of the development of the six major film and television groups in Hollywood

The six major Hollywood companies are media groups with immense economic and commercial strength. Each of these six companies has its own unique running and operating model. Meanwhile, they also have very similar company frameworks and structures, focusing on using existing resources, developing potentials, reintegrating resources, and making full use of synergies to enable companies to achieve the highest efficiency and maximize

Table 3.7 Total home entertainment expenditures for movies in the United States, 2010–2018 (million US$)

Type		2010	2011	2012	2013	2014	2015	2016	2017	2018
Sales	DVD and Blu-ray disc sales	10321.07	8951.8	8462.18	7779.19	6934.81	6070.17	5490.57	4716.37	4029.87
	Total sales (including streaming sales)	10829.15	9554.65	9270.6	8968.5	8535.79	7976.8	7527.34	6870.1	6494.47
Rent	Monthly subscription (DVD and Blu-ray only)	2309.32 2272.14	1599.21 1741.22	1216.02 1258.09	955.59 1015.06	692.59 793.11	616.27 658.87	488.05 547.57	388.97 454.87	317.08 364.15
	Self-operated rental machines near supermarkets and convenience stores	1269.1	1676.46	1937.77	1895.1	1836.81	1732.24	1514.87	1271.79	1104.62
	Total rental for DVD and Blu-ray	5850.56	5016.88	4411.89	3865.75	3322.51	3007.39	2550.49	2115.63	1785.85
	Including the total rent of streaming media rental	7602.22	6801.31	6424.19	5974.47	5303.9	4975.86	4655.55	4080.86	3872.84
Digital distribution	Streaming media sales	508.08	602.85	808.42	1189.31	1600.98	1906.62	2036.77	2153.72	2464.61
	Single paid streaming video on demand	1751.66	1784.43	2012.3	2108.72	1981.39	1968.47	2105.06	1965.23	2086.99
	Paid monthly streaming video on demand	–	1603.14	2394.73	3190.74	4066.29	5081.88	7286.7	9926.62	12911.9
	Total sales of streaming media and video on demand	2259.74	3990.42	5215.45	6488.77	7648.66	8956.97	11428.53	14045.6	17463.5
Total spending on home entertainment in the United States		18431.38	17959.1	18089.52	18133.71	17905.98	18034.53	19469.59	20877.6	23279.2

Note: The discrepancy between the total and the sum of each item is caused by rounding.
Source: Digital Entertainment Group, see (www.degonline.org/.

Table 3.8 The turnover of the six major Hollywood film and television companies and their parent companies in the fiscal years 2015–2018 (million US$)

Company	Revenues				Operating income			
	2015	2016	2017	2018	2015	2016	2017	2018
Comcast Corporation	74510	80736	85029	94507	15998	16831	18018	19009
NBC Universal Corporation	28462	31276	32836	35761	4819	5333	6177	6490
NBC Universal Pictures Entertainment	7287	6229	7595	7152	1208	615	1167	589
The Walt Disney Company	52465	55632	55137	59434	14681	15721	14775	15706
Walt Disney Pictures Corporation	7366	9441	8379	9987	1973	2703	2355	2980
AT&T Company	146801	163783	160546	170756	20362	23543	19970	26096
Time Warner Group/Warner Media Group	28118	29318	31271	18941	6865	7547	7920	5670
Warner Bros. Entertainment	12992	13037	13866	8703	1416	1734	1761	1477
21st Century Fox	28987	27326	28500	30400	6722	6597	7173	7032
20th Century Fox Film Corporation	9525	8505	8235	8747	1445	1085	1051	962
Viacom Company	13268	12488	13263	12943	3112	2526	2489	2750
Paramount Pictures, Inc.	2883	2662	3289	3041	111	–445	–280	–39
Sony Corporation	68582	72172	68259	80592	572	2620	2592	6594
Sony Pictures Entertainment	7335	8353	8107	9357	488	343	–723	388

Note: the financial years of each company were as follows: SONY Corporation ended March 31, Fox Corporation ended June 30, Walt Disney Company and Paramount Corporation ended September 30, and AT&T and Comcast Corporation ended December 31.

profits. Table 3.8 shows the annual turnovers of the six major Hollywood companies and their parent companies in the 2015–2018 fiscal years. The data is taken from the 10-K[1] statements of each company. The parent company of SONY Pictures Entertainment is SONY Japan, so the company's annual report in the United States was 20-F.

The operating profits of NBC Universal Group and NBC Universal Entertainment were calculated from adjusted EBITDA (earnings before interest, taxes, depreciation and amortization) data, which are used for reference only.

AT&T, one of the largest telecommunications companies in the United States, became the parent company of Warner Media and Warner Bros.

Entertainment in 2018. The structure of Warner Media Group is similar to that of Time Warner Group before the merger with AT&T. The figures in Table 3.8 for fiscal year 2015, fiscal year 2016 and fiscal year 2017 are the financial statements of the Time Warner Group, and fiscal year 2018 is the financial statements of the Warner Media Group. AT&T's fiscal year 2015, 2016 and 2017 results are for reference only, and the company was not associated with the big six in Hollywood at the time.

Companies calculate their profits in different ways, Table 3.8 lists the operating profit data for reference only. The top parent company of SONY Pictures Entertainment is Japan's SONY Corporation. The monetary unit of 20-F statements is the yen for SONY. This report, according to the state foreign exchange, announced the currency conversion rate against the dollar monthly, and the corresponding exchange rate is respectively: 1 yen = $0.00835 (March 31, 2015), = $0.00890 (March 31, 2016), = $0.00895 (March 31, 2017) and = $0.0094 (March 31, 2018).

As mentioned earlier, the six major Hollywood companies are film and television groups with multiple products. Tables 3.8 and 3.9 provide a clearer look at the position of the film division in the companies. Whether running income or revenue, the film division is not the most profitable one of a company. But film is precisely the key product for branding, which is extremely important to the company. Of the six major companies, with the exception of the Sony Corporation, the parent companies of the five companies own mainstream radio and television media groups in the United States. Over the past two or three decades, radio and television media groups have often been the most profitable and relatively stable parts of these film and television giants. So, despite the high risk of film investment, every major company seems to be able to afford it. In the past 10 years, with the emergence and development of streaming media, TV advertising revenue and PAY-TV audiences have been smaller than before, and the profits of broadcast television media have declined. The investment budgets of Hollywood blockbusters become higher and higher, shooting a blockbuster with an investment of US$150 million or more is not rare, and then investing the same size budget for global marketing and distribution. If the box office of this movie is not ideal, the company's affordability is tested. The gaps between the six major companies have also become greater in recent years. From Table 3.8 it is not difficult to find the differences between the companies.

The new status of the streaming media and the progress of Netflix in 2018

Netflix and the streaming media business

2018 was an important year for Netflix and the streaming media business to challenge traditional Hollywood companies, and 2019 was a new starting point for Netflix to become a mainstream media company in Hollywood. In January

Table 3.9 Turnover of Walt Disney Company in fiscal years 2015–2018 (million US$)

Company	Revenue				Operating income			
	2015	2016	2017	2018	2015	2016	2017	2018
Radio and television media group	23264	23689	23510	24500	7793	7755	6902	6625
Theme parks and resorts	16162	16974	18415	20296	3031	3298	3774	4469
Film and television entertainment group	7366	9441	8379	9987	1973	2703	2355	2980
Consumer products and interactive media division	5673	5528	4833	4651	1884	1965	1744	1632
Total	52465	55632	55137	59434	14681	15721	14775	15706

2019, Netflix joined the Motion Picture Association of America (MPAA), becoming one of the seven major Hollywood companies. Compared to the traditional six major Hollywood companies with nearly a century of film production and distribution history, Netflix is a home entertainment industry service company that started out as a DVD rental business. Headquartered in Los Gatos, California, the company was established in 1997, with a history of 20 years. In the first five years after its establishment, the company grew cautiously and followed innovative operating thinking and methods. In 1999, it launched a model that users only pay a dozen dollars a month to watch an unlimited number of DVDs at home, then in 2000 it began to change monthly subscription products to the unlimited time DVD rental model. The fast and cheap DVD rental service provided by Netflix quickly won the favor of many customers. Netflix had also developed from small beginnings to a significant size in a short time. In 2003, it realized an operating profit of US$4.5 million for the first time, and a total revenue of US$270 million, of which the net income was US$6.5 million; in 2004, the number of users increased to 2.61 million people, with an annual turnover of up to US$500 million, with a net income of US$22 million; in 2005, the number of users increased to 4.18 million, with an annual turnover of up to US$680 million, with a net income of US$42 million; in 2006, it had 6.32 million users, with an annual turnover of US$997 million, with a net income of US$49 million. At the 10th anniversary of the company in 2007, Netflix's performance was even better: the number of users increased to 7.48 million, the annual turnover reached US$1.2 billion, and the net income was US$67 million. Netflix's 2016 10-K statement showed that Netflix's turnover was US$8.83 billion and its operating profit was US$379 million. Netflix's 2017 10-K statement showed that Netflix's turnover was US$11.693 billion and its operating profit was

US$839 million. The financial report released by Netflix in early 2019 shows that Netflix's 2018 turnover was US$15.794 billion and its operating profit was US$1.605 billion.

Netflix, while focusing on marketing, has always paid attention to the number of licensed films in its own film library. In 2005, Netflix's library had 35,000 movies for users to choose from, and the number of DVDs rented daily was as high as one million. With the development of digital technology, bandwidth widening and speeding up of the Internet, in 2007, Netflix launched a monthly video-on-demand service for streaming media. In 2008, the number of clicks on Netflix's website reached 194 million, which was five times the number of visitors to BesTV, the largest film and audio chain store in North America in early 2000. In less than 10 years since Netflix's emergence, its service and operating model has caused many movie and television rental stores in the United States to close or change their operations.

Since 2010, Netflix's streaming media content on-demand service business has expanded overseas: the first stop was Canada, the second was Latin American countries. In 2012, Netflix began to expand its streaming media business in Europe. Up to the beginning of 2016, Netflix's global streaming businesses had expanded to more than 190 countries and regions, with a total of 74 million users. In April 2017, Netflix and the well-known Chinese video site iQiyi signed a license distribution contract, users can see many original videos and TV series owned by Netflix on the iQiyi website. At the end of 2018, the total number of customers of Netflix's global streaming media business reached 148 million (see Table 3.10).

Since 2011, in addition to obtaining authorized film and television programs from traditional Hollywood companies through copyright transactions, Netflix has also entered the field of original production of film and television programs. At that time, Netflix had less than 27 million users. *House of Cards* and *Orange Is the New Black* were among Netflix's first productions. Netflix directly challenged traditional film and television companies, including the

Table 3.10 Number of Netflix members, 2015–2018 (in 10,000s)

Type		2015	2016	2017	2018
Domestic streaming	All members	4473.8	4943.1	5475	6055.1
media	Paying members	4340.1	4790.5	5281	5848.6
International streaming	All members	3002.4	4436.5	6283.2	8790.4
media	Paying members	2743.8	4118.5	5783.4	8077.3
All streaming media	All members	7476.2	9379.6	11758.2	14845.5
	Paying members	7083.9	8909	11064.4	13925.9
Domestic DVD and	All members	490.4	411.4	338.3	273.1
Blu-ray disc	Paying members	478.7	402.9	333	270.9

Source: Netflix.

six major Hollywood companies. Netflix has a huge number of paying users and a relatively stable annual income, its purchase budget challenges art film brands belonging to the six major companies.

In recent years, Netflix has directly competed with the six major Hollywood companies by hiring top managers. Shonda Rhimes, an experienced producer of TV series such as *Grey's Anatomy*, *Scandal*, and *How to Get Away with Murder*, signed with Netflix in 2017. Later, in December 2018, Netflix signed the former president and producer of the Disney Company's ABC Entertainment, Channing Dungey, hiring him as Vice President of the company's original shows since February 2019.

In 2018, Netflix invested nearly US$13 billion in original film and television productions and copyright procurement, of which 85 percent of the budget was for original production. In 2018, Netflix released 82 new feature films over 90 minutes in streaming format, which was far more than any of the six major Hollywood companies. In December 2018, Netflix launched the thriller science fiction film *Bird Box*, starring American actress Sandra Bullock, which was first released at the American Film Institute Film Festival in November 2018 and launched in December on streaming platforms in dozens of countries around the world, including the United States. According to Netflix's report, the number of moviegoers in the first week of the film reached 45 million, and the total number of moviegoers worldwide reached 80 million in four weeks. By the end of 2018, there were almost 1,000 original TV series owned by Netflix's streaming platform. 2018 was also an important year for Netflix to innovate in producing original content and media expressions. Netflix launched its first video game-like feature film, *Black Mirror: Bandersnatch* on its own streaming platform on December 28. This was not only Netflix's innovation in streaming media business but also in feature film innovation in the form of audience viewing experience. Movie viewers are no longer just "viewers", which means just watching on the screen with their eyes, but become "personal experiencers", using their own imagination and expectations to influence the plots and ending of the film. Although this form of media expression is still in its infancy, and audiences have limited choices, this is at least a starting point for a new film viewing experience innovation. This innovator, however, is a latecomer who started with DVD rental and a streaming media business only 20 years ago, rather than other traditional film and television companies in Hollywood, who have a history of decades or even a hundred years.

On January 6, 2019, at the 76th Golden Globe Awards in Los Angeles, California, Netflix's original film and television works won a total of five Golden Globes (20 percent of all awards), becoming the big winner at the Golden Globes. The award-winning film *Roma*, a black-and-white movie, directed by Mexican film director Alfonso Cuarón, starring Aliza Abaricio and Marina de Tavira, was premiered at the 75th Venice International Film Festival in Italy on August 30, 2018, and was later screened at the Telluride

Film Festival in northern California on August 31, 2018. In the following months, it won dozens of awards and nominations at many international film festivals. Director Alfonso Cuarón won the 76th Golden Globe Award for Best Director for the film. In January 2019, *Roma* won the best film nomination in the 91st Academy Awards, and director Alfonso Cuarón also won the Best Director nomination.

Netflix also launched the film *The Irishman* in 2019, which was directed by Martin Scorsese, starring Robert De Niro and Al Pacino. The cost of the film reached hundreds of millions of dollars, a Hollywood blockbuster. In January 2019, Netflix raised the price of membership fees in the United States, increasing the monthly basic membership fee from US$7.99 to US$8.99, and increasing the monthly membership fee of standard-level from US$10.99 to US$12.99. Monthly advanced membership fees increased from US$13.99 to US$15.99. This substantial increase in membership fees was closely related to the increase in the number of members and the significant improvements in business performance of Netflix in 2018. It was also an important step in the development of Netflix's corporate strategy. In February 2019, Netflix also signed an authorization contract for the overseas distribution of *The Wandering Earth*.

Mainstream Hollywood companies gradually launch streaming services

Among the six major Hollywood companies, Disney, Universal Pictures, and Warner Bros. have accelerated the pace of providing streaming services. In 2019, Disney launched the Disney + streaming business. AT&T and its Warner Media Group also launched a streaming media service similar to Walt Disney's which is direct-to-consumers. Universal Television and its parent company Comcast will also join the group of film and television companies that provide streaming media services in 2020.

Walt Disney Direct-to-Consumer & International

The following are Disney's new developments in 2018. In May 2018, the Walt Disney Company established a new operating group subsidiary, with streaming media service as the main body, including the company's international business and home entertainment business, and even ABC, one of the three major American television networks, which was also owned by this new company. The new company is called "Walt Disney Direct-to-Consumer & International." The Walt Disney Direct-to-Consumer & International is a subsidiary of the Walt Disney Company. There also is a new major business unit that includes Disney Streaming Services (Disney + and ESPN +), Overseas Media Business, and ESPN Global Advertising Sales, The domestic television network ABC, the worldwide Disney Channel and other television channels' advertising, licensing and sales operations, etc., BAMTech Technologies also belong to the new company.

The Walt Disney Direct-to-Consumer & International is an important strategic step for the Walt Disney Company. The Company promoted Kevin Mayer, an experienced employee of the Walt Disney Company, who had been with the company since 1993, to be the executive of the new company. He reports directly to Walt Disney CEO Robert Iger. Kevin Mayer holds a bachelor's and master's degree in engineering as well as a master's degree in business administration from Harvard University. During his long career, he had participated in the acquisition of Pixar Animation, Marvel, Lucas and 20th Century Fox Pictures by the Walt Disney Company. It is predicted that Kevin Mayer might be the successor to Robert Iger.

In 2018, before film and television, the Walt Disney Direct-to-Consumer & International Corporation successfully launched sports media channel streaming products and service, which was named ESPN +. At the end of December 2018, Disney Corporation and the American telecommunications company Verizon reached a cooperation agreement. Together, they would continue to provide ESPN sports program services for Verizon's existing sports audience.

In 2018, the Walt Disney Company and the Internet giant Google also reached a cooperation agreement. The two parties would cooperate in the advertising business. This cooperation had been negotiated for a year. According to media information company ComScore, in September 2018, Disney's digital product content owned 23 million users worldwide, these users would spend 14 billion minutes watching Disney shows every month.

The Walt Disney Company completed the purchase of 20th Century Fox Films, one of the six major Hollywood companies, on March 19, 2019. In 2019, Walt Disney Direct-to-Consumer & International launched Disney streaming products and services Disney +. This product not only includes all the familiar Disney products, such as the Disney brand, the Pixar brand, the Marvel brand, the Lucas brand and the *Star Wars* brand, etc., but also includes 20th Century Fox, Fox Searchlight Pictures and other brands' products. In addition, Disney no longer continues to authorize other online channels before the term of the product content mentioned above has expired.

Comcast, the parent company of Universal Pictures Group, also merged with the Sky Broadcasting Media Group (Sky) (which used to be a subsidiary of 21st Century Fox and covered Europe's major radio and television telecommunications and mobile phone user groups) in 2018. The Walt Disney and Comcast companies' annual content production budgets reached nearly US$43 billion, accounting for approximately 20 percent of the global film and television entertainment media content production budget.

The operating performances of traditional Hollywood companies and new streaming companies in 2018 indicated that these content channels of different consumption forms and different platforms will continue to coexist. As consumers continue to change their consumption habits, content and

platform providers will also introduce new content and consumption forms that are more suitable to consumer habits and preferences.

Warner Media Group

In 2018 and early 2019, another major event in Hollywood was the change of the parent company of Warner Group. Warner Television Group and its sister companies, HBO Cable Broadcasting Corporation and Turner Broadcast, were taken over by AT&T, the largest telecommunications company in the United States, becoming its wholly owned subsidiary, named Warner Media. In 2019, Warner Media Group also launched a streaming service similar to Walt Disney's Direct-to-Consumer & International company.

Digital media production and distribution companies that have challenged traditional Hollywood media companies include Amazon Pictures, a subsidiary of Amazon Group, and YouTube. Not only do they compete with Netflix, but they also challenge traditional film and television production and distribution companies.

Development trends and future prospects of the North American film industry

Mergers and acquisitions of the North American film and entertainment industry groups will continue

The six major Hollywood companies developed into seven companies (with the addition of Netflix) in early 2019, but soon reverted to six major companies. This was the biggest event in Hollywood in 2018 and 2019. The Walt Disney Company completed the acquisition of 20th Century Fox, one of the six major Hollywood companies in March 2019 after acquiring Pixar, Marvel and Lucas. 20th Century Fox used to be not only a group company with a complete film and television industry chain, but also a company with a higher operating profit among the six major Hollywood companies, and once owned many Oscar-winning films and Fox Searchlight brands.

Six years after Comcast, the top parent company of Universal Pictures, acquired NBC Universal Pictures Entertainment, Comcast's ranking among the top 500 U.S. companies rose from 66th in 2011 to 33rd in 2018 and even 31st in 2017. In 2018, when Comcast acquired most of the assets of 20th Century Fox from the Walt Disney Company, it also acquired Star Broadcast Media Group in Europe, which used to belong to 21st Century Fox.

In 2018, AT&T, the largest telecommunications company in the United States, acquired Time Warner, becoming the parent company of Warner Media, and launched a streaming service similar to that of Walt Disney Direct-to-Consumer & International. The merger and acquisition made full use of the customer base, hardware services such as corporate

telecommunications and networking, and a large number of databases and creative resources of several companies before the merger to create an updated business model.

Sino-US film and television cooperation programs have made great progress

In 2018, the China-US co-production *The Meg* laid the foundation for the co-production in the market. The film, which cost about US$130 million to produce and distribute, premiered simultaneously in 15 countries, including China, the United States, and the United Kingdom on August 10, 2018. In August, the film was released in more than 40 countries around the world. The global box office reached US$530 million, of which China's box office was US$153 million and the US box office was US$145 million. The box office revenue of such an international film was only about 30 percent of the copyright revenue, and 70 percent of the copyright revenue came from the television licensing, DVD and Blu-ray disc markets, streaming media licensing, and aircraft and cruise ship licensing.

Of course, *Kung Fu Panda 3*, a Sino-US co-production by the Oriental Dream Works and China Film Company in 2016 must not be forgotten. *Kung Fu Panda* and *Kung Fu Panda 2* are both American films, and *Kung Fu Panda 3*, the large-scale 3D blockbuster was partly funded and produced by Chinese teams. *Kung Fu Panda 3* is really two original versions: an English original animation and a Chinese original animation. The production of this movie was difficult, the use of resources and the production period were extremely challenging. The film has a global box office of US$521 million, of which China's box office was US$154 million, and the US box office was US$143 million.

These two Sino-US co-productions have opened a new way to Sino-US film co-operation, which is valuable and worth learning. The hope is that in future there will be more exciting co-productions.

Future prospects for the new and the old companies

The impact of streaming media and the Internet on the traditional Hollywood model will inspire more new works, new forms and new stages that are welcomed by audiences. Traditional Hollywood film production and distribution companies are also constantly updating their operating models. A 2018 report from a media market research company showed that Internet companies, including Netflix, have not prevented loyal moviegoers from going to the cinema, but the moviegoers are mostly mainstream streaming audience who also stream on the Internet and spend more time watching movies.

Creating, innovating and setting new business models will continue to be one of the main tasks guaranteeing the enduring development of the American and global film and television industries.

Note

1 The 10-K statement is a statement required by the US Securities and Exchange Commission to be completed by all listed companies and filed with the US Securities and Exchange Commission within 90 days of the year-end settlement date. The 10-K statement is also a summary report that reports to the company's shareholders on the company's history, organizational structure, stock rights, subsidiaries, and audited annual financial statements at the end of the year.

4 The development of the European film industry between 2017 and 2018

Nannan Li

Introduction

In the new era of increasingly fierce competition and increasingly close contact within Hollywood films, European films have stood out from the challenges and made a difference because of their rich cultural diversity. The diverse performance of films from different countries and regions in Europe has attracted audiences from all over Europe to go to the cinemas. The success of local European films in 2017, with a 2.5 percent increase in attendance, attests to the very important and positive effects of policies and is measured by European governments to promote further prosperity in the film industry as a whole. In recent years, the joint efforts of European governments and related institutions have made European films more appealing to the general public. This is the result of continued significant investment in innovation by film operators and their partners in a variety of ways.

Over the years, Europe has been committed to developing local films, and in recent years it has focused on attracting more audiences to the cinema. Thanks to this long-term plan and continued investment, local films across Europe have shown tremendous growth in popularity. France, Italy, the United Kingdom and a small number of Eastern European countries, represented by the Czech Republic, can be seen as the main drivers of this positive trend in 2017–2018. Then again, the European box office has been primarily dominated by international blockbusters. In terms of audience attendance in 2018, France had about 250 million moviegoers, the UK about 170 million, Spain about 9.2 million, Germany about 9 million and Italy about 7.9 million.

Review of the European film industry, 2017

According to the International Union of Cinemas (UNIC), the number of moviegoers in Europe increased by 2.5 percent compared with 2016, creating a new record of 1.34 billion people and continuing to grow. Europe made a profit of 8.6 billion euros at the box office in 2017, contributing to 23 percent of the global box office, second only to the United States at 26 percent (see Figure 4.1).

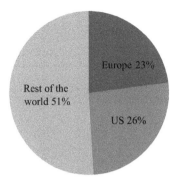

Figure 4.1 Global share of European cinema in 2017 (based on box office receipts).

In 2017, the film markets in Turkey, Russia, Poland and Slovakia grew to varying degrees compared to the few under-reported countries and even showed strong momentum. Due to the success of several home-grown films, French national cinema managed to attract 200.94 million viewers that year, which was the third-highest record in nearly 50 years. Due to its policy of pricing movie tickets at less than 4 euros for those under 14 years old, the total number of moviegoers throughout the year remained in the top three in Europe. The market performance boost in Russia (11.4 percent increase in box office revenue, 9.3 percent increase in movie attendance) and Turkey (25.9 percent increase in box office revenue, 22.1 percent increase in movie attendance) can also be attributed to the success of locally produced films. This growth of the Russian and Turkish film markets has been steady since 2016. In addition to the aforementioned countries, the film market in other Eastern European countries also achieved substantial growth in 2017. Even though the markets in those countries were less developed compared to their more progressive cousins, their success is still worth mentioning. For example, the Ukrainian box office grew by 32.2 percent, the Romanian box office by 14 percent and the Croatian box office by 5.8 percent.

As shown in Table 4.1 and Figure 4.2, the film market in southern Europe underperformed in 2017. Spain's total number of moviegoers in 2017 was less than 100 million. The most successful animated feature film, *The Great Adventure Stakes in Peru 2*, took the number five spot at the national box office. Spain's domestic film market share was only 17.1 percent. Due to the poor performance of American international blockbusters, the Spanish film market shrank in 2017. The Italian film market also fell sharply in 2017. Underwhelming domestic films and reduced screening of U.S. blockbusters led to a sharp decline in the market, with box office performance dropping by 11.7 percent and audience attendance down by 12.4 percent. Italy's local film market share in 2017 was only 17.6 percent, significantly less than the

Table 4.1 European countries' box office, 2014–2017 (million, local currency)

	Country	2014	2015	2016	2017	2016 change rate from 2017 (%)
1	Germany (Euro)	1023.0	1149.9	1023	1056.1	3.2
2	Austria (Euro)	123.1	136.0	132.8	130.2	–2.0
3	Bulgaria (Lev)	40.0	45.7	48.4	50.7	4.8
4	Croatia (Kuna)	121.0	135.7	126.8	134.2	5.8
5	Denmark (Kroner)	1055.2	1195.2	1127.5	1080.8	–4.1
6	Spain (Euro)	507.1	569.8	605.5	597.0	–1.4
7	Estonia (Euro)	11.8	15.3	17.7	19.4	9.6
8	Finland (Euro)	75.0	91.0	90.3	98.3	8.9
9	France (Euro)	1250.0	1329.4	1387.7	1380.6	–0.5
10	Greece (Euro)	59.3	63.4	64.4	65.0	0.9
11	Hungary (Forint)	13490.0	17225.6	19845.2	20652.4	4.1
12	Ireland (Euro)	101.9	104.0	107.5	113.8	5.9
13	Italy (Euro)	618.7	636.2	662.0	584.8	–11.7
14	Latvia (Euro)	10.3	11.2	12.2	12.9	5.7
15	Lithuania (Euro)	13.1	15.0	17.7	20.2	14.1
16	Luxembourg (EUR)	9.1	9.4	8.6	8.4	–2.3
17	Montenegro and Serbia (Dinars)	–	1151.5	1374.1	1463.1	6.5
18	Norway (Kroner)	1095.1	1214.3	1375.2	1260.9	–8.3
19	The Netherlands (Euro)	249.5	275.3	287.7	301.9	4.9
20	Poland (Zloty)	665.2	797.2	967.5	1072.4	10.8
21	Portugal (Euro)	65.4	75.0	76.7	81.7	6.5
22	The Czech Republic (Krona)	1424.2	1599.0	2011.0	2004.2	–0.3
23	Romania (Ley)	160.5	201.0	241.6	266.6	10.3
24	The UK (Pound)	1083.5	1240	1246.6	1277.9	2.5
25	Russia (Ruble)	41158.7	43986	47501.4	53289.5	12.2
26	Slovakia (Euro)	18.9	22.5	29.0	34.5	19.0
27	Slovenia (Euro)	11.1	10.2	11.9	11.6	–2.5
28	Sweden (Kroner)	1638.3	1810.0	1931.7	1968.2	1.9
29	Switzerland (Franc)	218.5	227.0	207.9	209.9	1.0
30	Turkey (Lira)	504.3	681.0	696.2	876.2	25.9

Source: UNIC.

market share in 2016 at 28 percent. The only successful Italian film for 2017 was *L'oralegale*.

Overview of the European film industry

As shown in Table 4.2, as in previous years, the European box office was mainly topped by some Hollywood blockbusters, including but not limited to *Despicable Me 3*, *Beauty and the Beast*, *Star Wars: Episode VIII - The Last Jedi*, *Pirates of the Caribbean: Dead Men Tell No Tales*, etc.

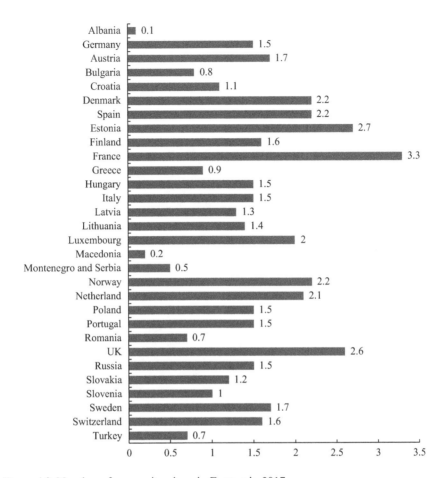

Figure 4.2 Number of per capita views in Europe in 2017.

The years 2017 and 2018 witnessed development in the European film market. It should be noted that since 2015, the aim in European countries to encourage people to return to the cinema had been met with positive response by fans. The European film market continues to be stable in terms of its global market share. From 2017 to 2018, the total box office receipts and the total number of moviegoers in the European film market increased slightly. This growth was not only due to the success of some local films, but also to the European film industry's continuous investment and attempts to attract audiences. In the past two years, Hollywood blockbusters have not fulfilled their market expectations. On the contrary, co-productions between European countries have often surprised the market. However, the European film market still had a certain dependence on Hollywood international blockbusters, and this phenomenon continued until 2018. In 2018,

Table 4.2 Top five box office films in major European countries in 2017

Country	1	2	3	4	5
Germany	Suck Me Shakespeer 3	Despicable Me 3	Star Wars: Episode VIII - The Last Jedi	Fifty Shades of Black	Beauty and the Beast
France	Despicable Me 3	Star Wars: Episode VIII - The Last Jedi	R.A.I.D. Special Unit	Valerian and the City of a Thousand Planets	The Boss Baby
Spain	Beauty and the Beast	Despicable Me 3	Tad the Lost Explorer and the Secret of King Midas	Star Wars: Episode VIII - The Last Jedi	The Fate of the Furious
The UK	Star Wars: Episode VIII - The Last Jedi	Beauty and the Beast	Dunkirk	Despicable me 3	Guardians of the Galaxy Vol. 2
The Netherlands	Despicable Me 3	Pirates of the Caribbean: Dead Men Tell No Tales	Beauty and the Beast	Star Wars: Episode VIII - The Last Jedi	The Fate of the Furious
Poland	Letter to Santa 3	Botox	Star Wars: Episode VIII - The Last Jedi	Despicable Me 3	The Art of Love: The Story of Michalina Wislocka
Italy	Beauty and the Beast	Despicable Me 3	Fifty Shades of Black	The Fate of the Furious	It
Norway	Star Wars: Episode VIII - The Last Jedi	Beauty and the Beast	Pirates of the Caribbean: Dead Men Tell No Tales	The Ash Lad: In the Hall of the Mountain King	The Fate of the Furious

Source: UNIC.

the revenue from Hollywood production films was still the highest in the box office in major European movie markets. The production of local films seems to have lost significant growth momentum since 2017. However, the box office income may not be sufficient to explain the overall trend of the film industry as there was a currency value fluctuation caused by the recent stagnation of European economic growth and the downturn of the euro. In this respect, the attendance figures would be a relatively objective measure of the film market.

The year 2017 was a very prominent year for the French film market, especially with France's position as a leader in the overall European film market. According to the statistics of the National Centre for Cinema and the Moving Image (CNC),[1] the total number of moviegoers in the French film market in 2017 was 209.4 million, which was the fourth consecutive year that France had movie attendance of more than 200 million. Among them, the French domestic film market share increased from 34.8 percent in 2016 to 37.4 percent in 2017, and the number of moviegoers reached 78 million. As shown in Table 4.3, the number of per capita attendance in France was 3.3, which was still the highest in Europe. The attendance for Hollywood movies in France decreased by 8.6 percent to 102 million, and the market share dropped to 48.8 percent. In 2017, the performance of the British film market was remarkable. The British film industry also explored the shortcut to catch up with Hollywood international blockbusters; the box office and filmmakers hit a record twice, up 2.5 percent and 1.4 percent, respectively. British and American co-productions blossomed in this year.

In 2017, the most popular movie in the UK was *Star Wars: Episode VIII - The Last Jedi*; the cinema admissions were about £100 million. It also set the fifth-highest record in the history of UK cinema admissions. The second and third placed films were *Beauty and the Beast* and *Dunkirk*, respectively. It is worth noting that the Anglo-American co-productions have indeed injected vitality into the British film market, but the actual profits have flowed to Hollywood. Therefore, the development of European films urgently depends on local quality production and investment.

In 2017, Russia's box office continued to rise, which had been a dark horse in the European film market in recent years. For the first time, audience attendance exceeded 200 million. It is worth mentioning that the movie attendance of Russian domestic films soared by 57 percent and increased by 73.3 percent in 2016–2017. The box office of Russian local films in 2017 was 12.6 billion rubles, accounting for 23.2 percent of the national box office. Judging by the higher box office movies, Russian fans are more willing to watch action films and cartoons.

Interpretation of the film industry data in European countries

France

According to the latest statistics of the National Centre for Cinema and the Moving Image (CNC), the sales volume of French cinema tickets in 2017

Table 4.3 Box office and movie attendance in European countries in 2017

Country and currency	Box office revenue million (local currency)	Growth rate (%)	Viewers (million)	Growth rate (%)	Per capita movie attendance (times)	Share of local films (%)
Albania (Lek)	180.0	7.00	0.3	7.00	0.1	–
Austria (Euro)	130.2	–2.0	14.5	–3.60	1.7	5.1
Bosnia and Herzegovina (convertible Mark)	5.7	21.00	1.1	17.80	0.3	0.2
Bulgaria (Lev)	50.7	4.80	5.6	0.80	0.8	7.9
Croatia (Kuna)	134.2	5.80	4.5	5.70	1.1	2.1
The Czech Republic (Krona)	2004.2	–0.30	15.2	–2.50	1.4	19.0
Denmark (Kroner)	1080.8	–4.10	12.5	–7.40	2.2	20.0
Estonia (Euro)	19.4	9.60	3.5	7.00	2.7	8.0
Finland (Euro)	98.3	8.90	8.9	3.00	1.6	28.0
France (Euro)	1380.6	–0.50	209.4	–1.80	3.3	37.4
Germany (Euro)	1056.1	3.20	122.3	1.00	1.5	23.9
Greece (Euro)	65.0	0.90	10.1	0.70	0.9	10.0
Hungary (Forint)	20652.4	4.10	14.9	1.90	1.5	9.0
Ireland (Euro)	113.8	5.90	16.1	2.10	3.3	–
Israel (NIS)	582.6	7.00	18.2	7.00	2.1	9.1
Italy (Euro)	584.8	–11.70	92.3	–12.40	1.5	17.6
Latvia (Euro)	12.9	5.70	2.5	–2.50	1.3	5.0
Lithuania (Euro)	20.2	14.10	4.1	10.70	1.4	22.0
Macedonia (Denar)	82.0	6.00	0.4	9.00	0.2	–
Montenegro and Serbia (Dinars)	1463.1	6.50	3.8	7.30	0.5	12.0
The Netherlands (Euro)	301.9	4.90	36.0	5.30	2.1	11.1
Norway (Euro)	1260.9	–8.30	11.8	–10.30	2.2	16.1
Poland (Zloty)	1072.4	10.80	56.6	8.70	1.5	23.2
Portugal (Euro)	81.7	6.50	15.6	4.40	1.5	2.6
Romania (Ley)	266.6	10.30	14.5	11.30	0.7	1.7
Russia (Ruble)	53289.5	12.20	212.2	9.30	1.5	23.2
Slovakia (Euro)	34.5	19.00	6.7	18.10	1.2	20.8
Slovenia (Euro)	11.6	–2.50	2.1	–11.20	1	7.9
Spain (Euro)	597.0	–1.40	99.7	–0.50	2.2	17.1
Sweden (Krona)	1968.2	1.90	16.9	–4.10	1.7	16.4
Switzerland (Franc)	209.9	1.00	13.8	0.80	1.6	6.7
Turkey (Lira)	876.2	25.90	71.6	22.10	0.9	56.7
The UK (Pound)	1277.9	2.50	170.6	1.40	2.6	21.2
Ukraine (Hryvna)	2380.0	32.20	29.8	32.20	0.8	3.7

Source: UNIC, CNC.

Table 4.4 Statistics of French film market from 2005 to 2017

Year	Per capita movie attendance (millions)	Box office revenue (million euros)	Box office revenue per capita (Euro)	Times (millions)
2005	175.6	1031.80	5.88	6.09
2006	188.8	1120.65	5.94	6.24
2007	178.5	1061.87	5.95	6.30
2008	190.3	1142.89	6.01	6.58
2009	201.6	1237.24	6.14	6.71
2010	207.1	1309.94	6.33	6.84
2011	217.2	1374.74	6.33	7.04
2012	203.6	1306.48	6.42	7.15
2013	193.7	1250.87	6.46	7.27
2014	209.1	1332.73	6.37	7.58
2015	205.4	1331.7	6.48	7.8
2016	213.1	1387.7	6.51	8.0
2017	209.4	1380.6	6.59	8.2

Source: Centre National de la Cinématographie (CNC).

was 209.4 million, a small decrease of 1.8 percent compared to 2016, but this was the third-highest record for France in 50 years and movie attendances exceeded 200 million for the fourth consecutive year (as shown in Table 4.4). As of 2017, movie attendance in France was still the highest in the EU. In different countries in Europe, the change in the attendance rate of cinemas was very thought-provoking. For example, compared to 2016, Germany grew by 1.01 percent in 2017, the UK grew by 1.4 percent, while Italy experienced a huge decline of 12.4 percent and Spain fell by 0.5 percent. France's box office receipts in 2017 were almost stable compared to recent years, reaching 1,380.6 million euros, the second-highest level after 2016.

Such good movie performance figures in the French film market in 2017 were due to several films that have achieved great market success. The record of non-French films in 2017 was set by *Dunkirk* at 2.55 million euros. In 2017, the number of viewers of Spanish films released in France dropped significantly by 43.55 percent, and the proportion of German films declined even more by 75.31 percent. In 2017, there were 56 movies with more than one million viewers, 18 of which were French native films. In 2017, there were 24 movies with two million people in attendance, and four movies with more than four million people viewers. Five French films attracted two million viewers, and two French films attracted four million viewers: *R.A.I.D. Special Unit* and Luc Besson's *Valerian and the City of a Thousand Planets*. In 2017, two American movies were viewed more than four million times: *Despicable Me 3* and *Star Wars: Episode VIII - The Last Jedi*.

With the number of people watching films breaking through 209.4 million, the attendance rate of the French film market in 2017 had reached another record level in the past 50 years, and two positive things were noticed. First, local French films have been progressively achieving success for many years;

Table 4.5 Film market share by production country in France, 2010–2017 (%)

	2010	*2011*	*2012*	*2013*	*2014*	*2015*	*2016*	*2017*
French films	34	39.8	39	31.9	43.1	33.8	34.5	36.2
American movies	50.2	47.6	44.6	55.6	46.4	53.4	54.7	50.7
European films	14.6	10.6	12.8	7.7	5.5	9.3	9.2	10.6
Other countries' films	1.2	1.9	3.5	4.7	5	3.5	1.6	2.5

Source: Centre National de la Cinématographie (CNC).

second, it was those films that have increased the share of French-language films in the film market to 37.4 percent in 2017, while the film blockbusters accounted for 36.2 percent (as shown in Table 4.5). The success of the French film industry was also closely related to the youth and the family audiences, thanks to the film promotion policy of "Moins de 14 ans, 4 euros." This policy reduces the VAT on cinema tickets and stipulates that all teenagers under the age of 14 can watch movies for a price of only 4 euros. Through this policy, film operators encourage young and future audiences to enter the theater. This policy has attracted a large number of young people and families with children to come to the theater. This has become one of the most important boosts to the French film market. According to the statistics of relevant institutions, the number per capita in the French film market in 2017 was 3.3, greatly surpassing the United Kingdom (2.6) and Estonia (2.7) and other European countries, becoming the winner in the 2017 European film market.

Towards the end of 2018, two historical events took place which can be considered major factors that affected movie attendance. According to data released by the National Centre for Cinema and the Moving Image, France's performance in the 2018 World Cup was eye-catching, causing movie attendance rate in France to drop by 14 percent and 22.1 percent respectively during the World Cup in June and July. By the end of 2018, the sudden "yellow vests" riots directly reduced the attendance rate, especially in Paris where cinemas were forced to close at weekends. The movie attendance rate in December dropped by 12.3 percent nationwide.

In 2018, three of the French native comedy films entered the top five of the annual box office list, namely *Les Tuche 3*, *La Ch'tite Famille* and *Le Grand Bain*. It has to be said that the strong performance of local films and the modernization of French cinemas are key factors in maintaining the annual viewing at over 200 million. The enthusiasm for local films and the policy of encouraging viewers of all ages to come to the cinema are still the basis for the high movie attendance rate.

The United Kingdom

In 2017, the British film industry sold a total of 170.6 million movie tickets (as shown in Table 4.6), showing an increase of 1.4 percent over 2016. The attendance

Table 4.6 UK movie attendance and box office revenue, 2001–2017

Year	Movie attendance (millions)	Box office revenue (million pounds)
2001	155.9	645
2002	175.9	755
2003	167.3	742
2004	171.3	770
2005	164.7	770
2006	156.6	762
2007	162.4	821
2008	164.2	850
2009	173.5	944
2010	169.2	988
2011	171.6	1040
2012	172.5	1099
2013	165.5	1083
2014	157.5	1058
2015	171.9	1242
2016	168.3	1228
2017	170.6	1280

Source: British Film Institute (BFI).

rate of British films has remained stable since 2002. In recent years American films no longer monopolize the top 20 spots of the British box office list. The market share of British movies reached a record of 45 percent and Anglo-American films are in the forefront of the rankings. In 2017, this trend continued in the UK, with local films accounting for 21.2 percent. British box office and movie attendance increased by 2.5 percent and 1.4 percent, respectively.

In 2017, a total of 760 movies (15 on average per week) were screened for a week or more in the UK and Ireland, 61 fewer than in 2016, but almost the same as in 2015. These films created nearly £1.4 billion in box office revenues (another record-breaking figure, up 6 percent from the new high set in 2015). Unlike the £1.3 billion mentioned above, the £1.4 billion figure here includes revenue generated from films released in 2017, covering the Republic of Ireland and the United Kingdom.

In 2017, the total annual revenue of box office in the UK and Ireland was £1.38 billion, an increase of nearly 4 percent compared to 2016. As shown in Table 4.7, the most popular movie in the UK in 2017 was *Star Wars: Episode VIII - The Last Jedi*, with a box office revenue of about £100 million, which also set the fifth-highest record in the history of the UK box office. The second and third movies at the UK box office were *Beauty and the Beast* and *Dunkirk*. The top 20 movie box office sales totalled £732 million, accounting for 54 percent of all box office.

According to the official website of the British Film Institute on January 31, 2019, the film market in the UK and Ireland developed well in 2018, with

Table 4.7 2017 box office top 10 films in the UK, Ireland and Malta (US$)

Ranking	Title	Producer	Box office	Release date
1	Star Wars: Episode VIII - The Last Jedi	Disney	109403018	December 14
2	Beauty and the Beast	Disney	90542359	March 17
3	Dunkirk	Warner Bros	78487166	July 21
4	Despicable Me 3	Universal Studio	62832430	June 30
5	Paddington 2	St canal	57357810	November 10
6	Guardians of the Galaxy Vol. 2	Disney	53060497	April 28
7	Jumanji: Welcome to the Jungle	SONY	43829219	December 20
8	It	Warner Bros	42361659	September 8
9	Thor: Ragnarok	Disney	40928752	October 24
10	Spider-Man: Homecoming	SONY	39582694	July 5

Source: Box office magic.

177 million viewers, an increase of nearly 4 percent from 2017, the highest since 1970. As shown in Table 4.8, the most popular movie in 2018 was *Avengers: Infinity War*, with box office revenue of approximately £70 million. The second and third highest-grossing films at the box office in 2018 were *Mamma Mia! Here We Go Again* and *Incredibles 2*. The top 20 sales totaled £711 million, accounting for 55 percent of all box office in the UK.

For the UK, 2018 was a turbulent year and the political environment can be described as the most intense period in recent years. The UK was making a decision on leaving the European Union: Brexit. As of the end of December 2018, the box office of several films in the UK at the box office grossed over £40 million. The new eye-catching musical film *The Greatest Showman* was called controversial by industry insiders, but the box office indicates that musical films have a bright future in the UK. Although there were no phenomenal blockbuster *Star Wars* movies in 2018, many of the films performed well at the box office. In this context, the box office and the viewer numbers in the UK have withstood the pressure to keep rising. It can be said that 2018 was a very remarkable year for the British film industry. The trend of box office revenue in the UK from 2008 to 2018 is shown in Table 4.9.

Russia

Russia's film market has developed well in recent years. In the past five years, movie attendance and box office have continued to grow steadily. In 2018, the piracy issue began to be partially curbed, the number of cinemas increased, and box office reports were more accessible than in the past few years. The FIFA World Cup held in Russia in 2018 had a certain impact on the box

Table 4.8 2018 box office top 10 films in the UK and Ireland (million pounds)

Ranking	Title	Distribution country	Box office	Producer
1	*Avengers: Infinity War*	UK/USA	70.8	Disney
2	*Mamma Mia! Here We Go Again*	UK/USA	65.5	Universal Studio
3	*The Incredibles 2*	USA	56.2	Disney
4	*Bohemian Rhapsody*	UK/USA	52.0	20th Century Fox
5	*Black Panther*	USA	50.6	Disney
6	*Mary Poppins 2. Mary Poppins Returns*	UK/USA	42.1	Disney
7	*Jurassic World: Fallen Kingdom*	UK/USA	41.6	Universal Studios
8	*Peter Rabbit*	Australia/USA/ UK	41.1	SONY
9	*Fantastic Beasts: The Crimes of Grindelwald*	UK/USA	34.0	Warner Bros
10	*Deadpool 2: Once Upon a Deadpool*	USA	32.7	20th Century Fox

Source: British Film Institute (BFI).

Table 4.9 UK box office revenue trends, 2008–2018

Year	Total box office revenue (million pounds)	Year-on-year growth rate (%)	Growth rate compared to 2008 (%)
2008	850	–	–
2009	944	11.1	11.1
2010	988	4.7	16.2
2011	1040	5.3	22.4
2012	1099	5.7	29.3
2013	1083	−1.5	27.4
2014	1058	−2.3	24.5
2015	1242	17.4	46.1
2016	1228	−1.1	44.5
2017	1280	4.2	50.6
2018	1282	0.6	50.8

Source: British Film Institute (BFI).

office. The performance of the Russian national team exceeded expectations and they entered the quarter-finals, and this diverted some moviegoers. However, in terms of movie attendance, Russia is now in line with France and is expected to become the largest film market in Europe. In 2017, the audience number reached 212.2 million, and stayed stable in 2018.

In 2018, the Russian Ministry of Culture continued to adopt a protection policy for the local film market share. The Russian government has even been

accused of trying to weaken Hollywood's dominance through age restrictions, prohibiting children from watching certain Hollywood films. At present, even in the context of the protection policy and the resurgence of local production, more than half of the films screened in Russia are Hollywood films. According to preliminary statistics, eight out of ten films on the list of top ten highest-grossing films of 2018 in Russia are American films.

The Russian production companies Central Partnership has continued to grow in recent years and has become a leader in the local film market. At the annual December holiday, Russia released the most anticipated local film, *Three Seconds*, on December 28, 2017. It was based on the real-life basketball finals during the 1972 Olympics in Munich. The Soviet basketball team went up against the US team who were defending their 36-year winning streak. During the last three seconds of the finals, the Soviet team pulled off an unexpected last-minute victory against the American giants, sending the whole of Russia into complete rapture. Since its release, the film has had an extended screening in cinemas and became the highest-grossing Russian film to date, earning more than US$37 million at the Russian box office in 2018, surpassing *Avengers: Infinity War* which made US$32.5 million at the domestic box office.

In 2018, Russia expected to have at least 100 films earning more than US$1 million each at the box office. Russia's film market has room to grow, and the annual local blockbuster can be said to have become the "trampoline" for the Russian box office, which has increased the flexibility of the Russian film market. In 2017, the Russian box office revenue reached US$841 million. According to preliminary data from 2018, this good momentum continued, with a box office income of about US$900 million in 2018.

Germany

After experiencing a decline in 2016, the German film market achieved a 3.2 percent increase in 2017 box office growth and a 1 percent increase in 2017 movie attendance. This was mainly due to *Suck Me Shakespeer 3* produced by Constantine Film in 2017. This film surpassed *Despicable Me 3* at the 2017 German box office and became the ace in the hole for Germany. However, good times don't last long, and 2018 was not a good year for the German film market. The Association of German Distributors predicted the overall box office revenue and the year-end results of the audience in Berlin in late November, which was very pessimistic. In 2018, the German box office was about US$850 million, and the audience numbers were about 86 million.

The German national football team has always been one of the most successful football teams at the FIFA World Cup. It was predicted that the Russian World Cup would have a direct impact on German movie attendance, but the early withdrawal of the German team did not affect

audience attendance. The high temperature of nearly 40°C in 2018 was an important factor in the decline of German cinema revenue and movie attendance. In June 2018, the audience numbers dropped by 45 percent compared to June 2017, while July 2018 showed a 37 percent decline compared to July 2017.

The summer of 2018 was longer than in previous years (May to October), and the swimming pool seemed more popular than the cinema on hot summer days. During the first half of the year, the grossing of movie tickets sold every weekend was no more than 1.3 million. This number can be described as bleak, proving that the weather and special events are important factors for the movie industry. It is worth noting that in 2018, no German domestic film entered the top ten at the box office. Disney's *Avengers: Infinity War* topped the box office with a total revenue of US$42.7 million. In addition, German viewers were not as enthusiastic about *The Incredibles 2* as viewers in other countries. *The Incredibles 2* had a revenue of only US$19.8 million in Germany, while it grossed US$42.8 million in France, and US$70.6 million in the UK.

There were two local children's films that were relatively successful in 2018: *Jim Button and Luke the Engine Driver* and *The Little Witch*. Since there were no blockbusters like *Suck Me Shakespeer 3* in 2018, the market share of German local films did not exceed 20 percent.

Spain

For a long time, the legal tax rate for Spanish movie tickets stayed at 21 percent, which was the highest in Europe. Spanish moviegoers were hoping for a lower tax rate, which could lead to a reduction in movie ticket prices. In July 2018, the tax rate was reduced to 10 percent, but not all theaters reduced the price, because some theaters found that the price cut did not lead to an increase in movie attendance. As of the end of 2018, the total audience number in Spain decreased by 0.8 percent compared to 2017, and the total box office revenue dropped by 0.3 percent.

In 2018, the market share of Spanish native films was about 17 percent, unchanged from 2017. A total of 19 Spanish local films had a box office of more than 1 million euros (about US$1.1 million), domestic films grossed 89.6 million euros (about US$120 million). The sports comedy *Champions*, directed by Javier Fesser, became the highest-selling local film in Spain in 2018 with a US$22.2 million box office, ranked after the Hollywood film *Jurassic World 2*, *The Incredibles 2* and *Avengers: Infinity War*. The appeal of *Champions* once again proved that Spanish native moviegoers favor comedy. As of now, Spain's highest box office record was still maintained by the Spanish native comedy *Spanish Affair*, which grossed more than US$70 million in 2014. Despite the lack of growth momentum for several years, Spain is still among the five most important film markets in Europe.

Conclusion

Since 2017, some new measures have been implemented in some European countries to promote movies, such as the cinema carnival in Spain and the "Moins de 14 ans 4 euros" in France. This shows that the theater's vigorous appeal for the development of potential moviegoers has been implemented. These measures, combined with a diverse marketing strategy involving social media, using big data and mobile services to help the film industry enhance competitiveness. This can increase the audience number during periods when the consumer becomes more cautious.

In 2018, the fairly mature film market in continental Europe faced major challenges: FIFA in Russia, the long, hot summer, and the continued march of Netflix and other streaming media giants. Many factors have caused the overall audience number and the box office in Europe to decline. From the slight decline in Spain to the slump in Germany and Austria, there are a lot of worrying situations in the national film market. Although the performance of the film market in many countries in Europe was not satisfactory, and most European films have always contained strong literary and market-deficient characteristics, when we look at it from the perspective of globalization and cultural diversity, European films still have a lot of room for development as a traditional market for the film industry.

The social and cultural value of European films has been widely recognized by international online platforms such as Netflix, Google and Amazon. In 2018, in an attempt to protect movies shown in cinemas, European Arthouse Cinema Day was organized in collaboration with Europa Cinema and initiated by the International Confederation of Art Cinemas (CICAE), which was composed of the Art Film Associations of ten countries. The "30 percent made in Europe" law was agreed upon by EU lawmakers in Brussels, requiring companies such as Netflix and Amazon to have 30 percent of their overall content consist of films or television series made in Europe. This meant that these international online platforms would increase their investment in the European film industry.

As American production companies increasingly target emerging markets, especially Asia, there is a clear opportunity for European film companies to produce and promote films that local audiences want in Europe. Under the new situation, Brussels lawmakers must be aware of the existence of this opportunity and make "European film success" their base for developing support policies.

Note

1 Established in 1946, the Centre National de la Cinématographie (CNC) is an administrative public body with legal and financial autonomy, under the Ministry of Culture and Communication in France, responsible for formulating and implementing various supportive policies for the film industry.

5 The development of the Latin American film industry between 2017 and 2018

Zhengshan Liu

The general development of the Latin American film industry

Latin America is composed of 34 countries and regions with a total population of 645 million. In 2017, the regional economic growth was 1.3 percent, which is lower than the world average. The development of the film industry is closely related to the development of the regional economy. Since 2014, the box office growth rate in Latin America has risen and then fallen, but the fluctuation is not significant (Figure 5.1).

Based on the regional box office gross (Figure 5.2), though the total population of Latin America is much higher than that of the United States or Canada, the gross domestic product (GDP) and the box office do not total even one-third of the box office of the United States or Canada. Globally, the box office of Latin America accounts for 8.4 percent of the global box office in 2017, while its residents accounted for about 9.3 percent of the global population.

Based on Figure 5.3, although the box office growth in Latin America has a downward trend (compared with Figure 5.1, some years are negative growth), the overall number of screens is increasing.

The development of the film industry in four Latin American countries

This chapter takes four major Latin American countries as examples: Mexico, Argentina, Brazil and Colombia.

Analysis of the Mexican film industry

Mexico borders on the United States, with a population of about 120 million, ranking 11th in the world in terms of economic strength. It is the region with the fastest economic development in Latin America and is about to become one of the emerging "Tiger Economies." In the mid-twentieth century, Mexican films had its golden age in its history of film, and a number of internationally influential films emerged, including the movie *Yesenia*, which

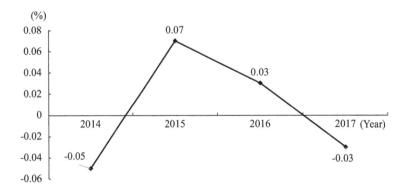

Figure 5.1 Box office growth rate of Latin America, 2014–2017.

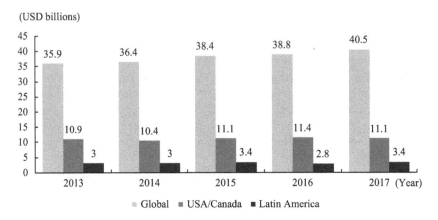

Figure 5.2 Comparison of box office in Latin America, North America and the world, 2013–2017.

is a household name in China. However, since the 1960s, due to the economic crisis, many Mexican film companies have gone bankrupt and have closed down, and the Mexican film industry entered a stage of decline. Since the 1990s, with the improvement of the economic situation, the government has paid more attention to the film industry, and introduced a series of policies to promote film development, such as the film promotion plan, a corporate 10 percent tax rate, and a high-quality film production fund (FOPROCINE), and the Film Investment and Incentive Fund (FIDECINE) to promote the production of movies. In terms of film industry infrastructure construction, Mexico's development rate is quite impressive. As shown in Figure 5.4, since

Figure 5.3 Screen growth rate in Latin America, 2014–2017.

Figure 5.4 Number of screens in Mexico, 2013–2017.

2013, the number of screens in Mexico has continued to rise, from 5,547 in 2013 to 6,633 in 2017, and the per capita level is comparable to that of China.

With the development of the economy and the improvement in the cinema infrastructure, the number of moviegoers in Mexico has continued to rise, though the growth rate is not as fast as that of the screen numbers (Figure 5.5). This shows that Mexico has a film market with sustained development and good prospects. However, box office growth in Mexico fluctuated slightly in 2018: 433 films were released in Mexico, down from 453 in 2017. In 2018, the movie box office reached 15.719 billion pesos, which was lower than 2017.

Based on Figure 5.6, the market competitiveness of Mexican domestic films is not strong, and the market share of domestically produced films is basically less than 12 percent.

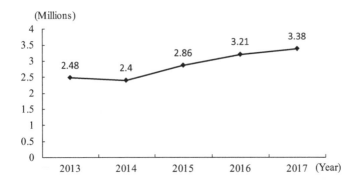

Figure 5.5 Cinema attendance in Mexico, 2013–2017.

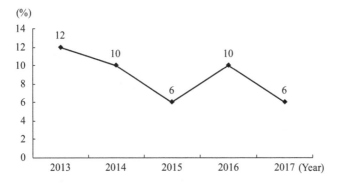

Figure 5.6 Market share of domestic films in Mexico, 2013–2017.

Judging from the results of Box Office Mojo and Internet Movie Database, the top ten box office movies in Mexico for 2018 are *Avengers: Infinity War*, *The Incredibles 2*, *Jurassic World: Fallen Kingdom*, *Aquaman*, *Black Panther*, *Hotel Transylvania 3: Summer Vacation*, *Overboard*, *Venom*, *The Nun*, and *Deadpool 2*. All these films are foreign language movies, mostly Hollywood movies.

Of the 433 movies released in 2018, there are 101 domestic movies. Comedy movies are the most popular genre in the top ten list of domestic movie box office, with the comedy *Ya Veremos* topping the list. Compared with its poor market share, the influence of Mexican movies is extraordinary. *Gravity* (2014), *Birdman* (2015), *The Revenant* (2016) and *The Shape of Water* (2017) are all directed by filmmakers of Mexican origin, who are all Oscar winners. In 2018, the global film critics' most popular film was *Roma*, directed by Mexican film-maker Alfonso Cuarón. The *New York Times* article "The Best Film of 2018"

lists *Roma* in first place. The film won the Golden Lion Award at the 75th Venice International Film Festival, as well as the 91st Academy Awards for Best Director, Best Cinematography and Best Foreign Language Film.

Analysis of the Argentinian film industry

The film industry in Argentina has experienced ups and downs, but in the twenty-first century it has entered a stable development path. In 2009, the film *The Secret in Their Eyes*, directed by the Argentinian director Juan José Campanella, won the Academy Award for Best Foreign Language Film. In the top ten list of the *American Film Review* magazine in 2018, the Argentinian female director, Lucrecia Martel's *Zama* topped the list. Founded in 1989, the Mar del Plata International Film Festival in Argentina is the only competitive international film festival in Latin America recognized by the Fédération Internationale des Associations des Producteurs de Film (FIAPF).

At the government level, Argentina attaches great importance to the film industry and introduced the Law on Domestic Film Industry Promotion. The National Institute of Cinema and Audiovisual Arts (INCAA), a specialized film authority, has incorporated film into the national industrial framework since 2003 and set up a "film production fund" to fund new movies. The amount of funding is based on the quality of the film. The fund also subsidizes new talents in film industry. At the same time, the bureau also has signed agreements with some of the largest banks in Argentina to offer more favorable interest rates for cinema facilities and technology upgrades, which promoted the improvement of the film infrastructure. The bureau not only cooperates with some universities to train film talent, but has also set up a special film school, and provides education and training for free. Theaters are also set up to support independent filmmakers with the opportunity to screen their films. These policies have driven the development of the film industry in Argentina. From the perspective of the film industry infrastructure construction, the number of screens in Argentina continued to grow, from 866 in 2013 to 963 in 2017.Although the growth rate of screens has declined in 2017, the growth has still been maintained overall (Figure 5.7).

Argentina's 2015 cinema attendance exceeded its previous record. However, since 2015, the numbers of moviegoers in Argentina have been declining (Figure 5.8). Compared to the past, the cinema attendance has remained high in recent years. In 2010, the number of viewers in Argentina was 38 million. In 2017, although it was down from the highest point of 50 million in 2015, there were still 47 million, far higher than that in 2010.

Theoretically, there is a strong correlation between cinema attendance and box office. A higher attendance often means a higher box office. With the decrease of the growth rate of attendance, the total box office growth rate in Argentina also showed a downward trend, but the two are not in synchronization. In 2015, the cinema attendance was at the highest level in recent years, and then it continued to decline. However, the box office growth rate lagged

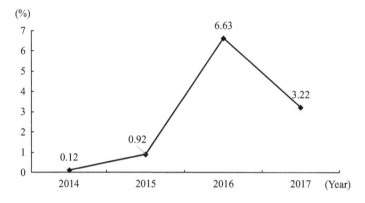

Figure 5.7 Growth rate of Argentina's screen numbers, 2014–2017.

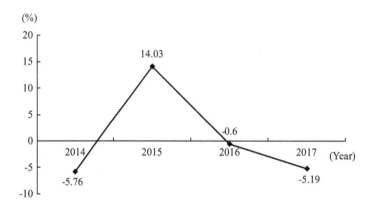

Figure 5.8 Growth rate of Argentina's movie attendance, 2014–2017.

behind for one year, reaching its peak in recent years in 2016 (Figure 5.9). The reason behind this may be related to the law of demand.

Comparing Figure 5.10 and Figure 5.9 shows that the growth rate of the average ticket price is consistent with that of the box office. Calculating the correlation coefficient between the two, the value is found to be as high as 0.94, which is obviously inconsistent with economic theory. According to the law of demand, price has a reverse relationship with demand, and the rise in entry fees has mostly led to a decline in the total box office. The case of Argentina seems to indicate that the rise and fall of the total box office are related to the rise and fall of movie entrance fees. Due to the lack of relevant data, the mechanism is still unknown, and the reasons behind this need to be studied further.

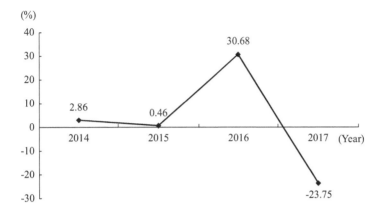

Figure 5.9 Growth rate of the Argentine box office, 2014–2017.

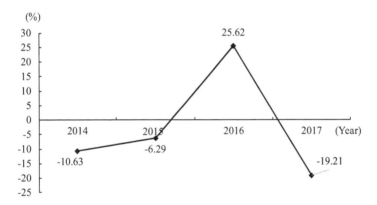

Figure 5.10 Average ticket price growth rate in Argentina, 2014–2017.

Like other Latin American countries, Argentina is also deeply influenced by neoliberalism and has adopted a policy of full openness to the film market, which led to the expansion of Hollywood films. In 2014, the domestic box office share was only 4.74 percent. In recent years, due to the effectiveness of the government's various film support policies, the box office performance of local films has become increasingly prominent. The best result is that of 2016, when the proportion of domestic movie box office jumped to 7.80 percent (Figure 5.11).

However, in general, the Argentine film market is still subject to Hollywood's dominance. For example, in 2018, the top ten box office movies in Argentina were *Avengers: Infinity War, The Incredibles 2, Coco, Hotel Transylvania 3:*

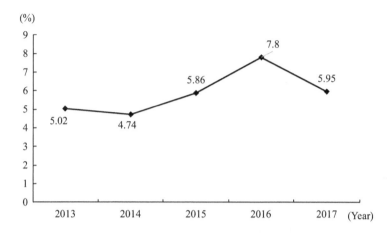

Figure 5.11 Market share of domestic films in Argentina, 2013–2017.

Summer Vacation, Jurassic World: Fallen Kingdom, Bohemian Rhapsody, Jumanji: Welcome to the Jungle, El Angel, Fifty Shades Freed, and *The Nun.* They are mostly Hollywood films.

Analysis of the Brazilian film industry

The Cinema Novo in Brazil, which began in the 1950s (the main idea is to develop local films in order to take back the Brazilian film market dominated by American films) has attracted widespread attention. Of these films, *The Given Word* won the Golden Palm Award at the 1962 Cannes Film Festival. However, since 1964, the film censorship system has tightened and the Cinema Novo has gradually declined. In the early 1990s, due to the economic downturn and the change of government, the Ministry of Culture and the Brazilian National Film Company were revoked, film funding was forced to stop, and film production began to sharply decline. The annual production was only two or three feature films, mostly medium-term budget ones. The market share of local films is less than 1 percent. This phenomenon attracted the notice of the public. In 1995, Brazil enacted the Audiovisual Law, which promoted the rapid development of Brazilian films through introducing a series of film industry promotion policies. Films such as *Exotic Hometown* and *Brazil Princess* were considered by academics to mark the "film renaissance" of Brazil. Since then, the market share of Brazilian domestic box office has continued to rise. The market share of local Brazilian movies in 2003 rose to 22 percent. Since the beginning of the twenty-first century, Brazilian films have been in crisis, and cinema attendance has been declining. As a result, around 2006, Brazilian industry insiders issued a call to "Save Brazilian Movies." In order to boost the film industry, the Brazilian government adopted

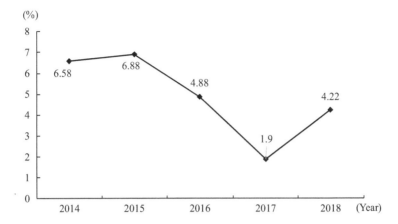

Figure 5.12 Screen growth rate in Brazil, 2014–2018.

a series of measures, including tax reduction, financial support, the establishment of the National Film Fund, the Brazilian Development Bank's preferential loans, and cooperative production. The Brazilian movie box office rose because of these measures, and successfully ranked among the top ten movie box office in the world. In order to protect Brazilian national cinema, starting in 2015, Brazil requires theaters to broadcast Brazilian movies for 28–63 days per screen, and to show 3–24 different domestic films, the number of which varies depending on the number of screens in the cinema. Inspired by a series of measures, the Brazilian film market has developed steadily. In recent years, cinema attendance has remained above 100 million.

Based on Figure 5.12, Brazil's screen growth rate has fluctuated since 2015, and declined from 2015 to 2017. However, in absolute terms, the number of screens continues to grow. In 1995, the number of screens in Brazil was only 1,033, and the number of screens in 2018 was 3,356, the highest point in Brazilian film history.

According to the analysis, cinema attendance reached 161 million in 2018, down from 184 million in 2016, but still higher than the 149 million in 2013. Meanwhile, the growth rate has continued to decline since 2015 (Figure 5.13).

Based on the box office data, Brazil's movie box office revenue has continued to grow and the market is relatively stable in recent years. In terms of box office growth rate, except for 2015, it is basically above the positive growth level (Figure 5.14). Judging from the development trend of movie ticket prices in Brazil, the box office growth rate has increased in recent years and the highest increase appeared in 2017, with a growth rate of 46.72 percent (Figure 5.15). However, the movie ticket price in Brazil is very low. At the beginning of 2019, the price ranged from 28.61 to 31.58 real. From a global perspective, it was one of the countries with the lowest movie ticket price.

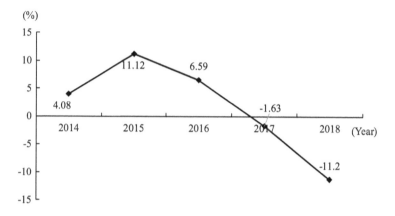

Figure 5.13 Growth rate of cinema attendance in Brazil, 2014–2018.

Figure 5.14 Box office growth rate in Brazil, 2014–2017.

In terms of market share, in recent years, the box office share of domestic films in Brazil has remained above 10 percent. For these films, the share in 2018 is 14.4 percent (see Figure 5.16).

In 2018, the top ten box office movies in the Brazilian film market were *Avengers: Infinity War, The Incredibles 2, Black Panther, Nothing to Lose, Aquaman, Jurassic World: Fallen Kingdom, Jumanji: Welcome to the Jungle, The Nun, Hotel Transylvania 3: Summer Vacation,* and *Venom*. Apart from *Nothing to Lose*, these are all Hollywood movies. However, the Brazilian-produced film *Nothing to Lose* is a box-office smash, which has driven the development of native films. The statistics show that in 2018, the moviegoers for domestic movies reached 23.25 million.

Figure 5.15 Growth rate of movie ticket price in Brazil, 2014–2017.

Figure 5.16 Market share of domestic movies in Brazil, 2014–2018.

Analysis of the Colombian film industry

The Republic of Colombia has a population of 48.653 million, its per capita GDP reached US$6,302 and the human development index was around 0.7 in 2017, making it one of the countries with the biggest growth potential. In 2003, the Colombian Film Law regulated the national film strategy, providing a film development fund, tax incentives, and demanding screen quotas. In 2013, in order to promote the overseas distribution of domestic movies, Colombia decided to exempt exported films from VAT. In the past 10 years, Colombia's economic trend has been relatively stable, and the film

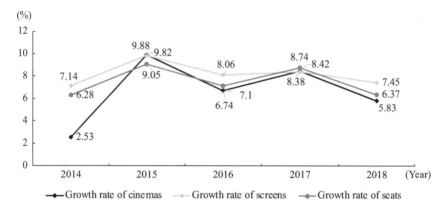

Figure 5.17 Rate of change in film infrastructure in Colombia, 2014–2018.

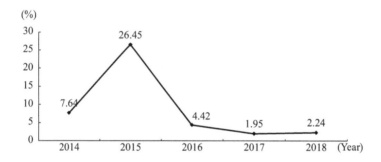

Figure 5.18 Growth rate of cinema attendance in Colombia, 2014–2018.

industry has made great progress. The gross box office has increased from US$290 million in 2011 to US$550 million in 2018. Colombia's film infrastructure has maintained steady and sustained growth. In 2011, there were only 135 cinemas in Colombia, increasing to 218 by 2018. There were 627 screening rooms in 2011 and 1,140 in 2018. The number of seats in theaters was 115,258 in 2011 and increased to 199,942 in 2018. Figure 5.17 shows the rate of change in Columbia film infrastructure from 2014 to 2018.

Since 2015, the growth rate of cinema attendance has been following a downward trend, but it tends to be stable and has maintained a level of stability in recent years (Figure 5.18). The data from 2016 to 2018 are basically stable with a cinema attendance of more than 60 million people. By comparison, before 2012, cinema attendance was less than 40 million.

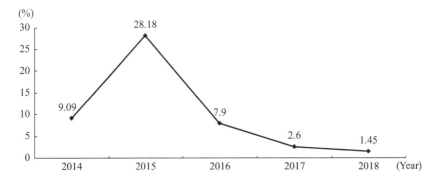

Figure 5.19 Colombia's box office growth rate, 2014–2018.

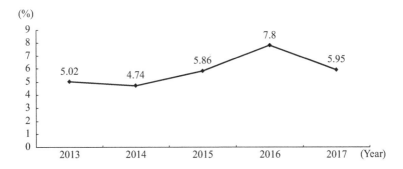

Figure 5.20 Market share of domestic films in Colombia, 2013–2017.

The growth rate of the movie box office is basically in line with the growth rate of the viewers (Figure 5.19). This is not to say that the film industry is declining but shows the maturity of the market. From 2011 to 2014, the box office grossed less than US$300 million; in 2015, it jumped to US$400 million; in 2016, 2017 and 2018, the revenue remained above US$500 million.

Like many other market economies, due to the open policy in the film industry and the lack of effective protection of the local film market, Colombia's domestic film market share has remained at around 5 percent in recent years (Figure 5.20).

According to the data from 2018, the top ten movie box office winners are *Avengers: Infinity War*, *The Incredibles 2*, *Aquaman*, *Jurassic World: Fallen Kingdom*, *Black Panther*, *The Nun*, *Hotel Transylvania 3: Summer Vacation*, *Venom*, *Deadpool 2* and *Bohemian Rhapsody*.

Conclusion

Three countries in Latin America entered the top 20 box office of the world. The scale of the film industry in Latin America is matched by its economic development. In recent years, the film market has been relatively mature and stable.

Judging from the situation of the four major countries in Latin America, the films of Mexico, Brazil and Argentina are more commercially and culturally influential, and have won many international awards. These countries have adopted a series of policies, such as film tax reduction, financial subsidies, and the establishment of a film fund to promote the development of the film industry. The results have been good, and the film industry has continued to develop steadily. In recent years, the box office and the numbers of cinema attendance in these countries have fluctuated, but also grown steadily overall, and the film industries in these four countries have matured after experiencing a few ups and downs. Although these national cinemas in Latin America have achieved significant development, a shift of focus to art-house films has caused the development of commercial films to lag behind relatively. Therefore, Hollywood movies have taken over the box office of these countries.

6 The development of the South Korean film industry in 2018

Korean Film Council

Market volume of the 2018 South Korean film industry

In 2018, the number of total admissions in South Korean cinemas totaled 216.39 million, 1.6 percent less than the previous year in terms of numbers. This decrease, however, is not significant, as the admissions figure for the past six years has remained relatively stable with slight fluctuations after reaching the 210 million mark in 2013. Film sales have continued the trend of a slight increase (Korean won (KRW) 1.8140 trillion), but this reflects an increase in special screenings and ticket fees, centered on multiplex chains in April rather than the structural growth of the market itself. With the steep decline in population growth, bordering on the negative, and the fact that South Korean film attendance per person is already one of the highest in the world, market growth in the form of film admissions shown in the past is not likely to be observed in the future. The rise of different activities other than films is also a threat to the film industry.

In 2018, the digital and online film market, on the contrary, totaled KRW 473.9 billion, an 8.6 percent increase from the previous year. Because the current measurements of the online film market fail to reflect the multitude of services available in the market, the actual size of the online film market in South Korea is expected to be greater than this estimate.

In terms of exports, film exports maintained similar levels to previous years. However, service exports, having relied absolutely on the Chinese market, halved, reducing the total sales by 34 percent to KRW 88.5 billion.

Overall, the total volume of the South Korean film market in 2018 was estimated at KRW 2.3764 trillion, reflecting an increase of 2.1 percent on the previous year (see Table 6.1, Figure 6.1).[1]

Theater chain and distribution

In 2018, the theater market did not deviate from its trend of low growth. The total admissions figure showed a reduction of 1.6 percent to 216.39 million (219.87 million in 2017), while the total film sales figure reached KRW 1.814 trillion, a 3.3 percent increase from the previous year (KRW 1.7566 trillion),

Table 6.1 Sales figures for the South Korean film industry, 2009–2018 (**KRW** 100 million)

Classification		2009	2010	2011	2012	2013	2014	2015	2016	2017	2018
Ticket sales		10,941	11,684	12,358	14,551	15,513	16,641	17,154	17,432	17,566	18,140
Ratio (%)		91.3	88.1	85.5	85.0	82.3	82.1	81.2	76.7	75.5	76.3
Additional markets		888	1,109	1,709	2,158	2,676	2,971	3,349	4,125	4,362	4,739
Ratio (%)		7.4	8.4	11.8	12.6	14.2	14.7	15.8	18.1	18.7	19.9
Overseas exports	In KRW 100 million*	155	462	382	414	651	664	628			
	Film								509	460	458
	service								664	883	427
	subtotal								1,173	1,343	885
	In US$ 10,000*	1,412	4,222	3,487	3,782	5,946	6,308	5,550			
	Film								4,389	4,073	4,160
	service								5,720	7,806	3,876
	subtotal								10,109	11,879	8,036
Ratio (%)		1.3	3.5	2.6	2.4	3.5	3.3	3.0	5.2	5.8	3.7
Total		11,984	13,255	14,449	17,123	18,840	20,276	21,131	22,730	23,271	23,764
Ratio (%)		100	100	100	100	100	100	100	100	100	100

Source: Korean Film Council.

Notes: * Film and service sales had been included since 2016.
Conversion to **KRW** follows 1 US$ = 1,101.47 **KRW** (average purchase rate for 2018).

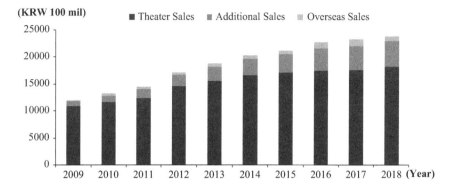

Figure 6.1 Sales figures for the South Korean film industry, 2009–2018.

its highest record. The average total ticket cost for the year 2018 was KRW 8,286, reflecting an increase of 4.6 percent from the previous year (KRW 7,925). This was the reason for the general increase in theater sales. The total admissions figure for South Korean films showed a reduction of 3.3 percent to 110.15 million (113.90 million in the previous year), while the total film sales figure reached KRW 912.8 billion, a 1.1 percent increase from the previous year (KRW 902.7 billion). The market share of South Korean films reached 50.9 percent, a decrease of 0.9 percent from the previous year, successfully maintaining the slight increase it had enjoyed for eight years since 2011. The average number of films seen per capita was 4.18, reflecting a reduction of 0.07 over the previous year. However, South Korea still has one of the highest average numbers of films seen per capita, which seems to indicate that the film industry will maintain its low-growth trend without large changes.

The distributor market share ranking reflected a significant change, with Lotte's ascent to first place with 17.1 percent of the shares from its second place in the previous year, followed by the outstanding performance of Disney (Korea) of 13.9 percent in second place. CJ ENM, the undisputed leader of the market for 15 years, was relegated to third place with a 13.3 percent share.

Digital online markets

The size of the digital and online market in 2018 reached KRW 473.9 billion, an increase of 8.6 percent from the previous year, thanks to the growth of TV video-on-demand (VOD) markets through Internet Protocol TV (IPTV) and digital cable TV. Even though the Internet VOD market has seen serious growth in the wake of fierce competition between domestic and international over-the-top (OTT) services, the South Korean digital and online film market is still dominated by TV VOD and its share of 83 percent. The highest grossing film in the TV VOD market was *Along with the Gods: The Two*

Worlds with more than 1.7 million views, followed by strong performances by crime dramas and action films.

The Internet VOD market saw a reduction in total sales of 3.2 percent due to tightened regulations. The DVD and Blu-ray market also saw the continuation of its dwindling performance.

Exports

2018 saw significant damage to the export prospects of South Korean films from macro-political events. 2018's export sales crashed to US$80.36 million. While the export of films (US$41.6 million) stayed the same as the previous year, service export decreased by 50.35 percent from the previous year (US$78.06 million to US$38.76 million). This reflected the over-reliance of South Korean firms on the Chinese market that drove most of the expanding technological services industry.

Taiwan topped the export market for the first time, and 2018 once again reaffirmed the dominance of the Chinese-speaking markets (China, Hong Kong, Singapore, etc.) with the share of sales at 48.2 percent.

Overseas films set in Korea were estimated to have collectively spent US$3.39 million in expenditure, a 57 percent decrease from the previous year. While 2018 did not have blockbuster-level films like *Black Panther* in 2017, it was also notable that six Chinese films included locations in Korea.

Data interpretation of the 2018 South Korean film industry

Theaters and multiplexes

The number of theaters nationwide increased from 452 in 2017 to 483 in 2018, an increase of 31, while the number of screens increased by 171 to 2,937 (see Table 6.2). Multiplexes accounted for 79.5 percent of the total number of theaters.

The distribution and investment company NEW started its screening business in 2017, and opened five theaters called CineQ. Theater chains like this vertically integrated investment with distribution and screening, occupied 381 affiliated multiplexes, and the number of its screens totaled 2,727.

In terms of administrative regions, 50 administrative regions had no theater at all, and two of them had a population of over 200,000.

Major players and market structure

2018 did not see any changes in the fundamental structure of the South Korean film industry or the vertical organization of major film companies from production to distribution and screening. Likewise, there were no changes in the trend of centralization of screening and distribution markets. On the contrary, NEW, the latest newcomer to join the screening market in

Table 6.2 Major statistical indicators for the South Korean film industry, 2009–2018

Classification		2009	2010	2011	2012	2013	2014	2015	2016	2017	2018
Admission (in 10,000)	Total admissions	15,696	14,918	15,972	19,489	21,335	21,506	21,729	21,702	21,987	21,639
	South Korean films	7,641	6,940	8,287	11,461	12,729	10,770	11,293	11,655	11,390	11,015
	Admission share (%)	48.7	46.5	51.9	58.8	59.7	50.1	52.0	53.7	51.8	50.9
	Foreign films	8,055	7,978	7,685	8,028	8,606	10,736	10,436	10,047	10,597	10,624
	Admission share (%)	51.3	53.5	48.1	41.2	40.3	49.9	48.0	46.3	48.2	49.1
No. of films released*	South Korean films	118	140	150	175	183	217	232	302 (167)	376 (164)	454 (194)
	Foreign films	243	286	289	456	722	878	944	1,218 (411)	1,245 (456)	1,192 (534)
No. of screens nationwide		2,055	2,003	1,974	2,081	2,184	2,281	2,424	2,575	2,766	2,937
No. of theaters nationwide		305	301	292	314	333	356	388	417	452	483
Average film admissions per capita		3.15	2.92	3.15	3.83	4.17	4.19	4.22	4.20	4.25	4.18
Return on investment for South Korean films** (%)		–13.1	–11.0	–16.5	15.9	16.8	7.6	4.0	17.6	18	–17.3

Source: Korean Film Council.

Notes: * No. of films released refers to the number of films that exceeded 40 screenings per year (daily screening in a week for a single theater yields approximately 40 screenings). This indicator has been included since 2016.

** Profit rate analysis focused on films "exceeding KRW 1 billion in total production cost" or films "screened in more than 100 theaters at its highest point" until 2016. In 2017, a new criterion of "films exceeding KRW 3 billion in actual production cost" was introduced to reflect the rising trend of production costs.

2017, expanded the number of its CineQ theaters to five, perhaps signaling its move to rise as the fourth multiplex giant of the South Korean film industry. Another note is CJ ENM's drop from its position of absolute dominance from 2013 to 2017, ending up in third place for the first time, due to the poor performance of its projects and the excellent performance of its competitors, Lotte and Disney (Korea).

Certainly, it is still too early to draw any conclusions about CJ ENM's performance in the South Korean market based on its performance in 2018 alone. CJ ENM was launched in 2018 through a merger of CJ E&M and CJ O Shopping, to expand the media content and platform projects to the area of merchandising. A comparison of the market capitalization in late 2018 shows that CJ CGV, the largest theater chain company in South Korea, has only one-third of the CJ-affiliated TV drama producer Studio Dragon, which in turn demonstrates CJ's interpretation of the future of media content industry.

The year 2018 was also characterized by the entrance of new players such as Merry Christmas, Acemaker Movie Works, and Haengnam to the distribution market, raising expectations for their activities from 2019 onward. Such developments show that the South Korean film industry may be standing on the edge of a zero-sum game between limited markets or a new way out through new movies.

Market concentration

The year 2018's screening market did not deviate from the trend of high concentration (Herfindahl-Hirschman Index 3,610); the largest accounted for 50 percent and the top three companies accounted for 97 percent of screenings, respectively. Future changes from this trend remain highly unlikely. If a distinction is made between affiliated multiplex and contract theaters, market concentration indicators tend to fall (HHI 2,353).

The distribution market reflected a slight increase in concentration, even though the market remains relatively dispersed compared to the screening market (the top one accounted for 16.9 percent, the top three accounted for 44.3 percent, HHI 1,030). However, concentration in South Korean film distribution remains significantly higher than the market average (the top one accounted for 25.8 percent, the top three accounted for 69.5 percent, HHI 1,871). The share of films ranking first to third in daily screening ratio has consistently increased over the past few years, eventually reaching 67.5 percent in 2018.

There were nine films that had more than a 40 percent screening ratio per day in 2018. *Avengers: Infinity War* had 21 days where its share remained over 40 percent, with the highest share reaching 77.4 percent. *Along with the Gods: The Last 49 Days* started with a 53.3 percent share and reached 59 percent on its fourth day, becoming the highest grossing film of 2018 with 12 million admissions.

Independent art films

A total of 496 independent art films were released in South Korea in 2018. While the number of films released remained similar to the previous year, 2018 was also marked by a sharp drop in the number of admissions (-12.3 percent). This trend appears especially dangerous to the health of South Korean independent films, as 113 South Korean-produced independent films accounted for only 1.1 million admissions or 12.9 percent of the total. This is only 0.5 percent of total admissions in 2018, half of the previous 1 percent share that independent films had managed to maintain for the previous three years.

The highest-grossing independent art film in 2018 was *What Happened to Monday* that gained 900,000 admissions. Only 15 films had more than 100,000 admissions in 2018, and the documentary film *Intention* was the only South Korean film among them. *Microhabitat* was the second highest-grossing South Korean independent art film in 2018, but its admission performance of 59,110 would have only been in ninth place in terms of the previous year's records.

Summary of the development of South Korean-produced films in 2018

Production costs and estimated ROI

The sum of production costs for 186 films that saw "actual release"[2] in 2018 (174 in the previous year) amounted to KRW 498.6 billion (KRW 458.2 billion in the previous year), with an average total production cost of KRW 2.68 billion (KRW 2.63 billion in the previous year) and an average pure production cost of KRW 2 billion (KRW 1.91 billion in the previous year). These represent a rise from the previous year's levels. The total sum of production costs for 40 commercial films that had a production cost of over KRW three billion (37 in the previous year), amounted to KRW 414 billion, with an average total production cost of KRW 10.34 billion (KRW 9.78 billion in the previous year) and an average pure production cost of KRW 7.9 billion (KRW 7.33 billion in the previous year).

The average estimated return on investment (ROI) for these 40 commercial films was estimated at -17.3 percent, a drastic drop from 2017's average (18 percent). After the positive shift of the ROI for South Korean films in 2012, their average ROI remained positive until 2017. The reason for this drastic drop is estimated to be the lack-luster performance of high-budget films in the box office with more than KRW 10 billion production cost, while profit rates also showed a decline for lower and mid-budget films with budgets of KRW 3–5 billion or 5–8 billion.

The underwhelming performance of South Korean films

In 2018, South Korean films accounted for 50.9 percent of the total admissions in the theater, which had passed the 50 percent boundary for eight consecutive years. It seemed to show, at least on the surface, that there were no problems associated with their performance. However, a closer examination reveals that South Korean films performed quite poorly in 2018 and that both commercial films and independent art films showed this tendency.

While the film *Along with the Gods* broke several records in its second consecutive release since 2017, other heavy-budget commercial films capitalizing on the high seasons of New Year, summer vacation, mid-autumn day, and end-of-the-year periods failed to perform well, both critically and financially. A general investigation of the film budget in South Korean commercial films conducted in 2018 showed that the average production budget was KRW 7.9 billion, an increase of KRW 0.57 billion from the previous year. There were 40 films that had over KRW 3 billion budget, in particular, 2018 saw five more films costing over KRW 8 billion in production more than the previous year. An estimate of their ROI put the profitability of such films on a sizable crash.[3] Certainly, this trend is only backed by estimates and will no doubt see some improvement once actual figures are included in the calculation. Nevertheless, most South Korean commercial films failed to perform beyond their break-even point and their critical performances were also found to be unsatisfactory. This fact is certainly a worrisome development. On the contrary, mid-to-low budget films between KRW 3–5 billion could break even and make a profit.

Such a gloomy performance extended to independent art films. Some 113 South Korean independent art films released in 2018 managed to attract only 1.1 million audiences, 0.5 percent of the total admissions. The documentary film *Intention* accounted for half of that figure (0.54 million), which shows that 112 independent art films shared 0.56 million moviegoers between them. That is even less than a day's figure for successful commercial films. Along with the continued calls for public support for the production and distribution of such films, a discussion of the future and sustainability of independent films seems to be required for the health of the South Korean film industry.

Film production in the 52-hour working week

The Labor Standards Act (Amendment) was passed by the National Assembly in February 2018. Film industry workers were excluded from the enforcement of the 52-hour working week before this amendment. This will result in the explosive surfacing of many problems hidden within South Korean film production. And even though the year's discussions and arguments have not yielded any fruitful results, the actual enforcement of the law planned in 2020 means that the South Korean film industry must find acceptable solutions to this dilemma during 2019.

"Me too" and gender equality in South Korean films

The year of 2018 saw the discussions of abuse and inequality within the South Korean film industry surface with the continuation of the "Me Too" movement. Testimonials from victims of such abuse forced many male members of the industry to cease their public activity, and in some cases, a completed film was filmed again in the wake of testimonials.

March 2018 saw the establishment of the South Korean Film Gender Equality Center, an agency dedicated to supporting the victims of sexual abuse and the prevention of sexual abuse within the film industry. It was followed by the establishment of the Sub-committee on Gender Equality under the Korean Film Council in August, which laid the basis for macro-level policies for gender equality. These discussions in 2018 have created plans to raise the mandatory gender percentage to 40–50 percent in the Korean Film Council.

Film statistics on female-produced films

Of the 77 commercial films released in 2018, 10 films are directed by female directors (13.0 percent), 15 films are associated with female executive producers (19.5 percent), 23 films are produced by female producers (29.9 percent), 24 films feature female protagonists (31.2 percent), and 23 films are written by female screenwriters (29.9 percent), which reflect a general increase across all areas, excluding production and cinematography. In particular, 2018 featured the highest ratio of female directors and leads in the last five years.

The average admissions to films directed by female directors rose to 593,319, which is an increase of 28.8 percent from the previous year and the fifth consecutive increase for the past five years. The average admissions to films with female leads rose to 572,858, which is an increase of 41.4 percent from the previous year.

Notes

1 The total volume of the South Korean film market, as reported by the South Korean Film Council, refers to the sum of: (1) sales from film tickets sold at the theater; (2) sales from digital and online market (centered on TV VOD); and (3) overseas sales (film and service export). Strictly speaking, the volume of South Korean film market itself should include all sales generated by companies within the market. As such, the total volume of the South Korean film market is estimated to be much greater than the estimate provided here. For reference, the 2017 South Korean Film Industry Survey conducted by the Korean Film Council estimated the total volume of the market as KRW5.4947 trillion.

2 Some 194 films were regarded as "actual release," but eight of them were identified as not belonging to the South Korean investment and production system. To accurately calculate production cost, only 186 films were analyzed. The figure here is different from Table 6.2.

3 The informal production cost survey conducted by the Korean Film Council at the beginning of each year, because of its timeframe, includes many films that did not pass through the primary balancing stages. In such a case, the survey uses the budget as a stand-in for the actual figures, which prevents the survey from accounting for the additional costs. In the commercial film ROI survey, conducted concurrently to the informal production cost survey, film rental sales are calculated by multiplying the total admissions figure of the South Korean commercial films with the previous year's average film rental sales per person. Consequently, a change in the film rental sales figure per person would mean that film rental sales as a whole would differ from the estimate. This is particularly significant as the average ticket cost rose by KRW 361 to total KRW 8,286 in 2018 (KRW 7,989 in 2017), which is expected to have increased the overall film sales for this year. Furthermore, fees and other costs (including incentives) are also calculated by multiplying the ratio of the previous year's fees and other costs by the estimated total sales of the year, and thus may be different from the estimated costs later on.

7 Opportunities and challenges for the British film industry

David Wilson

General state of the British film industry

According to data released by the British Film Institute (BFI), in 2018, along with the record high investment scale of film and television production, the British box office totaled £1.282 billion (the highest since the 1970s) (Figure 7.1), which indicates that Britain is still playing an important role in the world's film and television industry.

The 2018 film box office of UK was higher than the previous year, and one of the important contributory factors was the outstanding performance of domestic large-scale productions, such as *Mamma Mia! Here We Go Again*, *Bohemian Rhapsody*, *Mary Poppins Returns*, and *Fantastic Beasts: The Crimes of Grindelwald* (Table 7.1). In 2018, a series of blockbusters including *Pokémon Detective Pikachu* and *Star Wars: The Rise of Skywalker* started shooting, which are releasing or will be released worldwide in 2019–2020.

When talking about the British film industry in 2018, one important element should be considered is that the UK was going through Brexit. Obviously, Brexit will have a profound impact on British society. Economic factors such as national age ratio, social class structure, residents' income and education will change, British manufacturing and financial industries need to adjust accordingly.

The British film industry and the European Union have always been interdependent. Creative Europe plays a significant role in the European film marketing. A total of 39 countries (including 28 EU countries and 11 non-EU countries) are currently in the Creative Europe organization. Therefore, even after Brexit, Britain still needs to continue to have a cooperative relationship with Europe in the field of cultural creativity.

Many people believe that Brexit and the devaluation of the British pound promoted the growth of British film industry. The lower cost and tax reduction and exemption policies have attracted more American films to be produced in the UK. According to the British Broadcasting Corporation (BBC), from 2017, production costs from production agencies outside the UK reached £1.7 billion.

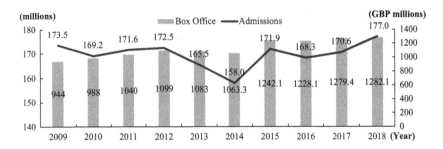

Figure 7.1 UK moviegoers and box office, 2009–2018.

Table 7.1 The top 20 films released in the UK and Ireland in 2018 (£ millions)

No.	Title	Countries	Box office	Production company
1	Avengers: Infinity War	UK/USA	70.8	Walt Disney
2	Mamma Mia! Here We Go Again	UK/USA	65.5	Universal
3	The Incredibles 2	USA	56.2	Walt Disney
4	Bohemian Rhapsody	UK/USA	52.0	20th Century Fox
5	Black Panther	USA	50.6	Walt Disney
6	Mary Poppins 2	UK/USA	42.1	Walt Disney
7	Jurassic World: Fallen Kingdom	UK/USA	41.6	Universal
8	Peter Rabbit	UK/USA/Australia	41.1	Sony Picture
9	Fantastic Beasts: The Crimes of Grindelwald	UK/USA	34.0	Warner Bros.
10	Deadpool 2	USA	32.7	20th Century Fox
11	A Star is Born	USA	29.9	Warner Bros.
12	The Grinch	USA	27.8	Universal
13	Mission: Impossible – Fallout	UK/USA	24.4	Paramount
14	Darkest Hour	UK	24.1	Universal
15	Aquaman	USA	22.1	Warner Bros.
16	Venom	UK/USA	20.2	Sony Picture
17	Hotel Transylvania 3: Summer Vacation	USA	20.1	Sony Picture
18	Solo: A Star Wars Story	UK/USA	19.4	Walt Disney
19	Coco	USA	18.9	Walt Disney
20	Fifty Shades Freed	USA	17.8	Universal

Source: comScore, BFI.

Note: Box office figures come from the UK and the Republic of Ireland, the single "territory" used for film distribution. Box office gross as of January 27, 2019, for films still in theaters on January 27, 2019.

Brexit also limits the free movement of people. *Forbes* claimed in 2018 that the healthy operation of the film industry relies heavily on the free movement of people and equipment in different workplaces. In the UK, about 40 percent of staff in post-production, visual effects and 3D animation are non-British.

The British film industry is bound to face new challenges in attracting outstanding foreign film talent. More filmmakers have been calling for more job opportunities for new creative industry employees, and trying to retain a sufficient number of high-level professional teams to meet the needs of international films shot in the UK.

Much of the money invested in British films comes from Continental European funds. This investment mode is closely related to the European film market. After Brexit, the impact is incalculable. Although Brexit will have a negative impact on the British film industry, the British film industry also faces new development opportunities. The UK and China, India, Brazil and other countries are jointly developing co-production programs.

The British Film Institute (BFI) has given British filmmakers advice to help them deal with the problems caused by Brexit. Ways of film financing are diverse, among which money from the National Lottery is a vital one. Filmmakers often face fierce competition to gain investment money from the National Lottery. The BFI has been in charge of Lottery financing since the British Film Commission closed in 2011. From 2011 to 2018, the BFI has issued £22,260,040,86 in film funding, of which 45 percent was invested in film production. The distribution of BFI fund investments from April 2012 to April 2018 is shown in Table 7.2.

For film programs that meet their criteria, the BFI Fund gives varying degrees of subsidies to enable them to be effectively completed, and subsidies would be given to but not limited to the following categories: author copyright, priority adaptation rights, program R&D costs, producers' daily expenses,

Table 7.2 Investment distribution of BFI funds between April 2012 and April 2018

No.	Type	Amount (£)	No.	Type	Amount (£)
1	Manufacture	99717783	9	Documentary	1882393
2	Education & training	36939567	10	Post-production and film completion	1686789
3	Audience and events	32409695	11	Publish (international)	1373361
4	Development and pre-production	18442878	12	Research and data support	822102
5	Publish (UK)	16296657	13	Other	552000
6	Publicity for country	6228910	14	Diversity	210925
7	Funds	3634100	15	Archive file	180000
8	Short film	2226927			

Source: Stephen Follows, see https:// stephenfollows.com.

legal staff costs, script editing costs in financing stage, pre-casting costs, and holding development rights fees, etc. Meanwhile, the BFI funding strongly supports original authors, including new filmmakers, relevant creative ideas to promote cultural progress, film programs with innovative content, innovative forms, film programs from outside London and the South-east region.

In 2018, the BFI announced the establishment of a new fund, the BFI Youth Audience Special Fund, whose aim is to promote the development of unique, high-quality content products that reflect the growth experience of British youth under the age of 18.

London has long been the most frequent shooting location in the UK, but from 2017 to 2018, Yorkshire became an emerging hotspot for film and television production. The natural scenery and historical and cultural relics of the UK have attracted Indian filmmakers to come to the UK. The number of crews from Bollywood grows rapidly. Bollywood crews bring more job opportunities to British film production staff than local film production does.

The rise of the video-on-demand (VOD) platforms

The development of high-speed broadband and Internet interactive television has significantly changed the way British viewers watch movies and TV shows, which has been reflected in the rapid development of video-on-demand platforms, such as Netflix and Amazon in recent years. Accordingly, the rise of VOD platforms has had an impact on the employment rate in British film industry. According to a report from the Information Dissemination Office of the UK government, user numbers of Netflix, Amazon, and Now TV platforms have significantly surpassed that of traditional limited pay TV. The high emphasis on original content is a key element in the rise of VOD platforms. In 2018, 38 percent of Netflix users said that "choose to watch original content" was the reason for them to be subscribers, compared to 30 percent in the survey in the first quarter of 2017 (Figure 7.2). The movie *Roma*, presented by Netflix, has won Academy Awards, which has sparked wide discussions among filmmakers about VOD platforms hitting traditional cinemas. The VOD platforms also provide screening opportunities for films that cannot be screened in traditional theaters.

Today, the budget for programs of VOD platforms is as high as. if not even higher than that of traditional feature films, which provides film industry personnel and production-related services (such as hotels, vehicles and equipment rental, etc.) with a full-year's business. The British film industry's demand for experienced crew members has grown for two consecutive years. With the boom in film and television production, existing British film shooting bases are not enough, and new studios and new shooting sites should be built as soon as possible.

Parents and educators are concerned that children and teens can easily browse and watch uncensored online programs, which could be harmful

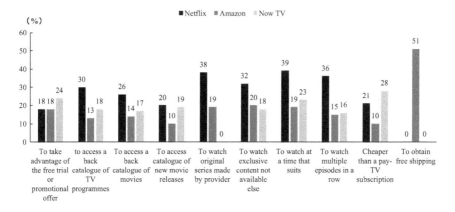

Figure 7.2 Reasons for choosing a video-on-demand platform.

to their mental and physical health. Netflix responded that it had obtained relevant permits, and its programs can be broadcast in the UK under the conditions of certain age. This was Netflix's response to social concerns, also the first time that the British film rating agency has granted a company the power to decide by themselves based on viewers' age under guidance. Netflix announced that they would use data calculations to decide whether to invest in a program, especially programs for non-adult audiences.

Bilateral cooperation between Britain and China (Bradford and Qingdao)

As early as 2014, China and the UK government signed an agreement to develop a mechanism to guide and encourage production agencies in both countries to cooperate in filmmaking. The UK has set up preferential tax policies and BFI fund assistance.

As the first "City of Film" recognized by UNESCO, Bradford has a rich and long history of film. Now, an increasing number of film and TV drama programs apply to the Bradford Film Office for filming licenses, including programs from the BBC and ABC ,as well as from Bollywood.

Bradford has been committed to developing partnerships with the Chinese film industry. Bradford, the City of Film, helped Qingdao in the process of applying for UNESCO City of Film status. A delegation from the China Film Association visited Bradford in April 2018. The Bradford delegation participated in the Golden Rooster and Hundred Flowers Film Festival in Foshan in 2018. Qingdao University of Science and Technology and the University of Bradford have begun cooperation in the field of animation education.

The city of Bradford is developing into another UK film and television production and education center after London. At present, the British film industry is in a period of healthy development. If international cooperation with emerging overseas markets, such as China, can be strengthened in the future, the British film industry will surely start a long-term and successful path to prosperity and stability.

8 The development of the Chinese film industry in 2018

Shuzhen Sun

The year 2018 was the 40th anniversary of China's Reform and Open Door policy. In light of the new era and spirit of the 19th Party Congress of China, 2018 was the first year for the Chinese film industry to thoroughly incorporate the socialist ideology with Chinese characteristics into its filmmaking practice. This is the key to implementing the 13th Five-Year Plan to achieve an overall prosperous society. The year of 2018 was also the beginning of the unified management of film work by the Central Publicity Department. To standardize and support the development of the film industry, the Central Committee of the Party and the State Council successively issued a series of film industry policies and measures in 2018. Along with an improvement in the audience's consumption level and the change of the consumption concept, the broad market and good consumption foundation further contributed to the development of the quality and quantity of Chinese film productions (Table 8.1).

Analysis of the environment of China's film industry in 2018

The policy environment of the Chinese film industry

In 2018, the Chinese film industry reform continued. *The Notice on Further Regulating the Taxation Order of the Film and Television Industry*, and the *Opinions on Accelerating the Construction of Cinemas to Promote the Prosperity and Development of the Film Market* and other film policies and regulations were introduced, one after another, resulting in the swift development of the film industry in China.

In recent years, on the one hand, the Chinese film industry has developed rapidly, and its growth momentum is strong. On the other, there are also problems, such as high salaries for stars, faked contracts and tax evasion. These problems not only lead to high virtual program costs, but also undermine a healthy filmmaking environment. At the same time, the problems above tend to mislead young people to blindly worship film stars.

In June 2018, the Publicity Department of the CPC Central Committee, the State Administration of Taxation, the National Radio and Television

Table 8.1 Main indicators of the development of China's film industry, 2012–2018

Classification	2012	2013	2014	2015	2016	2017	2018
Box office (100 million yuan)	166	215	294	439	455	558	607
Cinema (line)	45	45	47	48	48	48	48
Number of screens (block)	13118	18195	23592	31627	41179	50776	60079
Number of theatres	3062	3879	4926	6500	7912	9342	10485
Viewing people (100 million person-time)	4.66	6.17	8.34	12.6	13.72	16.2	17.17
Average fare (yuan)	36.3	35.3	35.5	35.0	33.1	34.4	35.5
The number of feature films produced (part)	745	638	618	686	772	798	902

Source: EN Film Think Tank.

Administration, the Ministry of Culture and Tourism, and the National Film Board jointly issued a notice on the management of the film industry's sky-high fees, faked contracts and tax evasion. *The Notice* stressed that it is necessary to formulate standards for the implementation of film and television program payment schemes, and clarify the maximum pay limit for actors and program guests; all film and television production companies and TV stations must strictly implement the total pay for all actors and guests, and must not exceed the total production budget of each film or TV series, and network audiovisual programs. The total payment for all actors/actresses of a film project cannot exceed 40 percent of the production cost, and the payment for the star actors/actress cannot exceed 70 percent of the total fee for all actors/actresses of a film project. Besides, the relevant department of film and television should strengthen supervision over the participation of film and television stars in entertainment programs and reality shows, with measures to counter possible tax evasion by stars. *The Notice* requests the supervisory department to strengthen the education of film professionals to put social benefits first and create a healthy environment for the film industry.

In October 2018, in order to further strengthen tax supervision, the State Administration of Taxation issued *The Notice on Further Regulating the Taxation Order of the Film and Television Industry*. *The Notice* stipulates that all film and television production companies, star studios and other enterprises and employees must undergo a tax review dating back to 2016. Any company and related film professionals who legally go through the tax review and pay taxes back, if there is any pending tax before 2019, will be exempt from legal prosecution and penalties.

By strengthening the film and television industry's taxation, the Chinese government has effectively regulated tax collection and further protected the legitimate rights and interests of taxpayers according to the law, thus achieving

the goal of maintaining a fair competitive tax environment and promoting the healthy development of the film industry.

On December 13, 2018, in order to promote the rapid development of the number of cinemas, the National Film Board issued the *Opinions on Accelerating the Construction of Cinemas to Promote the Prosperity of the Film Market*. According to the *Opinions*: (1) the total number of cinema screens will total more than 80,000 by 2020. The distribution of cinemas and screens will be more closely matched to the level of urban development and population distribution; (2) advanced screening technology and facilities are to be used in upgrading cinema construction; (3) the construction of county-level urban cinemas and township cinemas is to be encouraged; and (4) further reforms are to be applied to the Chinese cinema system with a focus on different characteristics of different cinema chains. The introduction of the *Opinions* will help balance the distribution of cinema resources in the central and western regions of China, coordinate the development of urban and rural areas, and provide solid policy support for the realization of strong film industry in the provinces.

The economic environment of the Chinese film industry

In 2018, China's economy progressed steadily with a positive trend of quality improvement and structural optimization. The main improvements are as follows: (1) the employment target of 11 million new jobs is completed three months ahead of the target deadline; (2) the willingness to invest in the private sector continued to increase; (3) the proportion of manufacturing investment increased substantially, and structural investment was gradually optimized; (4) the overheating of the real estate market has been eased. On the other hand, China's economy has been steadily changing. Due to factors such as an accumulation of household debt pressure, the widening gap between the rich and the poor, and the increased trade friction between China and the United States, a number of problems emerged, such as the continuous decline in consumer spending, difficulties in operating some enterprises, and declining market vigor. At the same time, the international economic environment has undergone tremendous changes, and there have been unfavorable situations, such as the slowdown in global economic growth, the prevalence of trade protectionism, the volatility of the RMB exchange rate, and the slight decline in foreign exchange reserves.

In 2018, the annual gross domestic product (GDP) was 900.30 billion yuan, which is an increase of 6.6 percent over 2017, achieving an expected development target of around 6.5 percent (Figure 8.1). China's economic growth ranks first among the world's top five economies, and its contribution to world economic growth is close to 30 percent. In 2018, China's macro-economy faced a complex and ever-changing external environment, but it still achieved good results mainly in the following aspects: (1) high-quality development led to remarkable results; (2) supply-side structural reforms are well

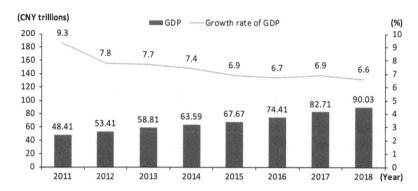

Figure 8.1 China's GDP and growth rate, 2011–2018.

advanced; (3) the initial achievements were made in a tough economic situation; (4) the Reform and Open Door policy has been continuedly practiced and enhanced; (5) China took proper measures to react to the Sino-US trade friction; and (6) overall the Chinese people's social and economic conditions improved.

The transformation of policy norms and concepts has injected a strong impetus into the sound development of Chinese films. The film industry in 2018 is still at a high-speed development stage. As the investment (especially investment from Internet platforms) gradually flows into the film industry, the industrial model of the film industry chain continues to undergo subtle changes. Based on the amount of investment, the competition in Chinese film industry has gradually extended to both ends of the industrial chain and is no longer concentrated in the traditional investment channels and fields of the film industry chain.

In the future, the Chinese film investment and financing market will present the following characteristics: (1) the film capital investment hotspot will be focused on deepening the commercial value of high-quality Internet Protocols (IP); (2) the next stage of film investment will affect legal services, financial services, ticketing systems, special effects production, artists brokerage and other film-related services; and (3) large amounts of capital continue to be invested in the entire film industry chain.

The social environment of the Chinese film industry

The demographics of the Chinese population are divided into three types based on the categorization of ages: 0–14 years old; 15–64 years old; 65 years old and above. At present, China's population is aging fast, which leads to many social problems, such as a reduction in demographic dividends, a shortage of labor, and an imbalance between men and women. In order to solve these social problems, China has implemented the "Comprehensive Second Child"

policy since 2016. Based on this policy, the experts foresee that although the current policy effects have not yet become obvious, in the future, the total population of China will remain stable and the structure of the population will mostly be balanced. This is undoubtedly a good factor in maintaining and increasing the size of the existing Chinese film market.

The consumption structure of Chinese residents consists of both material consumption and spiritual consumption. The upgrading of the consumption structure means that in total consumption, the proportion of service consumption and innovative goods consumption has gradually increased. Since the Reform and Open Door policy, China has experienced three upgrades in its consumption structure. The third phase of the current consumer structure upgrade is mainly due to the rapid growth of the IT industry, the real estate industry, the automotive industry and the cultural industry. With the upgrading of the consumption structure, the consumer's consumption focus shifts, and the proportion of service consumption in the consumption structure is increasing. Undoubtedly, the upgrading of the consumption structure will open up a new window for the development of the Chinese film industry.

The network technology environment of the Chinese film industry

Since the release of *The Promoting Internet Protocol Version 6 (IPv6) Scale Deployment Action Plan* in November 2017, Chinese operators have initially had the ability to support IPv6 over the network and are now moving from network capabilities to application adoption. China's international export bandwidth is 8826302Mbps, with a half-year growth rate of 20.6 percent. The Chinese Internet users now have faster Internet access, better cross-border roaming calls and better network quality. In 2018, the proportion of Internet penetration and mobile Internet users in China continued to increase. Figure 8.2 shows that from June 2013 to June 2018, the number of Chinese

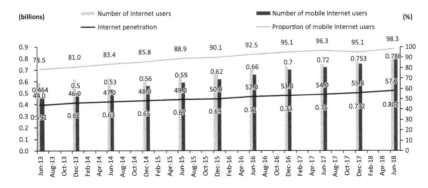

Figure 8.2 Scale and proportion of Internet users and mobile Internet users, June 2013–June 2018.

netizens increased from 590 million to 800 million, and the Internet pene-
tration rate increased from 44 percent to 58 percent. As of June 2018, the
number of video users was 594 million, accounting for 74 percent of the total
Internet users. Among the total number of netizens, the number of mobile
Internet users increased from 460 million to 790 million, and the proportion
of mobile netizens to all netizens increased from 78 percent to 99 percent. In
June 2018, the number of mobile video users reached 580 million, accounting
for 73.4 percent of the total number of mobile Internet users. The growth rate
of mobile video users is much higher than the overall growth rate of mobile
Internet users. The rapid increase in video users, especially mobile video users,
is the inevitable result of strong demand in the online entertainment market.

Box office analysis of the Chinese film industry, 2018

The Chinese film industry has maintained its momentum of rapid develop-
ment. The annual domestic box office has increased from 6.3 billion yuan in
2009 to 60.07 billion yuan in 2018, with a compound growth rate of 28.62 per-
cent. In 2018, the box office proportion of domestically produced films was
60.3 percent which is an increase of 6.2 percentage points from 2017. The
number of cinema admissions increased from 200 million in 2009 to 1.72
billion in 2018, with a compound growth rate of 27.01 percent. According
to the above statistics, Chinese film industry's box office has achieved rapid
growth, and its status as the world's second largest film market has been fur-
ther consolidated.

Analysis of the annual total box office of Chinese films in 2018

In 2018, the annual box office of Chinese films exceeded 60 billion yuan as a
new box office record after 2017. From 2011 to 2018, the annual box office of
Chinese films was respectively 13.1 billion yuan, 16.6 billion yuan, 21.5 billion
yuan, 29.4 billion yuan, 43.9 billion yuan, 45.5 billion yuan, 55.8 billion yuan
and 60.7 billion yuan, with respective growth rates of 29 percent, 27 per-
cent, 30 percent, 37 percent, 49 percent, 4 percent, 23 percent and 9 percent
(Figure 8.3). In 2018, the annual box office growth rate of Chinese movies was
less than 10 percent, which means that the domestic film market is gradually
returning to a rational environment, and the box office structure is continu-
ously improving. However, compared to the box office growth rate of 7 per-
cent in the North American film market in 2018, the Chinese film market still
has considerable potential, and the box office gap with the North American
film market has been gradually reduced.

Monthly box office analysis in 2018

Compared with the monthly box office in 2017, the box office growth rate
was positive in the first six months in 2018, and the next six-month box office

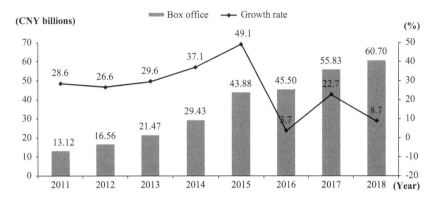

Figure 8.3 Annual box office and growth rate of Chinese films, 2011–2018.

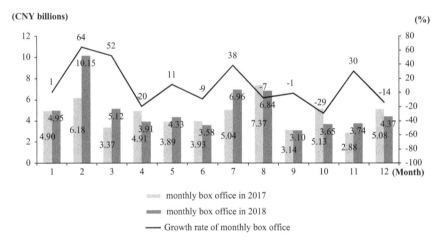

Figure 8.4 Monthly box office analysis for 2017 and 2018.

growth rate was negative. The monthly box office in January and September was basically the same as that of 2017 in the same monthly period. Box office declines occurred in April, June, August, September, October and December. Judging by four months in the second half of the year, the decline indicates that the monthly box office performance in the second half of the year was not as high as the previous six months (Figure 8.4).

In the first quarter of 2018, the box office performance was outstanding, achieving a daily increase in the box office on three consecutive days and a record of over 10 billion yuan in a single-month box office (with a box office

of 10.1 billion yuan in February). In February and March 2018, the total box office growth was 5.6 billion yuan, while the box office growth in 2018 was 4.9 billion yuan. The box office of the year mainly came from February and March.

In April 2018, the box office fell by nearly 1 billion yuan compared to that of the same period of the previous year. The main reason was that no new film in the *Fast & Furious* series was released. The monthly box office in 2015 and April 2017 increased on a yearly basis, but the monthly box office in April 2016 decreased. It is closely related to the release of *Fast & Furious*. The annual box office champion is the imported film *Avengers: Infinity War* which was released in May and increased the box office of the month by 400 million yuan. The box office in June fell by 300 million yuan, mainly because of the shortage of blockbusters.

In July, the box office rose by 2 billion yuan compared to that of the same period of the previous year, mainly because of the release of *Dying to Survive* (the month's box office of 3.056 billion yuan) and *Hello Mr. Billionaire* (the month's box office of 1.29 billion yuan). In August, the box office fell by 600 million yuan compared to that of the same period of the previous year. The main reason was that *Wolf Warriors 2* was released in August 2017, and the box office achieved 4.44 billion yuan in the same month. In September, the box office was basically the same compared to that of the same period of the previous year.

In October, the box office fell by 1.5 billion yuan compared to that of the same period of the previous year, which was the best month for the box office in 2018. The main reason was the fiasco of the National Day season. Also, the Ma Hua Comedy *Hello, Mrs. Money*, which was released during the National Day holiday week, achieved 1.44 billion yuan which is less than the box office of *Never Say Die* in 2017. In November, the box office rose by 800 million yuan compared to that of the same period of the previous year, mainly due to the imported Hollywood film *Venom*, which contributed 1.74 billion yuan to the box office and became the black horse of the box office. In December, the box office fell by 700 million yuan compared to that of the same period of the previous year mainly because of the weak performance of the national films, which should have been the main force of the Lunar New Year.

Analysis of the box office contribution of domestic and imported films

From 2011 to 2018, the annual box office of domestic films was respectively 7 billion yuan, 8 billion yuan, 13.4 billion yuan, 18.5 billion yuan, 28.5 billion yuan, 26.8 billion yuan, and 30.2 billion yuan, or 36.6 billion yuan, respectively accounting for 54 percent, 48 percent, 63 percent, 63 percent, 65 percent, 59 percent, 54 percent, 60 percent; and imported box office outlets were respectively 6.1 billion yuan, 8.6 billion yuan, 8.1 billion yuan, 10.9 billion yuan, 15.4 billion yuan, and 18.7 billion yuan, 25.6 billion yuan, and 24.1 billion yuan, respectively accounting for 46 percent, 52 percent, 37 percent,

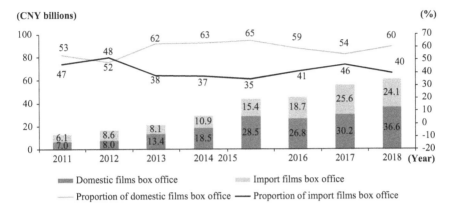

Figure 8.5 Box office analysis of domestic films and imported films, 2011–2018.

37 percent, 35 percent, 41 percent, 46 percent, 40 percent (Figure 8.5). Against the strong competition from Hollywood blockbusters, domestic filmmakers have tried to figure out the demand of Chinese audiences, and Chinese films are becoming more competitive at the box office. Since 2013, despite the box office's up and downs, the proportion of box office of domestic films has always been higher than that of imported films. In 2018, the box office of domestic films was 1.52 times the box office of imported films,' and domestic films have become the core driving force for the growth of the box office in China. The number of imported films in 2018 is higher than that in 2017, and the main reasons for the poor box office of imported films are: (1) most imported films are similar to other previously imported films, hence they present no surprise and attraction to domestic audiences; and (2) the average box office has declined.

From the top ten box office films released in 2018, the total box office was 24.13 billion yuan, accounting for 39.8 percent of the total box office of the year. Of the top ten films in the box office, domestic and imported films accounted for five each, and domestically produced ticket houses accounted for 14.93 billion yuan, accounting for 61.9 percent. The domestic box office appeal was higher than that of the imported blockbusters. Four of the top five films in the box office are domestic films, namely *Operation Red Sea* (3.651 billion yuan), *Detective Chinatown II* (3.398 billion yuan), *Dying to Survive* (3.1 billion yuan) and *Hello Mr. Billionaire* (2.548 billion yuan).

Annual box office analysis of a single film of more than 100 million yuan

In 2018, in the Chinese film market, there were 86 films with a box office of more than 100 million yuan, excluding *The Ex-File: The Return of the Exes*, *Youth*, *Hanson and the Beast*, and *Demon Bell* released in 2017. The newly

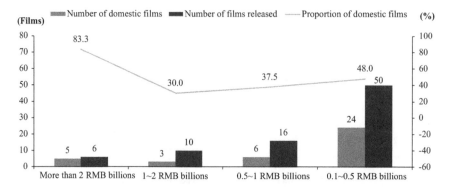

Figure 8.6 Number of films released with a budget of over 100 million yuan at the box
office in 2018.

released box office has over 82 million films in 2018: 43 domestically produced
films and 39 imported films. Among the six films that passed the annual
box office of over 2 billion yuan, there were five Chinese films, accounting
for 83.3 percent, namely *Operation Red Sea* (3.651 billion yuan), *Detective
Chinatown II* (3.398 billion yuan), *Dying to Survive* (3.1 billion yuan), *Hello
Mr. Billionaire* (2.548 billion yuan), and *Monster Hunt 2* (2.237 billion yuan).
Of the 39 imported films, *Avengers: Infinity War* topped the list with 2.391
billion yuan, while *Venom* (1.871 billion yuan) and *Aquaman* (1.852 billion
yuan) ranked in 2nd and 3rd place.

In 2018, ten films generated 1–2 billion yuan at the annual box office,
three of which were domestically produced films, accounting for 30 percent.
Some 16 films generated 510 million yuan to 1 billion yuan at the annual
box office, including 11 domestic films, accounting for 68.8 percent. Some 50
films generated 100–500 million yuan at the annual box office, including 24
domestic films, accounting for 48.0 percent (Figure 8.6). Based on the above
statistics, the films in the high-end box office segment of more than 2 billion
yuan all were of high production quality.

In 2018, the annual box office for the films that achieved box office of more
than 2 billion yuan was 17.3 billion yuan, of which the domestic box office in
China was 14.9 billion yuan, accounting for 86 percent. The annual box office
for the films achieving box office of 1.01–2 billion yuan totaled 14.1 billion
yuan, and the domestic box office in China was 4 billion yuan, accounting
for 28 percent. The annual box office for the films achieving box office of
510 million to 1 billion yuan was 10.8 billion yuan, and the domestic box
office in China was 7.3 billion yuan, accounting for 68 percent. The annual
box office for the films achieving box office of 100–500 million yuan was
11.3 billion yuan, and the domestic box office in China was 5.4 billion yuan,
accounting for 48 percent (Figure 8.7).

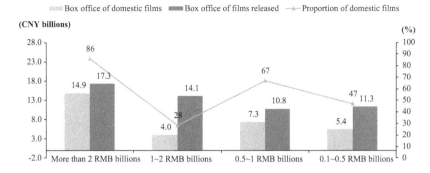

Figure 8.7 Proportion of films with box office over 100 million yuan in 2018.

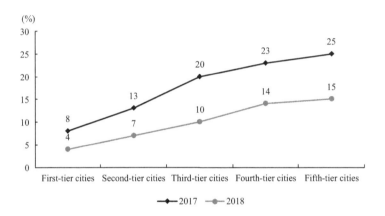

Figure 8.8 A comparative analysis of box office growth rates in first-tier, second-tier, third-tier, fourth-tier and fifth-tier cities in China, 2017–2018.

Analysis of box office from first-tier to fifth-tier cities

At the city level, the box office growth rate of first-tier and second-tier cities in 2018 is respectively 4 percent and 7 percent, which is lower than the national box office growth rate; the box office growth rates of third-tier, fourth-tier and fifth-tier cities are respectively 10 percent, 14 percent, and 15 percent, which is higher than the national box office growth rate of 9 percent. Especially in the fourth-tier and fifth-tier cities, the box office has increased significantly (Figure 8.8). By putting the first-, second-, and third-tier cities into one group, and then the fourth and fifth tier cities as another group, their box office growth rates are respectively 5.5 percent and 11.6 percent, and the growth rate of box office in the second group is significantly higher than in the first group.

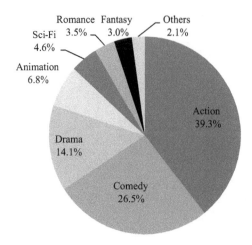

Figure 8.9 Box office distribution of films released nationwide in 2018.

According to the box office ratio, the box office in the third-, fourth- and fifth-tier cities accounted for 41.2 percent of the total box office in 2018 which is an increase of 1.4 percentage points over that of 2017. The daily viewing needs of the residents of the cities in the third tier and under still have some room for growth.

The box office distribution of film genres

Regarding the different genres of films released in 2018, action, comedy, and drama films are ranked the top three at the box office with a ratio of 39.3 percent, 26.5 percent and 14.1 percent. Other genres such as animation, science fiction, romance, fantasy, etc. accounted respectively for 6.8 percent, 4.6 percent, 3.5 percent and 3.0 percent (Figure 8.9). The distribution of different genres of films is clear, and animation, sci-fi and other genres are obviously low in the market. At the same time, from the perspective of geographical distribution, audiences' viewing preferences are also quite different. The audiences of first-tier and second-tier cities prefer drama films, and the audiences of third-tier, fourth-tier, and fifth-tier cities prefer watching romance films.

Analysis of the Chinese film industry production chain in 2018

The broad film industry production chain refers to the sum of original creation, film investment and financing, production, distribution, cinema, film derivatives and other film screening channels, which fully reflects the

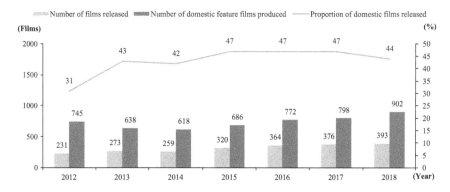

Figure 8.10 A comparison of the release rates of domestic feature films, 2012–2018.

relationship between the various aspects of the film industry's ecosystem. In the narrow sense, the film industry chain in the traditional sense refers to the integrated process of film production, distribution, and screening (this is the "produce-issue-release" procedure). This chapter interprets the 2018 Chinese film market from the perspective of the narrow film industry chain.

Production analysis

Production creation analysis

In 2018, China produced 902 feature films, 51 animated films, 61 science fiction films, 57 documentary films, and 11 special films, totaling 1,082. Of the 902 feature films produced in 2018, only 393 were screened in the theater with a 44 percent release rate, which is 3 percentage points lower than the 2017 release rate (Figure 8.10). Since 2014, the number of feature films produced in China has continued to increase, while the online screening rate has declined. There is a serious waste of resources caused by blind investment.

Analysis of the films made by domestic filmmakers

In 2018, *Dying to Survive, Detective Chinatown II, The Island* and a large number of excellent domestic films achieved great performance at the box office and also by word of mouth. The audiences highly praised the domestically produced films that are innovative. In contrast, films such as *Ashulu* and *Ipartment* are star-studded and costly, but their reputation and box office performance are unsatisfactory. It can be seen that high-quality domestic films are increasingly recognized by the market, and Chinese film audiences and filmmakers have become more mature and rational in terms

Table 8.2 2018 box office of top 20 new directors' film list (¥ 100 million)

Number	Name	Type	Director	Release date	Box office	Score
1	Detective Chinatown II	Comedy	Chen Sicheng	February 16	34.0	9.0
2	Dying to Survive	Feature	Wen Muye	July 5	31.0	9.6
3	Hello, Mr. Billionaire	Comedy	Yan Fei, Peng Damo	July 27	25.5	9.2
4	Us and Them	Love	Liu Ruoying	April 28	13.6	8.3
5	The Island	Comedy	Huang Bo	August 10	13.5	8.3
6	How Long Will I Love You?	Fantasy	Su Lun	May 18	9.0	8.7
7	A Cool Fish	Feature	Rao Xiaozhi	November 16	7.9	9.1
8	Forever Young	Feature	Li Fangfang	January 12	7.5	8.6

Source: Mao Yan data.

of film appreciation and film production. This will attract more talent and capital to concentrate on the production of high-quality domestic films. These excellent films will bring more recognitions, thus eventually forming a virtuous circle which will enhance the level of Chinese filmmaking and appreciation.

Behind the 60 billion yuan box office record in 2018, a group of new directors rapidly emerged. Among the top 20 box office films in 2018, the new directors' films contributed 40 percent to the box office (Table 8.2)., There are a lot of new directors, such as Wen Muye, Su Lun, Huang Bo and Liu Ruoying, who were actors and singers turned directors. There are also young directors, such as Yan Fei, Peng Damo and Rao Xiaozhi, who emerged on the market. These "new power" directors are the foundation and driving force for the sustainable development of the film market and are gradually becoming the backbone of the Chinese film market.

In order to tell Chinese national stories, literary adaptation films and television programs of high production quality with positive energy are highly encouraged. The government also aims to promote the rapid and efficient development of the cultural industry, and help the newcomers to be successful. The film channels and a number of literary organizations and the press have jointly established the "Excellent Project" program. On December 23, 2018, the "Excellent Project" program press conference was held in Beijing, and the first batch of six intentional cooperation projects such as *Hello 30, Shenzhen Road* and *School Defence War* were officially announced. The "Excellent Project" program will integrate domestic high-quality resources, break down barriers between various links in the film industry chain and supply and demand, and provide many talented young screenwriters, directors and actors with the opportunity to realize their cinematic dreams.

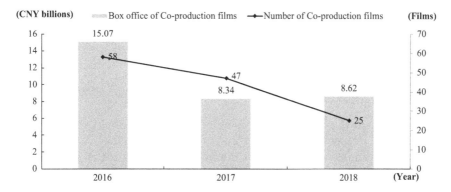

Figure 8.11 Number and box office of Chinese and foreign co-productions, 2016–2018.

Analysis of Chinese and foreign co-productions

Co-productions refer to a form of cooperation in which domestic and foreign production companies jointly produce films by sharing copyright, benefits and risks. Once they have had a good film review, the Chinese and foreign co-productions can enjoy the same benefits as domestic films enjoy, and gain more advantages in the film production, and sub-accounting, etc. which effectively reduces investment risks. Film labor, investment and other resources are jointly provided by China and a film's co-production country for film production.

In 1939, the first co-production documentary *The 400 Million* was born. In 1958, Sino-French co-produced their first feature film, *Kite*. In 1979, the China Film Cooperative Production Company was established. Since then, Chinese and foreign co-productions have entered a new phase of comprehensive cooperation. As China becomes the world's second largest film market, and the quality of filmmaking continues to improve, more countries and regions hope to cooperate with China. By December 31, 2017, China had signed co-production film agreements with 20 governments, including the United States, India, France, Singapore and South Korea. In May 2018, China and Japan signed a co-production film agreement, and the numbers of Chinese and foreign co-productions continued to increase.

In recent years, due to cultural differences, language barriers and other factors, the number of co-productions in China has declined (Figure 8.11). From 2016 to 2018, the number of Chinese and foreign co-productions was respectively 58, 47 and 25, with box office of 15.07 billion yuan, 8.34 billion yuan and 8.62 billion yuan respectively. The average single-part co-production box office was 260 million yuan, 180 million yuan, and 345 million yuan respectively. In 2018, the Chinese and foreign co-production single box office achieved a new leap.

At present, more Chinese young people are choosing to study filmmaking in Europe and the United States. In future, no matter whether they choose to return to China or continue to stay in the West for filmmaking, they will be the main force of Chinese and foreign co-productions. For Chinese and foreign co-productions, the age of the film crew appears to be getting younger.

Market analysis

The increase at the box office shows more high-quality films in the market. In addition, deepening the market and enhancing the effective connection between the film and the audience cannot be underestimated. In 2018, in addition to continuing to use traditional announcements, such as press conferences, business cooperation, and roadshows, the Internet has become the core of the Chinese film market. It uses the online booking platform for ticket replenishment, pre-sales, cross-border marketing, etc. to achieve accurate matching and maximum dissemination of film content. Thus, the use of Internet technology provides a better service to producers, theaters and movie viewers. Under the strong promotion of the Internet, on New Year's Eve 2018, the box office broke the single-day box office record in terms of one individual country box office in a global film market. The audience numbers also broke the single-day cinema admission record.

In 2018, the Chinese film market was further transformed and upgraded based on online and offline integration, mainly in the following three respects: (1) expansion of publicity channels and exploration of new consumer groups; (2) extension of marketing depth for full marketing connections; and (3) cross-border high-frequency industry to achieve leapfrogging.

Analysis of cinema and the cinema market

Cinema market analysis

In 2018, the top three, top five, and top ten city theater box office outlets in China were respectively 19 billion yuan, 28 billion yuan, and 41.7 billion yuan, with box office ratios of 31.3 percent, 46.1 percent, and 68.7 percent, respectively. The concentration of cinemas in the year increased slightly. The top three theaters in the box office are: Wanda Cinema (81.88 billion yuan), Dadi Cinema (6.05 billion yuan) and Shanghai Lianhe Cinema (4.84 billion yuan) (Table 8.3).

By December 31, 2018, there were 48 city theaters in China, of which 40 theaters have exceeded 100 million yuan, which is one theater more than in 2017. In 2018, there were 17 theaters in China with annual box office exceeding 1 billion yuan, which was the same as in 2017. There were 23 theaters with annual box office of 100 million to 1 billion yuan, which is one more than the same period of the previous year; the annual box office was below 100 million yuan of nine theaters, one less than the same period of the previous year.

Table 8.3 List of the top 10 city theaters in China in 2018

Rank	Theater name	Box office (100 million yuan)	Sessions (ten thousand times)	Number of people (millions)	Attendance rate (%)
1	Wanda	82	944	200	13.47
2	Dadi	60	1160	178	12.14
3	Shanghai Lianhe	48	668	130	13.89
4	Zhong Ying Nanfang Singanxian	45	849	129	12.8
5	ZhongYing Digital	44	946	130	10.66
6	ZhongYing Xingmei	39	609	109	13.95
7	GZ. Jinyi Zhujiang	30	463	83	12
8	HG	26	507	79	11.55
9	Hua Xia Lianhe	21	428	62	11.36
10	Jiangsu Omnijoi	21	344	60	13.47

Source: EN Film Think Tank.

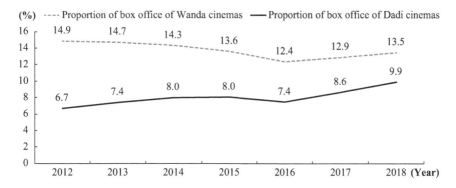

Figure 8.12 Proportion of the box office of Wanda Cinemas and Dadi Cinemas, 2012–2018.

Since 2012, the proportion of box office in Wanda Cinema has always ranked first in the country and has constantly remained above 12 percent and even reached its highest point at 14.9 percent. Due to the rapid growth of other cinemas, the proportion of box office in Wanda Cinema has been declining, and the gap with the second cinema line has been narrowing from 8.2 percentage points in 2012 to 3.6 percentage points in 2018 (Figure 8.12)

From 2014 to 2018, the number of new cinemas in China was respectively 1,106, 1,574, 1,412, 1,430, and 1,143, with growth rates of 22 percent, 24 percent, 18 percent, 15 percent, and 11 percent (Figure 8.13). In 2018, China built 1,143 new cinemas with a growth rate of 11 percent, which is 2 percentage

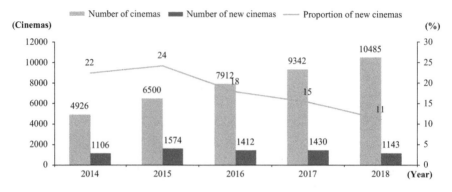

Figure 8.13 Total number of cinemas, the increase in number and the proportion of new cinemas in China, 2014–2018.

points higher than the annual box office growth rate (9 percent). The situation of oversupply led to a lower cinema admission rate (11 percent) and a single screen output (1.01 million yuan), which was a state of serious overcapacity reaching its lowest level since 2014.

In all aspects of the Chinese film industry chain, the corresponding income is mainly obtained through box office accounts. According to industry practice, the theater generally receives 50 percent of the box office income. The rank of the movie box office is directly related to the income of the theater. The top ten theaters in the box office in 2018 are Jackie Chan's Beijing Yaolai (799.20 million yuan), Jinyi Beijing Joy City IMAX store (69.6 million yuan), and Guangzhou Feiyang Studios (Zhengjia Branch) (68.2 million yuan), etc. (Table 8.4). Among the top ten theaters in the box office, Beijing accounts for 50 percent; Shanghai accounts for 20 percent; Guangzhou accounts for 10 percent; Wuhan accounts for 10 percent; and Nanjing accounts for 10 percent.

From 2014 to 2018, the annual growth rate of the number of screens was respectively 5,397, 8,035, 9,552, 9,597, and 9,303, with growth rates of 30 percent, 34 percent, 30 percent, 23 percent, and 18 percent respectively (Figure 8.14). Although the annual growth rate of screens has decreased from 2015, it is still much higher than the annual box office growth rate (9 percent). From 2014 to 2018, each screen output was respectively 1.25 million yuan, 1.39 million yuan, 1.11 million yuan, 1.1 million yuan and 1.01 million yuan. In 2018, the single-screen output reached a five-year low.

Online ticket market analyses

Online ticketing platform business model

The online ticketing platform has emerged from the "Low-cost Movie Ticket Group Purchase War" launched in 2010 by the "Sankuai Online" and "Baidu

Table 8.4 Top 10 cinema chains in China's movie box office in 2018

Rank	Cinema chain	Box office (ten thousand yuan)	Number of people (10,000 people)	Price (yuan)	Attendance rate (%)
1	Jackie Chan Beijing Yaolai	7992	178	45	22.60
2	Jinyi Cinema Beijing Joy City IMAX	6960	103	67	31.10
3	Guangzhou Feiyang Cinema(ZhengJia branch)	6820	121	56	24.70
4	Capital Cinema, Xidan	6347	115	55	28.00
5	UME Cinema (Beijing Shuang Jing)	5590	89	63	23.80
6	Nanjing Xinjiekou Cinema	5523	139	41	26.90
7	Shanghai Bailigong (Huanmao iapm)	5477	69.8	79	29.30
8	Wushangmoer International Cinema	5423	159	34	26.40
9	Lumière Beijing Changyi Tianjin IMAX Studios	5322	93	57	20.00
10	Shanghai Wujiaochang Wana Cinema	5348	91	57	20.70

Source: EN Film Think Tank.

Figure 8.14 Total number and the increase in and growth rate of Chinese screens, 2014–2018

Nuomi." The online ticketing platform, with its ticket sales as a breakthrough, continues to expand both upstream and downstream of the film industry chain, and has become a comprehensive platform covering production, promotion, ticket sales, and sales of derivatives, etc. (Figure 8.15).

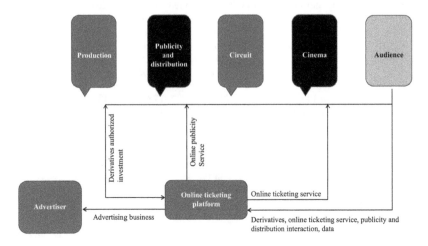

Figure 8.15 Online ticketing platform business model.

The main source of income for the online ticketing platform is the movie ticket sales revenue. For each movie ticket sold, the online ticketing platform charges a fee of about 3 percent of the entry price. The system service provider charges a further fee of about 3 percent of the fee to provide the ticket. The ticket collection machine charges a further fee of about 4 percent of the entry price (Table 8.5).

The second largest source of revenue for online ticketing platforms is investment production and distribution. The ticketing data and user data accumulated by the Internet giant behind the online ticketing platform attract more and more investors to use the platform to accurately announce a film. In addition to deepening the film distribution market, the online ticketing platform also selects quality projects for investment. The online ticketing platform participated in the production and distribution of the top five films of the 2018 domestic box office at different levels (Table 8.6).

The lowest percentage of online ticketing platform revenue is advertising services and derivatives sales. In terms of advertising services, in addition to the common types of banner advertisements and screen advertisements, the online ticketing platform also gives full play to its advantages to provide new forms of advertisements, such as logos, etc. In terms of derivatives sales, the online ticketing platform provides online link authorization, promotion, sales and other full-link services by partnering with relevant parties.

The United States and Japan are the main Internet Protocol (IP) sources for global film derivatives. The experience of the United States and Japan shows that when the per capita gross national income (GNI) is around US$10,000, the film derivative IP takes off. For example, when *Star Wars* was released in 1977, the average American GNI was US$9610. When the per capita GNI reaches about US$30,000, there will be a massive development of derivatives

Table 8.5 Online ticketing fee sharing mode (%)

Cost category	Proportion of price	Service provided
System service provider interface fee	3	Provide system services (currently, the TaoPiaopiao uses the Yueke Fenghuang Jiaying system, and other ticketing platforms are provided by third-party service providers)
Online ticketing added fee	3	Online ticketing service
Ticket collection fee	4	Provide ticket collection machine to pick up tickets
Total	10	

Source: CITIC Securities.

Table 8.6 The main investment and distribution of the online ticketing platform in 2018 (¥ 100 million)

Number	Movie title	Release date	Box office	Ali role	Enlight role
1	Operation Red Sea	February 16	36.5	Al co-produced, Tao Piaopiao joint issue	MaoYan and WeiYing co-produced
2	Detective Chinatown II	February 16	34.0	Tao Piaopiao joint issue	Youth and Eight co-produced
3	Dying to Survive	July 5th	31.0	Al co-produced, Tao Piaopiao joint issue	MaoYan and WeiYing co-produced
4	Hello, Mr. Billionaire	July 27	25.5	Al co-produced, Tao Piaopiao joint issue	MaoYan and WeiYing co-produced
5	Monster Hunt 2	February 16	22.4	Tao Piaopiao produced	MaoYan and WeiYing mainly co-produced

Source: MaoYan Data, CITIC Securities.

IP in film and television. When the Chi-bi Maruko released the theater version in 1990, the Japanese per capita GNI was US$27,850. Based on a compound growth rate of 6 percent, China's per capita GNI will exceed US$10,000 in 2020, and per capita GNI will exceed US$30,000 in 2040. The domestic derivatives IP will gradually be made into film and television projects, and the proportion of revenue will gradually increase.

Table 8.7 Development stages of China's online ticketing platform

Date	Stage	Development path
2010–2012	Growth period	Expanding the scope of cooperation with cinemas and generating an online-based business model
2013–2016	Development period	Ticket supplement, infiltration upstream and downstream of the industrial chain
2017–present	Integration period	Stable competition pattern, explore profit model through differentiated management

Source: Speedway Institute.

The development stage of the online ticketing platform

In 2010, with the introduction of the online selection service by Guevara Life Net, the online ticketing business model started operations in China. Later, with the rise of online payments and advances in Internet technology, use of online ticketing platforms has risen rapidly (Table 8.7).

Toward a standardized and rational Chinese film industry

In 2018, the middle and lower sectors of the Chinese film industry chain added incremental value to the industry. The State Press, Publication, Radio, Film and Television Administration changed its name to The National Film Board and was directly controlled by the Central Publicity Department, which reflected an increasing focus by the Party and the government on the Chinese film industry. Audiences also paid more attention to films' reputation, and the viewing preferences became more rational. Different kinds of films became popular in the market, with a realist film *Dying to Survive* gaining audience's special preference. The quality of domestic films increased substantially, and their box office exceeded that of imported films. The film market share of the top ten films at the box office reached 68.7 percent, and the market concentration further improved. The online ticketing platform shifted its focus by covering the ticketing business in the entire film industry chain. The positive trend displayed by all parties in the industry has enabled the Chinese film industry to enter a new stage of healthy development in which high-quality films are constantly being produced and the film industry's structure also tends to be rational.

The government's view: the national will to promote the development of the film industry

On March 21, 2018, the Central Committee of the Communist Party of China issued the "Deepening Party and State Institutional Reform Plan." The plan decided to change the name of the film board affiliated to the

State Administration of Press, Publication, Radio, Film and Television to "The National Film Board," and it is controlled by the Central Publicity Department. The aim is to bring about the unified management of film production. The promotion of the regulatory authorities means that the country will encourage cinema among the public and strive to make the Chinese national cinema an important carrier for exporting the core values of the country and open up a new window for future development of the film industry.

The film industry policy introduced in recent years (Table 8.8) shows that the country has been actively deploying film industry channel arrangements, industry standardization and film exports overseas.

The content: the quality of domestic films improved and became the main growth driver at the box office

In 2018, the box office of domestic films was 36.6 billion yuan, accounting for 60 percent of the total box office, which is an increase of 21 percent compared to that of the same period of the previous year. The box office of imported films was 24.1 billion yuan, accounting for 40 percent, which is a decrease of 6 percent compared to that of the same period of the previous year. At the same time, in 2018, there were 8 domestic films with box office exceeding 1 billion yuan, and 19 domestic films with box office exceeding 500 million yuan. With this excellent market performance, domestic films have maintained their box office advantage over imported films since 2013.

The statistical analysis of the 30 "MaoYan Movie Scores" of the domestic box office between 2015 and 2018 is shown in Figure 8.16. From the "MaoYan Movie" audiences rating, there are 11 excellent films with a score of greater than or equal to 9.0 in 2018, accounting for 37 percent; and 14 middle-level movies with a score of 8.0–9.0, accounting for 47 percent. At 7.9, there were three middle and lower-level films, accounting for 10 percent. The scores of less than 7.0 were considered to be "poor quality" films, accounting for 7 percent. Compared with the "MaoYan Movie", the "Douban" audience score is much stricter. *Dying to Survive* was the only domestic movie with a score of 9 points on the "Douban" users' rating since 2015.

In 2016, there were seven excellent domestic films with a "Mao Yan" user score of 9.0 or higher, accounting for 23 percent; six domestic and foreign language films with a score of 7.0–7.9 points, accounting for 20 percent. The overall quality of domestic films in 2016 was low, which was in line with the poor box office in 2016. In order to meet the increasing aesthetic taste of the audiences, domestic production companies responded positively. After 2016, the overall quality of domestic films continued to improve, and finally achieved excellent market performance in 2018. At the same time, with the release of government policies to explicitly limit the proportion of film stars' remuneration over the total budget of a film, the focus of film costs transferred from paying the stars to the production of the film itself, which resulted in an improvement in the quality of the films.

Table 8.8 Major film industry policies promulgated, 2012–2018

Date	Policy title	Main content
November 2012	Notice on Subsidizing the Creation and Production of Domestic High-tech Format Films	If the box office revenue is 300 million yuan (inclusive) to 500 million yuan in high-tech format films, then the rewarding support fund will be 5 million yuan; if the box office income is more than 500 million yuan (inclusive), then the incentive support fund will be 10 million yuan
January 2013	Current Measures for Strengthening the Management of Film Cooperation across the Taiwan Straits	Taiwanese films that obtained a film release license were released as imported films on the mainland. Films co-produced by the mainland and Taiwan enjoy domestic film-related treatment on the mainland
June 2014	Notice on Supporting Several Economic Policies for Film Development	The state promotes tax incentives and financial support for the film industry, and sells film copies and transfers of copyrights to film companies. From January 1, 2014 to December 31, 2018, VAT is exempted.
March 2016	Notice on Rewarding Overseas Promotion of Excellent Domestic Films	If the domestic box office revenue of a domestic film reaches or exceeds 1 million yuan, there will be rewards.
July 2016	Law of the People's Republic of China on Film Industry Promotion	Detailed provisions for film creation, filming, distribution, screening, and legal liability
December 2017	Notice on Rewarding the Screening of Domestic Films and Highlighting Cinemas	If the domestic film screening annual revenue accounts for more than 55 percent of the total income, and meets the reward conditions stipulated in the Notice, then it is awarded in three grades
October 2018	Notice on Further Regulating the Work Related to Taxation Order in the Film and Television Industry	From October 2018 to June 2019, in accordance with self-examination, self-correction, supervision and correction, key inspection, summary and improvement principles, further standardizing of the taxation work of the film and television industry

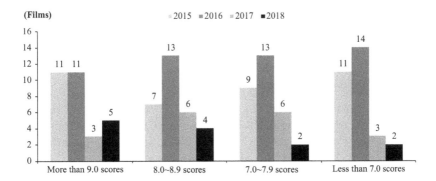

Figure 8.16 A statistical analysis of the top 30 "MaoYan" scores of domestic films in the box office, 2015–2018.

Audiences: the numbers increased

In 2018, the increase in the audience numbers for films in China is reflected in two ways: first, audience numbers are increasing generously across the board; second, the number of regular frequent moviegoers is increasing. With the increase in income and living standards, the age group of film audiences has also expanded, and more young and middle-aged people are becoming regular moviegoers. The "Mao Yan" data show that the proportion of audiences over the age of 30 increased from 38.3 percent in 2017 to 41.7 percent in 2018 which is an increase of 3.4 percentage points. At the same time, regarding the frequency of viewing, the number of viewers in 2018 decreased from 46.6 percent in 2017 to 44.8 percent in 2018, which is a drop of 1.8 percentage points. The number of viewers who went to the movies between 2 and 11 times increased from 50 percent in 2017 to 51.5 percent in 2018, which is an increase of 1.5 percentage points. The number of viewers who watched 12 or more movies increased from 3.4 percent in 2017 to 3.8 percent in 2018, which is an increase of 0.4 percent.

In 2018, the aesthetic taste of Chinese audiences improved significantly, and the quality of films continuously influenced the audience's decisions to view films. Among the many domestic films released, *Operation Red Sea* and *Project Gutenberg* are typical films that achieved box office success through positive word of mouth. On the opening day of *Operation Red Sea* (February 16, 2018), its box office was only 130 million yuan, accounting for 3.5 percent of the total box office. But high public praise (a "Douban" score of 9.0) made the follow-up box office rise. The box office of *Operation Red Sea* steadily rose for six consecutive days, eventually reaching a total box office of 3.65 billion yuan, ranking first at the 2018 Chinese movie box office. *Project Gutenberg* has a total box office of about 1.27 billion yuan, ranking 13th at the box office in 2018, but on its opening day in theaters (September 30, 2018), its box office

was also poor with only 54.82 million yuan. Following good opinions of it among the public (a "Douban" Rating of 8.2) six days after its release, the daily box office was basically stable at 90 million yuan.

Channels: relatively excessive production capacity and industry concentration continue to increase

The top ten cities achieved box office of 41.7 billion yuan, accounting for 68.7 percent, which was slightly higher than the box office (37.8 billion yuan) and box office ratio (68 percent) in 2017. The film market concentration further improved.

The size of the bargaining power of the cinema in the industry chain is determined by the strength of the final screening channels it owns. Generally speaking, the more final projection channels a cinema chain has, the more bargaining power it possesses. At present, in addition to China United, the other nine of the top ten cinema chains in China have been listed and have strong financial advantages. At the same time, according to statistics produced by the American Film Institute, the market share of the three mainstream cinemas in North America in 2017 was around 50 percent.

Driven by international practices and self-interest, China's cinemas have sufficient room for integration, and strong, well-funded theater companies will continue to acquire cinemas to promote industry concentration and overall operational efficiency. At the same time, smaller theaters have a stronger willingness to integrate in order to reduce costs and change the single profit model.

In 2018, the number of Chinese cinema screens totaled 60,079, which is an increase of 18 percent compared to that of the same period of the previous year. The growth rate of cinema screens exceeded that of the box office (9 percent) and that of the number of moviegoers (6 percent). As a result, the single-screen output and the average cinema admission rate continued to decline. At the same time, in 2018, China's single-screen viewings fell to 28,600, which is a decrease of 10 percent compared to that of the same period of the previous year. Single-screen output was 1.01 million yuan, which is a decrease of 11 percent compared to that of the same period of the previous year. It is expected that more and more theaters and cinemas will be under increasing operational pressure, and cinema integration will become imperative. In future, theaters that meet the expectations of viewers' refined operation requirements after upgrades will become the new focus of cinema development.

Online platforms: the formation of a duopoly pattern and the focus of competition shifts

Relying on the financial strength of powerful online platforms and the advantage of having the payment tool entrance, the two major platforms "MaoYan" and "Taobao" stand out from the fierce market competition, forming a pattern of "MaoYan" and "TaoPiaopiao" duopoly competition. "TaoPiaopiao" and

"MaoYan" have already broken free from the endless ticket battle by exploring a new profit model. As the Internet giants in China, they both use the ticketing platform as an important channel for data collection and monetization, and combine their own advantages to rebuild the entertainment ecosystem. The "TaoPiaopiao" is a major component of the listed company, Ali Films. The development strategy has been tilted toward the announcement service. The current development strategy has been revised to "two-wheel drive."

Direction of the Chinese film industry's development

The content: improvement in quality and structure

The healthy development of any form of cultural entertainment will need consumers' positive feedback on the quality of the content. High-quality content stimulates consumers to pay, and thus content creators will have sufficient funds and the incentive to develop more high-quality content, which further stimulates consumers' consumption. Films such as *Operation Red Sea*, *Project Gutenberg* and other titles gain success through word of mouth, which shows how audiences' positive feedback can result in box office success. In future, more filmmakers will focus on improving the quality of their work. Thus, their projects will speak for themselves to win the market.

Due to the matured window period and the multi-layer distribution system, Hollywood movie box office revenue accounted for only about 25 percent. Copyright revenue from TV, home entertainment and other channels accounted for around 75 percent. The core revenue of China's film content is mainly from the box office revenue share, and the proportion of non-box office income is significantly lower. Compared with box office revenue, channel-side copyright is relatively easy to predict, and an increase in channel-end revenue can reduce the risk of film investment. With respect to slower box office growth, improving the income structure and increasing non-cinema line copyright revenue are the main ways to increase revenue at the film content end in the future.

In November 2016, the film *I Am Not Madame Bovary* earned a total revenue from the content party of RMB 2.52 million, of which the box office share was 60 percent, and online copyright plus overseas copyright revenue accounted for 34 percent. Movies are one of the core products that video websites use to attract users. As Internet video websites gradually become mainstream channels, there is still room for improvement in the proportion of copyright revenues in China's content market.

Sales channel: the head effect continues to play a role, and the market concentration improved

From the development experience of the United States, Japan and South Korea, when the number of screens in a country approaches saturation point, the number of screens will remain stable and the number of theaters

will continue to decrease. The average number of screens in the theater will increase rapidly. Large-scale multiplex cinemas will gradually replace small-scale cinemas, and market concentration will gradually increase. In the United States, for example, the number of screens reached its peak around 2000, and the number of theaters has been steadily decreasing since then.

From the perspective of the number of screens, only the US market can be compared with China in a global context. Based on the development of the industry, the current screen density of Chinese cinemas is close to the peak of the number of US screens from 1998 to 1999. After nearly 20 years of industry development in the United States, the market share of the top three cinemas officially exceeded 50 percent. Compared to the US market, China has more screens and more problems in theater concentration, which will be a long-term process for perhaps more than 20 years.

From the perspective of the development of overseas matured markets, mergers and acquisitions are the main way to increase the concentration of the cinema chain industry. In the Chinese market, as industry competition intensifies, the demand for cinema mergers and acquisitions will gradually increase. Through mergers and acquisitions, the problem of single revenue and operation losses of cinemas can be solved and managed to a certain extent.

In short, to promote the development of the Chinese film industry, on the one hand, it is necessary to improve the quality of the domestic film content, to attract more viewers into the cinema through positive film reviews and word of mouth, and to increase the frequency of audiences' viewing; on the other hand. From the sales channel side, it is necessary to enhance the cinema screening experience in all aspects, such as equipment upgrade, management level, and cinema network brand effect.

Bibliography

Baidu. Encyclopedia. Available at: http://baike.baidu.com.

Baidu Index. Available at: http://index. baidu.com.

Bin, L., Xingzhen, N. and Zhengshan, L. (2018). *Global Film Industry Development Report (2018)*, Beijing: Social Science Literature Publishing House.

Box Office Mojie. Available at: www.boxofficemojo.com.

China Box Office. Available at: www.cbooo.cn.

China Film Association and China Federation of Literary and Art Film Center (2018). *China Film Industry Research Report*, Beijing: China Film Press.

China Internet Network Information Center. Available at: www.cnnic net.cn.

Douban Movie Leaderboard. Available at: https://movie.douban.com/chart.

Former State Press, Publication, Radio, Film and Television. Available at: www. sapprft.gov.cn.

Mengnan, X. (2018). On the New Film Law, Legislation Measures and Supervision of the Box Office of the Missing Detective, *Audiovisual*, No. 1, 36–37.

Ping, Z. (2017). Analysis of New Mainstream Film Marketing in the New Media Environment, *Contemporary Film*, No. 12, 167–169.

Shaoyang, L. and Yunyao, M. (2017). Chinese Film: Seiko Production and Connotation Exploration Collaboration, *Education Media Research*, No. 6, 30–32.

Shuguang, R. and Guanping, W. (2017). Chinese Film: Reflection and Adjustment, *Journal of Beijing Film Academy*, No. 1, 5–10.

Xie, X. and Donglei, F. (2017). A Preliminary Study on the Evolution of China's Film Industry in the New Media Era, *National Art Research*, No. 5, 107–112.

Xinru, G. and Shuqin, H. (2017). The Star Effect and the Empirical Study of the Chinese Box Office, *Modern Communication (Journal of Communication University of China)*, No. 12, 120–125.

Yan, C. (2018). *China Film Industry Development Trend Report*, Beijing: Communication University of China Press.

9 The development of the Chinese film production industry in 2018

Mingsong Li

Total number of films produced in China in 2018

The year 2018 is the 40th anniversary of China's Reform and Open Door policy. It is also the first year when the Publicity Department of the Communist Party of China (CPC) enforced a unified management policy on the Chinese film industry. The Film Industry Promotion Law was further implemented, and the reform of the film industry continued.

According to the data provided by the National Film Board, the total output of the films reached a new record. Some 1,082 films in total were produced in 2018, which includes 902 feature films, 51 animation films, 61 science fiction and education films, 57 documentary films, and 11 films of special categories. Both the number of feature films and the total number of films being produced increased by 13 percent and 11.55 percent, respectively, compared with that of 2017 (Table 9.1).

From 2014 to 2018, the government's support for film policies and the popularity of the film market increased the number of Chinese films produced, year on year, and the government's strong supervision and the benign competition in the industry have brought about improvement in the quality of domestic film production. In 2018, high-quality films emerged, and many films with ideological, artistic and entertaining content were successful at the box office through word-of-mouth reputation. There were 82 films that broke the box office record of 100 million yuan, and 16 of them broke the box office record of 1 billion yuan. Among them, there are many excellent works that gained both public praise and good box office, such as *Operation Red Sea*, in which the scenery is magnificent, *Dying to Survive*, which reflects reality and contains great humor, *Running to the Spring* and *The Photographer*, which pay tribute to the 40th anniversary of the Reform and Open Door policy and triggered a warm response from the public.

Analysis of domestic film production in 2018

In April 2018, Huang Kunming, a member of the Political Bureau of the CPC Central Committee, the Secretary of the Secretariat of the CPC Central

Table 9.1 National film production, 2000–2018

Year	Feature films	Animation films	Science fiction and education films	Documentary films	Special films	Total number of films
2000	91	1	49	10	0	151
2001	88	1	56	9	0	154
2002	100	2	60	7	0	169
2003	140	2	53	6	0	201
2004	212	4	30	10	0	256
2005	260	7	33	2	0	302
2006	330	13	36	13	0	392
2007	402	6	34	9	0	451
2008	406	16	39	16	2	479
2009	456	27	52	19	4	558
2010	526	16	54	16	9	621
2011	558	24	76	26	5	689
2012	745	33	74	15	26	893
2013	638	29	121	18	18	824
2014	618	40	52	25	23	758
2015	686	51	96	38	17	888
2016	772	49	67	32	24	944
2017	798	32	68	44	28	970
2018	902	51	61	57	11	1082

Source: *China Statistical Yearbook*, various years.

Committee, and the Minister of the Publicity Department of the Communist Party of China, delivered a speech at a film production and research symposium, emphasizing the need to thoroughly study and implement Xi Jinping's ideologies of the new era of Chinese socialism to build China into a country with a prosperous film industry. Taking the opportunity to celebrate the 40th anniversary of the Reform and Open Door policy, and celebrate also the 97th anniversary of the founding of the Communist Party of China, a number of mainstream films, such as *The Photographer*, *Running to the Spring*, *Hope of Road*, *Li Baoguo*, *The Connection* and *The Faithful*, were released.

The films released in China in 2018 continued to show great diversity in terms of themes, genres and production patterns. They achieved remarkable social and economic success. It is worth mentioning that realism in films gained great public praise and good box office in 2018, in films such as *Dying to Survive*, which ranked third place at the annual box office, and the romantic film *Us and Them*, the comedy *Hello Mr. Billionaire* (Mahua Fun Age), *Take My Brother Away*, *Cry Me a Sad River*, and *Einstein and Einstein*, and so on. Although these films are all of different genres, they all present appropriate and realistic portrayals of relevant real life and events. Realist films have become an important carrier for national identity. The stories of these films evoked strong emotional responses from the audiences.

Table 9.2 Top 30 domestic box office tickets in 2018 (¥ ten thousand)

Rank	Movie title	Main genre	Box office
1	*Operation Red Sea*	Action	365077.8
2	*Detective Chinatown 2*	Comedy	339768.8
3	*Dying to Survive*	Feature	309996.1
4	*Hello Mr. Billionaire*	Comedy	254757.2
5	*Monster Hunt 2*	Comedy	223707.7
6	*Us and Them*	Romantic	136151.5
7	*The Island*	Comedy	135504.8
8	*Project Gutenberg*	Action	127376.3
9	*The Meg*	Action	105178.1
10	*How Long Will I Love You?*	Fantasy	89988.4
11	*A Cool Fish*	Feature	79408.6
12	*Forever Young*	Feature	75429.7
13	*The Monkey King 3*	Comedy	72738.2
14	*Shadow*	Action	62898.9
15	*Detective Dee*	Action	60634.3
16	*Bear Emergence*	Animation	60550.3
17	*Hello, Mrs. Money*	Comedy	60435.2
18	*Hidden Man*	Action	58348.3
19	*Ipartment*	Comedy	55472.7
20	*Animal World*	Action	50967.7
21	*Amazing China*	Documentary	48056.3
22	*L Storm*	Feature	44298.4
23	*Take My Brother Away*	Comedy	37531.4
24	*A or B*	Feature	35861.1
25	*Cry Me a Sad River*	Feature	35664.9
26	*Golden Job*	Action	31527.5
27	*Lost, Found*	Feature	28528.3
28	*Fat Buddies*	Comedy	26106.6
29	*Till the End of the World*	Romantic	23448.3
30	*Meng vers la Rivière*	Comedy	20364.6

Source: Entgroup Data.

Thus, the public welcomed the return of cinema realism and this eventually resulted in the excellent performance of these movies at the box office. By presenting the real-life conditions of Chinese people, these realistic films are truly praised and appreciated by the Chinese public. Thus, themes of social care and emotional love stories have become common themes for film producers in China.

According to Table 9.2, based on the distribution of the top 30 domestic box office outlets in 2018, comedy and action genres have become the most mainstream commercial film genres. There are many films of a hybrid genre that mix comedy elements in the top 5 domestic films at the box office. In recent years, the genres of film production have become more sophisticated, and the themes of the films have become more popular. Films mixing two

or more genres have become popular. There are many movies like this in the top 30 of the box office in 2018, such as *Detective Chinatown 2*. Although the main storyline of this film is a typical suspense crime story, it also had many comedy generic codes and conventions in terms of characterization and narrative structure. The mixture of a detective story with comedy elements presents an alternative viewing experience and led to its box office success. *Project Gutenberg* is similar to *Detective Chinatown 2*. The film is both crime and action genre, and it successfully presented a fascinating suspense atmosphere with the film's twist of plots to its audiences. The "split personality" in this film also brings the story to climax that subverts audiences' conventional understanding of the story. The mixture of action, crime and suspense elements makes this film highly appealing to the public. Another low-budget movie *How Long Will I Love You?* is mainly a romantic film with time travel plots in the story. The magical elements and the theme of love are ingeniously combined, and the film also achieved success at the box office.

In recent years, the growth in the size of film audiences has led to a more mature film consumption market. In 2018, the literary adaptation film *Forever Young* finally gained 750 million yuan at the box office with a culturally profound theme and a strong cast, which made the film the best film adapted from a novel in 2018. Another good literary adaption is *Long Day's Journey into Night*, with a cast of film celebrities, such as Tang Wei, Huang Jue, and Zhang Aijia, and it received positive reviews, and it also achieved good box office. There are also a number of art house films, such as *Baby*, *Last Letter*, *Ash Is Purest White*, which have won awards at international film festivals and received positive film reviews. At the same time, the number of documentaries has also increased. The documentary film, *Amazing China*, has an inspiring theme, attracting audiences from all ages and backgrounds, and finally achieved a box office total of 480 million yuan.

Compared with 2015 and 2016, the production of fantasy genre films has declined for two consecutive years. *Monster Hunt 2* (2018) was an exception because it was released during the Chinese Spring Festival holiday season and audience are fans of this series. It gained the first place with 2.2 billion yuan at the box office, but the market response to other fantasy films was not so positive. The big budget fantasy film *The Monkey King 3* only took a box office of 730 million yuan during the Spring Festival holiday season. *Face of My Gene* (169.8 million yuan), *Airpocalypse* (123.59 million yuan), *Cinderella and the Secret Prince* (60.14 million yuan), *Ashura* (49.84 million yuan), *God of War* (3,808,000 yuan), *The Frozen Hero II* (34.49 million yuan), *Gu Jian Qi Tan II* (14.12 million yuan), *When Robbers Meet the Monster* (7.95 million yuan) and other fantasy movies all had a poor reception. Fantasy movies have innate advantages over other genres in terms of special effects, but the high-quality content of a film's story is the first motivation for moviegoers to enter a cinema.

Table 9.3 Top 10 in the box office list of China's animation film market in 2018 (¥ 100 million)

Rank	Movie title	Total box office	Country of origin
1	Bear Emergence	6.055	China
2	The Incredibles 2	3.544	USA
3	Spider-Man: Into the Spider-Verse	3.542	USA
4	Ralph Breaks the Internet	2.711	USA
5	Hotel Transylvania 3: Summer Vacation	2.229	USA
6	Doraemon: Nobita's Treasure Island	2.093	Japan
7	Ferdinand	1.720	USA
8	Peter Rabbit	1.684	USA
9	Totoro	1.595	Japan
10	The Big Head Son and Little Head Father 3	1.582	China

Source: Entgroup Data.

The imported animation films released in 2018 are still highly popular due to their strong special effects and sophisticated production quality. The 63 animation films released throughout 2018 include 32 domestic animation films, 29 imported animation films, and 2 co-produced films. Although the number of domestic animation films is higher than that of imported animation films, the latter still achieved much better results at box office because of their production quality and special effects. Eight of the top ten at the animation movie box office were imported films (Table 9.3).

The two domestic animation films on the list occupied the top and bottom positions, and *Bear Emergence* was the box office champion of animation films in 2018, with a box office total of 65.55 million yuan. It is not difficult to trace the market performance of animation films over the years. The advantages of a series of animation films are obvious. The two domestic animation films on the list in 2018 are both film series, and most of the imported animation films on the list are also film series. The success of animation films is ultimately due to the success of special effects development, so Chinese animation films need to catch up with imported animation movies, not only in terms of technology, but also in special effects development and promotion.

In recent years, many outstanding films directed by newcomers have emerged. The works of young directors contributed more than 10 billion yuan to the box office in 2018, and some of them are debut productions. Young directors became the backbone of the film industry and gradually became the mainstream filmmakers for domestic films in 2018. For example, Wen Muye's *Dying to Survive*, Rao Xiaozhi's *A Cool Fish*, Han Yan's *Animal World*, Huang Bo's *The Island*, Xin Yukun's *Wrath of Silence*, and Peng Fei's *The Taste of Rice Flower* have injected fresh blood into the film industry, with new filmic language and a more distinctive personal style.

A comparative analysis of domestic films and imported movies in 2018

The year 2018 saw a rise in the numbers of domestic films produced. Although 124 foreign language films were released that year, the numbers of domestic films were outstanding: 19 domestic films gained at the box office more than 500 million yuan, and 8 domestic films exceeded 1 billion yuan box office, with a total box office score of 36.6 billion yuan. The market share was 60 percent which is an increase of 21 percent compared to that of the same period of the previous year. It is worth mentioning that the top 3 at the box office were also domestic films, namely, *Operation Red Sea* (36.5 billion yuan), *Detective Chinatown 2* (3.4 billion yuan) and *Dying to Survive* (3.1 billion yuan). In competing with imported blockbusters, domestic films took first place in both box office performance and audience popularity. With local narratives and realistic themes that reflect the daily lives of Chinese people, these films were already in a better position to compete with imported films. The Open Door policies for the Chinese film industry, the increasing emergence of young film talents, the improvement of the film management system, and benign competition within the industry, all these created an environment in which only films of good quality will be successful. At the same time, the domestic audience's appreciation of good quality domestic films has increased, leading to a high market demand for domestic film production. But, of course, the competition from imported films still remained. In 2018, the number of imported films increased, and the performance of the US domestic market was weak. In order to inspire the audiences, the film *Aquaman* was released in China two weeks ahead of its release in North America, which proves that the Chinese film market is important to Hollywood. The imported films' total box office in 2018 was 24.1 billion yuan, accounting for 40 percent of the total box office.

Comparing the imported and domestic production of the top 20 Chinese box office in 2017 and 2018, among the top 20 in 2017, there were 8 domestic films and 12 imported films. In 2018, there were 12 domestic films and 8 imported movies (Table 9.4). Compared to the box office champion of 2017, *Wolf Warriors 2*, the overall competitiveness of domestic films in 2018 has been significantly enhanced, and they are the top four in the box office. The top three have all achieved excellent performances of over 3 billion yuan at the box office.

For both domestic movies and imported movies, high-quality content has become a driving force for films to gain economic and popular success. Domestic films are strong in comedy and drama, but in science fiction, animation and other genres, they are still relatively weak. With the competition within the industry and the opening up of the Chinese film market, the future of China's film production industry is ready to embark on a healthy path with improved product content and optimization of film resource allocation. The competitiveness of domestic films will continue to increase. The year 2018

Table 9.4 Top 20 Chinese box offices, 2017–2018 (¥ 100 million)

Rank	2017		2018	
	Movie title	Box office	Movie title	Box office
1	Wolf Warriors 2	56.79	Operation Red Sea	36.51
2	The Fate of the Furious	26.71	Detective Chinatown 2	33.98
3	Never Say Die	22.02	Dying to Survive	31.00
4	Kung Fu Yoga	17.53	Hello Mr. Billionaire	25.48
5	Journey to the West: The Demons Strike Back	16.56	Avengers: Infinity War	23.91
6	The Ex-file: The Return of The Exes	16.47	Monster Hunt 2	22.37
7	Transformers: The Last Knight	15.51	Venom	18.70
8	Dangal	12.99	Aquaman	18.52
9	Youth	11.88	Jurassic World: Fallen Kingdom	16.96
10	Pirates of the Caribbean: Dead Men Tell No Tales/Salazar's Revenge	11.80	Ready Player One	13.97
11	Kong: Skull Island	11.60	Us and Them	13.62
12	Coco	11.53	The Island	13.55
13	xXx: Return of Xander Cage	11.27	Project Gutenberg	12.74
14	Resident Evil: The Final Chapter	11.12	Mission: Impossible - Fallout	12.45
15	Duckweed	10.49	The Meg	10.52
16	Despicable Me 3	10.38	Rampage	10.04
17	Spider-Man: Homecoming	7.74	How Long Will I Love You?	9.00
18	Buddies in India	7.58	Ant-Man and the Wasp	8.32
19	Thor: Ragnarök	7.43	A Cool Fish	7.94
20	War for the Planet of the Apes	7.40	Forever Young	7.54

Source: Entgroup Data.

was the strongest year for domestic movies in recent years, and they achieved better performance compared to imported films.

Analysis of Chinese film production companies in 2018

Overview of the traditional Chinese state-owned and private film production companies in 2018

On the one hand, state-owned film companies, such as the China Film Group Corporation, the Huaxia Film Distribution Corporation and the Shanghai Media Group actively responded to the call of the government, with the production of a number of films which successfully promoted the main ideology. On the other, they took advantage of resources and brand

influence to actively participate in the investment of high-quality commercial blockbusters. In 2018, the China Film Group Corporation participated in the production and distribution of 22 domestic films, and its documentary film *Amazing China* achieved a box office of 480 million yuan. The number of domestic films that Huaxia produced was 111 films, including many films such as *Project Gutenberg* (1.27 billion yuan), *Monster Hunt 2* (2,24 billion yuan), *The Monkey King 3* (730 million yuan), and so on. The Shanghai Film Studio produced 9 films, such as *Ipartment* (555 million yuan), *European Raiders* (153 million yuan), *Lost, Found* (285 million yuan), *Ash Is Purest White* (69.974 million yuan), and the animation film *The Adventures of Avanti* (76.92 million yuan).

As shown in Table 9.5, of the top ten production companies for domestic film box office in 2018, there are several well-established private film companies such as Bona Film Group Limited, Wanda Media and Enlight Pictures. *Detective Chinatown 2*, mainly financed by Wanda, achieved second place at the annual box office. *Operation Red Sea* and *Project Gutenberg*, mainly financed by Bona, respectively won the annual box office champion and National Day Champion. *The Island* and *How Long Will I Love You*?, both financed by Enlight, also gained a higher box office. In 2018, Wanda, Enlight and Bona produced 16 films, 12 films and 9 films, respectively. These films made their production companies the top private companies in China in terms of film quality and quantity. Huayi's market competitiveness has been weakened because of the controversial issues with the new film project *Phone 2*. But the films such as *The Ex-file*, the art house film *Ash Is Purest White*, and the realist film *Lost, Found*, produced by Huayi, have all achieved good box office performance. In March 2018, LeTV Film was renamed LEVP Entertainment. It managed to maintain its market share by producing the new film *Shadow*, directed by Zhang Yimou. The above-mentioned well-established private film production companies have maintained their good positions in the Chinese film market for many years (Table 9.6).

Overview of the films produced by the Chinese Internet and emerging film production companies in 2018

In recent years, among a number of Internet film companies, Tencent and Ali have undoubtedly maintained their dominant duopoly position. Their ability to control product content has been increasing on a yearly basis, leading to a profound impact on the pattern of the Chinese film industry. Especially with the data and publicity platform support of MaoYan Entertainment and Tao Piaopiao, the two companies are developing strongly. In 2018, Ali Films produced *Dying to Survive*, *Kill Mobile*, and seven other films, which were all successful at the box office. Tencent Pictures and Penguin, which are both Tencent's companies, financed 13 movies in 2018. Tencent Pictures released *Shadow*, *Boonie Bears*, *Animal World* and eight other films. Penguin Film and Television released five films, including *Forever Young* and *Monster Hunt 2*.

Table 9.5 Top 20 domestic film production companies at the box office in 2018

Rank	Movie titles	Main production companies
1	*Operation Red Sea*	Bona Film Group, Chinese Academy of People's Liberation Army Naval Political Department Television Arts Centre, Online Star Dream Works, Emperor Entertainment Group Limited
2	*Detective Chinatown 2*	Wanda Media Co. Ltd, Shang Hai Shine Asia Movie & Culture Media Co., Ltd
3	*Dying to Survive*	Hua Manshan Group Limited, Joy Leader, Huanxi Media Group Limited, Beijing Culture, Qiankun Xingyu Group Limited, Tang De Limited, Dirty Monkeys Studio
4	*Hello Mr. Billionaire*	Xingkong Shengdian Group Limited, Xi Hongshi Group Limited, Mahua Fun Age, New Classics Media, Alibaba Pictures Group Limited
5	*Monster Hunt 2*	Ying Du Media, Lanse Xingkong Group Limited, Chinese Tencent Film, Anle, Shanghai Tencent Penguin Film Culture Communication Co., Ltd, Huaxia Film Distribution Co. Ltd., Zhe Jiang Film and Television
6	*Us and Them*	Shi Gu Film Company, Ying Er Film Company, MaoYan, Huahua Duoduo Company
7	*The Island*	Han Na Film and Television Company, Enlight Media, Spring Fusion Media Co., Ltd., Youth Light Film, Le Flower Film
8	*Project Gutenberg*	Bona Film Group, Emperor Entertainment Group Limited, Alibaba Pictures Group Limited
9	*The Meg*	Chinese Culture Group Corporation, Gravitational Film and Television Investment Co., Ltd., Warner Bros. Pictures
10	*How Long Will I Love You?*	True Music Culture, Youth Light Film, Jing Wumen Culture Company, Eight Media

Source: Entgroup Data.

Baidu's iQiyi production company released *A or B*, *I Am Your Mom* and six other films. *A Cool Fish* was the product of several companies mentioned above which jointly produced this film. In the era of digital technology, Internet companies have obvious strength in the Chinese film industry, and their industry competitiveness is increasing year by year.

In recent years, many new, previously unknown film company names have emerged in the Chinese film industry, and some of them are production companies for the top ten films at the 2018 national box office. Most of these companies are led by established filmmakers or actors. These filmmakers contributed to content selection and film production based on their rich filmmaking experience and superior resources in the industry. Ning Hao's Dirty Monkeys Studio and Xu Zheng's Joy Leader jointly produced *Dying to Survive*. In addition, Joy Leader also produced *The Wind Guardians*, *A or B*, *How Long Will I Love You?* and many other films. Chen Guofu's Gongfu Film

Table 9.6 Overview of film production by Chinese major film production companies in 2018

Company	Number	Movie titles
Zhong Ying	22	*Detective Chinatown 2, Monster Hunt 2, Forever Young, The Monkey King 3, Amazing China*, etc.
Shang Ying	9	*iPartment, Lost, Found, European Raiders, The Adventure of Afanti, Ash Is Purest White*, etc.
Wanda	16	*Detective Chinatown 2, Dying to Survive, Detective Dee, Bear Emergence, Hello Mrs. Money*, etc.
Bona	9	*Operation Red Sea, Project Gutenberg, Shadow, Big Brother, Happiness Comes Right Away*, etc.
Huayi	6	*Detective Dee, Lost, Found, Fat Buddies, Yunnan Valley, Ash Is Purest White, Nice to Meet You*, etc.
Enlight	12	*Detective Chinatown 2, A Cool Fish, How Long Will I Love You?, Bear Emergence, Animal World*, etc.
LEVP	3	*Shadow, The Frozen Hero 2*, etc.
Beijing Culture	7	*Dying to Survive, A Cool Fish, Kill Mobile, A Better Tomorrow 2018, BABY, Cats and Peachtopia*, etc.
Yaolai	8	*Detective Chinatown 2, The Monkey King 3, The Island, Lost, Found, A Cool Fish, Kill Mobile*, etc.
Ali	7	*Operation Red Sea, Dying to Survive, Hello Mr. Billionaire, The Island, Project Gutenberg*, etc.
Tencent	8	*iPartment, Bear Emergence, Shadow, Animal World, A Cool Fish*, etc.
Penguin	5	*Forever Young, Monster Hunt 2, Yunnan Valley, End of Summer, Fate Express* etc.
IQIYI	6	*A Cool Fish, A or B, I Am Your Mom, Really? The Blizzard*, etc.

Source: Entgroup Data.

Production was the main producer of the film *Detective Dee. Hidden Man*, *Einstein and Einstein*, and *Wrath of Silence* were produced by Cao Baoping, Xin Yukun and other famous directors in cooperation with HeHe Film. Yan Fei and Peng Damo's Xi Hongshi Film Corporation produced the movie *Hello Mr. Billionaire*. And *A Cool Fish* was produced by Rao Xiaozhi's Shaonian Pie Film (Table 9.7). The cutting-edge independent filmmaking companies, with filmmakers as their core, have an innate advantage in the production of film content. In future, this sector is bound to compete with traditional major film companies.

Nowadays, Internet film companies, traditional major film production companies, distribution companies and cutting-edge film production companies often join together to produce film projects. This helps them avoid the high cost of film production and low output risk, and they benefit from each other's resources. This has become the basic model of film production. In the top ten domestic films in the box office rankings of 2018, the average number of companies participating in a film project exceeded 20. Among them, there

Table 9.7 Overview of the films produced by Chinese film companies in 2018 (¥ 100 million)

Company	Movie titles	Number	Total box office
Huanxi	Us and Them, Dying to Survive, Ash Is Purest White, Nice to Meet You	4	45.82
HeHe	Hidden Man, Einstein and Einstein, Wrath of Silence, Till the End of the World	4	9.23
Shaonian Pai	A Cool Fish, etc.	4	8.39
XiaoMi	Detective Chinatown 2, Hello Mr. Billionaire, A or B, Girlfriend 2	4	63.66
Joy Leader	Dying to Survive, How Long Will I Love You?, A or B, The Wind Guardians	4	44.71
XinLi	Kill Mobile, Hello Mrs. Money, Hello Mr. Billionaire	3	36.79
HanNa	The Island, A Strong Insect Crossing the River, The Monkey King 3	3	23.74
MaHua	Hello Mrs. Money, Hello Mr. Billionaire	2	31.52
RuYi	Animal World, Airpocalypse	2	6.32
GongFu	Detective Dee	1	6.06
Dirty Monkeys	Dying to Survive	1	31.00
Xi Hongshi	Hello Mr. Billionaire	1	25.48

are 46 in *The Monkey King 3*, 38 in *Operation Red Sea*, and 36 in *The Island*. And even for low and medium budget movies like *A Cool Fish* and *Forever Young*, there are 23 and 16 companies involved, respectively. Co-production has become the best way for current movie products to succeed in the Chinese film industry.

Conclusion

The year 2018 was when the internal and external environment of the Chinese film industry underwent major changes. The film industry in China increasingly experienced supervision and governance by the national administrative departments. The industrial capital market suffered difficulties, and fiscal and taxation policies suddenly were changed. There were worries about the prospects of the Chinese film industry in 2018, but the outstanding achievements of Chinese films at the end of the year prove that "every cloud has a silver lining." The domestic film production reached a peak in recent years in terms of both the number of films produced and the cinematic quality. The production chain is the most important part of the film industry chain. Traditional state-owned film production companies, private film production companies, and newly established film companies complement each other in terms of sharing resources. With increasing co-productions among them, more good quality films are being made for the audiences in China.

Bibliography

China Statistical Yearbook (n.d.). Available at: www.chinayearbooks.com.

Hong Y., Tianyu L., and Yanbin S. (2019). Chinese Film Industry Memo in 2018, *Movie Art*, No. 2, 33–45.

Xiang G. (2018). Types of Film Integration, *China Art News*, November 14, 2018, 3rd edn.

10 The development of Chinese cinema circuits and the Chinese film market in 2018

Zenghan Zhuang

China's economy has been prosperous in many fields because of China's Reform and Open Door policies over the past 40 years. Unlike other industries in China, Chinese film industrialization reached only its 16th year in 2018, after the cinema circuit system reform in 2002. The year of 2018 saw a seemingly stable screening market concentration but was threatened by a growing crisis. The market needs to open up further, deepen the reform, and seek breakthroughs until a new turning point comes. The continuous high rate of cinema construction has also led to numerous cinema bankruptcies, while the gross per screen continues to decline. The film exhibition industry is facing a crisis, challenges, and new opportunities.

The developmental interpretation of cinema circuits

The number of city commercial circuits remained at 48 which appears to be a stable market structure in 2018. The top eight companies accounted for 61.8 percent of total film sales nationwide and the market concentration was slightly higher than in 2017 (Table 10.1). Apart from the absolute top place (Wanda Cinema), the ranking has alternated between the other top eight players over a few years. From 2015 to 2018, the market share of China Film Stellar Theater Chain (hereafter referred to as Stellar) continually declined, shrinking by 1 per cent in 2018, with hundreds of cinemas closing down.[1] As the company was dragged into labor disputes, Stellar suffered from underwhelming performance. 2018's film exhibition market did not deviate from the trend of box office polarization: the top ten cinema circuits accounted for more than 66 percent of total film sales and the top 20 were as high as 84.5 percent. The remaining cinema circuits only contributed 15.5 percent to the total box office outcome nationally.

Low profitability of large cinema circuits: horizontal consolidation becomes inevitable

Numerous cinema circuits and cinemas faced a business crisis in 2018. Large cinema circuits, including Wanda Cinema, Dadi Theater Circuit, Shanghai

Table 10.1 Market share of top eight cinema circuits, 2015–2018 (in terms of box office revenue) (%)

Cinema circuits	2015	2016	2017	2018
Wanda Cinema	13.6	13.4	12.9	13.5
Dadi Theater Circuit	8.0	8.1	8.6	9.9
Shanghai United Circuit	7.1	7.8	8.1	8.0
China Film South Cinema	6.8	7.1	7.3	7.4
China Film Group Digital	4.8	6.5	7.3	7.3
China Film Stellar Theater Chain	8.6	7.6	7.1	6.4
GZ. Jinyi Zhujiang Movie Circuit	6.6	6.1	5.3	5.0
HG Entertainment	4.5	4.5	4.4	4.3
Top eight in total	60	61.1	61	61.8

Source: Endata, statistics by 5 Jan. 2019.

United Cinema, GZ. Jinyi Zhujiang Movie Circuit (hereafter referred to as Jinyi), suffered different degrees of difficulties represented by their 2018 quarterly financial figures. In the third quarter of 2018, the net profit of Wanda increased by only 0.31 percent compared to the previous year. In the first half of 2018, Dadi's net profit decreased by 9.8 percent. Due to its loose franchise mode, it suffered from frequent problems of "box office splits"[2] by its franchising cinemas. The long payback period of capital resulting in the shortage of cash flow, and limited stock financing capacity, caused Dadi to be officially removed from the New Third Board in December 2018. Shanghai Film's net profits fell significantly for three consecutive quarters over the previous year (-45 percent in the second quarter, -34 percent in the third quarter).[3] Jinyi Film also performed poorly.[4] Revenues decreased 5 percent in both the second and third quarters.[5]

The year 2018 revealed that the film exhibition industry from cinema circuits to cinemas had sunk into an operating predicament. Average admissions per screen and the occupancy rate of the top ten circuits were tallied at 16.8 percent and 12.5 percent respectively, which showed reductions over successive years (Figure 10.1). This decrease could be seen to a different extent in other theater circuits, the admissions per screen and occupancy rate of the top 20 circuits reflecting decreases of 2–5 percent and 0.8–2.5 percent over the previous year. The "ticket subsidy" was prohibited from 2018 by the government. Withdrawal of the ticket subsidy lifted the average ticket price to a regular level that has made moviegoers reluctant to go to the cinema. Moreover, since the number of cinemas has been continuously increasing, cinemas have been facing tougher competition. This together with "one movie, one thousand cinemas" (content homogenization) pushed cinema circuits to their present low profitability.

An operational crisis of large circuits appeared everywhere. The contradictions between expansion and efficiency, development and management have been increasingly prominent, while companies are getting bigger

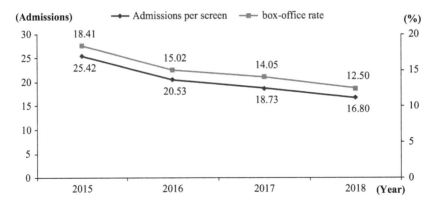

Figure 10.1 Average admission per screen and occupancy rate of the top 10 cinema circuits, 2015–2018.

and stronger. Generally, cinema circuits are aiming to seek new breakthroughs by acquisitions or cross-boundary financing: the industry reshuffle is accelerating.

Against the background of an overall slowdown of the screening industry, Wanda Film adopted expansionist strategies. Primarily, it promoted vertical integration through the merging of Wanda Film and Wanda Cinema. Moreover, relying on its strong cinema operation ability, it opened 103 new cinemas in 2018 and claimed that 80–100 more (excluding acquisitions) will be opened each year in the future, which complies with the trend of industry concentration. Wanda aims to win in the restructuring.

By fall 2018, as cinemas over-supplied in the third- and fourth-tier cities, there were signs of saturation and competition in the Chinese film exhibition industry, and the box office dropped. It has become unrealistic to increase film revenue by constructing cinema complexes in the third- and fourth-tier cities. The era of cinema circuits winning by volume has passed. Only horizontal mergers or deep resource integration can help some of them to stand out at this turning point for the Chinese film industry. Many theater chains had invested in the acquisition of high-quality cinemas and assets. Compared with 2017, mergers and acquisitions were not frequent. Instead, cinema investment companies that were established by some cross-boundary enterprises had very impressive performances, reflecting the new forces rising in the film exhibition market.

Medium-sized cinema circuits struggled: numbers of investment companies rising

The cinema circuits that were ranked 10–20, such as Zhejiang Times (no. 11), Sichuan Pacific (no. 12), Poly Wanhe (no. 13), Henan Oscar (no. 14), Perfect

Table 10.2 Operating statistics of the top 20 cinema circuits in 2018

Rank	Cinema circuits	Box office (¥ 100 million)	Average ticket price (¥)	Average admissions per Screen	Occupancy rate(%)
1	Wanda Cinema	81.3	41	21	13.47
2	Dadi Theater Circuit	60.1	34	15	12.14
3	Shanghai United Circuit	48.4	37	19	13.89
4	China Film South Cinema	45.1	35	15	12.8
5	China Film Group Digital	44.5	34	14	10.66
6	China Film Stellar Theater Chain	38.7	36	18	13.95
7	GZ. Jinyi Zhujiang Movie Circuit	30.3	37	18	12
8	HG Entertainment	26.3	33	16	11.55
9	Hua Xia United Circuit	21.1	34	14	11.36
10	Omnijoi Cinema Circuit	20.7	34	18	13.47
11	Zhejiang Time Cinema Circuit	18.8	34	15	12.78
12	Sichuan Pacific Cinemas	17.5	35	18	14.9
13	Poly Wanhe Cinemas	14.3	36	18	12.91
14	Henan Oscar Circuit	11.8	32	14	12.22
15	Beijing Hong Liyu Cinema	11.2	36	7	7.1
16	Perfect World Cinemas	10.5	33	13	11.21
17	Beijing New Film Association	10.1	38	21	16.02
18	Hubei Insun Cinema Chain	9.4	33	19	13.67
19	Zhejiang Star Lights Cinema Chain	7.7	35	17	13.27
20	Liaoning North Theater Chains	7.6	31	15	12.82

Source: Endata, statistics by 31 Dec. 2018.

World Cinemas (no. 16), showed stable performance (Table 10.2) in 2018. Beijing Hong Liyu Cinema jumped to no. 15 and has kept rising for four consecutive years. The driving force came from the newly built affiliated cinemas of the Edko Films investment company.

Another thing to note is the Beijing New Film Association's drop from its top five position at the early stage of the cinema circuit reform. It slipped gradually, ending up in 17th place in 2018 due to its rigid inner mechanisms and lack of capital, and is unlikely to go back to a top position. Companies ranking around 20 were fixed, including Hubei Insun and Zhejiang Star Lights, which hardly break developmental barriers. Medium-sized cinema chains have been struggling to survive, revealing they have an unlikely chance of expanding without outside impetus like recapitalization or reorganization.

In 2018, the number of cinema investment management companies reached 496, an increase of 136 from the previous year. Although the growth rate of cinema construction slowed down, new companies focusing on cinema management and acquiring high-quality cinema equity are rising. Compared with the traditional cinema circuits, companies controlling the cinema investment management market were backed by abundant capital. Movie exhibitors are cinema investment management companies that own and operate cinemas. They receive screening copies from the cinema circuits but retain control over the screening schedule (CJ CGV is an operator but not a theater circuit while Wanda Cinema is both). They generate revenue from their share of the box office, in-theater advertising and concessionaire sales.

Wanda has taken a dominant position due to the advantage of its centralized management structure of wholly self-owned cinemas. It had film sales of 5 billion yuan and 1.5 percent occupancy rate higher than the second largest, Dadi (Table 10.3). Wanda had the highest operating efficiency in 2018 nationwide, which reveals its strong business model and successful cinema control.

Dadi's own cinemas have only brought in 2.88 billion yuan in film grossing, and over 50 percent was contributed by franchised cinemas. The operating mode of half being direct investment and half being franchised has brought some revenue instability, which offers an unknown future. Likewise, Shanghai Film failed to meet profit expectations so that it dropped five places from 2017 and sold off cinema assets consequently.

Cinema investment management companies supported by foreign or cross-boundary capitals bucked the slowdown trend, such as CGV Cinemas, Bona Cinema Investment, Evergrande Cinema Line, Macalline Film. CGV demonstrated an eye-opening operating efficiency; its high-level and experienced management competence will gradually be increased.

Most newly established cinema investment management companies are not only financed by movie-related companies. It is common for real estate giants to build self-owned cinemas, so-called "build your own multiplexes in your own shopping mall." Companies intend to copy the Wanda model by taking advantage of rentals which could maximize profits, such as Evergrande Cinemas of the Evergrande Group, Bestar Cinemas of the Future Holding Group, BHG Cinemas of the Beijing Hualian Group, Dashang Cinemas of the Dashang Group, and Huayi Cinema of the Liqun Group, etc. Cinemas are easy to build but difficult to operate well. Under this investment model, the operation status of cinemas and shopping malls are closely related.

Multiplexes like Evergrande and BeStar, located in advanced fifth-generation commercial complexes (large-scale shopping malls), have obvious advantages and good operational conditions, while their ranking keeps rising. In contrast, in older department stores like Mykal, whose lack of experiential entertainment projections and fashionable atmosphere are facing upgrading, their cinemas have lower results (Table 10.4). Conversely, Suning Film Investment showed a remarkable performance. It expanded rapidly in

Table 10.3 Operating statistics of the top 20 investment management companies in 2018

Rank	Investment-management companies	Box office (¥ 100 million)	Screening times (10,000)	Admissions (100 million)	Occupancy rate(%)
1	Wanda Cinema	81.3	933.3	19.9	13.49
2	Dadi Theater Circuit	28.8	510.1	8.3	11.94
3	HG Entertainment	22.6	420.5	6.8	11.59
4	CGV Cinemas	17.5	183.5	4.2	13.5
5	China Film Group Cinema Investment	17.4	194.8	4.9	15.91
6	Jinyi Film	16.9	230.1	4.4	11.69
7	Stellar Cinema Investment	12.5	194.8	3.4	12.72
8	Pacific Cinema Management	10.1	130.2	2.8	17.14
9	HK. Broadway China	9.6	77.7	2	16.11
10	Jackie Chan Cinema	9.1	138.2	2.7	14.94
11	Poly Cinemas	8.8	103	2.3	13.73
12	Bona Cinema Investment	8.8	93.8	2.3	17.09
13	UME Cineplex	8.7	116.2	2.1	15.58
14	Shanghai Film	8.3	84.2	1.9	15.81
15	OSGH Cinemas	7.9	106.3	2.1	13.38
16	Omnijoi Cinema	7.8	100.3	2.3	14.49
17	Lumiere Pavilions	7.3	62.7	1.8	19.21
18	Red Star Macalline Film	6.9	83.5	1.8	15.55
19	Evergrande Cinemas	6.1	162.4	1.8	7.02
20	Sichuan Pacific Cinemas	5.6	76.1	1.6	16.78

Source: Endata, statistics, 31 Dec. 2018.

Table 10.4 Rank changes of some cross-boundary cinema investment management companies, 2015–2018

Companies	2015	2016	2017	2018
Red Star Macalline Film	71	48	21	18
Evergrande Cinemas	41	21	20	19
Shanghai Bestar Cinemas	—	206	49	26
Suning Film	—	141	58	34
BHG Cinemas	79	74	67	67
Dashang Group	57	51	63	79
Liqun Group	12	13	108	121
China Resources the Mixc	—	—	—	138

Source: Endata, statistics, 31 Dec. 2018.

the downturn of the industry, with film grossing of 210 million yuan, an increase of 78.4 percent. Likewise, Red Star Macalline's film industry rose steadily as well. As a home appliance retailer and a furniture retailer, Suning and Macalline have become successful models for outsider capital to enter the movie market.

Small cinema circuits acquired: rural cinemas continue to grow

In terms of small circuits, Sichuan Emei Circuit's ranking dropped five places and its box office decreased by 8 percent. On the contrary, Star Time Circuit showed a striking performance after its reorganization, with a 50 percent increase in box office and ranking up three places. The box office growth of Xinjiang Huaxia Tianshan Circuit and Inner Mongolia Cinema Line was over 26 percent, higher than the average growth of the market. Although no apparent change appears in the ranking, it reveals that China's ethnic minority film market in the western region is constantly expanding, and its great potential ought to be explored. But in the near term, small circuits are hardly comparable to those well-capitalized large circuits.

Most low-ranking small cinemas, established by provincial distribution companies in the early stage of the cinema circuit system reform, missed the ten-year golden development period of the Chinese film industry due to the relatively undeveloped economy or mechanism limitations.

The Guidance on Accelerating Cinema Construction and Promoting Film Market Prosperity was issued by the China Film Administration in December 2018, which was the first significant breakthrough in in-depth circuit reform since June 2002. The Guidance "encourages cinema circuit development" and laid down five conditions to apply for a "circuit license": investment companies that own over 50 cinemas or 300 screens, with an annual box office revenue no less than 500 million yuan, with no illegal records, are eligible to apply.

The Guidance redefined the threshold of the cinema circuit, according to its own criteria. The small or medium-sized cinema circuits lower in ranking than the 24th place in 2018 were not up to standard. The policies resulted in some small and medium-sized cinema circuits being eliminated or they will be acquired in the near future.

The number of rural cinema circuits was 330, and more attention was paid to improving the quality and efficiency of rural screenings, which offered more potential in the rural market. High-quality main ideology films, documentaries and traditional operatic films were popular with rural audiences, and frequently ordered by rural circuits. Some low or mid-budget films failed to get the ideal box office in city cinemas, so instead were promoted with long-term screenings in the rural market, with sales far exceeding expectations. Economically developed provinces like Zhejiang, Shandong and Hebei remained big buyers, and other provinces had different degrees of growth to meet the growing spiritual and cultural needs of rural cinema audiences.

Table 10.5 Box office and cinema screens growth, 2015–2018

Year	Box office (¥ 100 million)	Box office growth rate (%)	Numbers of cinemas nationwide	Cinemas growth rate (%)	Numbers of screens nationwide	Screens growth rate(%)
2015	440.69	48.6	6000	41.9	31726	34
2016	492.83*	11.83	7882	31.3	41179	29.7
2017	559.11*	13.56	9504	20.5	50776	23.3
2018	609.76*	9.04	10958	15.3	60079	18.3

Source: Endata, statistics, 31 Dec. 2018.

Note : *Box office figures include the service fee of online ticketing vendors (2017–2018).

Developmental interpretation of cinemas

In 2018, the number of cinemas reached 10,485 and the number of screens exceeded 60,000, which is an increase of 9,303, or 18.3 percent over the previous year. However, the average box office per screen dropped by 8 percent. The growth rate of urban cinema construction had declined for three consecutive years, falling to 15.3 percent in 2018, but was still higher than the growth rate of 9 percent of the annual box office (Table 10.5). The cinemas in the first-, second- and third-tier cities have been saturated, and an imbalance between supply and demand in the film exhibition market is increasingly apparent.

On the one hand, the increase in scale has reduced output efficiency, and cinemas are facing intensive competition. On the other hand, online ticketing reached 84.5 percent[6] and MaoYan (the biggest third-party online ticketing vendor) promoted the overall popularity of online movie ticketing. How to explore cinemas' advantages in developing new audiences, by optimizing the audience experience, and improving the operating competences has become an urgent task for cinema operators as online sales become mainstream.

The management mode needs to be transformed

Over the past three years, with China becoming the largest film exhibition market globally, the paradox of the high growth rate of cinemas with the decline of output efficiency per screen has puzzled the Chinese film industry, which perhaps signals the need to adjust investment, cinema construction, and management methods. From 2010 to 2018, the incredible speed of cinema construction made China the country with the largest screen ownership, from thousands to more than 60,000. However, in the past two years, the decor and equipment in cinemas are becoming widely worn out and cannot guarantee screening quality or even meet the increasingly critical audience quality requirements.

Table 10.6 Number of cinemas closed in 2017 and 2018

Year	First-tier cities	Second-tier cities	Third-tier cities	Fourth-tier cities	Total	Growth rate (%)
2017	12	62	30	77	181	—
2018	29	82	57	120	288	59.12

Source: MaoYan Research Institute.

Table 10.7 Cinema category by box office volume in 2018

Rank	Box office	Cinema numbers	Ratio of cinemas to total(%)	Box office (¥ 100 million)	Ratio of box office to total (%)
1	Over RMB 70 million	1	0.01	0.79	0.13
2	RMB 60–70 million	3	0.03	2.01	0.33
3	RMB 50–60 million	9	0.08	4.8	0.79
4	RMB 40–50 million	23	0.2	10.55	1.73
5	RMB 30–40 million	112	1.02	38.47	6.3
6	RMB 20–30 million	365	3.33	87.31	14.4
7	RMB 10–20 million	1356	12.4	189.1	31.2
	Total	1869	17.07	333.03	54.88

Source: Endata, statistics, 31 Dec. 2018.

As long as no solutions to the problem of low screening efficiency are found, and with more new cinemas opening, the profits will be diluted, and it will be more difficult for cinemas to survive. At the beginning of December 2018, Stellar announced "140 cinemas have been temporarily closed down out of some 320 cinemas operating in China," signaling that cinema circuits are facing reforms. According to data released by the MaoYan Research Institute (Table 10.6), 288 cinemas were closed in 2018; almost one closed every day, 29 in first-tier cities, 82 in second-tier cities, 57 in third-tier cities, and 120 in fourth-tier cities.

In 2018, of the 10,485 cinemas with statistics available, the top cinema gained an annual box office of more than 70 million yuan (Table 10.7), and the top 13 gained over 50 million yuan. In 2017, these figures were the top 3 and the top 18 respectively. Most of these super high grossing cinemas are located in first- and second-tier cities, such as Beijing, Shanghai and Guangzhou. Fierce regional competition caused revenues to be diluted in this cruel and competitive environment. Some 1,869 cinemas (an increase of nearly 100), with an annual box office over 10 million yuan, accounted for 54.88 percent of the total box office, but the contribution was 5 percent lower than that in 2017. The data prove the phenomenon generally felt by the industry: "the market is good; but the downstream is difficult."[7]

The main reason for this trend of collapse is cinema over-supply. The market rule of "survival of the fittest" has proved to be true, since the growth rate of the demand was far behind the supply. One of the top five, Stellar, which had intended to expand the number of cinemas to 450, met its "Waterloo" with a debt crisis resulting from staff remuneration and film studios, leading to the closure of 145 cinemas.[8]

The film exhibition market of the third- or fourth-tier cities has changed from the "Blue Ocean" to the "Red Sea." Market bubbles caused by the ticket subsidy vanished, and actual price increases dispelled moviegoers' willingness to visit cinemas. Qingdao's West-Coast Economic New Area screening market is an example. It was established as the ninth national "new area" in 2014 with an enormous inflow of capital. During 2014–2018, the number of cinemas in this area increased from 2 to 15, and the locations of 4 cinemas were less than 2 kilometers distant from each other. It was difficult for the profits from newly built cinemas to meet expectations. Old worn-out cinemas and new ones found it hard to break even. Film sales have been declining year by year and each cinema is struggling to survive. It is a long process to cultivate the movie-watching habits of third- and fourth-tier residents. Only by keeping a reasonable number of cinemas in the region can a healthy and stable development be maintained.

Cinema managers should draw lessons from cinema collapses caused by over-focusing on investment rather than on management, and by failing to use the way of "the Internet-of-Things" to upgrade management competences in time. With the Internet era, simply using third-party vendors, they ignored the development of their own cinema's special features. Once a new cinema opens, it will inevitably face the diversion of viewers. The homogenized competition made managers passively over-reliant on online sales vendors, losing the initiative to control their cinema's own operations.

Increase non-ticket revenue and develop films' marginal benefits

An improvement in a cinema's competitive advantage can result from many innovations. These include renovating equipment, redecorating interiors, joining the Nationwide Alliance of Arthouse Cinemas[9] to obtain different film sources, programming screening schedules to reflect local viewing habits, and researching the regional market, which could lead to greater brand recognition and satisfaction. On the basis of maximized audience numbers, we should think about how to maximize the consumption of every customer, including "movie derivatives" to increase consumption, and how to find more revenue growth points. Cinemas could generate revenues not only from admission tickets but also from non-ticket revenues (food & beverages retailing, in-theater advertising, venue rental, concessionaire sales).

Wanda's non-ticket revenue ranked number one in the industry with 2.53 billion yuan in the first half of 2018, accounting for 34.4 percent (38 percent in 2017) of its total revenue.[10] The figure for HG Entertainment reached

500 million yuan, accounting for 24.5 percent of its total revenue in the first three quarters of 2018. As retailing sales generate a much higher margin than ticket sales, companies are delighted to expand this business to further boost cinemas' revenue and improve overall profit margins.

Wanda's development strategy in the non-ticket business is worth taking a lesson from. In 2016, Wanda Cinema Media was established to create self-management in full screen advertising resources. They introduced a "membership +" strategy, innovated offline cinema consumption scenarios, interactive games, VR experience, etc. In terms of food and beverage retailing, they found that monotonous popcorn and cola cannot meet the diverse needs of the audience, so innovation in food categories and taste was the key. After forming an alliance with CJ CGV cinemas, its parent company, CJ Group, imported food from South Korea, which also helps Wanda's retailing business.

Compared with the US film market, where concessionaire sales are as high as 70 percent in total revenue, China's film derivatives are still in the early stage. Primarily, there is a lack of local blockbusters and serialized film products, so the development capacity of the derivatives is insufficient. Moreover, fraud was pervasive, there was a lack of marketing, and ticket prices were too high for the customers. All these factors restrict the development of a derivative business. Wanda adheres to the establishment of the "derivative" experience store, developing dozens of stores where it has cultivated the buying habits of audiences, gradually establishing brand awareness and identification.

Some mature theater management brands have made outstanding achievements in non-ticket revenue. Stellar's ratio is 41 percent and CGV cinemas' rate is 30 percent. Premier cinemas have unified logos and design standardization, reflecting a strong brand influence with cultural characteristics. This has a strong attraction for the main consumers, who are white-collar customers in the first- and second-tier cities, and the post-1980s and 1990s and 2000s generations who pursue new trends. The price of the retail products may be high, but the exquisite packaging, precise selections (such as the hot dogs, hamburgers, pizzas, which are common in high-end cinemas of the first- and second-tier cities), the comfortable environment and atmosphere are all reasons to encourage consumers to pay more.

The era of relying on investment increment to win has passed. Cinemas need to seek new core competitiveness to bring profit growth. In the current consumption mode of most Chinese moviegoers, there is little marketing room left for cinemas. People have certain movie-watching desires, they search the relevant movie reviews, select times and seats online, get to the cinema five minutes before the movie begins, and then give online feedback. It is more difficult to find the focus of theater management. Many theater managers are only doing executive and internal management, and cinema innovation shows a weakening trend. However, when most of the cinema's business models are solidified, it also provides opportunities for innovation.

Conclusion

The box office performance of the cinema circuit and investment management companies depends directly on the box office performance of their cinemas. The Guidance pointed out that the establishment of a cinema circuit must meet five conditions, including the number of direct-invest cinemas to be not less than 50, or the number of screens not less than 300, and revenues from direct-invest cinemas not less than 500 million yuan.

There are 48 city cinema circuits in China, where large differences exist among them. The top cinema circuits could reach an annual box office of 8 billion yuan with more than 200 million admissions, and with the added value of films, the annual turnover was more than 10 billion yuan. When considering the cinema circuit ranking after 40, the total annual box office of several cinema circuits is less than one financially strong cinema circuit in the top list. Under the current profit distribution model, it is hard for these circuits to survive, not to mention develop.

The Guidance proposed that the new cinema circuit establishment and its "exit mechanism" should be implemented at the same time. According to the statistics, of over 10,000 cinemas, 60 percent are franchised cinemas. Such a huge cinema self-focus is undoubtedly the biggest obstacle to the operation and management of cinemas. The opening application of a "cinema circuit license" will help to promote the reorganization and merger among cinemas. "To improve the mechanism of rewards and penalties, and mechanism of withdrawal in cinema circuit" is essential to optimize the cinema circuit environment and the market.

There are 3,079 low-quality cinemas with a box office of less than 1 million yuan in 2018, accounting for 28 percent of the total number of cinemas. This is in contrast to the goal of "the total number of screens joining the city cinemas circuits which should reach more than 80,000 by 2020." By 2020, there will be an explosion of cinema construction, but the "survival of the fittest" means that not all will survive, posing even more severe challenges for cinema operators.

Notes

1 Statistics from Endata or compiled by the author according to the data published by the Chinese Film Bureau and *China Film Daily*.
2 China-produced film box office revenue split: the upstream operators (i.e., the film producers and distributors) receive 43 percent of the box office split and downstream operators (i.e., the cinema circuits and cinema operators) receive 57 percent of the box office split in China. From *Guidance on the Modification of Domestic Films' Box Office Split*, SARFT, 2008. Cinemas are divided into direct investment and franchises. The actual split between cinema circuits and franchising cinemas depends on bargaining power. Generally speaking, the cinemas have stronger bargaining power when they are expected to generate greater films sales in the market.

3 Shanghai Film, the parent company of Shanghai United Circuit, mainly engages in operating cinemas.
4 Jinyi Film: Parent company of GZ. Jinyi Zhujiang Movie Circuit mainly engages in operating cinemas.
5 Tong hua shun Finance: Wanda Cinema, Dadi Cinema, Shanghai Film, Jinyi Film, September 2018.
6 "Goodbye 2018! China film market growth diary behind the 60 billion report," available at: Huanqiu.com, January 2019.
7 "The darkest moment of Chinese cinema," available at: Sohu.com, December 2018.
8 "Will Stellar be the first big Mac to fall in the cold winter?" available at: China Economic.com, January 2019.
9 "Nationwide Alliance of Arthouse Cinemas" established by China Film Archive in October 2016. Cinemas joining this alliance should guarantee showing art films at least three times daily and ten times weekly.
10 Tong Huashun Finance: Wanda Cinemas, June 2018.

11 The operational model of cinematic adaptation from Internet content in China

Xiaojuan Yan

Box office performance of film adaptation from online content

In 2014, *Old Boys: The Way of the Dragon*, a movie adapted from the microfilm *Old Boys*, took 25 million yuan at the box office on its first day of release, with 47 average viewers per show time, outperforming the Hollywood blockbuster *Transformers 4: Age of Extinction* which was released on the same day. In total, the Chinese film achieved a gross box office of 220 million yuan.

Another movie adapted from an Internet video program is *One Hundred Thousand Bad Jokes*, which achieved a total box office of 119 million yuan. Despite the fact that it barely surpassed the 100 million yuan threshold, the film marked a success in breaking the entrenched gross limit of 60 million yuan in the field of Chinese animation. Considering it cost only 10 million yuan in production and promotion, *One Hundred Thousand Bad Jokes* has achieved a considerably impressive return on investment.

In 2015, *Pancake Man,* a movie adapted from Sohu's drama *Diors Man*, achieved a total box office of 1.16 billion yuan. Apart from a high gross revenue, *Pancake Man* also received positive reviews with a score of 7 on Douban. The film's director Dong Chengpeng won "Best New Director" and "Best New Actor" awards at the 18th Shanghai International Film Festival.

Three years after the Internet drama *Surprise* was launched online, the show's producer UniMedia joined forces with Heyi Pictures to adapt it into a big-screen production of the same name, with Jiaoshou Yi Xiaoxing as director, Huang Jianxin as the executive producer, and Han Han as the art director. The film eventually achieved a gross box office of 320 million yuan.

A common feature shared by these films is that they are all adapted from microfilms or Internet dramas online that were highly popular for online viewing. Thus, these films eventually achieved extraordinary box office performances. Some experts estimate that big-screen films adapted from Internet-generated videos will bring a total revenue of more than 10 billion yuan in the next three to five years.

Reasons for the emergence of film adaptations from Internet content

There are many reasons why films are adapted from Internet dramas. In this chapter, these reasons are analyzed by considering the various factors of the Internet dramas and the film industry.

The film industry

Drama films adapted from the Internet cater to the audiences' tastes

With the advent of the Internet era, networks have become the major or even the only channel from which the public receive information, conduct communication and seek entertainment. The Internet culture has also long become the core of popular culture. Statistics show that the user population of the Internet is mainly comprised of young people aged between 15 and 35, who happen to be the major film viewing group. The high overlap between film audiences and Internet users prompts an increasing number of filmmakers to seek inspiration from Internet content in order to capture the attention and interest of the mainstream population of film viewers. Therefore, popular online fictions and videos naturally become top choices for cinematic adaptation.

For instance, *Diors Man* upon which the film *Pancake Man* is based, received four billion clicks after being launched online, accumulating a massive pool of original users. These users will naturally also be converted into target audiences for its cinematic adaptation on the big screen.

Adaptation effectively reduces film investment risks

Given the high-risk nature of the film industry and the relatively unitary profit model of China's film industry, the majority of domestic films risk losing money. However, a well-established intellectual property (IP) of, for example, a literary work, play, Internet drama or comic, may have already secured a fixed group of fans with its narrative and fictional characters tested by the market. Thus, it will be easier for its cinematic adaption to succeed. This was indeed the case if we look at the emergence of a large number of successful works in the Chinese film market in 2015: *Goodbye Mr. Loser*, *Go Away Mr. Tumor*, and *Jian Bing Man*, etc.

Using data analysis and other tools, Internet dramas can accurately target their audience and thus establish effective marketing strategies. As mentioned earlier, the Internet drama *Diors Man* received 4 billion clicks online, helping to generate massive data for the confirmation of the success of its big-screen adaptation. In the meantime, the director Dong Chengpeng also engaged in active interactions with users on social media which also facilitated acquisition of user information. The marketing campaign of *Pancake Man* was successful as it is close to the real daily problems of the audiences. The offline marketing

efforts also include events like "Da Peng Pancake Booth at Zhong Guancun" and "Da Peng Went to Lian Xiang Training School," as well as a roadshow in 35 cities. These marketing activities continuously accelerated the popularity of the film and successfully drew attention from audiences who were initially not fans of *Diors Man*, thus making the film an intensively debated topic among the public. With respect to online marketing, the marketing operator released different styles of posters based on the production cycle of the film to stimulate audience interest. A number of hot-spot events were also launched, for example, the Polish Beijing mini-game during Beijing's sandstorm season and the short animation *Mom, You Are on My WeChat Moments* on Mother's Day, which successfully helped the film obtain a favorable response from the audiences.

Low trial and error cost

At present, many content producers opt for developing Internet-generated content (i.e., content proprietarily produced by video sites, user-provided content on video sites) as intellectual properties and fan bases can easily be built online for such content at a relatively low cost. When a certain degree of maturity for Internet-generated content, models and details, and a certain level of fan recognition and fan numbers are reached, producers will be able to comprehensively upgrade their content. For instance, they may start to launch a broad range of offline activities to promote their content. When a story and its characters are generally accepted, an adaptation into a TV drama or film will become feasible.

A good example is the Internet drama *Surprise*, which was adapted into a film by its producers two and a half years after its initial release online. The producers have a very strict content selection process: they maintain a dozen production teams who propose a set of ideas for content creation every couple of months. The company's internal evaluation panel then decide whether a demo should be shot. If so, the demo will be evaluated to determine whether it can be further developed into a series or a microfilm, and on that basis, the question of whether investment should be made will be decided. Basically, it would take at least half a year for a project to be initially determined before entering the next stage of script development. If Internet dramas fail, this entails relatively lower costs, prompting repeated trial and error practice among producers.

Internet dramas

The advent of the age of Internet-generated content

With increasingly lowered technological thresholds, the rapid rise of mobile Internet and changes in users' content needs, the Internet-generated content has gained unprecedented prosperity with an unstoppable momentum. In the

US, the popular culture represented by YouTube's video products has already become part of people's lives, presenting characteristics of commercialization and clusterization. In the list of the "top ten most influential teenagers in the U.S." provided by *Variety* in 2015, the most authoritative magazine in the entertainment industry, eight were YouTube celebrities or what are called "the Internet celebrities." In China, the video industry has also witnessed rapid development for more than a decade. The success of an array of Internet-generated content, such as *Old Boys*, *Diors Man*, and *Surprise*, sufficiently indicates that a new era of Internet-generated content has arrived. Internet-generated content such as online fictions and dramas has moved on from its earlier frippery and grassroots images and is increasingly becoming a part of mainstream culture. Internet-generated content has not only penetrated into traditional realms of TV and the big screens, but it has also been introduced to the entire world as effective cultural exports and received high popularity ratings in many mainstream evaluation platforms.

As noted above, the Internet drama *Diors Man*, the original online source for *Pancake Man*, has achieved cumulatively 4 billion views online since its launch, gaining great popularity among Internet users. The producers contributed to the theme selection, content selection, and style establishment, which can attract a huge number of fans on the Internet platform. According to statistical data, the present-day netizens are predominantly students, the self-employed and white-collar groups. In the context of social transition and unevenly allocated resources nowadays, they are plunged into a constant state of fatigue or uncertainty about their future. In the face of immense pressures arising from various aspects of society, such as problems of finance, family and individual development, they often feel a pressing need to escape from these daily pressures. *Diors Man*, in this regard, uses a self-mocking approach to endow characters with distinct personalities and meaning, giving rise to a variety of scenes where a down-to-earth "nobody" is placed in real-life scenarios where contradictions are eventually resolved through self-deprecating comedies. Such a mode of plot setting, as it turned out to be, successfully catered to the psychological needs of netizens, evoking an intense response and thus gaining a huge number of faithful viewers. In terms of narrative format, *Diors Man* adopts an approach similar to that of a short play, in combination with a non-linear narrative structure, interesting and diversified role play, cameo appearances of celebrities, making the film highly aligned with a fragmented viewing mode on new media platforms.

Internet dramas need to find an effective profit model

Presently, there are mainly three modes for playing online videos in China. The first mode is AVOD – advertising-based video on demand: users can watch a video clip for free after viewing an advertisement. The second mode is TVOD – transactional video on demand: for example, a user may spend 5 yuan to watch a new video and 2 yuan to view an old video. This mode has

been implemented in China for more than five years but with little success. Globally speaking, this mode is only successful in a few particular markets such as South Korea, hence it can be considered as having little influence. The third mode is SVOD, which refers to subscription video on demand: this is a proven successful business model in the European, American, and Japanese markets. The viewing mode in China's Internet platforms is also gradually shifting from AVOD to SVOD. Works centering on content itself, such as films and Internet dramas, are also moving in the direction of SVOD. For instance, entire episodes of *The Lost Tomb* were launched online on the very first day of its release. Users can either view all episodes if they are willing to subscribe to it monthly or watch one episode per week otherwise.

Over a long period of time, China's Internet videos have mainly relied on advertising to sustain their operations. Since 2015, however, mainstream video sites have started to experiment with the paid viewership model for their dramas, but with limited profitability. Besides, it takes time to foster users' habit to pay for content. Therefore, adapting Internet dramas into big-screen films is the most effective way to make a profit.

How to effectively operate Internet-generated content

Judgment of the adaptation value of Internet drama

When discussing the phenomenon of IP-based adaptation, Zhou Tiedong says that four conditions must be met for a cinematic story: (1) it must be "shootable," that is, it is possible to transform it into visual and auditory languages; (2) it must be "financeable," that is, there must be investors who are willing to put money into it; (3) it must be "marketable," that is, the story has enough selling points to attract distributors and viewers to cover the cost; and (4) it must be "appreciable," that is, theater chains are willing to arrange screenings and audiences show their appreciation. These four standards also apply when judging whether an Internet drama should be adapted to the big screen.

Additionally, it is also crucial to judge whether an Internet drama has "communicability." The notion of communicability is simple: it refers to the ability to maximize the appeal to users' attention in order to pursue the maximum amount of stream frequency, which is also a goal sought by many producers today, as well as a starting point for producers considering adapting an online drama into a film project.

On the basis of communicability, a piece of online content should also have user "stickiness," that is, to facilitate users establishing a certain degree of loyalty and expectations of the content, encouraging them to continue to watch the second or third episode after the first episode, or even the big-screen film. Self-produced online content experienced three development stages, beginning with the "microfilm" stage. Microfilm was a concept popular in China around 2011, such as *Old Boys*. Subsequently, a new form of film called "micro-drama" emerged, with representative works such as *Diors Man* and

Surprise. These are largely low-budget works mainly relying on a comedic style to win in the market. The concept of "self-made Internet drama" emerged in 2014, represented by works like *Fleet of Time* with the cost of a single episode exceeding 1 million yuan, but surpassing traditional TV dramas in terms of either production standards or cost.

As discussed earlier, self-made Internet content has gradually changed from modular content to serial content. At the microfilm stage, a sufficient level of user loyalty has not been established either toward the video platforms or toward the content itself; at the micro-drama stage, there might be a certain level of user loyalty toward platforms, but there was still a lack of ground to foster a sufficient degree of stickiness due to a loose connection between different episodes. It was not until the emergence of phenomenal self-made Internet dramas that user stickiness started to be reinforced as audiences began to feel an emotional attachment to dramatic characters, which contributes to a better condition for film adaptations from Internet dramas.

The art of adaptation

The process by which Internet dramas moved toward adapted big-screen works should be examined from three dimensions. The first dimension is the form. A good content product usually focuses on a certain form of medium expression, which can either be reality shows, interviews or talk shows. In fact, the audience often have an inherently intense curiosity and craving for some types of content. It is, therefore, necessary to establish the most easily acceptable form for users.

The second dimension is the story structure, encompassing characters, theme, story, genre and structure. When the "tonality" of the leading character in a story frequently changes, the content of such a story basically does not hold together, and it has little chance of success in the future. To make a successful adaptation of a story, first and foremost, one must facilitate the viewers recognizing and liking the characters in the story. A firm control of genres is equally important. After years of development, Hollywood has basically developed an effective set of classification method in terms of viewers' habit and preferences to arrange the first climax and the first low point at the right time in a film. The regularities of production should thus be observed in order to gain the emotional recognition of audiences. The last dimension is values, which includes aspirations for truth, goodness, beauty, emotion, courage and endeavor. A timeless content should be able to evoke an emotional resonance among the audience.

For instance, the following points were undertaken, when the Internet drama *Pancake Man* was adapted to the big screen. First, it abandoned the "short, adaptable and fast" meme-like drama mode. Instead of combining incoherent memes just for the sake of being funny, it has a complete, coherent storyline. Arguably, the film has its origin in an Internet drama but has eventually surpassed Internet dramas by all standards. Second, the film adopts

a "drama within a drama" onion-layer structure, with a "superhero" inner narrative layer that reasonably connects the self-mocking performances of all the celebrities in the story. The outer layer, on the other hand, mainly functions as a depiction of the struggling and drifting life of Da Peng in Beijing. Such a structure effectively realized the combination of the original Internet drama and its film adaptation. According to Cheng Peng, the director, the pre-production period of *Pancake Man* took two years, and the filmmakers of each part had to follow the production procedures and standards of films strictly while adapting the Internet drama, which is why the film has gained broad recognition from the audience and the market.

All-round development to build a "Hollywood model"

Generally speaking, the "Hollywood model" means a cross-medium, cross-channel business operation model. The concept of a standalone film industry does not exist in Hollywood, rather, films are a sub-branch of a bigger enter-tainment industry. Major Hollywood media groups concurrently operate multiple forms of medium products, including films, books, TV shows, and games. Thus, content in Hollywood is developed in an all-round manner and one content product can create profits from a variety of medium channels. For example, when the Hollywood blockbuster *Harry Potter*, a very popular cinematic work among Chinese audiences was released, an array of products under the same name, including books, games, audiovisual products and licensed toys, schoolbags, and stationery products were also launched on the market. Leveraging the popularity of the film, these products generated sub-stantial profits through diverse sales channels.

In contrast, the box office has been the main source of profits for the film industry in China and revenues coming from related business are negligible. This, naturally, is connected to China's political and economic institutions as well as the degree of development in various industries. Today, the emer-gence of the Internet has provided an opportunity for transitions to take place in the culture, entertainment and media industries. The Internet has improved the users' efficiency in obtaining video information, enabling them to acquire more diversified and higher quality content with lower costs in terms of space, time and money. Instead of imitating the development course of traditional industries which rely heavily on offline investments, the growth of the video industry should be completed through online derivations. For instance, video-adapted games, films and a combination with e-commerce have all emerged to strengthen the explosive growth of the entire industry.

China's game industry has been a rapidly growing industry that entails light investments. In 2015, the total market value of the game industry exceeded 140 billion yuan. However, the connection between the game industry and the film and video industries had been quite loose in the past. Today, with the advent of the Internet, such a connection has becoming increasingly close. For instance, the streaming platform of the TV drama *The Journey of*

Flowers, which was released in 2015, engaged in various forms of cooperation with developers and operators. However, the total royalty and online advertising fees generated by the TV drama were significantly less than the revenues from the game of the same name. Therefore, games are a fairly good kind of derivative for Internet-generated content. This represents a light investment that combines content, especially in a form that is popular among young consumers, with entertainment in order to generate more value.

Presently, the connection between videos and products is still in its explorative stage, compared with TV shopping, which is now quite mature. Nevertheless, this connection is the correct way to follow because such a combination has greater potential for growth in future and may give rise to more detailed business patterns.

Compared with the predominant offline business model developed by Hollywood over a century, a similar online model can be established thanks to the Internet. Undoubtedly, this will occur, not through simple imitations, but through innovations by taking the characteristics of the Internet into account. As such, it can be said that films adapted from Internet drama represent an effective way to learn from the Hollywood business model with a view to creating a "mega-entertainment industry" of our own in China.

12 The development of the Chinese animation industry in 2017

Hong Lu

Overview of the Chinese animation film market in 2017

In 2017, the total revenue from the box office of Chinese films totaled 52.6 billion yuan (excluding online ticketing fees), a year-on-year increase of 15.1 percent. The Chinese film box office totaled 28.3 billion yuan, accounting for 53.8 percent of the total box office. Some 92 films created a box office revenue of over 100 million yuan each, including 51 Chinese films, and 15 films generated box office revenue of more than 1 billion yuan, an increase of nearly 70 percent compared with 2016. A total of 1.62 billion movie tickets were sold in urban cinemas with a growth of 18.08 percent since 2016. The total number of cinema screens in China reached 50,776, surpassing that of America, making China rank first in the world. According to Figure 12.1, Chinese films' box office in 2015–2017 remained within a relatively stable range. Figure 12.2 shows that the growth rate of the Chinese box office dropped significantly in 2016 compared with that of 2015. However, in 2017, it rose successfully. Phenomenal films such as *Wolf Warrior 2* and *Never Say Die* have helped the box office to rise again, maintaining a steady upward trend from 2015 to 2017. Many insiders believe that Chinese film market is gradually returning to profitability.

In contrast to the considerable success of China's animation film market in 2016, the performance in 2017 was poor with 10 million animation film screenings and 140 million tickets sold. In 2016, there were 12 million screenings and 220 million tickets sold, showing a decrease of 19 percent and 36 percent respectively. In 2017, the total box office was 4.7 billion yuan, a 41 percent year-on-year decrease, the first decline in the past five years (Figure 12.3).

A total of 52 animation films were released in 2017, which is 13 less than in 2016. The total in 2017 includes 29 domestic animation films, which was 8 less than in 2016, and 21 imported animation films and 2 domestic co-productions, which decreased by 2 and 3 from 2016 respectively (Figure 12.4).

The number of Chinese animation films in 2017 was 8 less than in 2016, but the total box office was 1.296 billion yuan which is 3 million yuan higher than in 2016 (Figure 12.5). This shows that the decline in the total box office

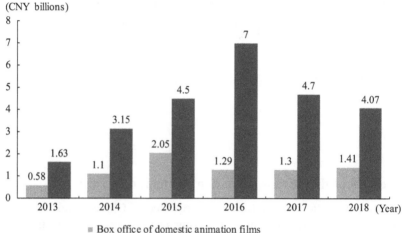

Figure 12.1 China's film market box office, 2013–2018.

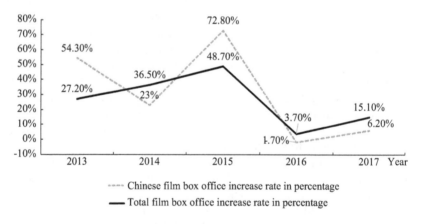

Figure 12.2 A comparison of the Chinese film market's increase rate, 2013–2017.

of animation films is reflected in imported film and co-productions, of which the box office totaled 3.365 billion yuan, a 2.425 billion yuan decrease from that of 5.80 billion yuan in 2016.

In 2017, the average box office of domestic animation films was 44.69 million yuan with 31 percent of the average of imported and co-produced animations (146 million yuan), which was almost the same as 32 percent in 2014. Although the figures were much lower than 45 percent in 2015, they were much higher

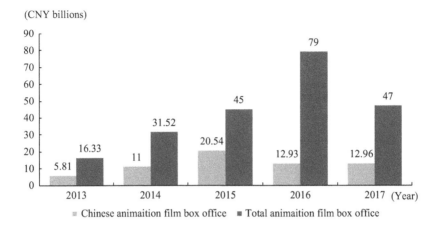

Figure 12.3 Chinese animation film box office, 2013–2017.

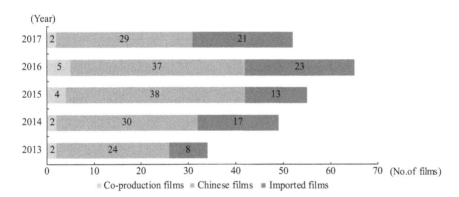

Figure 12.4 Types of animation films of China, 2013–2017.

than in 2016 which was only 17 percent. Three major reasons account for the box office performance of animation films in 2017 as detailed below.

One reason is that blockbusters, such as *Monkey King: Hero Is Back* (2015), that can create a cultural trend with social topics, were missing in 2017. Although "Three Giants": *Dahufa*, *Bigfish Begonia*, and *Monkey King* by Enlight Media did appear, the target audiences are mostly adults due to the "special" themes of the films. As a result, the audience pool will be relatively small, hence, it cannot form a nationwide viewing passion for films such as *Monkey King: Hero Is Back*.

The second reason is that Chinese animation films are facing strong competitors – a large number of imported films. Although the box office of

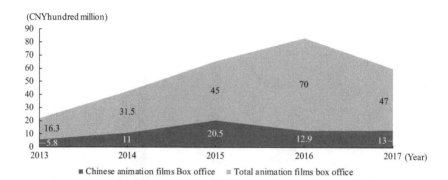

Figure 12.5 Trend of China's animation film box office, 2013–2017.

imported and co-produced animation films in 2017 has declined, the release date of *Coco*, the box office champion of animation films in 2017, was in late November 2017. In this chapter, the box office statistics cycle is based on the calendar year. *Coco* ranked top of the box office of animation films in 2017, reaching 1.1 billion yuan within a month. If *Coco* had been released in the first half of 2017, the figures would be similar to that of *Zootopia* which was released in March 2016. *Coco*'s box office could be higher than the box office of *Zootopia* which is 1.5 billion yuan. Chinese animation films do not compare well to Hollywood productions in terms of production quality and successful animation Internet Protocol (IP) projects.

The third reason is that the number of Chinese animation films has decreased without affecting its box office, which shows that, with policy support and industrial efforts, Chinese animation films have gradually gained an important position among Chinese audiences. A growing number of Chinese audiences now enjoy watching Chinese animation films in cinemas. Viewing habits have been changed by the tireless efforts of Chinese animators and investment companies over the years. Recognizing the audiences, in order to meet the growing demand of the public, Chinese animation filmmakers should continue to produce different types of excellent animation films for the different target audiences.

In 2017, the number of Chinese animation films recorded by the National Radio and Television Administration of China was 156, 26 fewer than in 2016, which was 182, but still higher than in 2015 (Figure 12.6).

According to the 2017 box office ranking for Chinese animation films, if a threshold of 100 million yuan in box office is set, ten films meet this record. The US and Japan are China's main competitors at the animation film box office. Of the top ten, the US accounts for five films, Japan accounts for one, and China, four (Table 12.1). In 2016, only two Chinese films were in the top ten for global animation films, while in 2015, there were three, and in 2014, there were four. Animation films are facing more and more pressure

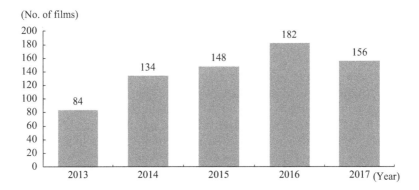

Figure 12.6 Chinese animation film record, 2013–2017.

Table 12.1 Animation films in China with box office over 100 million yuan

Ranking in animated film	Ranking in all films	Title	Box office (¥ 100 million)	Country of origin
1	11	*Coco*	11.53	USA
2	15	*Despicable Me 3*	10.38	USA
3	32	*Boonie Bears: Entangled Worlds*	5.22	China
4	60	*Sing*	2.16	USA
5	69	*Smurfs: The Lost Village*	1.74	USA
6	76	*Doraemon Nobitas Great Adventure in the Antarctic Kachi Kochi*	1.49	Japan
7	78	*Cars 3*	1.37	USA
8	80	*One Hundred Thousand Bad Jokes II*	1.34	China
9	81	*Backkom Bear: Agent 008*	1.26	China
10	92	*Seer Movie 6: Invincible Puni*	1.03	China

from the trend of diversification in other countries, and the types of imported films. With the acceptance of other imported films in addition to the US and Japan, the Chinese animation film market is likely to be further occupied by imported animation films. Although this has not yet happened, Chinese filmmakers must make long-term efforts to understand the need of audiences and produce animation films with new themes, in different genres and with high production quality.

While in 2016 there were two animation films in China's top ten box office, in 2017, no Chinese animation films ranked in the top ten. The animation box office champion *Coco* ranked 11th, and *Despicable Me 3*, which was hugely popular, ranked 15th. The author believes that such popularity was related to the phenomenal film *Wolf Warrior 2* in 2017. After *Wolf Warrior 2* was

released in late July, it created a strong competition in the market where animation films achieved great performance at the box office in summer 2017.

According to Entdata, 82 films were released during the traditional summer vacation from July 1 to August 31, 2017, with a total of 16.43 million screenings. *Wolf Warrior 2* ranked first at the box office (5.679 billion yuan) and in screenings (4.16 million times). For the number of screenings, *Wolf Warrior 2* accounted for one quarter of all 82 films. A total of 12 animation films were released, with a total of 3.14 million screenings, while *Wolf Warrior 2* had one million more screenings than all animation films in total. In 2016, 91 films were released in the summer, with 13.65 million screenings. *Time Raiders* ranked first at the box office (1.004 billion yuan) with the most screenings (1.03 million times) too. A total of 16 animation films were released with 3.23 million screenings. In 2016, the total box office champion, *Mermaid* by Stephen Chow, had 2.11 million screenings.

By comparing the figures, we can see that the scheduling and number of screenings have a great impact on a film's box office success. In 2015, the movie *Monkey King: Hero Is Back* was not circulated much on its opening. Due to outstanding word of mouth and market response, more screenings were arranged, and the release period was extended. Finally, the film generated over 900 million yuan box office revenue, which was a huge success. Of course, scheduling is only one of the factors impacting the box office sales. With its good reputation and consistent high quality, *Despicable Me 3*, which was scheduled during the same time as *Wolf Warrior 2*, received the second highest box office revenue among 82 films in the summer, which follows closely behind *Wolf Warrior 2*. From *Monkey King: Hero Is Back* to *Despicable Me 3*, the high quality of films is always the key factor to seize the market and increase their popularity with audiences.

At the beginning of 2017, the New Year movie *Bonnie Bears: Entangled Worlds* again broke the record with a box office of 522 million yuan, which showed that the series continued to be popular and it nearly doubled the box office of 288 million yuan compared to *Bonnie Bears: The Big Top Secret* in 2016. It moved in rank up from the 8th to the 3rd in the animation films' box office from 2016 to 2017 and replaced *Pleasant Goat and Big Big Wolf* as the new leader of the Chinese animation series. The latter has not released any new series for two consecutive years. *Dahufa*, one of the "Three Giants" (*Dahufa, Bigfish Begonia, Monkey King*) from Enlight Media, was released at the same time (in the summer of 2016) as *Bigfish Begonia*. However, because *Dahufa*'s adult theme is different from *Bigfish Begonia* and *Monkey King*, its less popular unique world-view and the degree of violence made it only suitable for a small public, and its final box office revenue was just 87.6 million yuan.

In 2017, there were 32 animation films with over 10 million yuan at the box office, including 14 Chinese animation films (Table 12.2), which is an increase of 6 from 2016. The box office is as follows: 1 animation film exceeding 500 million yuan (same as 2016); and 3 animation films exceeding 100 million

Table 12.2 Chinese animation films with over 10 million box office in 2017

No.	Title	Box office (¥ 10,000)
1	*Bonnie Bears: Entangled Worlds*	52248
2	*One Hundred Thousand Bad Jokes II*	13364
3	*Backkom Bear: Agent 008*	12636
4	*Seer Movie 6: Invincible Puni*	10329
5	*Dahufa*	8760
6	*Axel: Adventures of the Spacekids*	5041
7	*Dear Tutu: Food Rhapsody*	4298
8	*GG Bond series: Guarding*	4247
9	*T-Guardians*	4071
10	*Dragon Force Movie*	3169
11	*Tea Pets*	3040
12	*The Three Little Pigs 2*	2461
13	*Tofu*	1591
14	*My King My Father*	1570

yuan (an increase of 1 from 2016). Overall, Chinese animation films still achieved good results. Some 18 of 23 imported, and co-produced animation films exceeded 10 million yuan in box office, of which *Coco* and *Despicable Me 3* reached 1 billion yuan. It shows that the overall quality of Chinese animation films has improved, gaining an increase of the overall market box office and word of mouth popularity. However, the Chinese animation film industry does not have influential blockbusters. So far, *Monkey King: Hero Is Back* is the film with the highest box office revenue of 956 million yuan, which is still less than 1 billion yuan.

Compared with imported films, Chinese animation films are often released during the Spring Festival holiday season, Children's Day, summer vacation, and Chinese National Day Golden Week (Figure 12.7). However, the number of screenings, movie tickets sold, and box office revenue during these periods were not at the peak. On the contrary, sometimes these figures were low, which to some extent shows that the collective release of Chinese animation films will not be a key force leading the box office trend. What really made the monthly box office climb to the summit was the time when Hollywood's animation blockbusters were released, such as the July release of *Despicable Me 3* and the November release of *Coco* (Figure 12.8). In January, 8 Chinese animation films were released, as well as 1 imported film from the US, *Kubo and the Two Strings* ranking the first place in the annual screenings with a monthly box office of nearly 700 million yuan and ranking 3rd in the whole year box office. Although there were no animation films released in June 2017, in order to warm up the film market for the Children's Day, four Chinese and two imported animation films were already released on May 27th, 28th and 30th, which was close to June. However, this strategy did not have much

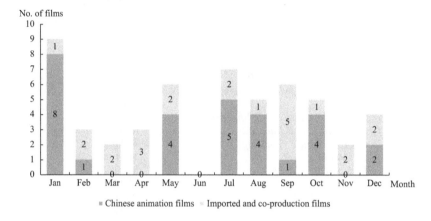

Figure 12.7 Number of animation films releases of 2017, by month.

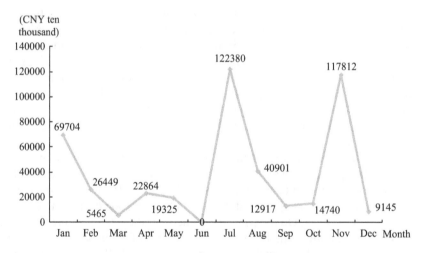

Figure 12.8 The trend of animation films' monthly box office of 2017.

influence on the box office. In the month of October, when Chinese National Day Golden Week starts, four domestic and one imported animation films were released. With four Chinese animation films released on October 1, the box office was still not satisfying. Therefore, better scheduling of screening in the holiday season for Chinese films cannot guarantee cinema admissions and box office. Even when the scheduling of the screening is favorable to Chinese animation films, they still face competition from live-action movies and the situation is not optimistic.

The industry characteristics of Chinese animation films in 2017

According to the data from 2013 to 2017, the trend of Chinese animation films is relatively stable and its box office is growing slightly, which is the promising result of the focus on quantity and quality by Chinese animation filmmakers.

The box office: steady increase and balanced development

Unlike the Chinese animation film structure in 2016, which was not a stable pyramid shape, the performance of Chinese animation films' box office in 2017 is more stable. First, the number of films with a box office of more than 100 million yuan and more than 10 million yuan are, respectively, two and six more than those in 2016, with the premise that the number of films shown in cinemas in 2017 was eight fewer than in 2016. In 2017, the box office rose from 10 million yuan to 500 million yuan with Chinese animation films distributing at almost every interval, but only a few Chinese animation films had a box office of more than 10 million yuan in 2016. Second, all four films with a box office of more than 100 million yuan are sequels, namely, *Bonnie Bears: Entangled Worlds*, *One Hundred Thousand Bad Jokes II*, *Backkom Bear: Agent 008* and *Seer Movie 6: Invincible Puni*, while in 2016, there was only one: *Bonnie Bears: The Big Top Secret*. It is an achievement that series films have been constantly improving for a long time. In addition to these 4 named 100 million yuan box office films, 10 of the other 25 Chinese animation films were also sequels. There are many popular intellectual property (IP) films occupying a certain market share, such as the *Dear Tutu* series *Food Rhapsody*, the *GG Bond* series *Guarding*, and the *Dragon Force* series *Dragon Force Movie*, etc.

 Bonnie Bears: Entangled Worlds inherited the attractions from the Bonnie Bears series and became the year's highest-grossing Chinese animation film, which made 522 million yuan at the box office. As a 500 million yuan box office film, *Bonnie Bears: Entangled Worlds* is still not a blockbuster compared to *Big Fish Begonia* which made 560 million yuan and became the top Chinese animation film in 2016. The author believes that an animation film blockbuster should have the following characteristics: (1) the film suits audiences of all ages; (2) its theme is relevant to social topics of the year; (3) it has originality and uniqueness; and (4) it shares a common value with most people. Obviously, *Bonnie Bears: Entangled Worlds* does not have the necessary characteristics of a blockbuster. However, *Coco*, released in November 2017, was a true blockbuster in this sense, because of its unique and splendid representation of the world, an emotional story, its suitability to audience of all ages and universally accepted values. Similar to *Zootopia* and *Monkey King: Hero Is Back*, the film *Big Fish Begonia* attracted great interest from investors and audiences by a short Flash video published eight years ago, and after several years' long wait. Based on the solid reputation of *Monkey*

King: Hero Is Back, when *Big Fish Begonia* finally released in 2016, its exquisite and delicate images as well as the familiar but unique representation of the world made it a blockbuster. But there are some deficiencies in its values, which led to the lack of emotionality in the characters, the unrealistic plot, and the lack of dramatic tension. These shortcomings made it second to *Monkey King: Hero Is Back* at the box office. In 2017, *Dahufa* possesses the last three characteristics: uniqueness and innovativeness, a world-view similar to that of audiences, and relevance to social topics of the year. Unfortunately, it expressed a realistic theme with exaggerated animation techniques and a rather violent and dark plot that went beyond most Chinese people's appreciation of animation films. Audiences who went to the cinemas seeking entertainment were disappointed or confused. Many audiences, especially many families with children, left the cinema in the middle of the screening. Animation films with this type of theme can only attract limited audiences. However, it does not mean that films of minority interest are not good. Some filmmakers want to produce their own products, rather than a product that most people are willing to watch. The Chinese animation film market still lacks films with adult themes. The author thinks that the audience's aesthetic habits are slowly developing. As animation filmmakers, despite the desire for self-expression or to guide audiences to develop an aesthetic habit, they should make more animation films for adults in order to gain the market. Animation films are not only for children, but also for adults. In this way, the Chinese animation film market would eventually progress.

The animation industry: a hotspot subdivision field of investment and financing

According to incomplete statistics from yulezibenlun (WeChat: yulezibenlun), in 2017, there were 110 financing events for animation projects, with a total amount of 4.053 billion yuan (excluding 12 non-disclosure amounts). Compared to the 128 events and the amount of 2.886 billion yuan in 2016, though the number of events decreased in 2017, the amount of financing increased by 40.44 percent. In addition, a single financing amount in 2017 was 41.36 million yuan, which was much higher than in 2016 (26 million yuan). The capital invested by Tencent, Alibaba Group, and Bilibili almost equals that of venture capital firms by percentage.

When the number of core ACGN (Animation/Comic/Game/Novel) users in China reached 82 million and the number of pan-ACGN users surpassed 250 million, the huge demand of the market and the lack of industrial supply made Internet giants and venture capital firms continue to invest in the animation industry in the future.

According to the data on the top 50 animation financing events of 2017, they have the following characteristics. First, as the two most favored segments of the animation industry, platform financed events accounted for 66.26 percent and content provider (CP) financed events accounted for 46 percent. The

financing stage of platform companies is mainly in series C and series D, while the financing stage of CP production companies is focused on early start-up funds, Angels Invest, and series A.

Second, the range distribution of financing of 1 million yuan levels and 10 million yuan levels accounted for 89.8 percent in total, while those of 100 million yuan and above accounted for 8.16 percent. Although this was a slight increase compared with 5.48 percent in 2016, the single financing amount is still less than that of heavily invested sectors, such as the video sector.

Third, from the perspective of rounds, angel investment (Angels Invest) accounted for 25.45 percent in 2017 which is lower compared to the 43.75 percent invested in 2016. At the same time, nearly half of financing events (48.18 percent) were centered in pre-A/A/A + rounds, higher than 36.72 percent in 2016. This shows that the financing rounds of animation industry have a significant backward trend. It means that some animation enterprises have been firmly established and even become the leading enterprises in the industry.

Fourth, Tencent, Alibaba and Bilibili are more like venture capitalists than traditional venture capitalists. They are keen on investing in the animation sector and form an industrial closed loop: Tencent directly participated in 11 financing activities for 10 companies in 2017, which is higher than in 2016. Tencent's overall arrangement in the animation field has exceeded most of the Chinese domestic companies for a few years, and few companies can compete with it. In the past two years, Tencent's investment in the animation field suddenly accelerated, widening the gap with the rest of its industrial competitors. The overall layout of the pan-entertainment field has taken shape. Alibaba entertainment has been able to compete with Tencent. Youku Tudou Inc. has increased its investment in the animation field in the past two years and has participated in the production of many animation films, such as *The Young Imperial Guard* and *Tea Pets*, and has continuously moved resources to content creation. In 2017, Bilibili invested in five animation companies, becoming a force not to be ignored in the primary market of the animation industry. From virtual idol to the ACGN community, from games to animation derivatives, the investment projects of Bilibili appear to be diversified and unconventional.

The animation sector continues to be the segment with the highest investment and financing frequency in the recreation primary market. Capital investment is still continuously entering the animation market and such strong financial support proves the sustainable development of the animation industry. On the one hand, it is a signal that the Chinese animation industry has the scale and potential for sustainable development in the next few years. On the other hand, people should not expect to solve all the problems by relying on the capital investment of the past two years. Whether it is to get government support or capital investment, the products still need to be tested in the market. From getting investment to releasing the final product (films,

television works or derivatives), the links, processes, departments and people involved need to be coordinated and managed scientifically. Without scientific management, even huge capital investment cannot produce positive final result.

The existing problems in the development of the Chinese animation industry are not new. Many experts have repeatedly mentioned them in their speeches, works and articles published in the past decade, such as inappropriate themes, lack of system rating, copyright infringement, too many sequels and lack of originality, unprofessional storytelling skills, and insufficient cinema scheduling, etc. It is not necessary to repeat the above problems and two new thoughts on these issues are shared as below.

First, the author believes that the reason for the unprofessional narrative structure is not about storytelling itself, nor plot setting, characters and their relationships, or cinematic pace control, but whether filmmakers clearly know what they want to express and what the core message of values a film tries to deliver. If they do not know, even for a film with a good theme, the story will not be able to achieve the expected impact among its audiences. The value of a film is like the foundation of a building: the whole building will crumble if its foundation is unstable. As mentioned above, the problem with the film *Big Fish Begonia* is that the views of the values of the characters conflict with the views of values of the audiences. The audiences do not self-identify with the characters. The demands, goals and ideals of the characters cannot be understood by the audience, hence there is no emotional resonance among the audiences. For example, recent popular American animation films such as *Zootopia*, the *Kung Fu Panda* series, *Moana*, the *Finding Nemo* series, *Sing*, *Coco*, and the *Despicable Me* series, all have very clear core values in their stories. They present values through the experiences and achievements of each character. These films are about how the characters realize their values through a series of events, and their relationship with other characters. Compared to live action films, the values of animation films are likely to be the same. However, they are often more positive, such as justice will prevail over evil, success belongs to those who persevere, being true to oneself, being courageous, having self-confidence and self-reliance, and willingness to help others, etc. If a filmmaker wants to be different, he/she needs to work hard and render the real world in an abstract animation format, for example, the role of the animal world in *Zootopia*, and the world of death in *Coco*. The values of a film are the soul of a work and the key to stimulate the audiences' emotional response.

Second, as mentioned above, it is a long and arduous journey to go from securing capital investment to the actual implementation of the project, and the final product release in the market. In this process, it is the production management team that leads the creative team to complete the project step by step with confidence, goals and plans. A good production management team can make a low-cost film a success, while a poor production management team can make a very expensive film a failure. An excellent

production management team must have the following qualities: (1) they can understand the process and rules of animation production; (2) a team has specialists to formulate technical solutions and provide corresponding cost budgets for the creative team and its investors; and (3) the team should have rich experience in financial management, legal management, and production management, and be able to review the situation, and coordinate between the creative team and its investors. If the Chinese animation film industry wants to make continuous and rapid development, it is equally urgent and crucial to educate animation production management talents as well as creative animation talents.

13 A case study of *Crazy Rich Asians*

The evolution and development of Asian Hollywood films

Yestin Deng

Crazy Rich Asians was the North American Weekend Box Office Champion (US$34 million) in the first week after its release on August 15, 2018. It was the North American Weekend Box Office champion in the following three weeks in a row. The global box office exceeded US$238 million (China released it on November 30, the box office was only 11.49 million yuan), *Crazy Rich Asians* has made the highest box office record of romantic comedy in North America of the past ten years.

Crazy Rich Asians was produced by Warner Bros., directed by Jon M. Chu, with an Asian star cast, Constance Wu, Michelle Yeoh, Henry Golding, and Lisa Lu. The story was adapted from one of the best-selling novels, *Crazy Rich Asians*, written by Kevin Kwan, an American-Singapore writer. The movie has won both remarkable box office and high acclaim, receiving 93 percent positive rating on Rotten Tomatoes (a famous American film review website), and was also praised by the Western media. This was a "politically correct" film telling a story of ethnic minorities, changing Hollywood's long-standing prejudice against Asian filmmakers.

The production process of *Crazy Rich Asians*

Kevin Kwan's novel *Crazy Rich Asians* was published in 2013 and was a great success. It has been translated into more than 20 languages, and more than one million copies were distributed worldwide.

Because of the popularity of the novel and the rapid development of the Chinese film industry, Hollywood decided to adapt this novel to the big screen. Kevin Kwan chose the famous producers of the *Hunger Games* series, Jacobson and Simpson. He only requested a US$1 adaptation fee, providing that he could be involved in the decision-making process of the film production. The two producers then invited John Penotti, the president and producer of SKGlobal Entertainment, to join the production team. John's company has offices in Singapore, Hong Kong and China, so shooting in Singapore and Malaysia was much easier.

In 2016, after the screenplay draft of *Crazy Rich Asians* was finished, the Hollywood director of Chinese origin, Jon Chu, received the adapted

screenplay on the same day he had just finished reading the novel. After Jon Chu officially joined the *Crazy Rich Asians* production team, in order to incorporate more cultural characteristics and more emotions into the screenplay, he invited the Malaysian-born TV screenwriter Adele Lim to be one of the screenwriters.

After the screenplay and the director were chosen, the next step was casting. Jon Chu released an online video to recruit English-speaking Asian actors worldwide. Constance Wu (who was born in Virginia, of Taiwanese origin) was the best candidate and she was confident to play this role. In fact, Rachel Chu was the role she had long been expecting to play. To match her schedule, the crew delayed the shooting time by five months. Another important female role in the film was Rachel Chu's mother-in-law, Singaporean rich lady Eleanor. Michelle Yeoh, a well-known Asian actress in Hollywood, became the best choice. The third important role was the rich man, Nick Young (Eleanor's son, Rachel Chu's boyfriend). Yang Nick was born in a rich and famous family and grew up in London. He is handsome, kind and sincere, with London accent. It was not easy to find such an actor. The accountant at the SK Global Entertainment Malaysia Office suggested a man. A few years ago, when he watched a travel show on BBC and the Asia Discovery Channel, he was impressed by the handsome Asian host with a strong British accent. The host was Henry Golding. He was born in the United Kingdom, his mother is Malaysian Chinese, and his father is English. When he flew to Los Angeles for the audition, Jon Chu and Warner executives unanimously said: "He is Nick Young!" After the main characters were determined, the casting team then tried to select the other 76 characters with lines in the film, who are all Asian actors. After the film was released, the audience saw many familiar actors who had appeared in Hollywood films and television programs, like Lisa Lu, Korean actor Ken Jeong (who used to be a doctor, then a comedy actress), British-Chinese actress Gemma Chan, Chinese-Korean rapper and actress Awkwafina, Nora Lum, talk show Chinese actor Jimmy O. Yang. Other actors came from countries such as Australia, Singapore, Malaysia, Thailand, Indonesia, Costa Rica, etc. The director Jon Chu admitted in an interview with *The New York Times* that he was concerned about the box office. If the box office performance is good, the Asian group would have more opportunities, if not, everything would be gone.

Jon Chu also incorporated his thoughts on this film when he chose the theme song. He decided to use Coldplay's *Yellow* (Warner Bros.) but the band disagreed as the color yellow is often used to vilify Asians. Jon Chu wrote a letter to the band Coldplay, explaining why he wanted to use this song. He himself had suffered insults being called "Yellow" in elementary school. Then he heard the song *Yellow*, in which the color yellow was seen as "the most beautiful color," and he felt that the word had been redefined. He said: "I want to adapt the British pop songs into Chinese culture, so that people can feel the feeling of being Chinese-American who are shaped by mixed 'identity' and 'cultural features.'"

In April 2017, *Crazy Rich Asians* began an eight-week intense shooting in Kuala Lumpur, Malaysia, and then moved to Singapore where production costs were higher for the next three weeks. A low production budget (US$30 million) had been carefully calculated.

On August 15, 2018, *Crazy Rich Asians* was released in North America as scheduled, and caught the attention of the public and the media overnight as a great success.

Five key factors in the success of *Crazy Rich Asians*

There are five main reasons why *Crazy Rich Asians* was popular in North America:

1. Narrative structure and operational mechanism under the Hollywood model.
2. New faces, new images.
3. Asian society's social status and identity.
4. The economic rise of Asia and the success stories of Asian filmmakers.
5. It shows off the wealth.

Narrative structure and operational mechanism under the Hollywood model

Since it was produced by Warner Bros., a major Hollywood studio, *Crazy Rich Asians* is a Hollywood film in nature. As mentioned above, *Crazy Rich Asians* is adapted from Kevin Kwan's best-selling novel, which means this is also an intellectual property (IP) movie. *Crazy Rich Asians* not only looked back at the changes of the past decades in terms of the social environment and status of Asian or Chinese people in North America, but also reflected the socio-economic conditions of the new generation of Asian or Chinese people. This is the main reason for widespread discussion. The director Jon Chu once said that, as a Chinese person living in the United States, when he returned to Asia for the first time, he found a completely different culture, and he was torn in two, but he also found a brand-new side there, and he hopes to show off the things he has experienced in the movie.

The conflict between Rachel and Eleanor in the film was both cultural and conceptual, as well as geographical and environmental. These conflicts are not alien to Asians, they have universal significance. Michelle Yeoh, who played Eleanor, thinks that the film "will make everyone feel the same." She said:

> Eleanor's concern is not because of the social and economic gap between the son and his future wife, but Rachel does not know what to do in a traditional Eastern family. She hopes that Rachel can do the same as herself: a supportive woman behind her successful husband, but Rachel was obviously not ready for it.
>
> (Huang An, 2018)

The Young family believes that Rachel's family has no wealth or social reputation, and she herself is a typical "banana girl," that is, "yellow skin with white soul, e.g. American-born Chinese." The traditional standard for Chinese marriage is to be "equally matched," that is, to look for people with similar economic, ethnic, linguistic and educational backgrounds in marriage. The cultural tradition of "the priority of family" considers the marital relationship to come second to the family's interests and needs. Women like Rachel, who pursue their own happiness and dreams, are completely different from the Young family. The characters in the film demonstrated that there is a cultural gap of values between traditional Chinese in the East and modern Chinese in the West.

The discussion of traditional family, marriage, love and friendship in the film also resonated among the audiences. This is the unchanging theme in the Hollywood romantic love comedy.

New faces, new images

The film chose Singapore as the main setting, which subverts the western stereotype of Asians. After entering the new millennium, Chinese people impressed the world with China's continuous significant economic growth. The Chinese national identity as an economically powerful nation is also represented in Hollywood movies, with Chinese people collectively associated with such an image. In the film *2012*, the world's last refuge was in China. In *Gravity*, China's International Space Station became the last refuge for Sandra Bullock. In *Pacific Rim: Uprising*, Jing Tian owns the largest arms company, and American audiences could see the strength of the Chinese economy. In *Wall Street: Money Never Sleeps*, there is a character played by Zhang Xin (the wife of Chinese real estate dealer Pan Shiyi) as a powerful Chinese businesswoman in the film.

Asian society's social status and identity

In addition to the high box office, *Crazy Rich Asians* projects positive images for both Asian filmmakers and Asians living in North America. The release of the movie raised discussions on these issues in the United States. Chinese journalist Kimberly Yam, born in New York, USA, wrote six articles in the Huffington Post on *Crazy Rich Asians* between August 1 and August 16. Over the years, the deviation and entanglement of Asian identity have become common pains for immigrants and their descendants. Kimberly concluded:

> Finally, at the age of 25, I watched a Hollywood movie with almost full Asian cast. For some reason I could not help crying, for it was the first time I saw a movie with such cast, and everyone is excellent, I'm proud to be a Chinese.
>
> (Tong Li, 2018)

A Chinese mother watched the film with her child, she said in an interview:

> The Asian faces on the screen are a breakthrough for overseas Asians. What is more important to me and my child is that these Asian actors are so sunny, humorous, confident, fashionable, and modern, they play favorable characters, we can't help but cheering for them.

She hopes that her child could fall in love with Asian and Chinese culture, and be proud of being Asian, whether living in China or in the United States.

After the great success of the *Crazy Rich Asians*, the responses from American-Chinese and Chinese students studying in the United States are not the same. One Chinese student said online:

> All ABCs (America-born Chinese) around me are applauding, while my Chinese friends think this movie is just average. It is like eating General Tsos Chicken in a Chinese restaurant in the United States, foreign students can't get the point what's so special to the Chinese students. Without the experience of living in North America and being influenced by its mainstream culture, it may be difficult for international students to understand why this film has made Asian American see the future of Asian American films. Therefore, it is not difficult to understand that *Crazy Rich Asians* encounters Waterloo at the box office in mainland China. Asians outside North America have not experienced the identity crisis of Asian-Americans or Chinese Americans (including Asian-American filmmakers) in North America.

The economic rise of Asia and the success stories of Asian filmmakers

Since the 1960s, Hong Kong, Taiwan, Singapore and South Korea have achieved great economic growth in a short period of time, becoming successful well-developed regions in Asia. In 1998, the financial crisis hit most Asian countries and regions, and many countries suffered recession. But the four economies in East Asia and Southeast Asia went through the crisis safely and became typical examples of development economics. In the 1990s, Thailand, Malaysia, the Philippines and Indonesia became emerging countries in Asia, known as the "Tiger Cub Economics." At the same time, China fully entered the period of Reform and Opening-up. China has now become the world's second largest economy. In the 1980s and the 1990s, more and more films from the Chinese Mainland, Hong Kong and Taiwan gained success at major international film festivals. A number of well-known directors emerged through international film festival circuits, such as Edward Yang, Hou Hsiao-hsien, Karwai Wong, Stanley Kwan, Zhang Yimou, Chen Kaige and Jia Zhangke, etc. Six major Hollywood studios have set up branch offices in China, and more and more co-production films between China and Hollywood have appeared. *The Last Emperor* (Bernardo Bertolucci, 1987) won nine Academy Awards.

In the same year, *Empire of the Sun* (Steven Spielberg, 1987) also won the Academy Awards for Best Cinematography and Best Original Music Score.

Hollywood and American audiences got to know Chinese films mainly through Bruce Lee, Jet Li and Jackie Chan's martial arts films. The martial arts genre did make a significant contribution to the promotion of Asian films in the early days, but Asian or Chinese films have never successfully blended into the mainstream of Hollywood.

Hollywood represents a matured film business in many ways. Asian filmmakers have been constantly working hard in Hollywood, and waiting for their opportunities.

Show off the wealth

Wealth-X's *Billionaire Census 2018* shows that Asia is now the region with the biggest increase in the number of billionaires (in US$) in the world, surpassing North America. In 2017, Asia's billionaire population increased by nearly one-third, accounting for 29.2 percent, and the number of rich people was 784, surpassing North America's year-over-year growth rate of 11.2 percent. The numbers illustrate the speed of Asians becoming rich. *Crazy Rich Asians* was made at the right time, which catered to the expectations of Asian audiences and satisfied the general audiences' "peeping tom" mentality to view the lives of legendary super-rich Asians. In recent years, as the numbers of Chinese investment immigrants moving to the United States and Canada have increased, shocking stories of wealthy Chinese people have been reported in newspapers and social media. Young students and tourists from China have become the major consumers of luxury goods in oversea markets. They purchase all kinds of luxuries, making Asians in the eyes of Westerners "rich and wealthy." In the film, the scene in which the rich lady (played by Michelle Yeoh) throws money in the receptionist's face in London impressed audiences. In addition to the fascinating scenery of Singapore and Malaysia, the film also shows the luxury life-style of the local rich: thermostatic wardrobes, villas in the forest, luxury cars at the airport, yachts on the top floor, numerous pieces of jewelry, and luxury items ... which go even beyond the audiences' imagination. When the luxurious yet romantic wedding scene appears in the film, "Oh My God" could be heard in the theaters. In *Crazy Rich Asians*, there are many private-ordered luxury products shown. The costume was designed by Hollywood's famous designer Mary E Vogt. She was the costume designer of the movie *Black Man* trilogy, and the creator of the cat woman image in the classic *Batman Returns* in 1997. In *Crazy Rich Asians*, she invited a large number of Asian designers in order to guarantee the classy design and tailoring quality for each character. For example, Rachel Chu starts by wearing the popular brand Ralph Lauren and the Italian brands Missoni and MiuMiu, and then she changes to wear the Marchesa wedding dress from New York as the bride. Nick Young's costumes are from the designer of the Royal Malaysian suits. Goh Peik Lin and her family's daily

dresses are Versace with big logos. The map handbag she shows to Rachel Chu is also specially designed for the film. In this sense it might also be safe to say *Crazy Rich Asians* is a fashion blockbuster.

From 2013 to 2017, Kevin Kwan's Rich Trilogy: *Crazy Rich Asians, China's Rich Girl*, and *The Rich People's Worries* were published and become bestsellers. Many readers believe that the novels are a faithful portrayal of the Kwan family, which is true. His family is not only one of Singapore's top three richest families, but his great-grandfather is one of the founders of Singapore's oldest OCBC Bank. This background has increased the audiences' expectation for the film *Crazy Rich Asians*. In the film, the characters seem to be more elegant, enjoying fashion, beauty and travel bloggers, luxury bags, limited edition shoes, high-profile dresses, luxury cars, houses and yachts, and private jets, etc. All of these are ideologically and visually iconic for the audiences to perceive and experience the madness of the rich Asians.

References

Huang An (2018). Available at: http://ent.people.com.cn/nl/2018/1204/c1012-30441487.html.

Tong Li (2018). Available at: https://m.guancha.cn/international/2018_08_22_469210_s.shtml.

14 Priest and director Alex Kendrick

The "manual workshop" and film industrialization

Linli Yu

Alex Kendrick is a pastor in Georgia. Since 2003, the plain pastor has constantly surprised the mainstream film market in the United States. He not only made gospel films with a small investment, achieved a box office miracle with a return rate of 102 times, but also has been a director, actor, screenwriter, film editor, film photographer, and even composer in the films' production. If the development of film industrialization makes all departments and links related to film tend to be independent subsidiary industries, then the "manual workshop" makes the industrialized and separate independent departments return to a unified and simple production mode. This mode of production brings unique aesthetic effects and industrial characteristics to the gospel film, which is a return to unity.

A "manual workshop" is a handicraft production unit in the feudal society of the Middle Ages. It takes manual labor as its main source. Generally, it does not employ workers, and there was no wage for helpers or apprentices, but only a small wage for subsistence. That is to say, a "manual workshop" has two factors: one is manual labor, the other is non-payment and non-employment. The term "mode of production" does not seem to have a substantial connection with the film industry. However, when we remove the form of manual labor, we find that the "manual workshop" is essentially a non-employment mode of production, behind which is non-profit or low profit self-sufficiency. In Alex Kendrick's gospel films, he and his brothers Harry Kendrick and Stephen Kendrick jointly undertook the work of directing, producing, writing, editing, photographing and even composing music for the films. Most of the actors were unpaid, and they did not view commercial success as the primary objective of the film. This kind of modern "manual workshop" mode of production has left behind the historical background of the feudal era. Although it is not in the lexicon of modern filmmaking, it can never stay out of the film business, which gives the gospel film dual attributes in the process of production.

Actors and composers: the "manual workshop" and professional commercialization

Films did not need professional actors, editors or even screenwriters at cinema's very beginning, just simply recording the content. This manual production method formed the original ecological workshop style of the film industry, without too much division of labor and refinement, and no industrialization. This kind of characteristic gave film double identities from the beginning. On the one hand, film had the function of non-practical, self-sufficiency expression, on the other, it had the beginnings of a commercial operation. With the development of the film industry, this form of "manual workshop" has been constantly challenged, and professional directors, actors, screenwriters, and cinematographers, etc. appeared. Commercial interests as a mode of operation stepped into the film business. Especially in the stage of film industrialization, the commercial interests and market returns became not only the important contents to be evaluated before film production, but also were the important index to evaluate the film's value after a film's release. When commercial operation started to take the key role in the film industrial chain, the non-practical self-sufficiency expression function became less important and even was sucked into being an element of commercial operation.

Film actors as business labels and as ordinary professionals

Charlie Chaplin was known as one of the five richest actors in the film industry back in his time in the 1920s. According to media reports, Chaplin made US$10,000 a week in 1916, equivalent to the current US$219,000. This considerable income amount did change the artist's lifestyle, he did not really live like his role in *Modern Times*. This historical anecdote indicates that Hollywood actors have become one of the biggest beneficiaries, besides film studios, in the process of the industrialization of the film industry, and the rapid growth of this kind of interest made actors directly develop into "stars". In 2018, *Avengers 3: Infinity War* ranked number one in the global box office. And its star, Robert Downey Jr. is a typical "second generation of stars" with countless fans. His father, Robert Downey, is one of an older generation of film and television stars in the United States. In a film with a total investment of about US$500 million, Robert Downey Jr.'s salary will be US$100 million. From the beginning of the *Iron Man* series, Robert Downey Jr. became a box office miracle. In *Iron Man*, his salary was US$500,000, with a global box office of US$5.85 million. In *Iron Man 2*, his salary was US$10 million, with a global box office of US$620 million. In *Iron Man 3*, his salary was US$50 million, with a global box office of US$1.22 billion. By the time of *The Avengers*, his salary was more than US$80 million, and the global box office totaled US$1.5 billion. In ten years, Robert Downey Jr.'s salary has increased nearly 200 times, and the global box office of his films have also increased several times, which is really amazing (see Table 14.1).

Table 14.1 Top 10 global box office in 2018 (US$100 million)

Title	Distributor	Domestic box office	(%)	Foreign box office	(%)	Global box office
Avengers: Infinity War	Buena Vista Pictures Distribution	6.8	33.2	13.7	66.8	20.5
Black Panther	Buena Vista Pictures Distribution	7.0	52.0	6.5	48.0	13.5
Jurassic World: Fallen Kingdom	Universal Pictures	4.2	31.9	8.9	68.1	13.0
The Incredibles 2	Buena Vista Pictures Distribution	6.1	49.0	6.3	51.0	12.4
Venom	Columbia Pictures	2.1	25.0	6.4	75.0	8.5
Mission: Impossible - Fallout	Paramount Pictures, Inc	2.2	27.8	5.7	72.2	7.9
Deadpool 2	20th Century Fox Film Corporation	3.2	43.4	4.2	56.6	7.3
Ant-Man and the Wasp	Buena Vista Pictures Distribution	2.2	34.8	4.1	65.2	6.2
Bohemian Rhapsody	20th Century Fox Film Corporation	1.8	29.3	4.2	70.7	6.0
Ready Player One	Warner Bros. Entertainment, Inc.	1.4	23.5	4.5	76.5	5.8

Source: Box office mojo (www.boxofficemojo.com/).

The nature of stardom is the commercialization of an actor's identity. Acting as a profession has developed into a subsidiary part of the film industry chain to maximize its interests in the film industry. In this sense, actors have now huge commercial value. This kind of value tag not only makes the actor's value professional and market-oriented, but also promotes the industrialization of the film industry. Many audiences are attracted to the cinema by some "idols," which becomes an important factor in realizing the value of the film industry.

When we turn our attention to the gospel films directed by Alex Kendrick, certain differences are obvious. Maybe it is because he has been a pastor, and has suffered huge difficulties, even misery, in his past. Or maybe he focused on the doctrine of God's words when he was a pastor. Alex Kendrick seldom played the role of church pastor in his films. He played a role in the comedy *Moms' Night Out* in 2011 as a stiff-faced, lifeless pastor. Besides this, most of

his other roles are ordinary people with different careers. The salesman in the first film *Flywheel* in 2003 was Alex Kendrick's first performance as an actor, in which he appeared to be dull and inflexible. In 2006, the movie *Facing the Giants* was a box office miracle. Alex Kendrick's role was a rugby coach, which did not bring him much success in his acting career. Maybe Alex Kendrick is not very satisfied with himself as an actor. In 2008, he did not appear as an actor in *Fireproof*. In 2011, however, in the film *Courageous*, Alex Kendrick delivered a remarkable performance by fully impersonating the character. His role as a policeman is associated with his father's identity. Hence, he was able to fully and profoundly show the father's emotion when he lost his daughter in the film. Especially at the end of the film, his speech on behalf of his father made many audiences cry. In *War Room* in 2015, Alex Kendrick grew a beard and looked like a businessman. Watching his work, we can see not only the development of the realistic theme of the gospel films, but also the maturity of a pastor's acting career, as the Bible states, "So we are not afraid. Although the outer body is destroyed, the inner body is like a new day."

In addition to Alex Kendrick, in these gospel films, at different times, the same actors often appear in different movies. For example, the black fire officer in *Fireproof* plays the role of a policeman in *Courageous*. The husband in *Mom's Night Out* plays the father of a Jewish family in *Courageous*, and so on. Perhaps limited by the theme of the gospel films, many actors are believers, members of the church, and most of the actors indeed play themselves without any payment. That is to say, in Alex Kendrick's films, actors have no commercial value tag. This kind of performance with non-commercial interests is like the apprentice in the "manual workshop." Everyone comes together because of the common faith and dedicates the work to God to complete God's mission. At this time, the production mode of the company's operation is based on family cooperation, greatly reducing the investment costs of a gospel film. But at the same time, the production mode of the actor's dedication is weak in market development, especially for the overseas market, and the actor agency company is much better at promotion of films.

Music: pop songs and hymns

Music has the power to directly touch people's soul. And music melodies are immersive and very often touch audiences emotionally. Film scores add a strong and powerful impact to cinematic images. The famous Oscar-winning song "Auld Lang Syne" is a typical example. The song was originally a poem by Scottish poet Robert Burns that praises sincere and lasting friendship. In 1940, the Hollywood movie *Waterloo Bridge* used this song as its theme song. Today, nearly a century later, though that movie might have been forgotten by many people, this song has spread all over the world, affecting generations of people. In addition to "Auld Lang Syne," there are many songs which make music and composition an important chain in the process of movie industrialization and bring great value. The theme song, "My Heart Will Go On," for

the movie *Titanic*, won the Best Original Song award at the 70th Academy Awards and the 55th Golden Globe Awards. It has achieved global commercial success, with music sales of more than ten million. The single was number one in the music charts of 18 countries, including the United States, the United Kingdom, Canada, Germany, France, Denmark, and Belgium.

Even in *Titanic*, a blockbuster produced by 20th Century Fox, there are elements of Christian music. When the ship is sinking, the violinists play two pieces of music with Christian themes: one is "Nearer My God to Thee," the other is pastor H. F. Lyle's "Abide with Me." The great commercial success of *Titanic* is related to the perfect use of music. But when we appreciate the episode in the film *Facing the Giants*, with music composed by Alex Kendrick, it brings different emotional feelings. The main melody of the whole movie is slow, in which four hymns are interspersed, and it does not form a unified overall style. Especially in the most important final scene of the football match, the 20-minute screen images accompanied by the theme music are indistinct and even noisy. The use of music plays a key role in the film. If one considers only the use of music, even the non-professional audience can be touched by the unprofessional use of music by Alex Kendrick. However, this film, despite having such a problem. has made a 102 times box office return, which has to be recognized as a "miracle." In Alex's view, music is made to worship God, just as in the movie *Praise God for Victory* and *Praise God for Failure*. It is this kind of hearty worship that takes the film to another level: the sincere joy of believing in new life and infinite admiration for the great power of God.

Stars and the film score are only two of the important business factors in the film industry chain. The expanding industry chain absorbs more factors and gradually realizes the maximum value. The "manual workshop" mode of production of a gospel film is different from the professional commercial mode of Hollywood mainstream filmmaking, as it demonstrates the director is the principal creative decision-maker. Today's film directors are more like art product merchants, or even entrepreneurs in the operation of art products. No matter from the aspects of investment, cost control, financial management, market management, risk aversion or team operation, the directors' identity has a new connotation of a financing operation. This new connotation is not only the result of industrialization, but also the further promotion of industrialization.

The gospel films show that Alex Kendrick is more of a pastor, who values the salvation of the soul and to preach the value of the gospel: "the power of continuous prayer in suffering, the guidance of the cross in loss, the glimmer of hope in destruction, the sincere praise and reverence in winning."

The operation of production companies and the film festival: the gospel film in industrialization

In every film directed by Alex Kendrick, the logo and credits of Sherwood Pictures are the last to appear in all cast lists of production companies. The

signs of the cross and the elliptical arc are like the sky and horizon. The name of Sherwood Pictures and the logo come from the Baptist Church in Sherwood, Georgia. The publicity image of the church inadvertently opened the door to the industrialization of the gospel films.

Sherwood Pictures and the six production companies

In 2003, deputy pastor Alex Kendrick was in charge of the Baptist media in Sherwood, Georgia. He set up Sherwood Pictures with US$20,000. That year, the gospel films began to change the pattern of the film market in North America and even the world. When Sherwood Pictures was born, North American films were controlled by a number of major studios, such as 20th Century Fox, Warner Bros., Universal, Buena Vista (Disney), Paramount, and Sony. Each production company has an operational organization and chain ranging from actors' agencies, film studios to distribution companies. They keep the film industry and global audiences firmly under the control of their own networks. As Figure 14.1 shows, the global market share of the six major film companies accounted for 69 percent in 2003. Among them, Buena Vista (Disney Company) has the largest market share, reaching 16.2 percent, and Sony company ranks second with 13 percent market share. Three years later, Sony Pictures Entertainment Company's global sales volume reached US$10 billion in 2006, accounting for 18.6 percent of the global market, becoming the world's largest film company.

Although the gospel films directed by Alex Kendrick have some characteristics of an independent film, in terms of production mode and capital operation, they are not completely independent films. On the one hand, the copyrights of the gospel films produced by Sherwood Pictures do not belong to the director. On the other hand, they are a co-production

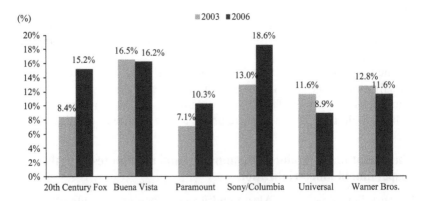

Figure 14.1 Global market share of the six major film companies in 2003 and 2006.

Table 14.2 Ranking of return on investment of gospel films with realistic themes in North America (US$10,000)

Movie title	Director	Investment amount	Global box office	Return on investment (%)	Distributor
Facing the Giants	Alex Kendrick	10	1024.3	102.43	Sherwood Pictures
Fireproof	Alex Kendrick	50	3345.6	66.9	Columbia Pictures
God's Not Dead	Harold Cronk	200	6466.8	32.33	Pure Flix Entertainment
War Room	Alex Kendrick	300	6779.0	22.60	Columbia Pictures
The Passion of the Christ	Mel Gibson	3000	61190.0	20.40	20th Century Fox Home Entertainment
Brave	Alex Kendrick	200	3452.2	17.26	Columbia Pictures
I Can Only Imagine	The Erwin Brothers	700	8348.2	11.93	Roadside Attractions
Heaven Is for Real	Randall Wallace	1200	10133.3	8.44	Sony Pictures Entertainment
To Save a Life	Brian Baugh	50	382.3	7.65	Sherwood Pictures
Miracles from Heaven	Patricia Riggen	1300	7388.3	5.68	Columbia Pictures

Source: Box office mojo: www.boxofficemojo.com/.

with Sony Company. In 2006, Sherwood Pictures released the film *Facing the Giants*. Its co-production companies include not only independent film companies (destination films and Samuel Goldwyn films), but also companies whose main content is Christian belief (Provident Films). Therefore, the original intention of Sherwood Pictures' films does not seem to be to explore the global market.

Co-production is the method of film production and distribution adopted by many film companies. On the one hand, it can partially reduce and solve the investment pressure, and the burden of human and material resources for film production. On the other hand, it can share in the division of the global economic interest chain in the global market. The co-production with Sony Company not only provides Sherwood Pictures a huge distribution market space, but also becomes the unique gospel label of Sony Company among the six major film companies. Compared with other companies, Sony has a higher share in the distribution of Christian films, and it has also reaped considerable benefits. In Table 14.2, we can see that of the top ten Christian films with the highest return on investment (ROI), Sony's films accounted for half of the total. As time goes by, Sony's distribution characteristics have

Table 14.3 Top 10 world famous international film festivals

Name of the film festival	When established	Dates of operation	The highest award
Cannes International Film Festival	1939	May 10–21	The Golden Palm Award
Berlin International Film Festival	1951	February 7–18	Golden Bear Award
Venice International Film Festival	1932	August 30–September 9	Golden Lion Award
San Sebastian International Film Festival	1953	September 21–30	Golden Shell Award
Tokyo International Film Festival	1985	October 28–November 5	Golden Unicorn Award
Moscow International Film Festival	1959	July 16–29	Golden St. George Award
Karlovy Vary International Film Festival	1946	July 5–15	Crystal Globe Award
Cairo International Film Festival	1976	November 7–18	Pyramid Award
Shanghai International Film Festival	1993	Early June	Golden Goblet Awards
Montreal World Film Festival	1977	August 25–September 4	The American Awards

gradually given it a potential advantage and have an impact on the global film pattern.

The celebration of the Christian film festival and the global film festival

In 1932, the International Film Festival started in Venice, Italy. By 2018, there are more than 700 film festivals around the world, about 50 of which are approved by the International Federation of Film Producers Association and have high quality entrants. According to the data published on the official website of the International Federation of Film Producers Association, there were 15 Competitive Feature Film Festivals in the world by 2015, including the Venice International Film Festival in Italy and the Cannes International Film Festival in France (Table 14.3). It means that there are film festivals almost every month of every year. Some 60 percent of them are mainly distributed in Europe and about 20 percent in North America. More than 30 film festivals have been held in more than 20 cities in the United States, which has become an important place for film exchange activities. Returning to the original intention of the film festival, its love for art and freedom broke through the barriers between countries. Culture, art, politics, economy, and trade collide and cooperate to realize the internationalization of the market in the process of the internationalization of exchange and cooperation.

At film festivals, many movie stars in gorgeous designer dresses and directors appear on the red carpet under the spotlights. This is an exciting moment for film. And it is an exciting moment to test their wisdom and hard work. Also, it embodies the different history of film development and records the important nodes of each stage. It promotes the in-depth development of the film industry chain. If we say that in the cinema, audiences are only watching the film, then at film festivals people watch reality shows. If audiences buy tickets because of their love for film art, then film festivals are the grand events of the global film industry chain. It promotes the rapid globalization of the film industry and the global film market, and extends the industrial chain.

Compared with the large number of established film festivals, the number of Christian film festivals is significantly smaller and less noticeable. According to the Christian film database (CFDB), there are currently 39 Christian film festivals around the world. Ten of them are in Canada, Australia, Brazil, the Philippines, India, Britain, Italy, and other countries, while the remaining 29 Christian film festivals are in 23 US states. Among them, the Global Christian Film and Music Festival held in Florida in May every year, the Christian Youth Film Festival held in California in March every year, and the online Christian Film Festival held in Virginia on the last Saturday of every month. That is to say, the Christian Film Festival held in the United States accounts for nearly three-quarters of the world's total. This is quite different from the distribution of non-Christian film festivals. The United States, as the Christian film base, has been influencing and radiating all over the world. Like many passionate and globally responsible Americans, director Alex Kendrick and his two brothers hold their own film festival in Franklin in March each year. Although no relevant records are found on the CFD database, they also warmly invite colleagues engaged in Christian film shooting around the world to participate in exchanges and appraisals. Compared with the international film festivals of commercial films, most of the Christian film festivals do not have a large number of media articles and do not have gorgeous star shows but quiet gratitude, praise, and worship. Although the Christian Film Festival offers exchanges and discussions, its industrial value and commercial value are not obvious.

Alex Kendrick practices his faith with his special gospel film works and Sherwood Pictures' film industrial communication form. Therefore, he was able to step into the film industry and achieve his position. As a pastor, his bold and persistent attempt not only changed his life, but also promoted the globalization of the gospel film. At the same time, he has also influenced countless people who pursue their faith.

Bibliography

Guanjun, J. and Yuming, W. (2012). *General Introduction of Film Industry*. Shanghai: Fudan University Press.
Ji, Y. (2011). *History of Chinese Film*. Chongqing: Chongqing University Press.

15 An analysis of the box office success of *Wolf Warrior 2* (2017)

Chao Yu

How *Wolf Warrior 2* became the most popular film of 2017

The year 2017 was the 90th anniversary of the establishment of the Army of the People's Republic of China. This is the army that serves its people and is directly led by the Party. Chinese national cinema in 2017 was also full of soaring and passionate heroism. The military action film *Wolf Warrior 2* created a miracle at the domestic box office at an astonishing speed since its remarkable release. Leng Feng, a tough man in the film, is both patriotic and romantic, becoming the symbolic image of a "hero." *Wolf Warrior 2* is the milestone or even the benchmark of domestically produced films, because military action films were never a popular genre in the Chinese film market before, and now, with the success of *Wolf Warrior 2*, this genre has become the "engine" of the box office.

Wolf Warrior 2 was released on July 27, 2017 in domestic major cinemas and exceeded 100 million yuan in 4 hours. The box office was over 200 million yuan the next day and reached 310 million on July 29. The total box office in the first three days exceeded 600 million yuan. On July 31, the box office reached 1 billion yuan, which broke the record set by the film *The Mermaid* (Stephen Chow, 2016) which exceeded 1 billion yuan in 92 hours. *Wolf Warrior 2* became the film whose box office reached 1 billion yuan the fastest. Riding on the effects of good acclaim, *Wolf Warrior 2* continuously renewed the single-day box office record, which was a phenomenon that had never before happened in the history of Chinese film, and finally it became the box office champion of 2017 with a box office performance of 5.68 billion yuan, creating a box office legend in Chinese film history. The numbers of moviegoers of *Wolf Warrior 2* are more than 100 million, which surpassed the 91.587 million moviegoers for *The Mermaid*, setting a new record for the highest number of cinema admissions on the domestic film market. The global box office of *Wolf Warrior 2* is US$870 million, of which the Chinese box office accounts for 98 percent. It is the only non-English film in the top 100 global box office ranking.

With such positive reviews and word of mouth reputation, *Wolf Warrior 2* was given 7.2 by voters on the Douban platform and 9.7 on MaoYan's

Movie platform, which was slightly below the most surprisingly popular film *Dangal* in 2017, whose grade was 9.8. *Wolf Warrior 2* won many awards, including Best Picture at the Golden Crane Award during the Chinese Film Week; Excellent Work Award in "Five One Projects of Spiritual Civilization Construction"; Best Picture Award at the China ASEAN Film Festival, and Asia Popularity Award at the Second Macao International Film Festival and Award. *Wolf Warrior 2* won My Favorite Feature Film Award, and Janson Wu won My Favorite Actor Award at the Second National Primary and Secondary School Students Film Week. Many students were inspired by the film to be as responsible, accountable and courageous as Leng Feng. All those awards and approvals showed that the influence of *Wolf Warrior* 2 was so widespread and significant that it was worthy of the title: "the most popular and phenomenal film of 2017."

Exploring the overseas film market is always the goal of Chinese national cinema. Cooperating with the *European Times* and the five most influential German mainstream cinema chains, Cinemaxx, Kinopolis, Cinestar, Cineplex and UCI, *Wolf Warrior 2* was screened in German cinemas on September 16, 2017. The viewing rate of the film was approximately 70 percent on its first-day debut and it was screened in more than 30 cities hereafter. CMC, the overseas release party, obtained the publishing rights of many European countries including Germany, Austria, the Netherlands and Belgium. This marked a good beginning for Chinese films to enter the European market. *Wolf Warrior 2* was also shown in Japanese art cinema chains on a minor scale, and the mainstream cinema chains, including Toho Company, later announced that the film would be screened across the country from January 1, 2018.

The box office success of *Wolf Warrior 2*

The reason why *Wolf Warrior 2* was the miracle in the history of the Chinese box office is that it happened at the right time, at the right place and with the right people. In order to foster the development of domestic films, the previous State Administration of Press, Publication, Radio, Film and Television had issued a regulation that Domestic Film Protection Months would be between July to August every year. During this period, domestic films would receive complete support from nationwide cinema chains and importing foreign blockbuster films would not be encouraged. There was only one Hollywood film showing, *Despicable Me 3*, when *Wolf Warrior 2* was showing. Compared with other domestic films such as *The Founding of an Army*, *Our Time Will Come*, *The One*, *Father and Son*, and *Our Shining Days*, *Wolf Warrior 2* undoubtedly had an advantage at the box office. Without any competition from foreign films and with the prominent film quality, the popularity of *Wolf Warrior 2* was unstoppable. Also, 2017 was the 90th anniversary of the PRC's Army being inaugurated and *Wolf Warrior 2* was released on July 27, 2017, which made it a gift for the celebration of Army Day by showing its love for the People's Liberation Army. This was also the reason why moviegoers chose

to watch this film. Besides, the incident when the Indian military invaded the non-disputed area in Chinese Tibet in June had also stimulated patriotism among people, and to some extent excited them with the passion and expectation for this film.

Another important factor that contributed to the success of *Wolf Warrior 2* was the delay in its removal from cinemas. On September 18, the China film group cooperative notified its nationwide cinema chains that the copyright screening period for *Wolf Warrior 2* would be prolonged for one month to October 28 (Table 15.1). This gave the film three months total screening time, which contributed to the moviegoers' passion for *Wolf Warrior 2*, enabling some fans to see the film several times.

Some 54 percent of *Wolf Warrior 2*'s audiences are female viewers. According to the nationwide average data accounts, their numbers are slightly higher than those of male moviegoers. In terms of age background, 35.9 percent of moviegoers are between 20 and 24 years old and 25.9 percent

Table 15.1 Statistics of domestic box office of *Wolf Warrior 2*

Week	Number of people per show (person)	Single-week box office (million)	Total box office (million)	Days on show
First week July 24 to July 30	68	99681	99691	4
Second week July 31 to August 6	62	217126	316799	11
Third week August 7 to August 13	41	140241	457025	18
Fourth week August 14 to August 20	26	56448	513467	25
Fifth week August 21 to August 27	17	26080	539545	32
Sixth week August 28 to September 3	16	17194	556738	39
Seventh week September 4 to September 10	7	5564	562302	46
Eighth week September 11 to September 17	6	2289	564591	53
Ninth week September 18 to September 24	6	1197	565788	60
Tenth week September 25 to October 1	5	619	566407	67
Eleventh week October 2 to October 8	20	1029	567437	74
Twelfth week October 9 to October 15	6	210	567467	81

Source: China Box Office: www.cbooo.cn/.

are between 25 and 29 years old. According to the analysis from the professional data of MaoYan Movie, the white-collar class (33.1 percent) and students (14.2 percent) make up the majority of cinema admissions for this film. According to the statistical data, the first-tier cities, such as Beijing, Shanghai, Guangzhou and Shenzhen, where the middle class is the dominant class, account for only 19 percent of box office; however, the third- and fourth-tier cities where the blue-collar working class and ordinary workers are the majority account for 40 percent and they have contributed significantly to *Wolf Warrior 2*'s box office success. There was a common characteristic among the top ten box office Hollywood films in China in 2017 such as *xXx: Return of Xander Cage*, *The Fate of the Furious*, and *Transformers: The Last Knight*. The leading characters in those films are all presented as showing strong individualistic heroism. The Indian film *Dangal* praises the aspirations of lower-class people who achieve great dignity through their undying efforts. The social classes of the moviegoers for *Dangal* are similar to those of *Wolf Warrior 2*. They come from third- or the fourth-tier cities, and they were the foundation of the success of *Wolf Warrior 2*'s box office. In *Wolf Warrior 2*, Leng Feng, a courageous man with principles and justice, is a hero whose military rank and identity have been removed. He is humorous, unrestrained, self-mocking, enthusiastic about football, and keen to exhibit his muscles. This unconventional image of the hero has greatly overturned our traditional concept of "heroes." The story of an ordinary man becoming a hero by saving many people's lives created strong resonance among blue- and white-collar workers. Eventually they contributed significantly to the box office.

The value of IP: intellectual property manifested in scripts

Jason Wu moved from being an actor to writer/director and film producer with *Wolf Warrior 2*. Only by having more and more Chinese film projects as intellectual property (IP), can the Chinese film industry truly develop and compete with Hollywood. Luckily, Jason Wu succeeded with *Wolf Warrior* and *Wolf Warrior 2*. The original meaning of IP is the ownership of knowledge (property). From the commercial and capital perspective, with the extension of the connotation, IP is the multi-development of cultural industry products. The *Wolf Warrior* series is Jason Wu's original works, and now can be further adapted into a TV series, games, etc. So, it can be safely considered as IP. The *Wolf Warrior* project is almost a brand, and has won recognition of moviegoers as an original IP with its production team focusing on the development of original content. It is considered the masterpiece of the military genre. Different from ethical films, romantic dramas, comedy, and the traditional action genre, the setting of the storyline is always overseas which successfully brought moviegoers visual beauty and exciting exotic sceneries. The characterization of the film is so innovative that the character Leng Feng has become the symbol of the Chinese hero, while some moviegoers even think that Jason Wu is the wolf warrior in real life. The success of *Wolf Warrior 2*

as China's champion of the box office benefits significantly from its favorable reputation and prominent film quality as well as the continuous refinement of its scriptwriting over four years. The background story of *Wolf Warrior 2* is set in the evacuation of overseas Chinese citizens. Similar background stories based on the real event of the evacuation of overseas Chinese include the robbery in the camps of Libya in 2011, the civil war in Monnai in 2015, the earthquake in Nepal, the earthquake in New Zealand in 2016 and the fires in Israel. The original intention of the *Wolf Warrior* series is to provide people all over the world with an opportunity to know about the Chinese military, including their wisdom, courage, kindness and responsibility. It tries to exhibit the action and image of a strong China in the face of world disasters and crisis. Different from *Wolf Warrior*, Leng Feng in *Wolf Warrior 2* is no longer a military man as he has had to retire from the service because he beat up local gangsters who tried to destroy and pull down innocent people's houses. But in his heart and soul, the blood of a soldier never stops running. He never forgets his inner duty, undertaking more responsibilities to protect his compatriots as well as everyone who is suffering from war.

Based on *Wolf Warrior 2*, we can conclude that the essential factors that contribute to the success of a film include a thrilling storyline, persistent efforts at style in the production period, and cultural connotations that comply with mainstream values. With the advantage of IP, we can expect more work from the *Wolf Warrior* series. At the end of *Wolf Warrior 2*, the viewer is left with a cliff hanger, letting us believe and hope that *Wolf Warrior 3* will triumphantly return in the near future.

A cinematic feast of international blockbuster standard

The action design has always been the advantage of Chinese action films, and the action scenes in *Wolf Warrior* series are remarkable. Compared with *Wolf Warrior*, *Wolf Warrior 2* has upgraded its production value with a broader international horizon. It is international because the setting of the story is abroad. Leng Feng, a retired military man from the special corps who goes to Africa to look for the woman he loves, unexpectedly is given an order in a critical situation to save unarmed Chinese civilians and fight ruthless villains, which puts him in a drastic situation. The plot of the story is based on the classic Hollywood narrative. It develops from a state of peace (Leng Feng's daily life in Africa) to a crisis (war and virus), and from crisis to the victory of breaking through the encirclement. In the meanwhile, love (the female doctor's kiss) and humor ("a spoilt brat" who is in charge of relieving the tension of the plot) run through the whole storyline. The film crew has an international team with members from 26 countries. The action director is Sam Hargrave from the *Captain America* series, and Frank Grillo, who plays the main villain Big Daddy in *Captain America*. There is also the underwater photography crew from *Pirates of the Caribbean*. Leng Feng's enemies are upgraded from a bunch of mercenaries to a rebellion army with organizational structure.

There are not only female snipers but also professional wrestlers and firearms experts among the villains. The variety of crew members and characters offers the chance of showing remarkable combat scenes in the film. Regarding film genre, the *Wolf Warrior* series could be classified as "military action film" which combines action with intense war battle scenes. *Wolf Warrior 2* is full of action scenes, such as the 6-minute underwater long-take combat scene; hanging on to a racing car with single-arm scene, a fight scene in a slum; "parkour" movements with a high degree of difficulty in the Chinese-owned factory, etc. The most amazing scene is the tank battle, which is the climax of the film. This might be considered the "tank version" of *Fast and Furious*. The tank chase and driving scenes between Leng Feng and the rebellion army surprised moviegoers with a brand-new form of tank battle.

Leng Feng escaped before the tank exploded while the "spoilt brat" Zhuo Yifan gets under the tank to dangerously place an iron hook. Leng Feng and the veteran He Jianguo make use of the advantageous terrain and special mechanical equipment to overturn the tank driven by Old Daddy. The ingenious use of the equipment and surroundings makes this a scene of human triumph against the battle with the tank. Finally, Old Daddy has to come out from the tank and confront Leng Feng face to face. The battle ends with a thrilling, exciting bare hands combat scene. By changing the rhythm and pace of the action scenes, the film creates an emotional wave of tension which raises strong and breathtaking feelings in the moviegoers. During shooting, in order to achieve realistic action scenes, all scenes involving explosions are designed to model real explosions in war. This level of realistic war scene also set a record in Chinese film production history. Tens of thousands of bullets, hundreds of tanks and the latest Chinese helicopters were used in the real combat shooting of the film. The crew blasted hundreds of types of equipment including an airplane, two 20-ton tank models, and approximately 100 cars. It is this huge investment that has ensured the extraordinary visual and audio effects of *Wolf Warrior 2*.

Cooperation ensures the extraordinary quality of the film

A successful film needs not only an exciting storyline and magnificent action scenes but also the devotion of the actors. To obtain the most realistic scenes for the story, the crew of *Wolf Warrior 2* went to Africa twice during pre-production where they were robbed a few times. Besides the difficult living environment, the crew also suffered from the harsh natural conditions. They hiked for hours in the snow with temperatures more than 10 degrees below zero, and were attacked by poisonous spiders. Jason Wu was dragged away by the ocean current at a speed of 15 meters per second when playing the diving scene from the deck, 13 meters above the water. To complete the stunning underwater action scenes, both the actors and crew members did not take any respirators or oxygen bottles and had to take turns to come to the surface to breathe. During four days of rehearsal, Jason Wu stayed in the water over

10 hours every day. To move freely and naturally in the water, he practiced by tying a lump of lead to his body, but almost killed himself because it was too heavy, and he dived too fast. In the fast-paced car scenes in the narrow streets of the slum, Jason hangs onto the car using only one arm, which was extremely dangerous. He also gained experience by training with the special troops for ten months to be able to finish the exciting gunfight scenes. In the breathtaking 5 minutes bare-handed battle with Frank Grillo, he gave up using the routine motions and played himself, in person, for every scene, without any stand-ins, stunts, or special effects, and every punch was directed to his body. The way the airplanes, tanks and off-road vehicles were blasted gave moviegoers very strong and realistic visual experiences, but Jason Wu became deaf in one ear temporarily during shooting. While filming the blast scenes, the temporary deafness phenomenon happened to many of the crew, but everyone carried on. In the "tank version" of the *Fast and Furious* scene, the actors bravely carried on even when they found that the tanks were leaking and they were likely to explode at any time.

Wu Gang, who is famous for the character Secretary Da Kang, played the veteran in the film and this is his first action film. In order to better present the military image, he was required to join military training to learn combat actions and the use of weapons. He even spent more than 20 days learning nothing but how to hold a gun. On average, he spent over 10 hours holding the submachine gun that weighed 10 kilos, finally changing from someone who knew nothing about guns to almost a weapon expert who can change a clip with a single hand. He got injured many times, taking painkillers to finish all the scenes in an effort not to slow down the shooting progress. His working attitude deserves our respect. Zhang Han, who plays the "rich second generation" Zhuo Yifan, also learnt military tactics and received training by watching military induction videos, which enabled him to transform from "the spoilt brat" into a real soldier. Based on their favorable collaboration in *Wolf Warrior*, Ju Nan, who played Long Xiaoyun, joined the crew again. Lu Jingshan, who collaborated with Jason Wu for the second time, finished 10 months of shooting without taking a stunt double. In order to be able to meet the film's tight production schedule, Yu Qian, who perfectly played the character of a "profiteer," had to miss the performance of his own shows at Deyun Crosstalk Association. With strong determination, under Jason Wu's leadership, everyone contributed with all his/her passion to the accomplishment of such a high-quality film, which eventually led to a box office miracle.

The cultural value of the nation-state promoted the film-viewing experience

The national cinema has long been the carrier of national cultural identity, and it has often projected national mainstream ideology. Chinese national cinema, at a certain level, also contributes to the "soft power" (national image) of

China on the international stage. In recent years, mainstream films such as *The Taking of Tiger Mountain* (880 million yuan box office), *Operation Mekong* (1.18 billion yuan box office) and *The Founding of an Army* (400 million yuan box office) have gained tremendous market influence. The *Wolf Warrior* series, which are mainstream films, have artfully combined the commercial elements with mainstream ideologies in a typical military action film genre. The continuous upgrading of advanced military weapons in the film from bare-handed combat, gunfire to rocket projectiles; and from drones, tanks to warships has impressed the viewers and accomplished a Chinese version of *The Expendables*, *Band of Brothers* or *Saving Private Ryan*. As expected, the *Wolf Warrior* series has developed a "tough man" culture with strong confidence and determination, which matches the individualistic heroism in the superhero series in American Marvel comics or detective comics. China has hence created its own patriotic and courageous superhero films. In the *Wolf Warrior* series, the core theme is: "Anyone who offends China will be punished, no matter how far away he is." This follows the national mentality of the contemporary development phase of China and provides people with an emotional outlet.

In *Wolf Warrior 2,* the cross-border emotional resonance between Leng Feng and the refugees deeply moved the viewers whose sense of honor and pride rose up when Leng Feng raised the national flag and went through the war zone in Africa without any hindrance. The last scene of the film is a picture of a Chinese passport, on the back of which is written: "Citizens of the People's Republic of China: when you encounter danger abroad, please do not give up, because there is a strong China behind you." This is an announcement to the Chinese people around the world that a Chinese passport may not take you everywhere in the world, but it can surely rescue you from every corner of the world. This is the scene that touches its viewers and even made them cry. Most Chinese people feel proud and excited about a strong China, and their patriotism is ultimately inspired by these touching scenes, which has developed a new realm for film language and tapped into the mainstream emotions.

The domestic film industry is still immature. Except for some low-cost romantic films, comedies, literary films and youth films which have gained a place in the market, the so-called blockbuster is still crossing the river by feeling the stones. The domestic film breakthrough of *Wolf Warrior 2* is taking the initiative of the Chinese blockbuster and also marks the beginning of prosperity for Chinese film exports. *Wolf Warrior 2* is the first military action film that was distributed and screened in an overseas market. Essentially, the fundamental purpose of film exports is to give domestic film production the ability to communicate with the world and to make an authentic international cultural product. The biggest success of *Wolf Warrior 2* is not its 5.68 billion yuan box office but the opening of a new era, and it sends out a strong signal that we can make remarkable Chinese blockbusters that can be

popular internationally. We believe that *Wolf Warrior 2* is an opportunity. As long as we carry both the industrial and craftsmanship spirit, and keep the film industry developing in a healthy way, China will eventually transform from a country with a large number of film audiences to a country with high quality of film productions.

16 Chinese film IP resources development strategy

Dandan Li

Film IP development

Definition and source of film IP

IP originally refers to intellectual property, such as copyright, adaptation right, or ownership of knowledge, also known as the intellectual property right.[1] However, in the age of digital media, the meaning of IP has been extended more widely from literature to film, forming a diversified development trend. IP film is a new business model combining the Internet with films. At present, the sources for IP films in China are mainly from literary adaptations, TV contents, online videos, games, animation, comics, music, etc. Since 2014, a large number of influential cultural products have become the source of film adaptations, such cinematic adaptions from online novels, games, music and TV content started an unprecedented upsurge of IP films in China.

The concept of IP film development

Traditionally, the development of film derivatives is also known as the post-film development, which refers to the production company's continuous exploration of the films' influences after being released. There are many kinds of film derivatives, including novels, posters, comics, toys, props, souvenirs, games, theme parks and shooting studios, etc. Traditional development refers to film production companies producing films, and the scope of development is the production process of the films. However, in the age of digital media, IP film development is significantly different. The resources in other fields have been integrated into the film development process, which extends the scope of the film into other objects. In addition to film companies, Internet companies, cultural companies or individuals with IP resources have also become IP developers, and the objects have also extended from being pure derivatives to a variety of cultural capitals that can serve the production of films. The process of IP film development follows such a pattern: IP developers rely on the converged media platforms to facilitate IP film projects' creation and development for the film industrial chain, and eventually work to establish IP

film projects as a brand. Thus, a transformation from cultural capital to IP film's economic capital is achieved.

Current situation of IP film development in China

In recent years, the box office earnings of Chinese films have been increasing year by year. From 2009 to 2017, the growth rate for each year was 42.96 percent, 63.91 percent, 28.93 percent, 30.18 percent, 27.51 percent, 36.15 percent, 48.69 percent, 3.73 percent and 22.31 percent, respectively. Although the growth rate plunged to 3.7 percent in 2016, the overall market showed a return to normal growth (Figure 16.1). With the addition of online income to box office earnings, the nominal box office will increase by 6–8 percent in 2017. According to the previous data of the State Administration of Press, Publication, Radio, Film and Television, the annual box office of Chinese films exceeded 50 billion yuan on November 20, 2017. In 324 days, the Chinese film box office has totaled more than 50 billion yuan with the number of audiences exceeding 1.448 billion, which set a record at the box office. The box office of domestic films has reached 26.2 billion yuan, accounting for 52.4 percent of the total earnings, and the box office of foreign films has attained 23.8 billion yuan, accounting for 47.6 percent. In total, there are 82 Chinese and foreign films with a box office of over 100 million yuan, including 13 films which have achieved a box office of over 1 billion yuan (Figure 16.2), showing that the Chinese film market is thriving.

The achievements of Chinese IP film development

Tremendous market share and strong competitiveness

In 2017, the annual box office revenues of Chinese films came in at 50 billion yuan, achieving a record high. Meanwhile, IP films showed strong

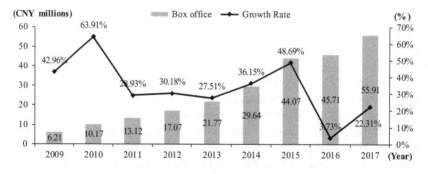

Figure 16.1 Box office and growth rate, 2009–2017.

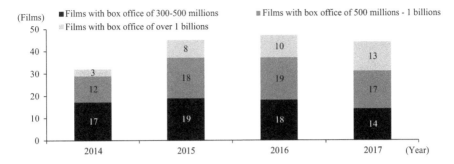

Figure 16.2 Box office segment statistics, 2014–2017.

competitiveness. The development of IP films has become the main source of film content as well as a boost for the box office. Judging from the top ten domestic films in the box office ranking, most of the content of the films comes from IP resources. In 2017, the top ten domestic films except for *Kung Fu Yoga* and *Chasing the Dragon*, were all based on IP sources (Table 16.1), and the total box office of these eight IP films reached 13.092 billion yuan, accounting for nearly 43.50 percent of the total box office (30.1 billion yuan) in 2017 (Figure 16.1),, which indicates that IP films remain as mainstream domestic films with an impressive market share.

Converged media motivate IP production normalization

In the age of digital media, converged media means that communication is no longer limited by a single carrier and it can understand the interconnection between different media. With the advent of the era of converged media, all content that can be adapted to the big screen is constantly being explored. For example, the TV variety show, *Where Are We Going, Dad?* of Hunan Satellite TV, has become a typical example of the development of IP's whole industrial chain (Table 16.2). From the second season, it launched a documentary and animation, together both co-broadcast on the Internet and TV, and in 2014, the film *Where Are We Going, Dad?* was released. After mastering the two major TV and film media, Hunan Satellite TV continued to march to the mobile phone screens and explore the IP value of *Where Are We Going, Dad?* cooperating with other companies to develop a Parkour mobile game called *Where Are We Going, Dad?* Its downloads have already reached 120 million. In order to better explore its economic and social value, Hunan Golden Eagle Press has made full use of traditional print – newspaper – by issuing 22 books in a series as well as related comic books of *Where Are We Going, Dad?*, forming an IP production normalization in the era of converged media.

Table 16.1 Top 10 box office films in China in 2017

Title	Genre	Director	Release date	Box office (100 million yuan)	Original form
Wolf Warrior 2	Action	Jing Wu	July 27, 2017	56.79	Fiction
Never Say Die	Comedy	Yang Song, Chiyu Zhang	September 30, 2017	21.97	Stage play
Kung Fu Yoga	Comedy	Stanley Tong	January 28, 2017	17.53	
Journey to the West: Demon Chapter	Fantasy	Hark Tsui	January 28, 2017	16.56	Fiction
Duckweed	Feature	Han Han	January 28, 2017	10.49	Fiction
Buddies in India	Comedy	Baoqiang Wang	January 28, 2017	7.58	Fiction
Wukong	Fantasy	Derek Kwok/ Chi-kin	July 13, 2017	6.97	Fiction
Chasing the Dragon	Action	Jason Kwan Chi-Yiu/Jing Wong	September 20, 2017	5.75	
To the Sky Kingdom	Romance	Anthony LaMolinara/ Xiaoding Zhao	March 8, 2017	5.34	Fiction
Bonnie Bears: Entangled Worlds	Animation	Liang Ding	January 28, 2017	5.22	TV animation

Source: Yien Film Think Tank.

Table 16.2 IP development of *Where Are We Going, Dad?*

IP production	Title	Presenter	Category
Key productions	*Where Are We Going, Dad?* Season 1-5	Hunan TV Channel	TV show
Affiliated IP production	*Where Are We Going, Dad?* documentary	Hunan TV Channel	TV show
	Where Are We Going, Dad? animation	Aniworld TV (Golden Eagle cartoon)	TV show
	Where Are We Going, Dad? film	EE-Media	Film
	Where Are We Going, Dad? book	Aniworld TV (Golden Eagle cartoon)	Book
	Where Are We Going, Dad? game	Mangofun	Mobile game

Source: open access.

Maximum satisfaction of the audiences' demand

The development of IP films employs the most practical Internet thinking at present. By analyzing the advantages of Internet big data, we can accurately define the psychological needs of the audiences for a particular type of film. By catering for audiences' taste, film production companies produce and customize the film's contents accordingly. Based on relevant data statistics, in 2016, the Chinese film and television market planned to develop about 200 domestic IP projects, including 61 percent online novels and 29 percent traditional novels. IP films can attract more audiences according to their interests in Internet novels and comics, benefiting from the loyalty of the audiences. At the same time, with the increasing number of IP sources, audiences have more choices. Therefore, audiences' film experience can be optimized to the greatest extent.

Problems in the development of Chinese IP films

The pursuit of the maximization of commercial interests and entertainment

Films should be related to both social and economic benefits, with a focus on their impacts on social benefits. However, in order to maximize commercial benefits, in recent years, Chinese films have absorbed excessive entertainment elements in the process of IP film development, while lacking creativity and investment in the essence of film art. Major films and television production companies only pay attention to entertainment and high return rather than insight and connotation, which intensifies the entertainment of IP films.

The lack of relevance in IP film development

According to the current development system of Chinese IP films, after acquiring an IP, film production companies will apply all the production concepts of traditional films to the making of IP films, without contemplating the overall orientation of film projects. Thus, it neglects the impact of IP in the original fields. In order to obtain immediate economic benefits, some companies will authorize the IP without carefully communicating the cultural value of the IP with the authorized party, which results in the lack of relevance between IP development and its utilization, with negative impacts. This development concept which lacks symbiosis will only end up damaging the actual value of the IP.

Homogeneity of film categories and single derivatives

Although a large number of IPs offer abundant contents for films, IP content also damages the originality of films. At present, the young generation is the major film target audience, which makes feature films cater to young people's

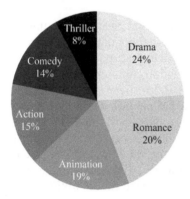

Figure 16.3 Percentage of film categories in 2017.

taste with mostly romance, myths, and fantasy genres. This has become the mainstream theme of major film production companies (Figure 16.3), leading to the homogeneity of film categories.

Journey to the West, known as super IP, has become the IP development model for many film and television production companies. It is expected that in 2018, there will be several IP films adapted from it, such as *The Monkey King 3*, *Dare to Ask Where the Road Is*. Most IP films associated with *Journey to the West* belong to fantasy, comedy, and romance genres with serious homogenization.

At present, the development of film derivatives in China is mainly based on dolls and toys (Figure 16.4), and the development and influence cycle are relatively short. The film derivatives are usually popular before the premiere of the film, but the craze for the derivatives soon subsides after the release. In the initial design stage, derivatives fail to be thoroughly integrated with the connotation and plot of the films, so it is difficult to arouse the interest of the audience. Looking at the development of derivatives in foreign countries, the developers will conduct long-term market research in order to understand the psychological needs of the audiences before infusing the elements of IP with design and production. Meanwhile, they will develop theme parks and roll out cross-border marketing using the characteristics of new media, so as to ensure the innovation and sustainable development of IP value.

Development strategies for IP films

Highlight the literariness of IP and extend its connotations

As a cultural product for mass consumption, films are also commercial products. Therefore, it is essential for film companies to pursue films' commercial value. However, if they ignore films' artistic quality and excessively focus on films' commercial value, the exploitation of IP film will become utilitarian.

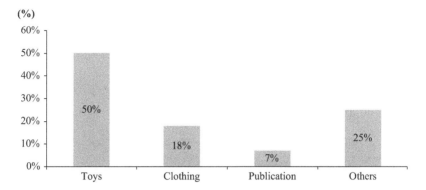

Figure 16.4 Proportion of various derivatives in the domestic film market.

In order to avoid such a situation, film production companies should actively explore the potentials of IP, grow outstanding filmmakers, and create more high-quality works.

The developers of IP films should consider audiences' expectations as there is already a huge number of loyal target audiences for the original content. Therefore, filmmakers should make full use of the Internet big data to accurately define the needs of audiences, and actively explore the potentials of any IP projects. Hence, more IP film projects will be produced of high quality to meet the aesthetic needs of audiences.

To improve the IP film development system and build a systematic industry chain

In order to form an interactive and mutually improved development system, the development of IP films should focus not only on the success of IP itself, but also consider the development in terms of creativity, production quality, distribution, and derivatives, because only a consummate IP development system can produce IP films that meet the expectations of audiences. At present, China Tencent Literature company focuses on the development of entertainment IP, providing the one-stop IP development service, such as creativity, investment, production, and marketing. It also expands the field of IP development other than film and television, which includes games, animation, theme parks and landmark tourism, etc. Such a virtuous circle of the whole IP industry chain improves the IP development system and maximizes its value.

High-quality IP original content and the realization of sustainable development of derivatives

As an important part of the cultural industry, if a film industry wants to achieve sustainable development, content creativity will be important. Instead of being homogenized, it is better to carry out differentiated competition of

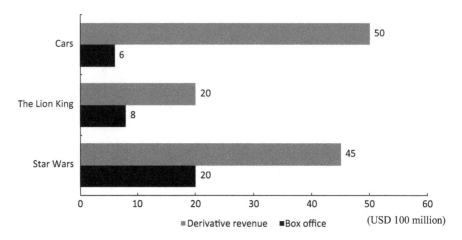

Figure 16.5 Box office and derivative revenue from overseas films.

original IP. In the content-dominant era, creativity is the key to IP films, which means it is essential to innovate the themes and forms of expression to promote the development of the IP industrial chain. Film companies and cultural enterprises should take the strategy of exploring IP's potential value and diversified development. At the same time, they should also place emphasis on the cultivation of those designers with creative ideas and the innovative use of film technology, so that IP films can be creatively transformed all the way from pre-production stage, production stage, to post-production stage. And with film promotion and marketing, the cultural, artistic and commercial value of IP films can be better achieved.

At present, foreign language films are able to double or triple their box office earnings by developing sustainable development of film derivatives (Figure 16.5). Therefore, the developers of IP film derivatives in China should emphasize industrial development and design by considering the audiences' interests. Integrating the converged media and relying on the loyalty of IP fans, developers should engage with different industries and markets such as publishing, games, variety shows, branding, thematic activities, and other valuable peripheral industries. This will enable the derivatives in a single field to achieve mutual benefits, and finally contribute to the establishment of a complete cross-field industrial chain of IP derivatives.

Conclusion

In recent years, Chinese IP film development has been thriving and has become an important role in film production. Consequently, the developers of IP film should meet the psychological demands of audiences through originality of

content and novelty of form. Thus, a connection will be established between IP films and their derivatives in the whole industry chain. A brand new consumption experience will be offered to audiences with the maximum economic and cultural benefits of IP, and eventually will empower IP films as the leading force for the development of the film industry.

Note

1 Baidubaike. Available at: https://baike.baidu.com/item 知识产权/85044.

Bibliography

Shaofeng, C., Wenming, X. and Jianping, W. (2015). *Report on Chinese Film Industry.* Huawen Press.
Zhenzhen, W. (2015). IP Movie: China Mass Consumption Era. Modern Movie.

17 Impact of the Film Industry Promotion Law on the significant growth of the Chinese film industry

Yanqiu Guan

Legislative background of the Film Industry Promotion Law

The implementation of the Film Industry Promotion Law is an important achievement for Chinese cultural legislation, which had suffered a long and tortuous process. For decades, there have been calls for film legislation, which was also mostly expected by Chinese filmmakers. In January 1981, *Popular Movies* (a Chinese magazine) published an article calling for film legislation. This article inspired widespread discussion among people in different cultural fields, and film legislation began to take shape. In the late 1980s, there were many differences and disagreements over the film industry. The film industry of China has not yet been fully explored as a system adapted to the reality of social democratic politics. It was not the perfect time for film legislation. In the early 1990s, the State Council first formulated administrative regulations. In 1996, the Film Management Regulations were enacted. Subsequently, the development of the Chinese film industry was significant, accumulating matured experience and laying a solid foundation for further legislation. Since 2002, the year of the film industrialization reform, the structure of China's film industry has undergone major changes and the film industry has made great progress. After the film industrialization reform, the box office and number of films being produced in China have increased in terms of both quality and quantity. A film promotion system and a development protection policy have spontaneously been enforced through the strong application of the policy to the standard operation of the market. The knowledge gained from observing China's growing cultural industry enabled various policies for its future development, which were later codified by law. In 2004, the draft and formulation of the Film Promotion Law were initiated. Opinions were received from various sectors of society and the film industry. Seminars were held to speed up the legislative process. In 2009, the Film Promotion Law was renamed the Film Industry Promotion Law. During this period, China's socialist democratic politics continued to advance, and the cultural industry of China developed rapidly. Since the Communist Party's 18th National Congress, China has made vigorous efforts to develop the cultural industries

as one of its important strategic goals, and has achieved innovative advances. The Film Industry Promotion Law has been implemented at the most appropriate time and is of great significance for promoting the sustainable and healthy development of the Chinese film industry.

The Film Industry Promotion Law clarifies the attributes of "film as an industry" for the first time. A series of measures, such as introducing more preferential support policies and encouraging Chinese films to "go out into the world" have indicated the direction for the Chinese film industry and promoted the healthy and sustainable development of the film industry. In 2017, the total box office of the film industry was 55.911 billion yuan, a year-on-year increase of 13 percent. This shows that the Chinese film industry is striving for stability and is well positioned to achieve rapid and healthy development in future.

Several issues regarding the Film Industry Promotion Law

Decentralizing power, simplifying the approval process, and lowering the entry threshold of the film industry

One of the main highlights of the Film Industry Promotion Law is the decentralization of power, which simplifies the complex approval process for administrative agencies. The authorities' powers have been decentralized because central power and the market restrict each other. The decentralized powers respect the rules of the market and encourage enthusiasm for creativity and market vitality. This is one of the landmark initiatives of China's film reform. Attempts have been made to improve the institutional environment and strengthen the incentives and norms of the system, so that key elements in the film industry, such as human resources, capital funding and film technology can be optimized. There have also been moves to redefine the role of the government in the development of the film industry. Government functions have been transformed from direct management and administrative intervention into a free and open external institutional environment in order to fully stimulate filmmakers' creativity. This policy has injected a large amount of social capital into the Chinese film industry. The film market became more open and inclusive with tremendous sources of funds and more films being made. In recent years, some new genres and new filmmaking directions among Chinese films have appeared, and certain types of bold innovations have been widely praised. The progress of the Chinese film industry has been exciting. It can be seen from the domestic box office that China has become one of the biggest film markets in the world. In recent years, the domestic box office has grown rapidly from 10.172 billion yuan in 2014 to 55.911 billion yuan in 2017. At present, China ranks as the second largest box office market in the world and has become the market with the greatest growth potential.

Protect intellectual property rights in movies

Film intellectual property rights protection and clarification of the rights and obligations of film production

As the most important part of the cultural and creative industry, the film industry plays a defining role in the development of China's cultural industry. The protection of intellectual property rights relating to films is particularly important. For a long time, the profit resource of Chinese movies had been relatively unitary. The income from box office receipts and advertisements accounted for more than 80 percent of the total profits of each film. This was in sharp contrast to countries with matured intellectual property protection systems, such as the United States. Article 7 (Item 1) of the Film Industry Promotion Law stipulates that intellectual property rights related to movies are protected by law, which means no organization or individual may infringe such rights. This emphasizes the protection of intellectual property rights for movies, encouraging the development of film derivatives and international film trade. It reflects the country's determination to protect intellectual property relating to the film industry.

The government has strongly encouraged film production companies to develop film derivatives, but because of the long-term lack of copyright consciousness and experience in derivatives development, the domestic film derivatives market has not yet grown significantly. In 2017, the box office of *Wolf Warrior 2* was 5 billion yuan, which set a record for China's box office. However, 90 percent of this revenue was from box office earnings and the film's commercials – the market in "spin-off" items was negligible. After the release of *Wolf Warrior 2*, a large number of "copycat items," such as bullet necklaces, lighters, and keychains, etc. emerged on Taobao and other e-commerce websites and even became best-sellers. However, because these goods were not authorized by the copyright owners, they were called "similar items" to avoid infringing the copyright law. One of the reasons for this phenomenon is that awareness of intellectual property protection in the film industry is weak. On the other hand, the relevant laws and policies are still to be completed, and the punishment measures are weak. Regulatory control of copyright still has much room for improvement. At present, the legal protection of intellectual property rights related to movies in China has not solved all the problems of the film industry, and there is still a long way to go.

Intellectual property protection in the American film industry

The United States has always attached great importance to the protection of intellectual property. The Constitution of the United States of America has a section that directly confers on the US Congress the right to protect authors and inventors, allowing them to enjoy exclusive rights to use their works

and inventions for a certain period of time, aiming to promote scientific and technological advancement. This is the foundation of copyright protection in the United States. In addition, the US legislature has introduced a number of laws to protect copyrights, such as the Digital Millennium Copyright Act in 1988, the Copyright Term Extension Act in 1998, the Home Entertainment and Copyright Act in 2005, the Copyright Law in 1976, and the amendments made in 1989 and 1990. These laws provide comprehensive legal protection for copyright in the United States.

The United States adopts the principle of indirect infringement in peer-to-peer (P2P) technology infringement cases. The network service providers are guilty of infringement if the following criteria are met: (1) if the provider manufactures or sells the infringing products; and (2) if the customers use the products. As for the P2P technology infringement, two typical cases in the United States are the *Napster* case and the *Gorkster* case. Although these two cases do not deal directly with film copyright protection, their final judgments are still relevant to the copyright protection of movies, because the two cases established legal precedents to protect copyright and combat its infringement. The laws of the United States are heavily dependent on precedents established by case law.

On February 4, 2016, representatives from 12 member states, including the United States, formally signed the Trans-Pacific Partnership Agreement (TPP) in Auckland, New Zealand. Although the United States announced its withdrawal from the TPP on January 20, 2017, it is believed that the United States will continue to adapt to the new situation and severely crack down on copyright infringement in the film industry to protect the copyright of films.

China could learn from US protection policies for film-related intellectual property rights, and implement the provisions for intellectual property protection given in the Film Industry Promotion Law. In recent years, there have been frequent cases of piracy infringement in the film industry. Many films have been pirated after their theatrical release and film production companies have suffered tremendous commercial losses. The Film Industry Promotion Law clearly states: "Intellectual property rights related to films are protected by law and no organization or individual may infringe." In addition, the department responsible for intellectual property rights enforcement at the county level or above shall take measures to protect the film industry. Intellectual property rights and infringement of intellectual property rights are applicable to movies, in accordance with the law. Article 31 directly states that no person shall, without the permission of the rights holder, record and videotape the film being shown, and it also gives the cinema the right to "exercise such law enforcement." These regulations respect and protect the labor of the majority of creators, standardize the film market and reflect China's efforts and determination to increase the protection of the intellectual property rights of movies.

The film censorship system

The film censorship system in China

The subject of film censorship relates to an organization or institution that is authorized by law or commissioned by industry associations to review films before their release, using specific standards to determine whether they can be released and at which rating. Film censorship is dealt with by organizations, such as government regulatory agencies, industry self-regulatory organizations, and production units. The Film Industry Promotion Law clarifies that the film censorship system will continue to apply to all Chinese films. This is determined by China's national laws and has become common sense to all people. However, it still faces many difficulties. On the one hand, theoretical research on the Chinese film industry is not extensive, and the theoretical research results are relatively inadequate. On the other hand, due to the lack of experience in the rule of law at the practice level, specific rules are lacking. If there is not a mature policy system and enforcement, we should first look at the developed countries and regions of the global film industry, and learn from and draw on their relatively matured theory and practical experience.

The American film rating system

A film rating system is different from a film censorship system. In a film rating system, each film is classified according to the content of the film. Films of different levels are open to audiences of suitable ages: children and teenagers are prevented from accessing inappropriate audio-visual images while adults can watch whatever films they choose.

A rating system does not limit the screening of movies. It only divides the film levels and distinguishes the audience. At present, most developed countries and regions adopt a film rating system, such as the United States and Canada. Hollywood is a pioneer in in global film industry, and its film rating system is also relatively mature. The film rating system was established through a series of judgments by the Federal Supreme Court. It is also a transitional model from the administrative subject review mode to the modern one. After World War I, Hollywood films began to reflect changes in certain ethical standards. Sex, violence, alcoholism, drug abuse, and other "new symbols of modern life" became popular film themes. This change caused public outrage, and conservative moral defenders launched strong protests and boycotts on films. In order to prevent the federal government from intervening in film censorship (filmmakers have always regarded government involvement as "the end of Hollywood"), Hollywood organizations established industry self-regulatory organizations. American film producers and the Publishers Association attempted to conduct a self-regulation review through the association, to avoid the risk of the government intervening in film censorship. The American Film Rating System is administered

by the Rating Committee, a committee organized by the American Film Association. It evaluates a film on behalf of parents, based on the language, violence, pornography, and drug use scenarios of a film. The judges of the American Film Rating System are a rating committee affiliated with the Classification and Rating Authority of the Motion Picture Association of America. The chairman of the rating committee is appointed by the chairman of the Film Association. The committee consists of 8–13 members, all of whom must be parents. As an independent branch of the Film Association, the organization's remuneration packages are provided by film producers or publishers who apply for a rating, and the Film Association must not interfere with their work. Members of the rating committee conduct a secret ballot when rating the film, and then discuss the level after the result of the vote. If producers want to expand the audience and strive for a bigger market, they can delete or modify some of the content of the film and send it to the rating committee for re-rating. If producers are dissatisfied with the rating decision made by the Rating Committee, they may also appeal to the Appeal Board. The Appeal Board consists of 14–18 members, all of whom are from the Film Association and the National Theatre Owners Association. Members of the Appeal Board will review the appeal and will hear the appellant's statement and the Rating Committee on the relevant disputes. The appellant and the Rating Committee can question each other and the Appeal Board will make the final decision.

The film rating levels in the United States have been revised several times and were finally determined as a five-level system. Standards for rating films in the United States mainly focus on whether the film contains violence, sex, and drug abuse. Then the rating system quantifies these scenes in films. For example, a film containing a sex-related dirty word should be rated as PG level. If there is more than one word like this, then it should be rated at least as R level. These measurable quantifiable standards make it easier for producers to evaluate their film works based on specific criteria. The American Film Rating System was the result of the balance of interests of all parties. It breaks the unified standard of the film censorship model. Giving a film a rating does not pose any limitation to its release while the rating at the same time can provide parents with information to protect their children.

There are many limitations in China's current film censorship system. Among them, the relation between production units and administrative organizations needs to be more balanced. There is a huge contradiction between the increasingly diversified demands of the public and the actual films produced. To pursue the prosperity of the film industry, filmmakers are calling for the protection of creative freedom and say the audiences want more film variety, which urgently demands the reform of the film censorship system as soon as possible. The Film Industry Promotion Law did not make any substantial change to the current film censorship system. The film industry is closely related to the political, economic and cultural factors of individual countries. The film industries of developed countries have established good

systems for rating films, and China also needs to adopt an improved censorship system suitable to its own national conditions.

How to improve China's current film censorship system

First, China needs to enhance the independence of film censorship. Under the dual leadership of the Communist Party and various government bodies, Chinese film censorship organizations lack independence and the legitimacy to make real decisions. The review committees are not well selected in terms of profession and age background. To reform film censorship, the following actions could be taken: first, reduce the proportion of administrative officials and their roles. The dominant positions on the review committee should be assigned to senior filmmakers. Second, increase the democratization of the review institutions and involve the public in the review process. Hong Kong's model is worth following: setting up a film advisory group to engage with the public so that members of different social classes, occupations, and ages can participate in film censorship. Third, increase the proportion of young and middle-aged members of the committee. Film is an art form that is changing all the time. Young and middle-aged members can better understand the current film culture and make more appropriate review decisions. Finally, arrange reasonable conditions for the members and refer to the practice of the US Review Board whose reviewers must include parents as film reviewing's aim is to protect children. Parents have the biggest concern for their children's best interests, and consequently a parental review board can make the film review more rational.

Second, there is the need to enhance the clarity of the review criteria. Although the Film Industry Promotion Law governs the Chinese film censorship system, in practice, the film censorship standards are too vague and immature in operation. Thus, the administrative organizations have a great deal of discretion. The review criteria must be clarified and clearly stated as policies. On the one hand, the review criteria should be clear and specific, and the words should be certain and accurate. For example, what is "national interest" and what is "obscene content" in the current policy? The criteria should enable judgments to be made regarding whether or not the content of a film harms the national interest. The criteria should also determine whether an audience would understand the film and whether it might influence their behavior. On the other hand, film censorship standards should be quantified, as their language can easily cause ambiguity. After quantifying the standard, the ambiguity and the operability of the standard can be eliminated as much as possible. When setting the film standard, the US rating standard should be the reference, such as the number of times scenes of taking drugs or smoking appear in a movie.

The international distribution of Chinese films

It is important to increase both Chinese films' international distribution and expand the international market share of domestic films to transform the

Chinese film industry in terms of both cultural and commercial strength. The Film Industry Promotion Law encourages and supports domestic films competing with foreign films, by increasing Chinese films' distribution abroad and balancing or reversing the trade deficit of this sector. The Chinese national cinema is the carrier for projecting authentic national images of China through film distribution abroad, allowing other countries and regions to gain more experience of China. However, at present, China is still at a relatively early stage of its films' international distribution. Some films have achieved a new box office record in China but they failed to perform in international markets due to various factors (cultural factors and filmic ideology etc.). For example, *Wolf Warrior 2* (the box office champion in China in 2017) had a weak box office performance in North America. It took only US$190,000 at the box office over three days, which was far less than that of its domestic box office. Some countries, such as the United States and South Korea, long ago started the policy of distributing their films abroad, and have now formed a relatively mature film distribution abroad system.

Hollywood's global film distribution strategy

American movies are very influential and competitive. The six major Hollywood studios in the United States are the main studios for American movies' global distribution. Hollywood films' distribution abroad covers the global film market with emphasis on China, Japan, South Korea, the UK and France. Hollywood distributes many films to international markets, especially blockbusters of different genres, such as science fiction, action, suspense, and romance, etc. Hollywood blockbusters have become a cultural symbol, exporting American heroism and ideology to the global film market, while earning outstanding global box office receipts. There are two main reasons why Hollywood films have achieved such a high global box office. First, as primary superpower in the world, the US has consolidated its status as a leading force in the global cultural industry. Many audiences are willing to learn about American culture, lifestyle, and values through movies. Second, American films are most advanced in terms of production technology. For example, the use of digital technology, 3D special effects, and especially the rise of VR technology in recent years, have provided sensory changes and astounding visual impacts for audiences, bringing a new viewing experience. This is also an important reason why audiences are willing to pay for American movies.

The strategy of South Korean cinema culture

During the long period from the 1960s to the 1990s, South Korean cinema had its period of crisis and challenge. Hollywood's global dominance of the film market, together with the popularity of Japanese cinema, Hong Kong cinema, and Taiwanese cinema, put tremendous pressure on the South Korean film industry. In order to solve the crisis, South Korea formally proposed a strategy which was to define the cultural industry as a pillar

industry for national development in the twenty-first century. The film and television industry has been a key link in the overall strategy of South Korea's development of the cultural industries. South Korea has adopted a series of effective policies to combat competition from Hollywood movies, and to increase the international distribution of South Korean domestic films. In September 1996, the first Busan International Film Festival was held, with screenings of more than 160 movies from 31 countries. The festival was a great success and became a major film event to celebrate Asian films and now is one of Asia's most influential international film festivals. This has greatly promoted the international influence of South Korean cinema and eventually led to the expansion of South Korean films' international distribution. In addition, South Korea also supported the development of its domestic film industry by setting up a Film Promotion Committee, with a quota system and a newly created film distribution system. Since the 1990s, the number of South Korean films distributed abroad has gradually increased. Since 2000, South Korean cinema has penetrated various international markets with a significant number of films distributed in nearly 30 countries in Asia, Europe and North America.

Countermeasures for the international distribution of Chinese films

First, more supporting policies for the international distribution of Chinese films are needed. There are some policies in the Film Industry Promotion Law to encourage and increase the international distribution of Chinese films. In addition, it is necessary to further improve relevant laws and regulations, and make the policies better implemented through various means, such as financial support, policy support and simplifying the administrative procedures.

Second, the government's promotion of Chinese films needs to be strengthened. There are many management departments for films, hence Chinese films' international distribution involves a wide range of sectors and procedures. These departments should comprehensively coordinate the interests of all parties by exchanging information and strengthening the guidance and supervision of international film distribution. They should also communicate more with international film festivals, film exhibitions, and film organizations by holding regular meetings to guide Chinese film production companies and ensure the smooth and steady development of the international distribution of Chinese films.

Third, the international competitiveness of Chinese films needs to be improved. Chinese films should focus on advanced film technology to produce high quality films to tell Chinese stories. Thus, they will appeal more to both Chinese and foreign audiences. Also, Chinese national cinema should enhance cultural self-confidence and project a positive Chinese cultural identity. Large numbers of Chinese people live abroad who strongly self-identify with Chinese culture, and they form another potential market for Chinese films' international distribution.

Conclusion

The innovations of the cultural industry should be in step with the trends of our time. From black and white pictures to "talkies" to today's highly manipulated digital cinema, film has been through a long journey of development. In the era of digital innovation, film still maintains its original entertainment function. As a cultural industry that China strongly supports, film has become a symbol of national development and serves various sectors, such as education, technological development, and the transformation of the political situation.

The Film Industry Promotion Law not only attaches importance to the system construction and improvement of the film industry, but also emphasizes the normative nature of the film market development order, by actively disseminating socialist core values and insisting on cultural security as its mission. The governmental bodies should service and introduce more institutional guarantees for the development of the film industry. The implementation of the Film Industry Promotion Law gives a clear legal remit. Meanwhile, Chinese films still need to conform to the rationalization of related media laws at different national levels. The administrative regulations or departmental regulations related to the film industry should be revised, so that these regulations are in accordance with the Film Industry Promotion Law. Therefore, it is necessary to carry out a corresponding revision and improvement of related media laws to make sure they function in a unifying system at different national levels. In addition, when legislation is approved, very often the law enforcement power is insufficient, which poses an urgent problem for the transformation of the Chinese film policy situation, as the law should be strictly observed and implemented.

Since the 19th National Congress, Chinese socialism has entered a new stage. With the new situation and policies, the development of Chinese films has also entered a new era. Supported by the multi-functional policy of the Film Industry Promotion Law, Chinese films will continue to improve in terms of quality and quantity, strengthen their core competitiveness, and disseminate China's culture, China's voice, and China's image to the international community. All of this will further enhance China's excellent reputation abroad.

18 Copyright issues of Chinese films adapted from the Internet literature

Guanqun Gao

With the rise of online literature, more and more original works, such as online novels and screenplays have been adapted to the big screen. Many online literary works have won both popularity and high box office receipts for their cinematic adaptations. At the same time, many legal issues have arisen, such as contract disputes, plagiarism, and infringement in the process of pre-production, production and post-production, all of which originated from the copyright of online literary works. The industrialization of online literary works and films requires a good industrial environment and a set of reasonable copyright dispute resolution mechanisms.

Overview of Chinese cinematic adaptations of online literature

Definition of online literature

Online literary works refer to literary texts, practical texts and discourse texts represented on Internet media platforms through computer technologies, such as hypertext links and multimedia interpretation. Text types could include poems, plays, novels, biographies, news survey, essays and prose, etc.

The connotations of Chinese cinematic adaptations of online literature

According to Article 10, the 14th item of the Copyright Law of the People's Republic of China, "Adaptation right is the right to adapt a work and to create an original new work." The adaptation right is a kind of property right, rather than a personal right. The adaptation of Internet literary works to the cinema involves transforming words into audio-visual language on the big screen, thus it becomes an original new work.

Films adapted from online literature create a new form of text media communication. The rich expression of cinematic language provides a broad space for online literature. The fact that the work originally appeared online also provides its cinematic adaptation with a large number of existing fans and guarantees good box office. Many online literature readers are willing to watch the adapted movies, so the filmmakers can save huge costs for publicity. The

low cost of adapting online literary works is an important factor considered by the filmmakers.

The development of cinematic adaptations of online literature

Emerging development period (pre-2000)

In 2000, the film *Flyn' Dance*, made by Shanghai Film Studio, was the first online literary adapted film in China. In the 1990s, Cai Zhiheng (net name: Pzi Cai) serialized the online novel *Flyn' Dance* in Taiwan's BBS community which gained huge popularity after its publication in Mainland China. Shanghai Film Studio purchased its cinematic adaptation rights, featuring celebrities such as Chen Xiaochun and Shu Qi in this film, which started the historical process of online literary adaptation in China. In 2001, the online literary work *Beijing Story*, a homosexual theme novel, was adapted by the director Guan Jinpeng into the film *Lan Yu*, starring Hu Jun and Liu Ye. The film won five awards at Taiwan's Golden Horse Film Festival and achieved great success. In the following years, the genres and quality of online literary works continued to improve, yet the cinematic adaptation of online literary works had not yet become a significant phenomenon.

The period of rapid development (2010–2014)

During this period, the number of films adapted from online literature grew rapidly and the quality of such adaptations continued to improve. The genres are mostly romance for young audiences, such as *To Our Youth That Is Fading Away* and *Fleet of Time*.

Many excellent online literary works have provided creative material for Chinese filmmakers and even well-known directors such as Chen Kaige also started making films adapted from online literary works.

The in-depth development period (2015–present)

The State Administration of Press, Publication, Radio and Television issued notices on the promotion of outstanding original online literary works for four consecutive years from 2015 to 2018. The selection and promotion of outstanding online literary works reflected the government's attention and support for the online literature market. This promoted the development of films adapted from online literature, and the genres of films adapted from online literature have also become diverse. At the same time, the three Internet giants – Baidu, Tencent and Alibaba – proposed a strategy of "Internet + Movies." Based on the Tencent video website, Tencent developed high-quality literary works to create a "Tencent Movie +" film and television platform. Baidu established Baidu Literature. By purchasing Chinese reading websites such as Zongheng China and 91 Panda Reading, and by focusing on the

copyright of original online literary works, it integrated Baidu's video and audio platforms, such as iQiyi, to create a full film industry chain. Alibaba has invested in Youku video website and film production companies, etc. and focused on Internet financial capital to establish the film industry. At this stage, with the promulgation and implementation of the supporting policies from the government, the external environment for adapting films to network literature was improving. With the arrival of the multi-network convergence era of telecommunications networks, radio and television networks, and computer communication networks, the film industry has opened a new development stage.

Reasons for the phenomenon of cinematic adaptation of online literary works

To provide high quality scripts to the film industry

A good screenplay is essential to a movie. In China, the role of screenwriters in the entire film industry is constantly marginalized, compared to that of directors or producers. On the one hand, the lack of excellent screenwriters, and the time-consuming and high cost of developing original film scripts have led to a serious shortage of high-quality screenplays. On the other, there are enormous amounts of online literary works of various stories. Screenwriters can extract high-quality novels and adapt them to movie scripts. Many online literary works are already well established in terms of story and artistic/commercial values, which is convenient for screenwriters when making decisions for cinematic adaptation. Thus, online literary works are one major source to solve the problem of the shortage of scripts in the film industry.

Guarantee of high movie box office receipts

For film production companies, the box office is the essential criterion for judging the success of a movie. The high popularity of high-quality online literary works provides a guarantee of its cinematic adaptation's box office. Generally speaking, the bigger the influence of online literary works, the more audiences the cinematic adaptations will have. For example, the movie *Cry Me a Sad River*, which was released in September 2018, focuses on the theme of campus bullying. It was adapted from Guo Jingming's best-selling online novel of the same name. With huge popularity, the film's box office went all the way up the rankings, and finally the film achieved 0.35 billion yuan at the box office.

Copyright issues in cinematic adaptations of Chinese online literary works

Ambiguous boundaries for protecting the integrity of works

According to Article 10, item 4 of the Copyright Law of the People's Republic of China: the author has the right to protect the integrity of the work, that is,

the right to protect the work from distortion and tampering. Protecting the integrity of the work comes under the category of personal rights of the author. The essence of the adaptation of films from online literature is the behavior controlled by the right of adaptation, which comes under the category of copyright property rights. The current Chinese laws and regulations regarding the right to protect the integrity of the work have always been ambiguous. Only a conceptual provision is provided. How to apply it to judicial practice is difficult, which also makes it difficult to control the adaptation of online literary works and movies. Adapting from the text to the screen generally needs to go through the creative process of "online literary works—>movie script—>movie production." First, film production companies should obtain the approval of the copyright owner of the online literary works to adapt its original works through legal authorization. After obtaining the legal authorization, film production companies should find screenplay writers to adapt a literary work to a script. Finally, screenwriters hand over the modified script to a film's producers, according to the requirements of the film production companies. Whether it is writing a screenplay or making a film, it is impossible to be 100 percent true to the content of the original work, so all online literary works face the issue of protecting their integrity.

Regarding the infringement standards for the integrity of works, there has always been an argument in China's judicial practice. There are two kinds of disputes: *Subjective* theory holders believe that any adaptation that does not conform to the original intention of the copyright owner is an infringement. However, the main discourse of *objective* theory is that the authorized person has already obtained the legal authorization to adapt the work, and the original copyright owner should be tolerant of the adaptation. Only when the authorized person's adaptation objectively reaches a degree that damages the reputation of the original copyright owner, then can it be considered an infringement. *Chronicles of the Ghostly Tribe* (with a box office of 688.3 billion yuan), adapted from the online literary work *The Adventures of Three Tomb Raiders* series, was released in 2015. However, in the same year, Zhang Muye, the author of *The Adventures of Three Tomb Raiders* sued director Lu Chuan and the film production company, claiming that the integrity of the original work had been violated. The case caused wide discussion on the protection of the complete right of ownership of the work. The court finally determined that the film did not infringe the right of protecting the integrity of the original work.

The issue of the right of authorship of films adapted from online literature

According to Article 10, item 2 of the Copyright Law of the People's Republic of China: the right of authorship is the right to indicate the identity of the author. Although the current Chinese law states that authors have the right to sign, there is no written terms and conditions for how the authors of online literary works can realize their rights and there is also a lack of relevant guidance on specific issues, such as how and where they should sign. The

State Administration of Press, Publication, Radio, Film and Television's Film Bureau has issued the Regulation of Domestic Film Subtitles, which contains more detailed management methods for film credits, but there is no explicit stipulation on the authorship of original works of adapted films.

Recommendations to improve the copyright issues of cinematic adaptations of online literary works in China

Clarify the boundaries of ownership to protect the integrity of works

China's Copyright Law treats distortions of and tampering with original works as violations of the right to protect the integrity of works. However, there is no specific legal rules on what constitutes a distortion or tampering action. It can only be interpreted literally based on the principles of jurisprudence. Therefore, different people will have different interpretations of the problem from different perspectives.

The following elements should be comprehensively considered when judging distortion. First, protecting the integrity of works is mainly about protection of the main story line of the author's original work. In the process of adaptation, arbitrary changes to the main content and original plots are considered distortions. Second, consideration of the subjective intentional should be considered an element of infringement of the integrity of works. When an online literary work is being adapted to a movie, the adaptor or filmmaker knows but ignores the subjective intentions of the author, and this is called "intentional." Otherwise, for example, due to improper shooting methods of the adaptor or filmmaker, if the film adaptation deviates from the original shooting plan, this would not be considered distortion. Finally, the result of the actual damage should be taken as an element of infringement, such as a damage of an author's reputation or damage of the original work's social reviews.

Implement rules for the authorship right of Chinese cinematic adaptations of online literary works

Authors of online literary works possess the right of authorship. The author has the right to determine whether, when, how, what and where to sign his or her signature as a manifestation of authorship. From an economic perspective, movies adapted from online literary works are often distributed based on the popularity of the original works which already have accumulated a certain number of fans and readers. This could save a large publicity fee. For legislators, improving the implementation details of the right of authorship of adapted films is also in accordance with the legislative purpose of promoting the development of online literary works. In practice, the exercise of the right of authorship often involves the order of appearance of names of authors and screenwriters in the credits of cinematic adaptations of online

literary works. The implementation rules on the right of authorship should be more detailed on this issue.

Establish a film copyright option trading system

A film copyright option trading system refers to the situation when a film production company and an author of an online literary work should sign a copyright transaction agreement for a certain period of time. Thus, within the agreed period of time, the film production company has priority when the author decides to sign a License Agreement. The nature of this agreement is an option priority agreement, during which time the film production company only needs to pay a small fee to secure the development of the cinematic adaptation project. If the development is all going well, the final copyright licensing agreement can be negotiated between the author and the production company with a full copyright fee in accordance with the priority agreement. If the development of the project is not going well, the film production company could abandon the project and lose only a small fee. For authors, on the other hand, signing a film copyright option agreement is only transferring the priority of the issuing the copyright of their work to others, and the copyright is still theirs. Thus, this can prevent film production companies from using online authors' work without their full authorization.

Conclusion

The numbers of cinematic adaptations of online literary works have increased rapidly in recent years in terms of both quality and quantity. Online literary works provide more high-quality scripts for the Chinese film industry. Their established popularity offers a guarantee of the box office of their cinematic adaptations, thus contributing to the prosperity of the film market. At the same time, the issue of ambiguous boundaries to protect the integrity of works and the issue of the exercise of the authorship right also limit the further development of the industry. Clearly defining the legal boundaries of the right to protect the integrity of original works, and improving the implementation details of the authorship right for online literary works, together with the establishment of a film copyright option trading system, will consolidate a strong foundation for the future development of Chinese online literary works.

Bibliography

Guobin, C. (2014). *Theory and Cases of Copyright Law.* Peking: Peking University Press.

19 Developing the integration of the Chinese Internet and the film industry

Luyao Li

The year 2017 was the year of continuous expansion of China's film market. The total box office of China's film market exceeded 55.9 billion yuan. The vigorous development of the film industry has attracted the attention of a group of the major Internet enterprises, such as BAT (Baidu, Alibaba, Tencent). The Internet has reshaped how films are produced, distributed, marketed and screened. On top of that, the Internet has allowed the traditional film industry to be optimized for online interactivity, mobility and fragmentation.

The Internet reshapes the film industry

With the help of new media, big data and other technologies, the Internet has created full integration of resources. With the increased Internet speed, movies made in the era of digital media have had a bigger impact on the industry than the films made previously. The Internet has reshaped the production mode of domestic films and brings new thinking and a breakthrough in film marketing. The emergence of cross-border capital has also provided an important impetus for the development of domestic films. With content as its core, the film industry integrates with the Internet industry to produce diversified and precise marketing, quickly gathers core users and spreads to other audiences, drives the derivatives market, and gradually forms the "industrial chain" of domestic films.

The Internet reshapes the film production mode

In the traditional film production mode, script creation, team building, actor casting and other preparatory work all centered on the director. Project capital, filming technology, publicity and distribution channels, and other resources are mostly undertaken by enterprises. In such a situation, the traditional film industry formed a film production mode where the company takes the lead, while the director and stars are the center of the production team. In the context of the Internet, the mode for domestic film production has changed dramatically. Internet enterprises have unique advantages in big data

utilization. Users change from recipients to participants, which makes the slogan "everyone is the director of life" true. It is necessary for the producer to participate deeply from the beginning of production.

We are in a period of social change. Young people are the main force of online consumption, and the mode of consumption directly affects production. Understanding the needs of young people is the key to film production in the Internet era. The user is the market, and the user is the center. The video website is not only the investor, but also the channel and the producer.

The Internet reshapes film distribution

Traditional methods of film distribution include cinemas, TV stations, film and television companies, etc. With the advent of the Internet, China is the country with the largest change in film distribution mode. The traditional cinema mode is now challenged. Online video websites attract a large number of users by virtue of content diversity, broadcast nonlinearity and portability of the viewing equipment. The numbers of videos on iQiyi, Tencent Video, Sohu Video and other major video websites have increased dramatically. In 2017, video websites became the new battlefield of film distribution with a higher degree of content segmentation. At the same time, with the rapid development of the Internet, and ticketing platforms such as MaoYan movie, Taobao movie and Gewara movie, film distribution has been changed by virtue of the advantages of "data + users." These ticket platforms provide online ticket sales, seat selection, and other services, and change the traditional offline box office recycling mode into an "online + offline" mode, which advances the traditional ticket purchase time before the film is released, causing a change in the film distribution mode.

The Internet reshapes the film marketing mode

The era of Web 2.0 has given the Internet interaction characteristics. This has become the biggest tool of film marketing in the new media era. The traditional film marketing mode is dominated by advertisements, posters and film press release conferences, which are characterized by high consumption and short duration. In the age of the Internet, Weibo and WeChat are the two social media platforms that are the biggest exporters of movie marketing. Sina Weibo has set up an interactive platform between the film creation team and the film audience, with 297.5 billion film articles in 2015. Weibo platform has become a huge data platform, reaching users through precision marketing. The movie *Monkey King: Hero Is Back* was effectively marketed with the help of Weibo during its release. With the help of "tap water," the final box office reached 950 million yuan, achieving a box office reversal. Unlike Weibo, WeChat users have strong connectivity.

On the one hand, all major cinemas have set up a public WeChat account to convey the latest movie information to the users. On the other hand, the new applications of WeChat application and expression pack provide more channels for film marketing. Taking *Monster Hunt 2* which was released on the first day of the Spring Festival in 2018 as an example, WeChat formed a closed-loop marketing chain from watching movies to buying ticket apps. During the Spring Festival, the New Year expression pack of *Monster Hunt* was favored by users.

The Internet reshapes film screening

Cinema is the main channel for Chinese films. But only less than a third of the films produced in China are shown in theaters every year. This means that the remaining films do not reach audiences or are put into the industrial chain in order to achieve profits. With the development of network technology, mobile communication technology, and new business models, online video websites are becoming a comprehensive platform integrating content production, marketing, promotion and broadcasting. Online paid viewing is increasingly being accepted by more users. Personal computers and mobile devices become the realization mode of multi-channel projection after the cinema screen. In future, home terminals and intelligent hardware terminals will become the next preemptive position.

As of December 2017, the number of Internet users in China reached 772 million, while the proportion of young Internet users reached 500 million, which accounts for more than 70 percent of the total number of Internet users. Most of the paying customers of video websites are young users, aged between 19 and 30 years. The group of young users is huge; they have the highest requirements for content and a strong willingness to pay. The data show that in 2016, the number of paid users reached 74.7 million, and the payment penetration rate was only 13.7 percent. In 2017, the number of paying customers reached 112 million. It is expected that in the next three years, the number of paying customers will exceed 250 million, and the payment penetration rate will reach 47.3 percent. Of them, the market size of paying customers will reach 45.846 billion yuan. If unforeseen factors are included, the market size can reach 60 billion yuan or even 100 billion yuan.

How to integrate the film industry and the Internet enterprises represented by BAT

In recent years, a large number of Internet enterprises represented by BAT have begun to take part in the film industry, relying on a large number of user groups to achieve seamless docking between film products and target users, and penetrating into all aspects of the film industry chain. The Internet can be seen in script selection, fund raising, film shooting, distribution, screening, publicity, etc.

Film production data

Big data have changed the production mode of Chinese films. In the Internet age, every click is network flow, every network flow is data, and every bit of data is the label of users, which represents the value pursuit and aesthetic standards of users. In terms of creation, users have changed from one-way receivers in the era of traditional films to being active participants in the market. With the rapid development of Internet technology, when the film is examined by the investors, it not only requires the attraction of the script content but also requires the demand summary and revenue and expenditure estimation after big data analysis. With specific data support, it is more persuasive in negotiation and cooperation. Moreover, because the high-quality content itself accumulates a large number of fans, in addition to the audience, who can be directly converted into film consumers, it also plays a very important role in the publicity process of the film.

In future, we will open up the whole industrial chain from the original script to the consumer level, and use data to connect with the service providers vertically. The main direction of data-based production is to connect the advertiser's e-commerce with accurate data, extend the upstream and downstream, and give timely feedback.

Diversified financing modes of the film industry

Traditional film industry financing channels are relatively single, focusing mainly on advertising, bank loans and pre-sale copyright. Famous directors and large-scale productions are often given priority access to these resources. In recent years, the rise of Internet companies has diversified the financing methods of the film industry, and cooperative introduction, joint self-made, brand self-made, investment and production modes have brought innovation in financing. "Online crowdfunding" has become a new method of film financing. Crowdfunding is a convenient and instant financing platform that lets the public participate. Users can contribute any amount to a movie, and get some additional rights and benefits when they give a certain amount, such as meeting their favorite stars in the film crew, visiting the film shoot, etc. At present, the projects of movie crowdfunding available to the public include "entertainment treasure" and "BaifaYouxi," which provide users with a sense of participation. Users can turn their favorite intellectual property (IP) into a movie project without leaving the comfort of their home. Network crowdfunding puts social funds easily into film financing, which to a certain extent breaks the investment monopoly situation of large film and television companies in the film market. It provides opportunities for some minor films and small productions to enter the film market. As a new channel for "Internet +" films in the production process, "Internet public funding" has even played a role in promoting film publicity to a certain extent, and has

become a "marketing mode under the financing shell." For example, with the help of "entertainment treasure," Alibaba film makes everyone an investor and gain dividends through a small amount of investment, so that financing can penetrate into all links.

Movie script intellectual property (IP)

For a long time, Chinese films have been faced with the lack of original scripts. The advent of the Internet era has broken the tradition that script production can only be done by professional screenwriters. The production of movie content changes from finding a good script to finding a hot IP. Internet novels, online games, online comics, and online songs are all likely to become a hot IP. IP became a hot word in the film and television industry in 2014, which can be said to be the first year of domestic IP movies. Before that, there was no movie based on existing IP in the domestic film industry. In that year, many major projects announced by film and television companies centered on IP adaptation. For example, Tencent established the film and television business platform "Tencent film +" with high-quality IP as the core, focusing on the adaptation of film IP. Ali film industry also solemnly launched a "popular IP + fan film + celebrity director" mode of film project – *Ferryman*, which was directed by the famous writer Zhang Jiajia. If 2014 is the year of the birth of IP, then 2015 was the year when the IP battle became increasingly fierce. Major film and television companies not only scrambled for popular IP, but also built IP to become an important direction for major film and television companies to establish diversified business development channels. Looking back at 2015's domestic hot movies, there are 28 film adaptations of Chinese IP, which made nearly 8 billion yuan at the box office, including *Goodbye Mr. Loser*, *Wolf Totem*, *Mojin – The Lost Legend*, *Running Man*, *You Are My Sunshine*, *Forever Young*, and *The Left Ear*, etc. Among them, *Goodbye Mr. Loser*, *A Hero or Not*, and *Monkey King: Hero Is Back* and other films have won both box office and public praise, and even become the black horse of the annual box office. Due to the high box office capacity of IP films in the summer archives in 2015, major film companies are still optimistic about the influence of the IP boom, so 2016 was still a year of IP content flooding. However, the popularity of IP to the movie spectator seems to have cooled down in 2016. The top six IP films in the total box office are all over 600 million yuan, but only *Time Raiders* barely exceeded 1 billion yuan. But as the top IP, *Time Raiders* seems to have less influence than expected. In recent years, IP movies have been almost regarded as the magic weapon of success by the film and television industry, but gradually they seem to be showing some shortcomings. In 2017, after the decline of the IP boom, the online movies are moving forward with high-quality products.

Flexible film screening

The development of film technology directly determines the level of film productivity, which guarantees the innovation of the screening conditions. The impact of the development of technology on film is obvious. The first benefit is the cinema market. From traditional cinemas to IMAX halls, from 2D to 3D, a huge market has already been formed in China. Through constantly updating the network terminal, the naked eye 3D will not be difficult to be put into practice in cinemas. Within the next ten years, 3D holographic images can be projected through mobile devices or an even more sophisticated piece of technology. At the same time, with the progress of science and technology, the content carrier is also transferred from the PC to the mobile. The era of increased broadband will bring the ultimate network speed experience. The coming 5G technology will stimulate the full popularization of high-quality streaming media, and network audio-visual will enter the era of "big video." After Baidu's acquisition of iQiyi and PPS, almost all movie lovers can be satisfied by using these video platforms to show movies; Alibaba film industry is also actively involved in traditional cinema lines, investing in Dadi cinema, trying to create a screening mode that combines online and offline, meeting the viewing habits of different audiences, and realizing no dead ends in watching movies.

Diversification of film derivatives

At present, the main source of profit in China's film industry is the box office, while in other developed countries, the box office is not as important as other sources of income, as the box office only accounts for one-third of the total income. In addition to the film itself, many other forms of film products have been developed to make profits. The profit model of domestic films will also change dramatically, and the film industry ecosystem, which is comprised of upstream, copyright, midstream, production, promotion, downstream, and derivative market is in full swing. With the development of "Internet +" films, the value of derivatives is once again taken seriously and is involved in the profit link. The products derived from movies, including toys, office supplies, clothing, games, animation, catering, and theme parks, bring new opportunities for the prosperity of the derivative market and improve the film industry chain. With the help of Alibaba, Taobao, and other e-commerce platforms, Alibaba film analyzes the purchase behavior of businesses and users through big data technology, and develops derivatives accurately.

Strategies for the integration of traditional film companies and the Internet industry

In the face of the development trend of "Internet +" movies, the traditional film companies should follow certain strategies: (1) establish user-oriented

customization; (2) build a content-based ecosystem; and, finally, (3) promote cross-border operation with the idea of "Internet +."

Establish user-oriented personalized customization

In the Internet age, personalized movies and accurate user groups can improve the loyalty of users and extend their influence. In recent years, users' demand for different works has grown, aesthetic requirements have improved, and more fresh content is needed to stimulate the senses. This requires us to be user-oriented, have the ability to predict, find the needs through data, meet the needs through a variety of services, and create needs through personalized recommendations. Traditional film and television companies can only make steady progress in the Internet era if they focus on subdividing content and identifying users.

Build an ecosystem supported by content

In the 100 years of film development, every technological advance has brought a new sensory experience to the audience. But movies are always supported by content. Traditional film companies can use projects to tap deeply into the social and commercial value of the story and maximize the value of the content. The Internet has changed people's consumption mode and service concept, but that does not change the essence of the movie. The movie also needs high-quality content as support. For example, the domestic animated film, *Monkey King: Hero Is Back*, released in the summer of 2015 is adapted from the old IP *Journey to the West*, but it retells the classic tale in a unique way which gets audiences interested, resulting in a huge profit at the box office. High quality content is the foundation of the sustainable development of domestic films. Instead of buying IP blindly, it's better to build a new IP with real value.

Promoting cross-border operations with the idea of "Internet +"

In the era of "Internet +," the boundaries between industries are blurred, and movies interact with other industries in depth. Cross-border marketing can make movies popular in a short time, extend the industrial chain and expand the profit space. Traditional film companies should break the boundaries of branding, publicity and platform, and develop high-quality integrated products. To some extent, this will change the marketing mode of domestic films, which focuses on box office earnings, and make the profit mode of films more diverse and effective.

The advent of the Internet era has brought new opportunities and challenges to the development of China's film industry. It has reshaped film production, distribution, projection, and marketing. Through this change, the traditional film industry can only achieve leaps in development by putting the users first, giving priority to content, and taking "Internet plus" as the pattern to follow.

20 The UNESCO world "City of Film"

A new engine to boost Qingdao's urban development

Shuzhen Sun

Located on the eastern coast of China, Qingdao is a beautiful, fashionable and creative coastal city with a permanent population of 9.29 million. Qingdao's film history can be traced back to the beginning of the twentieth century. It is the birthplace of Chinese cinema, also known as a "natural environmental studio" for Chinese film and television because of its pleasant climate and beautiful scenery. Furthermore, it has been praised as China's "cradle of film and television stars" as Qingdao is the home of a number of well-known movie stars. In recent years, Qingdao has promoted cinematic creativity as a significant strategic factor for sustainable urban development. From the perspective of the pattern of global film development, it has established policies to support the development of the film industry and planned to build a 44-sq km film and television cultural industrial zone. With the construction of the world's largest film and television shooting base, Oriental Movie Metropolis, more than 150 film and television companies were established and located in Qingdao, and many film and television companies or studios from around the world come to undertake film production in Qingdao. The internationalization and the high-end technology of the film and television industry both contribute to making Qingdao the most promising film and television city in China.

Qingdao, the UNESCO "City of Film"

Founded in 2004, the UNESCO Creative Cities Network (UCCN) aims to strengthen international cooperation between cities that view creativity as both a strategic factor for sustainable development and an important element of urban development. It aims to integrate culture and creativity into local developmental strategies and plans, and promote exchanges and cooperation between member cities in the development of creative industries, professional training, knowledge sharing, and the dissemination of products and services.

The Creative City Network covers seven creative city types: Design Capital, Film Capital, Crafts and Folk Art Capital, Food Capital, Capital of Literature, Media Art Capital and Music Capital. Currently, the UNESCO Creative Cities Network has already included 180 member cities from 72

Table 20.1 Twelve cities approved by UNESCO as Creative Cities

Types	Creative City	Approval date
City of Film	Qingdao(Shandong province)	October 2017
City of Design	Shenzhen (Guangdong province)	November 2008
	Shanghai	February 2010
	Beijing	April 2012
	Wuhan (Hubei province)	October 2017
City of Crafts & Folk Art	Hangzhou(Zhejiang province)	April 2012
	Suzhou (Jiangsu province)	December 2014
	Jing Dezhen (Jiangxi province)	December 2014
City of Gastronomy	Chengdu (Sichuan province)	February 2010
	Shunde (Guangdong province)	December 2014
	Macau	October 2017
City of Media Arts	Changsha (Hunan province)	October 2017

countries. On October 31, 2017, Qingdao was awarded the title of world "City of Film" by UNESCO, one of the 18 "City of Film" sites approved by UNESCO as well as the first "City of Film" in China (Table 20.1).

The rationale for Qingdao's application for UNESCO's world "City of Film" award

The UNESCO Creative Cities Network was founded in 2004 and covers seven areas: design, film, literature, music, media art, crafts and folk art and food. Initially, Qingdao also considered applying for "City of Design" in 2010. However, due to the large gap between Qingdao and other cities who were planning to apply at that time, such as Beijing and Shanghai, in terms of design resources, it did not submit its application. In 2011, following further research, Qingdao decided to apply to be the "City of Music," and the relevant governmental bodies formally submitted an application to the National Commission for UNESCO of China; however, for various reasons, the application was not successful. Based on the lessons learned from this unsuccessful application, the committee in Qingdao thoroughly studied the successful experiences of cities such as Beijing, Shanghai, Shenzhen, Hangzhou and Suzhou, and conducted a comprehensive SWOT analysis of Qingdao's own advantages and disadvantages, opportunities and challenges. Qingdao finally decided to apply to be the "City of Film" in 2015.

The reasons why Qingdao had respectively considered applying for "City of Design," "City of Music," and "City of Film," and finally decided to apply for the latter can be explained by the following three aspects.

First, of all the seven areas, film has a stronger connection to social culture than design and music, etc. It is more relevant to the strategy of promoting China's cultural power and can better represent Chinese cultural identity and tell Chinese stories internationally. Chinese national cinema is ideal for

spreading Chinese ideology and Chinese culture and promoting Chinese influence in the world.

Second, film is an essential cultural industry. Chinese film industry is growing significantly, and China is also becoming an influential country in the global film market with its huge box office earnings. Compared to music and other creative fields, the film industry possesses a comprehensive industrial chain and far-reaching influence. It plays a leading role in the cultural industry, and promotes cultural creativity and the development of related industries and the overall competitiveness of the city.

Third, relying on its remarkable film culture and related industrial foundation, Qingdao has a strong advantage in applying to be the "City of Film." It is a "natural environmental studio" as well as a "cradle of movie stars" in China. Especially in recent years, the Qingdao Municipal Party Committee and the Municipal Government have attached great importance to the development of the film and television industry, striving to create a culture brand for the city as "the city of film and television," and considering the film and television industry as an important strategy for sustainable urban development. Qingdao has formulated a high-end film and television industry development plan, and created the most favorable filming subsidy policy in the world, with the establishment of the Lingshanwan Film and Television Cultural Industrial Zone and the largest film and television production base in the world. A world-class software and hardware service system is also in place. In addition to this, it is attracting high-end film resources from both domestic and overseas markets for the development of a world-class film and television industry chain ecosystem, and is vigorously promoting the prosperity and development of film and television industries. A trillion-scale film and television industry cluster are taking shape. Qingdao has become the "new magnetic pole" and China's most promising "city of film and television."

The history of Qingdao's application to be the "City of Film"

As of 2015, UNESCO had approved eight cities as world "City of Film" sites, i.e., Bradford (UK, 2009), Sydney (Australia, 2010), Busan (Korea, 2014), Galway (Ireland, 2014), Sofia (Bulgaria, 2014), Bitola (Republic of Macedonia, 2015), Rome (Italy, 2015) and Santos (Brazil, 2015).

In view of Qingdao's good foundations in natural environment, history and culture, film talents and its existing film industry, the Qingdao Municipal Party Committee and Municipal Government reviewed the situation and worked out a strategy for applying to become the City of Film in 2015. The application points scheme included the "2016 Work Points of the Municipal Party Committee's Steering Group on Deepening Reform" and the "Government Work Report." In 2017, the Qingdao Municipal Bureau of Culture, Radio, Film and Television Press and Publications Bureau established the "City of Film" Application Office to fully oversee the application process and the city officials visited Hangzhou, Suzhou and other cities

to learn from their successful experiences. The Shanghai Center for World Heritage Protection and the Research Center of the UNESCO Asia-Pacific Region were commissioned to organize the documents of the application and to promote Chinese ideology. The Application Office also strengthened liaisons with creative cities at home and abroad, and steadily promoted the construction of the Qingdao Film Museum and other related work.

In 2017, Qingdao's endeavors in the application for "City of Film" finally paid off and they were successful. From May 22–24, 2017, Qingdao organized an expert review meeting to apply for UNESCO "City of Film": status. From June 6–8, the Qingdao Municipal Government held the UNESCO Creative City Network Film Capital Summit. The representatives of the world "City of Film" and the representative of Qingdao jointly released the "City of Film Qingdao Declaration." On June 15, Qingdao submitted the application documents to the National Committee of UNESCO and the Mayor of Qingdao, with the letter of support from the China Film Association and the China Film Review. On June 19, the Northeast Asia Regional Consultation Meeting on the Convention on the Protection and Promotion of the Diversity of Cultural Expressions, sponsored by UNESCO, was held in Qingdao. The image of Qingdao as the center of a booming film and television industry was well promoted, and this consolidated the foundation for Qingdao's application for the world "City of Film" award. On July 21, Qingdao entered the judging process through UNESCO's technical review. In August, UNESCO conducted the final review of the creative network of the city. On October 31, the list of new cities in the UNESCO Creative Cities Network was announced, and Qingdao was awarded the title of "City of Film."

The journey that Qingdao followed to become "City of Film" was not an easy one. Qingdao has expended a great deal of effort on this application in the past two years. The Municipal Party Committee and the Municipal Government set up a Film Capital application working group to coordinate and mobilize the power of ideology, culture, finance, foreign affairs, education and other related departments to fully promote the application preparation.

The Qingdao Municipal Bureau of Culture, Radio, Film and Television Press and Publications Bureau established the Film Capital Application Office to scientifically analyze the domestic and international situation, and coordinate the mobilization of the relevant departments and the strengths of all sectors of society. Based on the successful application experiences of creative cities at home and abroad, and carefully evaluating the criteria for "City of Film," they explored the advantages of Qingdao's film industry as well as what might be the shortcomings. After establishing a solid plan for the application, including systematic management and coordination of the reporting route, and key links, they formulated strategic advancement plans and work schedules, etc. The application work was carried out in seven application categories: application material, UNESCO, the world "City of Film," hardware construction, film exchange activities, domestic and international

publicity and information liaison. Qingdao officials have constantly led the team to take advantage of all opportunities to win the support of UNESCO and the National Commission for UNESCO of China. Hence, they completed the construction of Qingdao's Film Museum to the highest standards, and updated all the working hardware, and created the bold slogan "Qingdao, a city born for film." At the same time, they carried out international communication and cooperation, continuously expanding Qingdao's "circle of friends" in the creative city network, and organized a series of film and cultural activities to conduct multi-dimensional publicity. There were dozens of trips to Beijing for docking application work with ten revisions to improve the application documents. There was also mobilization and planning to build three distinctive film museums, and to secure letters of support from the China National Commission for UNESCO, and the Film Industry Association and other institutions. The committee held a total of 12 international and domestic film exchange events, and hosted a high-level UNESCO international conference, which consolidated Qingdao's close relationships with 8 domestic creative cities and 8 foreign cities with the title of world "City of Film." Twelve cooperation agreements were signed with two world "City of Film," which promoted the strength of Qingdao's film sector to the President of the UNESCO, the President of the Executive Board, and the Director-General and the Assistant Director of Culture, etc. Qingdao's film and television colleges, enterprises and social groups all actively assisted the application, such as visiting Paris to invite renowned filmmakers to promote Qingdao's film industry through various means. Through such continuous efforts, Qingdao has gained high recognition from UNESCO and the experts in the domestic and the international film industry, and ultimately successfully secured the application.

With a new development strategy, the supply-side structural reform, and accelerating this transformation through a new and dynamic energy, Qingdao aims to create a cultural and creative industry with film as its major component. The means Qingdao had to seize its opportunities, and face its problems, which means taking on such historical responsibility to be the pioneer for the integration of culture + economy + technology. This fully demonstrates a commitment to the aims expressed in Qingdao's Declaration. The Declaration lays down future plans for Qingdao's role as "City of Film," and explains the hard work still to be undertaken, the journey ahead and the perseverance in the entire process. It also demonstrates the strong determination of the people of this island-city: to remember this mission and to courageously take on the responsibility.

The significance of Qingdao's application to be the "City of Film"

Qingdao has become China's first "City of Film" and the ninth one in the world. This will vigorously promote the development of Qingdao's film industry and accelerate the pace of Qingdao's international communication,

which will improve Qingdao's reputation and influence on the international stage. This could be achieved by the following four methods.

First, Qingdao needs to fully maximize its strength in terms of its natural environment and its history and culture as a coastal city. Creativity can be an engine to promote the integrated development of Qingdao's environment, culture and economy. Qingdao will be made into a creative film city comparable to the world's great other coastal cities, and this will contribute to the development of cultural and creative industries in China, Asia and the world as a whole.

Second, by taking advantage of the leading and radiating role of Qingdao's creative industries, and by maximizing their potential to attract global creative resources, Qingdao will be established as a vibrant center which will become a global hub for international creative talents.

Third, there is the need to bring out the creative potential of ordinary people, and to encourage them to participate in the construction of a creative city. By sharing the achievements of the creative industries, people can make their own contributions to the protection of cultural diversity and the development of creative industries worldwide.

Fourth, we need to promote Chinese culture to "go out into the world," and enhance the "soft power" of China. Throughout the hundred-year history of film's development, film has become the most popular media because of its easy-to-understand and entertaining features. Chinese national cinema is also the important carrier for projecting national/cultural identity to the world, which enhances China's cultural influence internationally. Qingdao's status as "City of Film" will maximize the role of cinema as a vehicle of mass media, which will further spread Chinese culture and its influence, and enhance the soft power of China.

The foundation and advantages of Qingdao becoming a world "City of Film"

The reasons why Qingdao was able to become China's first "City of Film" were not only because of its unique natural environment and deep-rooted film culture, but also because of strong support from the film industry and its creative talent. Qingdao has an intimate relationship with film. It was one of the first Chinese cities to screen films for commercial cinema in China. Qingdao has the first cinema operated by Chinese people, with the earliest Chinese documentary and the first 'talkie' being shot in China. This demonstrates Qingdao's rich cultural heritage of film. From the high-end film industry development plan to the most favorable filming subsidy policy in China; from Lingshanwan Film and Television Cultural Industry Zone to Qingdao Wanda Film and Television Industrial Park, the city of Qingdao has established the largest film and television production base in the world. With the high-end film resources from home and overseas, and the construction of the film industry chain, a 100 billion yuan film and television industry agglomeration

is taking shape. Qingdao is becoming the "new magnetic pole" of the film industry and the most promising "city of film and television" in China.

A long history of "natural environmental studios"

Qingdao is a harbor city with mountains, gardens and much historical architecture, attracting millions of tourists every year. Its unique natural features and cultural customs attract large numbers of film crews to shoot films there. As a "natural environmental studio," with its seashore, beaches, Chinese and Western architecture and picturesque streets, it offers beautiful locations and sceneries for mise-en-scène and cinematography. Early Chinese films such as *Peach after the Robbery*, *Sons and Daughters of the Storm*, *Go to Nature*, and *Gold and Sand* were all shot in Qingdao.

The beaches at Shinan, Eight Great Passes, Luxun Park and Old Lane are the commonest places used as settings for movies such as *Miao Miao* and *Sons and Daughters of the Storm*. The TV series *Soong Ching-ling and Her Sisters*, *Family Status*, and *Summer Days in Midsummer* were all shot in the beautiful scenic location of Eight Great Passes. At present, more than 200 film crews come to Qingdao every year. Some outstanding works include *Tough Guy*, directed by Dingsheng and starring Liu Wei, *Chinese Divorce*, starring Chen Daoming, and Jiang Wenli's *The Strong Woman*, starring Hai Qing.

Throughout the world, only cities that meet the demanding requirements of film in terms of natural environment, economy and culture, etc. are likely to become economically sustainable to be the "City of Film" for the long term. Thus, over the years, film becomes an integral part of a city's image, and is transformed into an important dimension of a city's urban cultural identity, finally becoming a "City of Film" in people's minds. Over the past 100 years, Qingdao and its cinema have grown together and have benefited from each other in this mutual relationship, perfectly achieving the inseparable symbiotic relationship between the city and its cinema. Qingdao is known not only as a "natural environmental studio" but also as one of the most important cradles of Chinese cinema. The city has risen rapidly with the growth of its film industry – just like Los Angeles and Hollywood.

For the past 100 years, Qingdao has witnessed the development of Chinese film, with many unique film heritage landmarks in the city, which have become an indelible memory of its urban culture. The Sailors Club, located at No. 17 Hubei Road, is the earliest preserved historical building in China which was used for commercial film screenings. It has a history dating back more than 100 years. Similarly, in 1931, the first Chinese-run cinema in Qingdao was built in Zhongshan Road. This cinema, the Shandong Grand Theater – the predecessor of Chinese cinema – is still in operation and is turning to a new chapter nowadays. In order to preserve the precious memories of Qingdao and Chinese films in the future, in 2015, Qingdao systematically promoted the construction and development of the Film Museum, encouraging local organizations to protect and develop Qingdao's film heritage. In April 2016,

Qingdao Butterfly House Film Museum was officially opened to the public. On May 20, 2017, the oldest commercial cinema in China, the former site of the Sailors Club, was transformed into the 1907 Film Museum, which was inaugurated on September 20, 2017. The Qingdao Film Museum, which integrates film and technology and is sponsored by the Qingdao Municipal Government, was located in the Lingshanwan Film and Television Cultural Industry Zone on the West Coast. Qingdao now has three film museums with different themes, and they have become a new platform to showcase Qingdao's film heritage to the world. The museums have also become a powerful part in Qingdao's local communities' efforts to build the "City of Film."

Oriental Movie DreamWorks: a studio that aims to compete with Hollywood

Behind the successful application for world "City of Film" status is the strong support of Qingdao's booming and fast-changing film and television industry. Qingdao has always attached great importance to the development of its film industry, and has always considered cinematic creativity an important strategic factor in sustainable urban development. Starting from its vision of global film development, Qingdao has actively connected with the international community.

Several reports on industrial development and other policy initiatives were written to support the development of Qingdao's film industry. These reports include "Opinions on Promoting the Construction of Cultural Qingdao and Building a Strong Cultural City" and the "Qingdao High-end Film and Television Culture Industry Development Plan (2014–2020)". These laid out an overall development strategy for the city of Qingdao with the film industry as the key player, and pointed out various ways for the integration of film and television with other economic sectors, such as manufacturing and tourism in the city.

The "Opinions on Promoting the Development of the Film and Television Industry" focus on the key links of the development of the film and television industry, such as the land, taxation, investment and financing, quality awards, talent and other aspects of targeted support. The city-level key film and television enterprises, celebrity studios, film and television industry parks and film and television shops were identified as the four key support targets, together with subsidies for outstanding films produced in Qingdao. In 2016, Qingdao Municipal Government and Wanda Group jointly launched a special fund for the development of the Qingdao Oriental Film and Television Industry, with a total cost of 5 billion yuan (investment of 1 billion yuan per year for five consecutive years) to subsidize production costs for "excellent film and television productions" completed in the Qingdao Lingshanwan Film and Television Cultural Industry Zone. The scope of subsidies includes renting exterior sites, studios, setting up sets, renting equipment, hiring extras, food and accommodation, transportation, costume props and post-production, etc. These subsidies can cover up to 40 percent of production costs and 10 percent of tax

refunds. It is currently the most favorable film support policy in the world, and the subsidy for a single film can go up to 120 million yuan.

The West Coast New District's good location allows optimum industrial planning, using new dynamic energy to create the Qingdao Lingshanwan Film and Television Cultural Industry Zone with a total planned area of 44 square kilometers. Film and television enterprises that are located there will receive financial support covering 10 percent of their annual operating costs. At present, the Industry Zone is led by "Oriental Movie Metropolis" and attracts a large number of specialized organizations and talented people. Since the first quarter of 2018, it has attracted 159 film and television organizations to settle there, building a whole industry chain covering film and television scripts, filming, production, distribution, screening and sales promotion, etc. A number of cultural industry agglomerates with a total investment of 150 billion yuan in film, television, art and digital creativity have been established. Qingdao's Lingshanwan Film and Television Cultural Industry Zone has become a major platform for the exploitation of new dynamic energy in Qingdao.

The Qingdao Oriental Movie Metropolis, which aims to be the "Oriental Hollywood," has a total investment of 50 billion yuan and covers an area of 376 hectares, which makes it the largest film and television industry base in the world. The film and television industry park, Wanda Mall entertainment business, Binhai hotel group, Grand Theater, the International Theatre, the Yacht Club, the international hospital, the international school and other multi-sector functional areas have all been completed. The Oriental Movie Metropolis forms a complete film ecosystem, with the film industry park as its core and the surrounding industries as the supporting materials. Covering an area of 166 hectares, it is China's first film and television industry park that provides a full range of production services and competitive subsidies for filmmakers from around the world. It is committed to working with leaders in the global film industry. It helps the development of China's film industry by creating a new base for the film industry, and is the world's largest and most attractive production base. The Oriental Movie Metropolis Park production area will have 52 high-tech studios of the highest international standards. Thirty studios will be completed in the first phase and 10 studios will be built in the second phase, including the world's largest single studio with an area of 10,000 square meters, the world's only indoor and outdoor combined underwater cinematography studio, film and television costumes and props studio and the world's most advanced film and television post-production studio. The Industrial Park's exterior covers an area of 60 hectares, equipped with a street built in European and old Shanghai style to meet the shooting needs of different types of film and television work. In addition to a large number of super-advanced facilities, the unique "Service +" platform of the Film and Television Industry Park cooperates with well-known equipment brands of the global film industry, and jointly launched the highest quality one-stop production service. When this project has been completed, it is estimated that

30 foreign feature films and 100 domestic film and television works will be produced in Qingdao's Oriental Movie Metropolis every year. At present, there are many Chinese and foreign blockbusters being shot and edited here, such as *The Pacific Rim: Thunder Re-emergence*, *Crazy Alien*, *Wandering Earth*, and *Hope Island*. *Great Wall*, directed by Chinese filmmaker Zhang Yimou and produced by Legendary (Hollywood), was awarded 16 million yuan in film production subsidies.

Qingdao issued a series of policies to offer the film industry more needed support, and integrated multiple advantages to form a powerful synergy. Qingdao not only has the location resources of "red tiles, green trees, blue sea and blue sky," but also has world-class film and television facilities, a comprehensive production guarantee, the world's highest subsidies and abundant reserves of talent. Qingdao's dream of film has grown from the simple "cradle of stars" and "natural environmental studio" to today's "Oriental Movie Dream Factory" that can compete with major studios in Hollywood. In summary, Qingdao's Lingshanwan Film and Television Industry Cultural Zone of about 44 square kilometers, enjoys a total investment of 150 billion yuan, including 5 billion yuan of special funds for film and television industry development, and a production cost subsidy policy of up to 40 percent. There 159 film and television companies/studios make an average of 200 films per year, accounting for one-third of Chinese mainland films and television dramas. All these figures demonstrate the rapid rise of Qingdao's film industry.

A rich and profound film culture

Qingdao is a famous historical and cultural city in China. Located on the Yellow River and near Mount Tai, the Chinese cultural tradition represented by Confucius constitutes the cultural background of Qingdao. Facing the Pacific Ocean, the influence of various foreign countries has left an indelible imprint on the city. This blend of Chinese and Western cultures, including Qingdao's own marine culture, means that multiculturalism has become the city's most distinctive cultural identity.

Film not only blends into every corner of Qingdao, but is also deeply immersed in its soul and in the daily life of its citizens, which makes film the most important and unique urban cultural emblem of Qingdao. There are three film museums, more than 20 film clubs, and more than 60 cinemas in Qingdao. Various cultural events such as film salons and open-air film screenings have been deeply integrated into public life. Watching films together has become an important way for people to enjoy themselves, especially in the holidays, when many cinemas in Qingdao are crowded with long queues. According to statistics, the city's movie box office revenue earned 515 million yuan in 2017 (Figure 20.1). It is the audiences' passion for movies and strong purchasing power that are behind the good performance of its box office.

In order to bring film culture to its ordinary citizens, as well as the commercial screenings, Qingdao has turned the streets and lanes into the "second

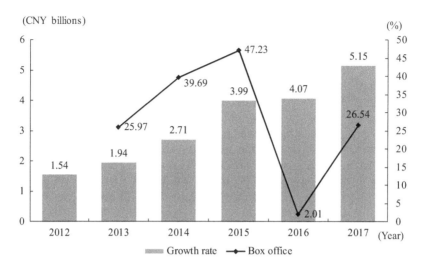

Figure 20.1 Qingdao box office earnings and growth rate, 2012–2017.

cinema line" for public welfare film screenings. With the aim of meeting the basic cultural needs of urban low-income residents, migrant workers, and special groups such as students, the elderly and the disabled, Qingdao continues to increase its spending on public cultural services and on the expansion of the coverage and service targets of public film screenings. Qingdao widened the audiences for films by showing them to people in the countryside, the local urban community, construction sites, public squares and welfare institutions.

More than 70,000 public welfare films were screened throughout the year. Qingdao founded the Farmers Film Festival in 1998 and the School Film Festival in 2001. Subsequently, they have been held year after year, continuing to this day. In recent years, through strengthening facilities, enriching the supply of film sources, improving the quality of screenings, and broadening service channels, Qingdao's public film service has gradually improved, and people's spiritual and cultural life has become increasingly rich. In order to meet the new expectations of citizens for a better life and to increase their cultural benefits, Qingdao will also organize a film festival for its citizens and carry out a series of film and cultural activities such as Watching Movies with Parents and A Celebration by the Ambassadors of the Film Capital, to encourage the public to express their feelings and to share the fruits of cultural development. Film is becoming a spiritual ambassador and cultural brand of this charming city, which is full of vitality.

Qingdao has always attached great importance to cultural exchanges with the international film industry, and has held international film activities, such as New Zealand Film Week, Indian Film Week, Sino-French Film Week and German Film Week, etc. Appreciation of outstanding Chinese and foreign

films and the talks by the filmmakers held by the 1907 Light and Shadow Club, the Qingdao Literature Museum and other organizations, have become frequent, creating a paradise for film lovers. In 2016, Qingdao signed a Memorandum of Understanding on the City of Film with Bradford in the UK, and held a film summit in Los Angeles to promote Qingdao's film and television policy globally. In June 2017, Qingdao Municipal Government invited the world "City of Film" cities to participate in the world "City of Film" conference in Qingdao, and jointly published "the World City of Film Qingdao Declaration," which aims at strengthening the cooperation in film and other creative fields. The Qingdao Film and Television Industry Elite Exchange was held in 2017, which attracted six major Hollywood companies to visit and negotiate further cooperation. This was followed by the 2017 Chinese Film Festival, the 2017 Asian Film and Television Cultural Forum, the 16th Film Performing Arts Society Awards, the Golden Phoenix Award, the Qingdao Film Fair and the 15th National Cinema Film Promotion Conference. In April 2018, the 16th National Cinema Film Promotion Conference was held in Qingdao. In June, the SCO National Film Festival and China (Qingdao) International VR Image Week were held in the city again. Film has become an important medium between Qingdao and other global creative cities. Film and cultural exchanges in the global creative city network promote exchanges and cooperation in the fields of economy, education, science and technology, tourism, etc., and create a more open and human environment for the development of the city.

Ongoing development of film education

In addition to its claim to be the home of numerous film stars, Qingdao also provides talent support for the development of the industry through multi-level and all-round film education and training. There are nearly ten colleges and universities offering film and television performance courses as well as a large number of performing arts training organizations, providing ample space and opportunities for young people to receive film-related education and training.

The apex of Qingdao film and television education is Beijing Film Academy Modern Creative Media College, which is the only independent college of the Beijing Film Academy. It is an undergraduate full-time degree, educational institution officially approved by the Ministry of Education. The College has eight film major departments and one basic teaching department, with subjects ranging from literature, directing, performance, cinematography, photography, visual art, sound and technology, animation, to media management. Launched in 2011, the College has followed a policy of "scientific planning, step-by-step implementation, education with focus, and the encouragement of crossovers" as its philosophy for program design. And it also proposed "Controlling scale, moderate development, focusing on connotation, and paying attention to quality" as its philosophy for program

development. The college has created its academic programs with film art as the programs and the four majors: art, management, literature and law. Since 2011, 22 undergraduate majors have been launched, including drama, film and television, literature, film and television directing, performance, cinematography, film and television design, animation and cultural industry management, etc. There are nearly 2,000 students in total. Drama, together with film and television studies, have all been listed as key education disciplines by the city of Qingdao. The majors in drama, film and television, literature, drama and film directing, performance, cinematography and animation are the College's main undergraduate majors, and the College directly reports to the Shandong Provincial Department of Education. The College adheres to the philosophy of strong integration, a solid foundation and practical work in educating film and television talents. The syllabus includes digital film and television production, new media art, network art and animation game design. These skills are urgently needed by the country as Chinese young people are familiar with film and television and understand modern technology. There are nearly 1,500 graduates enrolled in three-year courses, and they are highly praised by employers on account of their good basic quality, professional skills and comprehensive ability.

The Qingdao Shanghai Theater Academy Art School was established in December 2011. Jointly established by the Shanghai Theater Academy and the Qingdao Economic and Technological Development Zone Management Committee, it is a full-time, comprehensive secondary art school with national recognition. The School is headed by the Huangdao District Government of Qingdao, which is fully responsible for its operation and development.

With the goal of "educating first-class practical artistic talents with the potential to adapt themselves to the needs of the cultural industries and cultural undertakings, and providing high-quality art students for higher art institutions," the School offers ordinary high school academic art classes and secondary vocational educational art classes. Currently, there are nearly 740 students and 124 faculty members.

The College has employed a group of famous academic staff and filmmakers from home and abroad to participate in the teaching and management of the College. Since the formal enrollment in the fall of 2012, the School's operation and management have been well run, with ongoing improvement of professional strengths. The rate of graduates' enrollment has greatly exceeded the average level for Shandong Province. Students and academic staff continue to win awards in various professional competitions both locally and nationally, which also reflected well on their reputation in return.

Conclusion

Based on a comprehensive analysis of its own strengths and weaknesses, and opportunities and challenges, Qingdao has identified its position in a global network, and strategically determined its identity as a world "City of Film."

Based on such considerations, Qingdao seized the opportunity to fully launch the application for UNESCO's "City of Film." With UNESCO, one of the most influential international organizations, Qingdao will be able to promote itself internationally such as showcasing its strength in the film industry, its international popularity and global recognition. Thus, Qingdao will become an international film hub to attract global film talents and to achieve the leap forward to develop Qingdao's film industry to an international standard.

In light of the national strategy for the transformation toward a nation of new and dynamic energy, and a modern economic system, Qingdao takes film as the major player for the development of its cultural industry. This is also due to the application of the following five concepts of national advocations: "innovation, coordination, green awareness, openness, sharing." The overall implementation of this "five in one" policy is the guidance for the development of Qingdao's film industry. As a result of large-scale investment and construction, Qingdao's Lingshanwan Film and Television Cultural Industry Zone has seen a "butterfly transformation" from a remote rural area to a new industrial zone. In this new journey of constructing Qingdao as the "City of Film," the local film industry is bound to become the new engine for the transformation of Qingdao's urban development, and the "Oriental Hollywood" will definitely emerge soon in China.

Index